The Music of Nobuo Uematsu in the
Final Fantasy Series

Studies in Game Sound and Music

Series editors: Melanie Fritsch, Michiel Kamp, Tim Summers, and Mark Sweeney

Intellect's Studies in Game Sound and Music publishes accessible, detailed books that provide in-depth academic explorations of topics and texts in video game audio. Titles in this series present detailed analysis, historical investigation, and treatment of conceptual and theoretical issues related to game audio.

The series does not seal game audio into a scholarly suburb but is instead outward-looking: it seeks to engage game audio practitioners and researchers from a range of disciplines, including anthropology, performance studies, computer science, media studies, psychology, sociology, and sound studies, as well as musicology.

The Music of Nobuo Uematsu in the *Final Fantasy* Series

EDITED BY

Richard Anatone

intellect

Bristol, UK / Chicago, USA

First published in the UK in 2022 by
Intellect, The Mill, Parnall Road, Fishponds, Bristol, BS16 3JG, UK

First published in the USA in 2022 by
Intellect, The University of Chicago Press, 1427 E. 60th Street,
Chicago, IL 60637, USA

A catalogue record for this book is available from the British Library.

Copy editor: Newgen
Cover designer: Tanya Montefusco
Production manager: Sophia Munyengeterwa
Typesetting: Newgen

Hardback ISBN 978-1-78938-554-0
Paperback ISBN 978-1-78938-860-2
ePDF ISBN 978-1-78938-555-7
ePub ISBN 978-1-78938-556-4

Part of the Studies in Game Sound and Music series
ISSN: 2633-0652 / Online ISSN: 2633-0660

Printed and bound by Lightning Source.

To find out about all our publications, please visit
www.intellectbooks.com.
There you can subscribe to our e-newsletter, browse or download our current
catalogue, and buy any titles that are in print.

This is a peer-reviewed publication.

About the Companion Website

https://www.ludomusicology.org/studies-game-sound-music/uematsu-final-fantasy/

A companion website accompanies *The Music of Nobuo Uematsu in the* Final Fantasy *Series*. This site includes supplemental musical examples that were unable to be included in this collection. Readers will find endnotes within this collection that direct readers to supplemental examples (e.g., "see Supp. 4.5") that provide annotated musical examples, tables, charts, and other figures that were not included in this book. Additionally, any updates to the book, additional materials, and corrected errors will be posted to this website.

Contents

Illustrations

Examples

Figures

Tables

Foreword

Dear Friends

William Gibbons

I laughed the first time I heard the term "Xennial" because I thought it sounded like an especially cheesy *Final Fantasy* (*FF*) boss. It is not, of course—trust me, I checked. Turns out Xennial actually refers to people like me, born around 1980 and blessed with hazy recollections of a pre-internet childhood. I think my initial reaction to my microgeneration's name is appropriate, because like a lot of geeks about my age, I grew up with *FF*. I am no completionist, but I *have* played every game in the main series, usually within a year of their release.

These decades of dedicated fandom give me license to offer up a deep truth about the *FF* series: not one of these games makes any damn sense. At last count there are fifteen main series titles, each of which suffers from some combination of gaping plot holes, uneven pacing, absurd dialogue, needlessly complicated game-play systems, and a host of other complaints. So what keeps me coming back time and again? Two things: the people, and the music.

We all have our favorite *FF* characters—the ones who you just *have* to keep in your party, and who stick with you long after the credits roll. But none of those characters exist in isolation. In fact, I do not think it is an exaggeration to say that if there is a theme that links every *FF* game, it is the idea that there is a special power in relationships. Over and over, *FF* tells stories of ragtag, motley groups of deeply flawed misfits who nonetheless join together to save the world. That is a compelling message, especially for those of us who always felt a bit like misfits ourselves. And despite most *FF* titles being single-player experiences, over the years these games have helped millions of people feel less alone.

I am a case in point. Learning to play *FF* on the tiny tube TV connected to our NES offered 8-year-old me a rare chance to bond with my chronically ill father.

As a painfully shy sixth-grader at a new school in a new state, I met a new friend when I heard someone picking out a tune from *FFIV* on the choir room piano during lunch. The copy of *FFVI* I got as a birthday gift the summer before high school helped me find common ground with my much cooler cousin who had just moved to town. *FFVII* and *VIII* turned my basement into a social hub for my own motley group of high school friends—and *IX* gave us a reason to come back together after we all left for college. "And so it goes, on and on," as the epilogue to the first *FF* tells us.

For all those reasons, it has always seemed particularly fitting to me that one of the first touring concerts of Nobuo Uematsu's *FF* music was titled *Dear Friends*. Not only are my memories of the *FF* games deeply connected to other people, but the music itself feels like an old friend. I have spent countless hours with Uematsu's music, whether through playing the games, conducting my research, or just listening for pleasure. Like any good scholar of musical multimedia, I know how sound works to manipulate our emotions—but despite my cynicism, I can never suppress a nostalgic frisson when the "Crystal Theme" sneaks its way into each game.

These two worlds of *FF*—the music and the people—came together for me again some years ago, when the study of game music began to really gain traction. By virtue of my Xennial status, I was able to get into game music research early on, around 2008 or so. Over the course of more than a decade pursuing the study of game music, I have had plenty of opportunities to write about Uematsu and *FF*. But more importantly the great pleasure to read, hear, edit, critique, and otherwise enjoy the work of dozens of thoughtful scholars, each of whom has been passionate about this music in their own way.

Our meetings—real or virtual, formal or informal—are places where "One-Winged Angel" and the "Aria di Mezzo Carattere" do not require an introduction, where you can start a conversation with a stranger when you compliment their chocobo pin, and here "spoony bard" jokes always get an appreciative chuckle/groan. They are spaces of friendship, and music, and friendship *through* music.

All of which brings me to this book. The collection of essays in this volume address the monolithic position Uematu's *FF* scores occupy within game music. And in true *FF* fashion, Richard Anatone has tackled this truly daunting task by forming a party. Each of these disparate scholars contributes unique benefits to the party as a whole, and they show us that by working together we can collectively accomplish what none of us could as individuals.

I have known most of the authors in this volume for years. One of them has an office across the street from me, one of them co-wrote a chapter on *FF* with me last year, two of them invited me to be on their master's thesis committees, and several

others I have met through conferences and gatherings around the world. In each case I am better for knowing them and their research. I plan to spend time with this fascinating book, and its equally fascinating contributors, for years to come. And I hope that by engaging with this scholarship and being part of the community learning about the music of *FF*, you will also come to view all of us—even those you have not yet met—as dear friends.

Introduction

Richard Anatone

I still vividly remember going for long daily bike rides during my childhood summer breaks. We did not have a nearby bike path, so I would circle around the neighborhood dozens of times, spanning what was likely several hours at once. I also did not have a portable radio or Walkman to listen to as I biked, so like Winnie the Pooh, I often hummed a little something to myself for hours on end. And as an avid fan of the Nintendo Game Boy, I naturally hummed the music to one of my favorite games, *Motocross Maniac*, a motorcycle racing game. I do not quite recall whether I actually envisioned myself racing against a group of 8-bit fictitious green/gray cyclists, but it is certainly possible; I *was* in grade school, after all.

Fast forward some twenty years, where I attended graduate school in Indiana. Lo and behold, there was a 62-mile bike path minutes from my apartment. This time, I had better gear, and so I adamantly rode this path any chance I could get during warmer weather. Choosing to forego the use of my mp3 player as I biked, I again found myself humming the same tunes from *Motocross Maniac* that I used to hum to myself all those years ago. To this day, I *still* find myself humming one melody in particular—the music from Course 1—when I am biking, driving, or engaging in physical activity. I even quoted a fragment of this tune in a funk fugue that I wrote for sax quartet.

I know that it may seem odd to begin an introduction to a volume on the music of Nobuo Uematsu in the *Final Fantasy* (*FF*) series about the music to a fairly obscure Game Boy title—one that I am not sure even my friends are familiar with (except my siblings and cousins, of course). But if you are reading this book, I would like to hope that it makes sense, because regardless of the game, the platform, the audio technology, or even the so-called legacy status of the game, these tunes stick with us and often carry more personal meaning than music from the traditional or "classical" canon. Whether it is a classic melody like the theme to *The Legend of Zelda*, or it is a more obscure tune like the background track to *Revenge of the Gator*, this music was with us during our more impressionable

1

years as we played—played with the games themselves, played with our friends and family with whom we shared the gaming experience, and played with the music from these games.[1] The nostalgia factor alone within these tunes is enough to make grown adults—many of whom are not musicians—tear up when listening to these melodies from their childhood: one simply needs to scour the YouTube comments on classic NES and SNES soundtracks to see how impactful this music is to adults currently in their 30s, 40s, and 50s.[2] I would like to think that all video game fans have their own obscure *Motocross Maniac* tune that has stuck with them all throughout their years.

And yet, as meaningful as these tunes may be to us, the soundtracks to the "legacy" titles seem to garner much more attention in both popular culture and academic research, for a variety of reasons. Certainly, this is in part due to the popularity of the games themselves—whose fans often enjoy the music as much (if not more!) than the games they enhance. It is certainly not a stretch to suggest that titles that sell multiple millions of copies worldwide will garner more popularity in their soundtracks, simply because of their reach. Indeed, composers like Nobuo Uematsu, who have had the advantage of working on iconic franchises during their inception and throughout much of their lifespan, are among the most popular and beloved composers in the field and have arguably attained a type of informal canonic status—whether intentional or not—within the world of video game music fans and scholarship.

Did this informal canonization within the fanbase happen organically, simply as a result of the game's (and, by extension, its music's) worldwide popularity? While this may be a possibility, there are certainly other contributing factors. For example, William Gibbons cites the increasing popularity of video game music concerts and studio recordings as a leading component. He separates these concerts into two types: (1) those that celebrate individual composers and/or games; and (2) the "musical potpourri" concerts, which contain works that span the "history" of video game music,[3] which often include music from legacy titles. To be sure, Uematsu's music is often included in both of these concert types: Gibbons writes, "As high-profile symphonic concerts of game music become increasingly common, and those concerts then make their way into studio recordings and Spotify playlists, the canonizing process is speeding up" (2020: 77). Indeed, Stefan Greenfield-Casas's chapter in this volume addresses "Uematsu and the concert hall," arguing that early concertized performances of *FF*'s music in the 1980s reinforced its status in the video game music canon.[4] While the concertizing of video game music may not be the *sole* contributing factor in the establishment of the canon, it is certainly a component due to the "high art" status that often comes with the traditional concert setting, which is only heightened further through performances by world-renowned orchestras.[5]

And of course, canonicity is not without its inherent problems, from the perspective both of accurate historicity and of equal representation. The inaugural issue of the *Journal of Sound and Music in Games* contains a four-part colloquy dedicated to this very issue, with each writer approaching different aspects of the underlying issue.[6] And yet, this is where studies of game music have a unique advantage over the traditional repertoire: as the field is relatively new (at least compared to other subfields of musicological research), scholars are aware of potential problems inherent with canonicity in other art forms and are adamant about preventing these issues from overtaking the field. While most agree that a canon is being formed and history being written, they recognize the importance of preventing it from being the *only* history that is conveyed to fans and scholars through concerts and scholarship. In other words, scholars can effectively have their cake, and eat it too—we can recognize the importance of the influential legacy composers while at the same time ensuring that their story is not the *only* story being told, thus ensuring equal representation in both performance and scholarship. This sentiment is reflected in Karen Cook's contribution to the colloquy, writing:

> In no way do I wish to deny our founding figures their rightful place or to suggest that we not continue to make use of their excellent work, of which I imagine there will be much, much more [...] if one of our concerns as a field is the creation of canons, and potentially one of our goals the mindful avoidance of canonic entrenchment, then to fill the field with diverse people and their different perspectives can only help.
>
> (2020: 98)

We can, indeed, recognize and continue to celebrate the "founding figures" who have attained—perhaps ostensibly—canonic status while ensuring that their history and works are not the only history and works that are acknowledged. Gibbons sums it up thusly:

> The narrative presented at these [video game music concerts] is one of a panoply of possible histories of game music. At the same time, however, we must be wary of allowing it to be the only history of game music with which listeners are presented, or permitting [*Video Games Live's*] limitations to pass by uncritically. Indeed, I hope that scholars of game music will actively resist replicating the historical weaknesses and structural inequalities of the classical canon. The monumental process of writing and rewriting cultural memory plays out in an endless series of small choices, even as innocuous as video game music concerts.
>
> (2020: 80)

I briefly address the issue of canonicity here because, for better or for worse, Nobuo Uematsu *is* a canonic composer in video game music. He has been likened to Beethoven, John Williams, and Wagner;[7] his music has won multiple official awards over the years;[8] his music is arranged and performed regularly by professionals and amateurs alike, attaining hundreds of thousands of views on YouTube; his original soundtracks have garnered millions of views on YouTube; his music continues to appear on "fan favorite" lists in gaming magazines and on the internet; his music has been, and continues to be, the topic of academic research.[9] I say this not to elevate Uematsu to a godlike status (we all know what happened to Kefka and Sephiroth), but this does raise the question: what is it about *his* music that generates so much interest? What causes grown adults to cry when listening to his melodies, whether it is chiptunes, MIDIs, or live performances? What is it about his music that causes so many people to painstakingly arrange it themselves so they can perform it, both in concert settings and on personal amateur YouTube accounts? And, more pertinent to this book, how can we address his music from a variety of analytical techniques in order to gain a deeper understanding of the meaning behind his music and the stories that they enhance—stories that, in many ways, have more philosophical meaning to fans than many classical works?

This book attempts to provide insight into the last question through a variety of different methodologies. While the groundwork for ludomusicology lies in the foundational research of Karen Collins, William Cheng, William Gibbons, Tim Summers, and Isabella van Elferen (among others), I refer to the second chapter of Tim Summers's *Understanding Video Game Music* titled "Methods of Analysis": here, he discusses various techniques for analyzing video game music, separating them into what he calls "In-Game Sources" and "Satellite Sources." While the latter contains sources outside of the video game itself (game documents, reviews, player comments, interviews, etc.), the former considers—as its name would suggest—sources within the game, including: (1) analytical play, (2) programming and music data, and (3) musical material. The last of these is, quite obviously, of particular significance and is further separated into a variety of methodologies, many of which serve as the framework for individual chapters within this collection: (1) mapping motivic relationship and thematic development; (2) harmonic analysis; (3) topic analysis, semiotics, and intertextuality; (4) psychological effects; (5) hermeneutic; (6) form analysis; (7) ethnomusicological study; and (8) performance (Summers 2016: 39–44).

This list does not represent an exhaustive list of methodologies, nor does Summers suggest a single approach when conducting analysis:

> I certainly do not wish to prescribe a single approach to investigating game music—
> such an attitude would be entirely antithetical to the aim of this volume. Instead,

I hope to point the way towards some of the sources and modes of analysis that I have found to be most useful and rewarding.

(2016: 33)

As readers will see, the chapters herein approach Uematsu's music from a variety of methodologies. This book therefore serves as a demonstration of how many different analytical tools may be applied to a single composer in a single franchise—albeit a composer who spanned multiple generations of consoles within the same franchise.

The individual chapters in this book have been organized into four sections with consideration to the type of methodology used to approach Uematsu's music; and as an homage to the role-playing game (RPG) (as well as an attempt to play with terminology), I have named these four sections after well-known locations from the *FF* series—each representing a different musical cue found within the RPG genre[10]: "Coneria Castle," "Nibelheim," "The Lunar Whale," and "World of Balance."

In medieval fantasy-based RPGs, castles represent a strong tradition within the game's narrative. It is within these castle walls that players learn the history of the fictional world. Indeed, the original *FF* begins with the heroes standing outside of Coneria Castle[11] before speaking to the king who gives them their first mission. The first section of this book, named after Coneria Castle, therefore contains three chapters that employ more traditional methodologies to Uematsu's music: motivic and formal analysis, Schenkerian analysis, neo-Riemannian analysis, and contemporary rhythmic analysis. In Chapter 1, Jessica Kizzire suggests that following Kefka's rise to godhood in *FFVI*, villains in subsequent installments of the series followed a similar trajectory, which, as she demonstrates through motivic, formal, and timbral analysis, is reflected in their associative music. Due to its legacy as both a fan-favorite and a technological hybrid of live choir with MIDI, James S. Tate conducts a formal analysis of *FFVII*'s "One-Winged Angel," employing both Schenkerian and neo-Riemannian techniques to help foreground Uematsu's compositional methods and influences. And lastly, following the theories of diatonic rhythms put forth by Jay Rahn and Mark Butler, Ross Mitchell's contribution conducts rhythmic analysis on a variety of battle music across the *FF* series, suggesting the need for a new category of rhythmic grouping.

Towns often represent "safe spaces" for characters in RPGs—free from villainy and monsters. Yet, they sometimes represent areas where players learn secrets of the game's history: through talking to the townspeople, players learn the hidden history of the town, the fictional world, and, of course, characters within the game. Such is the case in *FFVII*'s village of Nibelheim, where the player begins to learn the secrets of the Sephiroth, Jenova, and the Ancients, as

well as Cloud and Tifa's backstory. Thus, the second section of this book, named after the town of Nibelheim, contains three chapters that consider Uematsu's music from the perspective of semiotics and hermeneutics, attempting to find hidden meaning in the soundtracks. Beginning with *FFVI*, I consider the opening ten-measure sequence "Omen" as a satirical parody of both Richard Strauss's *Thus Spake Zarathustra* and Uematsu's own rising fourth motive, as well as a symbolically dense introduction that musically foreshadows the entire game's narrative: the rise and fall of the Gestahl Empire. Sean Atkinson's chapter examines the music associated with Vivi and Garnet/Dagger from *FFIX*, building two separate webs of interconnected thematic families related to each character. Through tropological analysis, Atkinson demonstrates how Uematsu reveals each character's hidden past and their surprising future through each subsequent transformation of their themes. And lastly, James L. Tate approaches *FFIX* through the lens of nostalgia: building upon Kizzire's (2014) earlier work, Tate suggests that the game's success is in part due to its returning to its roots through the use of self-quotation and allusion—musically and narratively. Through musically induced nostalgia, Tate argues, *FFIX* harks back not only to the high-fantasy setting of previous installments of the series but also to the childhood of individual players.

All good RPGs contain an airship—a fantastical transportation device that allows the party to explore not only the known world, but also worlds unknown. The airships in *FFIV*, for example, allow players to travel across the globe, underground to the world's cavernous underbelly, and into outer space destined for the moon. The third section of this book is therefore named after the "Lunar Whale"—the airship from *FFIV* that brings the players to outer space for the first time in the series—and contains chapters that explore Uematsu's music outside of the traditionally expected *FF* series. Alan Elkins's chapter, "Penultimate Fantasies: Compositional Precedents in Uematsu's Early Works," for instance, gives a comprehensive analysis of the over one dozen games that Uematsu worked on prior to the first installment of *FF*—spanning multiple genres and platforms, most of which are relatively unknown in the West. Stephen Tatlow tackles the underlying problems of MMORPGs and their shared musical and narrative experience due to the asynchronous nature of multiplayer online gaming. Based off of his own analytic gameplay, Tatlow provides readers with an in-depth discussion of the successes—and failures—of the different musical events and experiences. Lastly, Julianne Grasso's chapter approaches the two rhythm-based games dedicated solely to Uematsu's music, *Theatrhythm Final Fantasy* and its sequel *Theatrhythm Final Fantasy: Curtain Call*, initially released in celebration of the franchise's 25th anniversary. As Uematsu's music has been repurposed for this new

rhythm-based game, Grasso explores how *Theatrhythm* allows players to re-experience the music through the process of remediation.

Which brings us to the last section, named after the "World of Balance"—the overworld from *FFVI*—which quite literally refers to the open world, where the possibilities are endless, much like the chapter topics within this section. Indeed, as the name suggests, our musical understanding attains balance when we employ every type of methodology at our disposal. Thomas B. Yee's chapter approaches Uematsu's leitmotifs through the lens of feminist musicology, addressing musical representation of gender in the *FF* franchise. Here, he discusses Uematsu's more traditional approach to gendered leitmotifs within *FFIV–IX* and demonstrates how later composers shift away from these tropes through the use of more progressive compositional techniques. Stefan Greenfield-Casas examines the transfer of Uematsu's music from the console to the concert stage, focusing on two such strategies: arrangement and transcription. For the former, Greenfield-Casas looks at *Final Fantasy X: Piano Concerto*, addressing how arrangements can provide listeners a way to both re-experience the game and also experience an entirely new hearing of the game's narrative. Regarding transcription, he examines several different versions of *FFVI*'s "Dancing Mad" and the "political" decisions behind each transcription. And finally, Andrew Powell and Sam Dudley address *FFX* from the perspective of musical allegory, as they trace the various musical transformations of the recurring Hymn of Fayth and its religious symbolism regarding the game's underlying narrative.

My first encounter with *FF* and thus the music of Nobuo Uematsu occurred when I was in grade school, with 1994's release of *FFVI* (*III* in the United States). Like so many others, I was completely mesmerized by the in-depth storyline and intricate soundtrack, and over the years, I sought out every *FF* title I could get my hands on, seeking out fan-sites in the early days of the internet, downloading MIDIs from the various games, engaging in the "Mystery MIDI" group on AOL, and even going so far as to create the unofficial *Final Fantasy Newsletter* through America Online as an outlet for fans to provide their thoughts and insights on the games and music. It is clear that I was not alone in my interests; over the years, thousands of fans and scholars have approached the franchise from philosophic, political, religious, and, of course, musical perspectives. And although this collection focuses primarily on Uematsu's music within the series, the musical analysis leads to a greater understanding to the allegories they enhance through the intersection of these different branches of study. While this collection is by no means an end-all when it comes to this composer or series, it is my wish that it may serve as a framework for further studies when considering single composers and game series.

NOTES

1. Tim Summers discusses how music can "harbor ludic qualities," proposing that video games "highlight how music in its concert, cinematic, and game presentations can be understood to be implicitly playful, primarily through our awareness of its 'potential to be otherwise;' " as players consider the musical possibilities within a game, they engage in what he terms "playful listening" (see Summers 2021: 702).

2. William Cheng makes this observation in his chapter "How Celes Sang" regarding Celes's "Aria di Mezzo Carattere." As of this writing, one of the many YouTube recordings of this track from the OST contains over 306,000 views, with many comments regarding its emotional impact. Ses Chapter 2 of Cheng (2014).

3. As Gibbons (2020) discusses, "whose history?" is an important question regarding these concerts. He suggests that the programmed music for Video Game Live concerts may portray an inaccurate understanding of video game music history while at the same time focusing on more recent works with a narrow player demographic. Both of these issues suggest a skewed version of history.

4. Greenfield-Casas builds some of his work on Elizabeth Hunt's research into the history of video game concerts. See Hunt (2017).

5. Gibbons discusses the "high art" status associated with traditional art music and the complicated relationship between video game music and the concert hall: while concertized video game music may bring in a larger audience and an increase in revenue for struggling orchestras, critics see this as a gimmick, with the "ultimate goal" of bringing people back to see composers like Beethoven and Mozart. Still, other critics see this is completely counterproductive, because it "devalues" the high art status of the traditional canon. See chapter 11 of Gibbons (2018).

6. The four-part colloquy contains a variety of different perspectives regarding video game music canonicity: William Gibbons discusses the concertizing of video game music, while Julianne Grasso suggests that both official and fan arrangements of video game music may relay different personal experiences of game play. Hyeonjin Park discusses the problems of canonicity regarding diversity and equal representation in the field, and Karen Cook approaches the canon through an academic and pedagogical lens. See *Journal of Sound and Music in Games*, vol. 1.

7. ClassicFM's article is but one of dozens of articles that compare him to Beethoven and Wagner. See ClassicFM (2019).

8. For instance, *FFVI*'s music was awarded Best Music for a Cartridge-Based Game in 1995's issue of *Electronic Gaming Monthly's Buyer's Guide*, as well as Best Music in *Gamefan Magazine* (1995), vol. 3, issue 1. Additionally, the ballad "Eyes on Me" from *FFVIII* was the first video game piece to win Song of the Year (Western Music) in the Fourteenth Annual Japan Gold Disc Awards in 1999.

9. For instance, the free online bibliography for the Society for the Study of Sound and Music in Games yields fifteen different entries for the term "Final Fantasy," which is among the

most entries for any game title (along with "Mario" and "Zelda"). Many of these results are articles, papers, or chapters that are dedicated solely to the music from this series. Additionally, there have been several scholarly books published on *FF*, including *Final Fantasy and Philosophy* (2009) and *Final Fantasy and Psychology: Surpassing the Limit Break* (2020).

10. Gibbons discusses a variety of different "location-based" musical cues and "game state" musical cues. See Gibbons (2017).

11. "Coneria Castle" is the translation of this castle in the 1990 US release for the NES. The name was retranslated to "Castle Cornelia" in the 2002 PlayStation release *Final Fantasy: Origins*, as well as subsequent rereleases of *FF*.

REFERENCES

Anon. (1995), "Gamefan's Third Annual Megawards", *Gamefan Magazine*, 1:3, pp. 68–75, https://archive.org/details/GamefanVolume3Issue01January1995/page/n71/mode/2up. Accessed September 28, 2020.

Baysted, Stephen (ed.) (2020), *Journal of Sound and Music in Games*, 1:1–4.

Cheng, William (2014), *Sound Play: Video Games and the Musical Imagination*, New York: Oxford University Press.

ClassicFM (2019), "Here's How Nobuo Uematsu Changed the Course of Classical Music with His Final Fantasy Score," June 10, https://www.classicfm.com/composers/uematsu/music/final-fantasy-soundtrack. Accessed September 28, 2020.

Cook, Karen M. (2020), "Canon Anxiety?," *Journal of Sound and Music in Games*, 1:1, pp. 95–99.

Gibbons, William (2017), "Music, Genre, and Nationality in Postmillennial Fantasy Role-Playing Games," in M. Mera, R. Sadoff, and B. Winters (eds.), *The Routledge Companion to Screen Music and Sound*, New York: Routledge, pp. 412–27.

Gibbons, William (2018), *Unlimited Replays: Video Games and Classical Music*, New York: Oxford University Press.

Gibbons, William (2020), "Rewritable Memory: Concerts, Canons, and Game Music History," *Journal of Sound and Music in Games*, 1:1, pp. 75–81.

Grasso, Julianne (2020), "On Canons as Music and Muse," *Journal of Sound and Music in Games*, 1:1, pp. 82–86.

Hunt, Elizabeth (2017), "From the Console to the Concert Hall: Interactivity, Nostalgia and Canon in Concerts of Video Game Music," *Ludomusicology 2017*, Bath Spa University, April 20–22.

Kizzire, Jessica (2014), "'The Place I'll Return to Someday': Musical Nostalgia in *Final Fantasy IX*," in K. J. Donnelly, W. Gibbons, and N. Lerner (eds.), *Music in Video Games: Studying Play*, New York: Routledge, pp. 183–98.

Park, Hyeonjin (2020), "The Difficult, Uncomfortable, and Imperative Conversations Needed in Game Music and Sound Studies," *Journal of Sound and Music in Games*, 1:1, pp. 87–94.

Summers, Tim (2016), *Understanding Video Game Music*, New York: Cambridge University Press.

Summers, Tim (2021), "Fantasias on a Theme by Walt Disney: Playful Listening and Video Games," in C. Cenciarelli (ed.), *The Oxford Handbook to Cinematic Listening*, New York: Oxford University Press, pp. 690–711.

PART 1

CONERIA CASTLE

1

Dancing Mad:
Music and the Apotheosis
of Villainy in *Final Fantasy*

Jessica Kizzire

Hee, hee! Nothing can beat the music of hundreds of voices screaming in unison.
(Kefka Palazzo from *Final Fantasy VI*, Square 1991)

Known for his iconic synthesized laughter and remorseless homicidal behavior, *Final Fantasy* (*FF*) *VI*'s Kefka Palazzo stands out as one of the most infamous villains in video game history.[1] Ruthless in his quest for power, Kefka poisons the water of a town under siege, murders the emperor he supposedly serves, and eventually destroys the world in his ascent to godhood. Unlike the antagonists of other *FF* titles, Kefka enjoys an unusual degree of success; although the game's protagonists eventually overcome the deified villain, they do so only *after* he has completed his quest for power. By permanently restructuring the world according to his own desires, Kefka leaves a legacy that lasts well beyond his defeat. Indeed, Kefka's influence extends well beyond his own game, shaping the aspirations and musical treatment of villains in subsequent *FF* titles.

In addition to this exceptional antagonist, *FFVI* features several other notable characteristics, many of which dramatically altered the trajectory of subsequent games. Originally released for Super Nintendo in 1994, Square's *FFVI* was the first game to introduce industrialization to the franchise, thus breaking with the shorter fantasy-based narratives and medieval settings of previous titles. In addition to the expanded narrative structure and significantly increased cast of characters, the game included an extensive musical soundtrack by composer Nobuo Uematsu. Drawing on elements of Wagnerian opera, Uematsu's score presented

a substantial number of distinctive character themes, which operate as leitmotifs throughout the soundtrack.[2] It even contained an in-game operetta, which the player must perform to advance the storyline.

Not surprisingly, the game and its antagonist have proven a rich source of study for scholars in many disciplines, including philosophy and musicology.[3] Kylie Prymus (2009), for example, examines Kefka's nihilism from a philosophical perspective, interrogating our motivations for labeling him as a madman. By contrast, William Cheng (2014) approaches the game from an aural perspective, beginning his analysis of synthesized voices in *FFVI* with a close reading of the sonic impact of Kefka's distinctive laughter. These scholars explore different facets of Kefka—character and sound—both of which are important for our understanding of the villain, but they only begin to scratch the surface.

So far, links between Kefka's character and his musical themes remain largely unexplored, as is his influence on the themes of subsequent *FF* villains. This chapter provides a close reading of Kefka's primary theme and its significance for our understanding of the character before turning to an examination of his musical legacy. Themes associated with the primary antagonists of subsequent games exhibit clear stylistic influence (as in Sephiroth's themes from *FFVII*) or contain direct musical allusions to Kefka's themes (as is the case for Ultimecia's many themes in *FFVIII*). This chapter undertakes a comparative analysis of themes associated with the primary antagonists of *FFVI–IX*, tracing the musical influence of Kefka's apotheosis on subsequent antagonists who would attempt the same goal.

Defining allusion

Any examination of Kefka's musical legacy necessarily begins with a closer examination of our definition of allusion. Originating as a literary device, scholars agree that allusion is, at heart, a referential act; an object, person, event, or idea in the present refers to another object, person, event, or idea as a conveyor of one or more associated meanings.[4] As Michael Leddy notes, allusions are small-scale devices operating only at a local level (1992: 110). In other words, an allusion is an individual referential gesture contained within a broader text, rather than a more general reference made by an entire work. For this reason, Leddy questions whether allusion-words are appropriate descriptors of nonverbal media, concluding that "allusion is a verbal category without very obvious non-verbal equivalents" (1992: 115).

In musicological scholarship, allusion remains an elusive term, since these types of referential gestures are usually subsumed under descriptions of musical borrowing or quotation. J. Peter Burkholder (1985, 1987) has written extensively on quotation and paraphrase in the music of Charles Ives. He has also called

for greater critical focus on issues of musical borrowing, proposing a detailed taxonomy of different categories and types (Burkholder 1994: 854). Burkholder includes "stylistic allusion" as one of the many possibilities, but this application of the term takes it beyond the local level and thus would be more rightly described in the broader language of stylistic influence. Other scholars have used the term "allusion" as a means of distinguishing varying degrees of fidelity to the original musical source; for example, regarding Elgar's second symphony, Allen Gimbel argues that although quotation and allusion both constitute conscious borrowing on the part of the composer, they can be distinguished from each other based on "exactitude, specifically of the pitch parameter" (1989: 233). However, as Leddy (1992: 116) observes, such distinctions are problematic from a literary perspective because allusion and quotation are not synonymous processes.

Nonetheless, a few scholars have chosen to look more specifically at the process of musical allusion. One of the most extensive treatments of the subject is Christopher Alan Reynolds's *Motives for Allusion: Context and Content in Nineteenth-Century Music* (2003). After noting the lack of critical attention given to the operational details of musical allusions, Reynolds goes on to distinguish two primary ways in which they operate, either accepting or subverting the meaning found in the original source (2003: 16). Reynolds's analyses remain focused on local musical gestures, largely avoiding Leddy's (1992: 116) criticism that allusion-words in music are often misapplied to encompass much broader questions of form, style, or technique.

Taking these existing definitions and concerns as a starting point, this chapter focuses on the more specific term of "allusion" rather than the musical concept of quotation. Discussing these examples in terms of musical allusion allows for a closer examination of the associations they bring to bear on their context, which a discussion of quotation would not sufficiently capture. Furthermore, although referential to other musical gestures in significant ways, many of the examples discussed differ significantly from the musical ideas to which they refer. The use of allusion, rather than quotation, reflects this musical distance. For the remainder of this analysis, a musical allusion will be considered a local referential musical gesture that brings one or more musical or extramusical associations to bear on its context, without the use of direct musical repetition.[5] Any instances requiring broader discussions of stylistic influence that fall beyond the local scale of allusion will be clearly indicated as such.

Final Fantasy VI: Kefka Palazzo

Dressed in colorful garb and makeup befitting a jester, *FFVI*'s Kefka Palazzo is widely regarded as an evil madman. Court mage to Emperor Gestahl, Kefka is

the product of genetic experimentation—the first attempt to infuse magicite (the crystalized remains of magical beings called Espers) into a human. The operation has limited success, allowing Kefka to wield magical powers, but it also causes a deterioration in his mental state, leaving him increasingly prone to angry and violent outbursts. Cheng summarizes Kefka's character effectively when he says, "Meet Kefka—flamboyant jester, trickster extraordinaire, nihilist psychopath" (2014: 57). Kefka's actions throughout the game show him to be short-tempered, unpredictable, and hungry for power, as other characters question his sanity and his humanity at various points throughout the game.

When composing the soundtrack for *FFVI*, Uematsu closely associated Kefka with two pieces of music: the first, "Kefka," occurs during significant narrative moments involving the character; the second, "Dancing Mad," plays during the four-stage final boss battle. When players are first introduced to the character, "Kefka" begins before he becomes visible on screen, helping to frame our expectations of what type of figure he will be. Overall, the piece has a playful and dance-like quality, moving at a moderate tempo with a light texture and an emphasis on woodwind timbres. This theme and his characteristic laugh serve as markers of his presence throughout the game. By contrast, "Dancing Mad" possesses more musical weight and complexity, demonstrating clear influence from Western Baroque church music, particularly in the third movement, which features solo organ and includes quotations of J. S. Bach's *Toccata and Fugue in D Minor*. The four-section piece relies on organ and choral timbres, as well as contrapuntal textures and elaborate ornamentation, to signal Kefka's transformative ascent to godhood. Because subsequent allusions to Kefka's music typically refer to "Kefka" and because "Dancing Mad" has been addressed in detail by Dana Plank (2018) and on widely available internet sources (SWE3tMadness 2009; Harris 2016), this analysis will focus primarily on the implications of Kefka's primary theme.

Like the character whose name it bears, "Kefka" deceives players, concealing the depths of his psychosis until later parts of the game. Kefka first appears in a mid-level position, commanding men of his own but clearly answering to a higher authority, Emperor Gestahl. In addition, his flamboyant costume and face makeup, which are reminiscent of a court jester, make it difficult to take the character seriously. Only later, when Kefka overthrows the emperor and takes the power of the Gods of Magic for himself, does it become apparent that he is the true primary villain of the game. Like his colorful garb, "Kefka" makes it difficult to take the villain seriously during his initial appearance; the light textures and syncopation lack the sense of weight or foreboding typically associated with the primary villain of a video game. Furthermore, it lacks overt musical indicators of instability, such as unpredictable rhythmic changes, harmonic instability, sudden shifts in tessitura, dynamics, or textures, or the frequent use of dissonant harmonies.[6] Only

FIGURE 1.1: Nobuo Uematsu, *FFVI*, "Kefka," form.

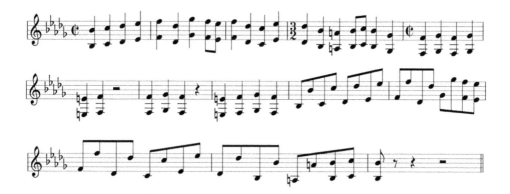

EXAMPLE 1.1: Nobuo Uematsu, *FFVI*, "Kefka," A section.

in later contexts does Kefka's theme take on more narrative power, revealing a clearer picture of his true nature.

Despite its initial façade, Kefka's theme contains peculiarities that suggest he is not quite normal—most notably the irregular phrase structures and syncopated rhythms. As the formal outline in Figure 1.1 indicates, the musical phrases that comprise "Kefka" are either unusually long or participate in unusual patterns of repetition. The A section (Example 1.1) is twelve measures long, with an unexpected one-measure meter change in m. 4. By contrast, the B section is highly regular in length, using a standard eight-measure structure, followed by a two-measure tag (Example 1.2). However, the uneven repetition of this musical idea disrupts listener expectations; in "Kefka," the B section repeats twice more (up an octave and with a thicker texture than the initial statement) before repeating the two-measure tag. Balanced repetition of the phrase would dictate one statement of B at the higher octave, followed by the tag (for a total of two statements), or a repetition of the tag in between the second and third statements of B (for a total of three). Uematsu avoids these options, effectively thwarting players' aural expectations.

The unbalanced repetition of the B section and tag is further reinforced through metric and melodic emphasis. Throughout the B section, syncopation

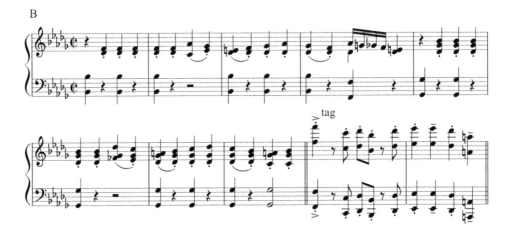

EXAMPLE 1.2: Nobuo Uematsu, *FFVI*, "Kefka," B section and tag.

and upper-neighbor motion shift the metric focus to the weaker, second half of the measure, further subverting the regularity of this eight-measure phrase. The two-measure tag interrupts the B section with a sudden shift in tessitura, strong downbeat, unison texture, and increased volume. Viewed in light of its irregular repetition as related to the B section, this tag operates as a musical outburst, analogous to Kefka's sudden verbal outbursts that occur throughout the game. "Kefka" concludes with another unusually long phrase, the eleven-measure C section (Example 1.3), which returns to the tessitura and texture of the preceding B section before feeding seamlessly back into the initial A section.

"Kefka" succeeds in deceiving audiences because reliable motion away from and back to the tonic within each phrase glosses over any irregularities in phrase structure. In particular, the melodic and harmonic motion throughout the three-section piece progresses with little disruption to expected conventions. For example, the melodic motion of the A section clearly emphasizes a tonic minor triad, reinforces the dominant for several measures, then returns to the tonic minor triad, ending on scale degree 1.[7] Similarly, conventional harmonic relationships occur in the B section and the C section, both of which begin on a minor tonic harmony, move to the major submediant, and return to tonic via descending melodic motion beginning on the fifth scale degree.[8] Each of these musical ideas logically presents melodic and harmonic motion beginning and ending on tonic, meeting players' aural expectations and giving the impression that Kefka is generally stable. During his initial appearance, "Kefka" signals the antagonist might be a little off, but he is not a significant concern.

As the game progresses, "Kefka" occurs in different narrative contexts, taking on new layers of meaning and signaling more clearly his deteriorated psychological

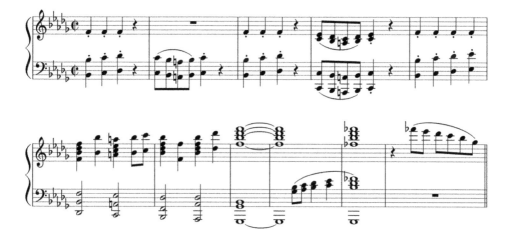

EXAMPLE 1.3: Nobuo Uematsu, *FFVI*, "Kefka," C section.

state. The first such instance happens during Kefka's infamous poisoning of Doma Castle's inhabitants. After a series of prolonged eaves-dropped conversations, players learn that Kefka intends to end the empire's siege of the castle swiftly and mercilessly, despite protests from his own men. A confrontation between the protagonists and Kefka ensues, resulting in Kefka's retreat from battle. Players then see Kefka standing at the river's edge, pouring poison into the water and reveling in the destruction he is about to cause, while his theme enters in the background. The light textures and playful articulations of the theme create a striking contrast to the events on screen, as players see the citizens of Doma Castle falling to their death one by one. The same elements that created Kefka's musical façade during his initial appearance now reveal him to be dangerous and homicidal. The lightness of his music is at odds with the gravity of his actions, suggesting not only that he feels no guilt but that he enjoys the carnage.

These later contexts juxtaposing the light musical content of "Kefka" with the narrative weight of situations involving widespread destruction and mass murder gradually reveal Kefka's true nature as the primary antagonist of the game. The musical and narrative façade of a simple court jester—a comical villain destined to be beaten on the way to the real villain of the game—eventually shows him to be something much more formidable. The same musical elements that create his façade become alarming indicators of a dangerous and unstable man. More than any other element, this opposition of musical content and narrative context gives "Kefka" its emotional power, creating an unsettling theme for the primary antagonist of the game.

Final Fantasy VIII: Ultimecia

Like Kefka, the villains of subsequent *FF* titles pursue a path to ultimate power, seeking to reshape their respective worlds according to their own desires. These characters reflect Kefka's influence narratively, in terms of character development and goals, but also musically through allusions to Kefka's themes. The most comprehensive and direct allusions occur in the music associated with *FFVIII*'s Ultimecia, a sorceress who shares Kefka's nihilistic perspective. Ultimecia attempts to absorb all of time into herself, thereby creating a world in which she alone exists. Allusions to "Kefka" (and to a lesser extent, "Dancing Mad") permeate Ultimecia's themes throughout the game, culminating in the themes heard within her castle and during the final boss battle sequence.

Tracks like "Succession of Witches" and "Fithos Lusec Wecos Vinosec" connect Ultimecia with her court jester predecessor through small-scale allusions. Both occur early in the game when a sorceress named Edea seizes control over the state of Galbadia. Just as players were deceived to believe Emperor Gestahl would be the primary villain of *FFVI*, so are players of *FFVIII* deceived by Edea. Only later in the game does it become clear that Edea has been possessed by Ultimecia, a powerful sorceress from the future who can project herself into the past. Musically, these themes clearly establish the sorceress as her own character, but allusions to "Kefka" within her themes encourage players to draw parallels between the two. For example, in "Succession of Witches," the melody of the final section uses a similar contour to the two-measure tag that follows the B section of "Kefka."[9] Uematsu combines this melodic allusion with an additional allusion to the C section of Kefka's theme in the accompaniment.[10] Beginning four measures before the melody enters, the accompaniment repeats a single rhythmic gesture throughout, with each measure including three repeated staccato quarter notes followed by a quarter rest. This rhythmic and melodic gesture begins the C section of "Kefka," and its presence immediately invites players familiar with *FFVI* to link the two characters. The oboe timbre that introduces the melody further indicates stylistic influence from Kefka's theme, which uses the same high woodwind timbre for its melody. In musical terms, "Succession of Witches" offers players their first introduction to the sorceress; the combination of allusion and stylistic influence in its final section invokes a subtle connection to Kefka and opens the door for further development of that relationship.

Like Kefka's theme during his initial appearance, "Succession of Witches" establishes a misleading initial persona for the sorceress, Edea. The piece begins with a haunting harpsichord melody, repeating a disjunct and dissonant eighth-note figure.[11] This brief introduction gives way to a sparse texture of chanting female voices and arpeggiated harpsichord accompaniment with the start of the

A section. These timbral elements stand apart from the other sounds encountered in the music up to this point in the game, giving the opening an eerie and suspenseful quality. The slow tempo and unsettled harmony further contribute to the sense of unease, while Edea's actions on screen present her as a powerful opponent. Unlike Kefka who appears trudging through the sand, the sorceress enters with a display of formidable power, materializing out of thin air, incapacitating the protagonists, and disappearing again while the player's party remains powerless. This combination of magical prowess and musical characterization portrays Edea as a threatening and villainous individual; only later in the game do players learn that Ultimecia has possessed Edea, who is actually a kind and gentle person. "Succession of Witches" effectively points to Edea as the game's primary villain, accurately identifying the sorceress (Ultimecia) as the main antagonist, but also misrepresenting Edea's character in the process.

The allusion made in "Fithos Lusec Wecos Vinosec" offers a more obvious and deliberate linkage between the villains of *FFVI* and *VIII*. This track occurs during an in-game cutscene, when Edea participates in a parade following her ascension to power. In this instance, the musical allusion is reinforced through simultaneous visual references to Kefka's character design. While the final section of "Fithos Lusec Wecos Vinosec" includes a direct melodic allusion to the B section of "Kefka" (Example 1.4), the images on screen reinforce this strong melodic parallel; the costumes of the parade dancers leading Edea's float resemble Kefka's court jester garb in *FFVI*.[12] Taken together, this visual and aural display in *FFVIII* invites players familiar with *FFVI* to recall Kefka as they approach their first confrontation with the sorceress.

While Uematsu's early-game themes may suggest a potential link between Kefka and Ultimecia for attentive players, the late-game music composed for Ultimecia's castle makes this tentative connection explicit. Ultimecia has been revealed as the

a) "Fithos Lusec Wecos Vinosec," D section melody

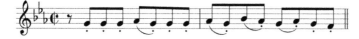

b) "Kefka," B section melody (transposed)

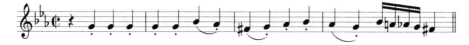

EXAMPLE 1.4: Nobuo Uematsu, *FFVIII*, "Fithos Lusec Wecos Vinosec," melodic comparison.

Intro │: A trans. B C :│

FIGURE 1.2: Nobuo Uematsu, *FFVIII*, "The Castle," form.

true villain of the game, and the protagonists have traveled through time to reach her castle, far in the future. In this setting, Uematsu's theme, "The Castle," provides key information about the antagonist for two reasons. First, it marks the protagonists' only face-to-face encounter with Ultimecia as a physical presence. Second, it is the only time in which the protagonists enter her domain; until this point, she has always come into their world. In Ultimecia's castle, players experience the villain's presence unfiltered by the protagonists' world or her possession of others, thus lending additional narrative weight to the music selected for her domain.

"The Castle" provides the most directly representative music for Ultimecia's character, using a combination of stylistic influence and musical allusion to draw parallels with Kefka in every section of the form. The piece begins with a short introduction before moving into the three-section form that makes up the main loop (Figure 1.2). As players approach the steps leading up to Ultimecia's castle, an unexpected major tonality greets them. The dark visuals and narrative weight of the location stand at odds with the bright major harmonies and sequential melodic figures of the introduction, suggesting two possible interpretations. Coming from the preceding area—a dangerous passage through compressed time—the major tonality offers a small sense of victory as the game's protagonists successfully regroup. At the same time, this short passage lulls players into a false sense of security, temporarily downplaying the threat the protagonists will soon face. This short reprieve ends with the onset of the A section when the tempo slows and the organ timbre shifts from the light flute stops of the introduction to the darker sounds of the principals, more appropriately signaling the narrative context of the setting.

In the introduction, Uematsu's use of elements that are stylistically similar to passages found in "Dancing Mad" highlights the similarities between the two antagonists, namely their shared nihilistic goals. The major harmonies, sequential melody, and organ timbre immediately recall the style of "Dancing Mad, Part 3." Like the opening of "The Castle," the music accompanying the third tier of Kefka's final boss battle shifts suddenly to a major tonality. This change in musical character comes as players face a pair of enemies known as Lady and Rest, which appear in a form reminiscent of Michelangelo's *Pieta*. The shift to a higher tessitura and light counterpoint over a pedal tone characteristic of "Dancing Mad, Part 3" reinforces the religious symbolism of the visuals, helping to associate Kefka with the divine. In "The Castle," Uematsu uses similar musical elements as players enter Ultimecia's realm for the first time, further reinforcing her connections with Kefka.

The A section continues to use clear stylistic references to "Dancing Mad, Part 1," relying on strong similarities in structure and rhythmic profile to make its effect. Both selections feature a general trajectory moving through three distinct subsections, beginning with a slower tempo melody and shifting to a faster-paced melody in the final subsection. "Dancing Mad, Part 1" begins with a quotation of the piece "Catastrophe," originally heard during Kefka's destruction of the world, performed on the organ with the dark sound of the principals.[13] As this quotation comes to a close, wordless synthesized female voice enters with a rhythmically augmented fragment from the C section of "Kefka," effectively maintaining the pace established in the opening quotation.[14] The final subsection of "Dancing Mad, Part 1" suddenly increases the tempo and reduces the melodic content to a simple two-note fragment. Following a similar path, the A section of "The Castle" opens with a slow, half-note melody with a pedal tone.[15] The second subsection adds contrapuntal material, elaborating on the preceding melody before moving into the fast-paced final subsection.

Further similarities in texture and timbre reinforce these structural and rhythmic stylistic references to Kefka's final boss music. Just as "Dancing Mad, Part 1" begins with organ followed by a vocal melody in the second subsection, the A section of "The Castle" begins with organ before introducing a high flute countermelody in its second subsection. A sudden shift in tempo and texture adds intensity to the final subsections of both pieces, which rely on rapid sequential melodies counterpointed by longer note values in other voices. In "Dancing Mad, Part 1," the organ performs the rapid sequential counterpoint in contrast to the vocal melody. By contrast, the final subsection of "The Castle" relies on harpsichord to provide both the rapid sequential melody and sustained pedal tones that provide support. This choice of instrumentation connects "The Castle" with music previously associated with the sorceress, such as the introduction to "Succession of Witches." As in that piece, the harpsichord sonically marks Ultimecia's otherworldly power within the game. Furthermore, because gothic architecture serves as the basis for the appearance of Ultimecia's castle, the harpsichord also plays on general associations between castles and Baroque harpsichord—a technique Uematsu also uses extensively in the subsequent game, *FFIX*.[16] Although the melodies for each selection are clearly unique, these examples of stylistic influence throughout the A section invite players to recall Kefka's boss music as they begin to explore Ultimecia's castle.

The melodies of both the B and C sections of "The Castle" contain musical allusions to "Kefka," further solidifying the connection implied by the stylistic references to "Dancing Mad" earlier in the piece. The B section references the opening melody of "Kefka," following a similar contour to the A section of that piece (Example 1.5). In "The Castle," the ascending scalar passage is modified,

a) "The Castle," B Section, melody

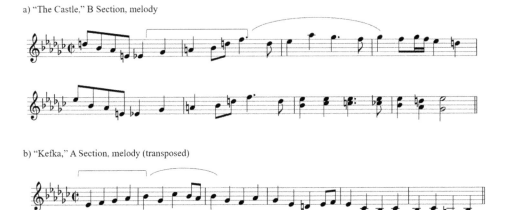

b) "Kefka," A Section, melody (transposed)

EXAMPLE 1.5: Nobuo Uematsu, *FFVIII*, "The Castle," B section, melodic comparison.

a) "The Castle," C section, melody

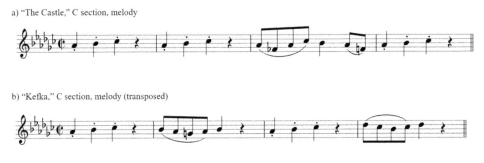

b) "Kefka," C section, melody (transposed)

EXAMPLE 1.6: Nobuo Uematsu, *FFVIII*, "The Castle," C section, melodic comparison.

extending the space between each note from a series of seconds to a series of thirds, while the melodic contour of the second half of the allusion remains much closer to the original. The C section of "The Castle" alludes to the final section of "Kefka," using the same ascending scalar gesture, followed by a one-beat rest (Example 1.6). In Ultimecia's piece, this ascending figure is repeated before moving into an eighth-note figure reminiscent of Kefka's theme.

These melodic allusions in both the B and C sections use an interplay of contrasting timbres to help clarify Ultimecia's character, both in relation to and distinct from Kefka. The harpsichord melody of the B section gives way to a repeated statement on the organ's principal stops—a timbre strongly linked with Kefka via "Dancing Mad." The C section follows a similar pattern, stating the initial melody with harpsichord before repeating it with the addition of the organ's high flute

stops, originally heard in the introduction to the piece. This abrupt contrast of light and dark timbres (harpsichord vs. organ) and use of timbral sounds closely associated with Kefka have a twofold effect. On the one hand, they reinforce the allusions occurring in the melody. At the same time, the contrast created between the harpsichord, an instrument unique to Ultimecia's music, and the various organ sounds of the principal and flute stops, timbres closely linked to Kefka, suggests a sort of dialogue that defines Ultimecia as unique from Kefka. In each section, the allusion to Kefka's music is first filtered through her timbre, the harpsichord, before timbres associated with "Dancing Mad" restate them. Like the modifications to the melody in the B section allusion, this application of the harpsichord timbre serves to distinguish Ultimecia from her predecessor while simultaneously using stylistic references to acknowledge the parallels between them.

After these clear linkages between Kefka's themes and the music of Ultimecia's domain, Uematsu limits the use of musical allusions in the final battle sequence. The most notable allusion comes during "The Legendary Beast," a piece that plays during the second stage of the final battle after Ultimecia summons the magical beast Griever. Like the allusion in "Succession of Witches," this example relies on the use of a shared skeletal structure with the B section of "Kefka."[17] The bass guitar melody of "Maybe I'm a Lion," the music for the third stage of the battle, also bears a resemblance to parts of Kefka's theme.[18] Following the introduction of a layered percussive ostinato, the bass guitar begins a slowly rising scalar melody; the second melodic phrase begins with an eighth-note figure reminiscent of "Kefka." As previously discussed, "Fithos Lusec Wecos Vinosec" references the same passage of Kefka's theme, making it likely that this allusion refers to Ultimecia's previous themes, rather than offering a direct reference to Kefka. However, "Maybe I'm a Lion" also shares timbral similarities with "Dancing Mad, Part 4," which relies on the heavy use of electric bass within a broader rock band sound. The inclusion of electric organ near the end of the main loop further reinforces the timbral links with Kefka's boss music.

Overall, the overt references to Kefka's themes in Ultimecia's castle and the subsequent lack of allusions during the final boss sequence provide a clear identity for the sorceress. The music of her domain, her castle, demonstrates the close links between her goals and Kefka's. She does not want to rule the world, but like Kefka after his ascent to godhood, she shares his nihilistic perspective and attempts to destroy everything. However, Ultimecia's methods, reasons, and form of defeat differ significantly from Kefka's, and the lack of musical allusions during her final boss battle sequence reflects this difference. The allusions that do occur happen when Ultimecia is either not participating in the battle ("The Legendary Beast") or she has merged temporarily with another entity ("Maybe I'm a Lion"). In the end, Ultimecia is her own villain who meets her own fate.

Other influences: *Final Fantasy VII* and *Final Fantasy IX*

FFVIII intentionally reinforces musical and narrative connections between Ultimecia and Kefka throughout the game; so, too, do *FFVII* and *IX* draw narrative parallels between their respective villains and the jester. Like Kefka, Sephiroth and Kuja are both the result of genetic experimentation. After learning the truth about his origins as a genetic experiment with alien cells, *FFVII*'s Sephiroth loses his mind. He then attempts to obtain the power of a god and eventually tries to destroy the world, much like Kefka. Kuja of *FFIX* also demonstrates overlap with Kefka's character, rebelling against his creator, Garland, after gaining a newfound power. The scene in which Kuja seizes control over the world and kills Garland directly parallels Kefka's murder of Emperor Gestahl in *FFVI*.

Musically, Sephiroth's themes contain few allusions to "Kefka" or "Dancing Mad," relying primarily on stylistic references to make their connections. In both Sephiroth's main theme, "Those Chosen by the Planet," and his final boss music, "One-Winged Angel," Uematsu relies on similar textures and timbers in similar narrative contexts to highlight the overlapping aspects of Sephiroth's and Kefka's characters. The tolling church bells, wordless choir, and synthesized organ of "Those Chosen by the Planet" suggest Sephiroth will attempt a path to godhood and operate as reminders of Kefka's final boss music. The melody itself is a direct quotation of *FFV*'s "Book of Sealings," but a similar idea appears in Kefka's "Dancing Mad, Part 2."[19] When this melody appears again in "One-Winged Angel," the timbre and texture more closely resemble "Dancing Mad, Part 2" than the earlier organ statement of "Those Chosen by the Planet" or the original statement from "Book of Sealings."

Sephiroth's "One-Winged Angel" contains several stylistic references to Kefka's themes, particularly within the introduction. Easily one of the most iconic pieces from throughout the *FF* repertoire, "One-Winged Angel" opens with a juxtaposition of contrasting musical timbres and melodic fragments.[20] After two measures of a dissonant march-like figure in the low brass, high woodwinds give a contrasting siren-like response. The march figure returns in m. 6, and once again the upper woodwinds respond with a rapidly descending melody. The sudden shift to sixteenth-note triplets, descending contour, and upper-neighbor ornamentation in each triplet create a striking contrast with the surrounding musical content. While the march-like undertone suggests a sense of mission (destroying the planet) or relentless progress, the abrupt introduction of the bright woodwind timbre and rapidly descending melodic activity hint at Sephiroth's insanity by suggesting a mind spiraling out of control.[21] Despite his unrelenting focus on his goals, Sephiroth, like Kefka before him, has gone mad.

Subsequent passages in "One-Winged Angel" further reinforce the Kefka-esque madness suggested by the woodwind outbursts in the opening measures. The first such section occurs late in the introduction, when a brief and unexpected rhythmic shift occurs. From the first beat, "One-Winged Angel" establishes a regular rhythmic structure, reinforced throughout the introduction by the steady quarter-note march. However, the central measures of the fourth melodic idea feature a sudden shift to 7/8 time.[22] This unexpected meter change not only speaks to Sephiroth's unpredictability and underlying madness but also subtly ties his musical theme back to Kefka, whose "Dancing Mad, Part 4" features similar rhythmic unpredictability with frequent shifts between cut time and 7/8 (Plank 2018: 283).

The most direct representation of Sephiroth's madness, occurring midway through the piece, relies on both broader stylistic references and a more direct musical allusion to "Kefka." With its thick orchestral timbres and dense full choir singing a Latin text, "One-Winged Angel" carries a sense of musical weight befitting the final encounter against the game's primary antagonist. However, the middle of the piece contains a striking solo flute passage that is disconnected from the texture, timbre, and meter of the surrounding musical material.[23] This unexpected passage comes across as uncharacteristically playful, creating an almost comical interruption in Sephiroth's otherwise serious battle music. Its presence suggests a degree of insanity in Sephiroth while also creating connections to the nihilistic court jester of *FFVI*, whose character theme produces its unsettling emotional effect through its juxtaposition of playful music and grim narrative content. These stylistic references are reinforced through a subtle musical allusion: the flute solo of Sephiroth's theme inverts the melodic contour of the A section of "Kefka."

In *FFIX*, similar stylistic references mark Kuja's visual appearance and musical themes, embedding these references within the game's broader nostalgic aims.[24] Like the parade dancers in *FFVIII*, Kuja's visual appearance reminds players of previous games.[25] His red eyeshadow, flamboyant attire, and long feather directly parallel aspects of Kefka's appearance, while his long silver hair marks a clear reference to Sephiroth. The character design for Queen Brahne's twin jesters, Zorn and Thorn, also references Kefka's image via their costumes and face paint. The duo operate as comedic villains throughout the majority of the game, narratively fulfilling the role we initially expected of Kefka in *FFVI*.

Musically, Kuja's themes draw inspiration from multiple games throughout the franchise, and as a result, links with Kefka are often buried amidst other musical allusions or connect indirectly through second-hand associations.[26] For example, "Immoral Melody," the music that accompanies Kuja's cutscene introduction and shares its melody with Kuja's theme, alludes to Sephiroth's "Those Chosen by the Planet" and "Book of Sealings" from *FFV* through its melodic contour.[27] At the

same time, the juxtaposition of its slowly moving melody with a heavy rock drum beat also alludes to *FFVII*'s "Shinra Company," a theme associated with the primary antagonizing force of the game. Shinra's experiments with alien cells created Sephiroth, who is the primary antagonist, and throughout the game players face off against the corrupt corporation. Coupled with the thick vocal timbre and organ introduction of "Immoral Melody," these melodic and textural references situate Kuja's music within a broader framework of stylistic references that have consistently tied villains in preceding games with Kefka.

Kuja's trance theme, "Dark Messenger," relies on a similar strategy, mixing stylistic and second-hand references to Kefka's themes. Like the introduction to Ultimecia's castle theme, the slow organ introduction to Kuja's final music evokes Baroque church music in ways reminiscent of Kefka's "Dancing Mad," inviting characters to recall both Kefka and Ultimecia before the main loop begins. Clearly referencing the style of Ultimecia's rock-inspired boss theme, "Maybe I'm a Lion," the main loop contains further second-hand allusions to Kefka: the repeated ostinato of "Dark Messenger" alludes to the previously discussed bass guitar melodic fragment of "Maybe I'm a Lion," itself a loose reference to the B section of "Kefka" (Example 1.7). In addition, the timbral emphasis on bass guitar, rock drums, and use of electric organ all contribute to the linkage between Kuja, Ultimecia, and Kefka.

The final battle of *FFIX* against Necron, a nihilistic entity summoned by Kuja's fear of death, likewise offers an eclectic blend of nostalgic elements, referencing multiple prior games in the franchise. Narratively, Necron's appearance and goals

a) "Dark Messenger," ostinato

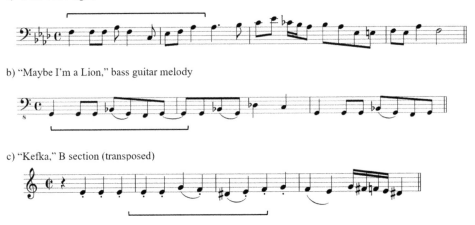

b) "Maybe I'm a Lion," bass guitar melody

c) "Kefka," B section (transposed)

EXAMPLE 1.7: Nobuo Uematsu, *FFIX*, "Dark Messenger," melodic comparison.

directly mirror those of Neo-Exdeath in *FFV*, who appears after the protagonists defeat the primary villain and the Void absorbs him. Neo-Exdeath emerges with promises to return existence to nothingness—the same goal Necron espouses when he appears in the final battle of *FFIX*. Musically, Uematsu packs Necron's battle music, titled "The Final Battle," with allusions and stylistic references to a number of games throughout the franchise. The piece opens with an allusion to "Pandemonium," a theme associated with Garland (Kuja's creator) in *FFIX*. Like Garland himself, the theme for "Pandemonium" references early games in the series, offering players a slow-tempo version of the final dungeon theme "Castle Pandemonium" from *FFII*. This quotation features the heavy principals of the organ as the primary timbre, at once connecting the melody from the early games with the associations to Baroque church music seen in Kefka's, Ultimecia's, and Kuja's themes.

Following the lengthy introduction, the up-tempo main loop continues to include allusions and stylistic references to other games, notably *FFV*, *VI*, and *VII*. The main loop begins with a driving percussive beat and dissonant harmonies.[28] While the harmonies used and the order in which the chords are built differ substantially, the gradual process of stacking chords through the introduction of sustained pitches is similar to the opening of "Dancing Mad, Part 4."[29] As in Kefka's theme, the pacing and increasing dissonance of the passage builds tension in anticipation of the melodic material that follows. This allusion to Kefka immediately gives way to a melodic gesture reminiscent of Sephiroth's "Birth of a God" boss battle music from the penultimate stage of the final battle in *FFVII*.[30] In "The Final Battle," the long-short articulation on the first two quarter notes approximates the emphatic feeling of the dotted-quarter figure in "Birth of a God," and both fragments follow a similar structure, repeating the opening idea after a contrasting quarter-note idea. A unique musical identity for Necron does not emerge until the syncopated eighth-note melody enters after a repeat of the stacked chords. Even then, the melodic contour of this eighth-note melody points back to the intervals of Exdeath's theme in *FFV*.[31] Late in the main loop, Uematsu reinforces this link to *FFV* with a quotation of Gilgamesh's battle theme, "Clash on the Big Bridge."

Thus, stylistic references invoking associations with Kefka are just one of many nostalgic references and allusions made within Necron's battle music. Aside from the connections with Sephiroth's themes as previously discussed, the other villains and locations referenced in "The Final Battle," particularly those from *FFII* and *V*, bear no clear connection to Kefka or his themes. Of all the antagonists who come after Kefka, Necron's music appears to be the least under the jester's influence. The primary reason for this apparent lack of influence lies in the intentional nostalgic aims of *FFIX*'s creators. The strong desire to return to the aesthetics and narratives of the early games in the franchise influences the choice of material for the

musical allusions Uematsu uses throughout the soundtrack. In "The Final Battle" these allusions manifest as references to villains, including Garland, Exdeath, and Gilgamesh, who all pre-date Kefka's conception. Significantly, allusions to Kefka through the stacked-chord fragment stand alongside these early-game references, while references to Sephiroth of *FFVII* are limited and references to Ultimecia and *FFVIII* remain absent. In looking back, *FFIX*'s Necron includes Kefka among the models it seeks to recapture through its nostalgic allusions to prior games. Even here, among a wide selection of potential villains, Kefka stands out, and his inclusion in *FFIX*'s nostalgic project speaks to his important influence and his legacy within the larger *FF* franchise.

Conclusions

Just as *FFVI* permanently altered the narrative trajectory of the franchise, writing for Kefka left an indelible mark on how Uematsu composed character themes and final boss music for subsequent antagonists. A deceptive theme for a deceptive character, Kefka's theme presents a stable façade that gradually reveals the sinister depths of his character through changing narrative contexts. In *FFVII*, Uematsu relies on shared timbres and textures to highlight the antagonists' shared goal of attaining godhood, while brief and unexpected timbral and textural shifts in Sephiroth's final boss music suggest the mental instability characteristic of both. When composing for Ultimecia, Uematsu's deliberate allusion to the music associated with Kefka within the theme for Ultimecia's castle invites players to recall Kefka and reflect on the villains' similarities as they approach the final confrontation. Finally, in *FFIX*, Uematsu situates stylistic references to Kefka's themes within a larger nostalgic dialogue, inviting players to recall not only the villain of *FFVI* but many others as well.

Regardless of whether Uematsu intended to hide a clever reference to Kefka in the music of subsequent antagonists, the similarity of these passages allows players to hear a connection, thus bringing previous experiences and meanings to bear. Some of these musical allusions are so direct as to be near quotations, as is the case in portions of Ultimecia's themes. More often, however, the shared structure lies deeper within the music, leaving players with a vague sense of similarity—a sense of "this reminds me of ..."—that has the potential to arouse thoughts of other villains from other games. At the least, the distinctive character theme and complex boss music Uematsu composed for Kefka changed the way he approached the music for subsequent antagonists. Sephiroth, Ultimecia, and Kuja all aspire to similar goals of world domination, and like aspects of their character, parts of their music look back to his model; they all have a little Kefka in them.

NOTES

1. *FFVI* has been released under multiple titles and formats. I will reference the game by its original Japanese number throughout this chapter. All quotes and descriptions of game-play come from the *Final Fantasy Anthology* rerelease of the game for PlayStation 1.

2. For more on Wagnerian influence in video games, including *FFVI*, see Summers (2014) and Thompson (2020).

3. For further discussion on Kefka and his musical symbolism within *FFVI*, see Anatone's chapter in this volume.

4. Allusion is also a significant compositional technique within *FFIX*. See James L. Tate's chapter in this volume.

5. This definition does not address issues of authorial intention, which is debated within the literature on musical borrowing. Gimbel (1989) argues that a passage can only be an allusion or a quotation if the composer consciously borrows musical material from another source. Burkholder (2018), by contrast, allows that audiences can hear borrowings that were not intended by the composer, but precision in replication becomes increasingly important as the allusive idea becomes shorter. For my purposes, I follow Burkholder's lead; audiences familiar with *FFVI* and subsequent titles have the potential to recognize allusive gestures regardless of Uematsu's compositional intent.

6. For more on musical markers of insanity in Kefka's music, see Plank (2018: 236–93).

7. See Supp. 1.1.

8. See Supp. 1.2.

9. See Supp. 1.3.

10. See Supp. 1.4.

11. See Supp. 1.5.

12. See Supp. 1.6.

13. See Supp. 1.7.

14. See Supp. 1.8.

15. See Supp. 1.9.

16. Ultimecia's castle resembles the castles that appear in the *Castlevania* series, and the music for those games prominently features Baroque harpsichord. While an allusion to the *Castlevania* games is possible, more likely Uematsu uses this timbre for its more general historical associations. Kizzire (2014) offers an analysis of the use of timbre to create associations with previous historical periods.

17. See Supp. 1.10.

18. See Supp. 1.11.

19. See Supp. 1.12.

20. See Supp. 1.13. For further discussion on "One-Winged Angel," see James S. Tate's chapter in this volume.

21. Plank (2018: 260) describes how sudden shifts in mood can serve as markers of madness in music, particularly in relation to Kefka's themes in *FFVI*.

22. Supp. 1.14. In this description, I divide the introduction of "One-Winged Angel" into the following subsections: (1) opening juxtaposition of light/dark timbres, (2) syncopated brass melody with woodwind flourishes, (3) triplet military fanfare, (4) mid-range woodwind and brass melody with time change, (5) final section of half-note chords.

23. See Supp. 1.15.

24. For more detailed discussion of nostalgia in *FFIX*, see Kizzire (2014).

25. See Supp. 1.16.

26. By second-hand associations, I mean specifically that the example references another work, which is itself a reference to the original. For example, if A is the original, a fragment from B might offer an allusion to A. If work C in turn provides an allusion to that fragment in B, it creates an allusion to both B (and all its associations) and the original work A. This reference to the original work is secondary, but because the associations with the original are brought to bear on the allusion in B, they also come into play in C's subsequent allusion to the same material.

27. See Supp. 1.17.

28. See Supp. 1.18.

29. See Supp. 1.19. For an analysis of appearances of this stacked fourth motive, see Anatone's chapter in this volume.

30. See Supp. 1.20.

31. See Supp. 1.21.

REFERENCES

Burkholder, J. Peter (1985), "'Quotation' and Emulation: Charles Ives's Use of His Models," *Musical Quarterly*, 71:1, pp. 1–26.

Burkholder, J. Peter (1987), "'Quotation' and Paraphrase in Ives's Second Symphony," *19th-Century Music*, 11:1, pp. 3–25.

Burkholder, J. Peter (1994), "The Uses of Existing Music: Musical Borrowing as a Field," *Notes*, 50:3, pp. 851–70.

Burkholder, J. Peter (2018), "Musical Borrowing or Curious Coincidence? Testing the Evidence," *Journal of Musicology*, 35:2, pp. 223–66.

Cheng, William (2014), *Sound Play: Video Games and the Musical Imagination*, New York: Oxford University Press.

Gimbel, Allen (1989), "Elgar's Prize Song: Quotation and Allusion in the Second Symphony," *19th-Century Music*, 12:3, pp. 231–40.

Harris, Michael W. (2016), "The Music of *Final Fantasy VI*–Act IV: 'Dancing Mad' and the Insanity of Kefka," The Temp Track, August 20, https://www.thetemptrack.com/2016/08/20/the-music-of-final-fantasy-vi-act-iv-dancing-mad-and-the-insanity-of-kefka/. Accessed July 11, 2019.

Kizzire, Jessica (2014), "'The Place I'll Return to Someday': Musical Nostalgia in *Final Fantasy IX*," in K. J. Donnelly, W. Gibbons, and N. Lerner (eds.), *Music in Video Games: Studying Play*, New York: Routledge, pp. 183–98.

Leddy, Michael (1992), "Limits of Allusion," *British Journal of Aesthetics*, 32:2, pp. 110–22.

Plank, Dana (2018), "Bodies in Play: Representations of Disability in 8- and 16-Bit Video Game Soundscapes," PhD thesis, Columbus: Ohio State University.

Prymus, Kylie (2009), "Kefka, Nietzsche, Foucault: Madness and Nihilism in *Final Fantasy VI*," in J. P. Blahuta and M. Beaulieu (eds.), *Final Fantasy and Philosophy: The Ultimate Walkthrough*, Hoboken, NJ: John Wiley & Sons, pp. 20–32.

Reynolds, Christopher A. (2003), *Motives for Allusion: Context and Content in Nineteenth-Century Music*, Cambridge, MA: Harvard University Press.

Square (1991), *Final Fantasy VI*, Tokyo: Square.

Summers, Tim (2014), "From *Parsifal* to the PlayStation: Wagner and Video Game Music," in K. J. Donnelly, W. Gibbons, and N. Lerner (eds.), *Music in Video Games: Studying Play*, New York: Routledge, pp. 199–216.

SWE3tMadness (2009), "*Final Fantasy VI*'s 'Dancing Mad', A Critical Analysis," Destructoid, December 15, https://www.destructoid.com/final-fantasy-vi-s-dancing-mad-a-critical-analysis-157570.phtml. Accessed July 11, 2019.

Thompson, Ryan (2020), "Operatic Conventions and Expectations in *Final Fantasy VI*," in W. Gibbons and S. Reale (eds.), *Music in the Role-Playing Game: Heroes and Harmonies*, New York: Routledge, pp. 117–28.

2

The Devil in the Detail: Analyzing Nobuo Uematsu's "One-Winged Angel" from *Final Fantasy VII*

James S. Tate

Introduction

Nobuo Uematsu's soundtracks have often been feted by video game fans and scholars alike (Greening 2013), drawing comparisons to Ennio Morricone's film music (Lochner 2013) and Delia Derbyshire's music for television (Niebur 2010). Video game scholarship has only recently begun to make a commitment to musical analysis in contrast to the extensive literature surrounding works of the classical canon. With such analyses rare, it is high time to appraise video game music with the same analytical tools used in traditional "art" music, acknowledging its important role within recent culture and the exemplary compositional challenges of the medium.

Final Fantasy (*FF*) *VII* is a Japanese role-playing game (JRPG) released by Square Co., Ltd. in 1997 as the seventh home console installment in the *FF* series. It was the first *FF* game to be published on Sony's PlayStation rather than on a Nintendo console, later released for Microsoft Windows and later still for numerous other platforms. Square's decision to move from Nintendo's cartridge-based Nintendo 64 system to Sony's CD-ROM-based PlayStation was summarized by Hironobu Sakaguchi, the creator of the *FF* series: "[a]s a result of using a lot of motion data + CG effects and in still images, it turned out to be a mega capacity game, and therefore we had to choose CD-ROM as our media" (Sutherland 2005: n.pag.).

Cartridges had the advantage of faster access times than CD-ROMs but were disadvantaged by their smaller storage capacity. Even so, *FFVII* spanned three CDs on the PlayStation release and five CDs on the PC release (including two installation CDs), with much of the storage being taken up by the game's full

motion video sequences (FMVs)—a first for the series. The game's data files also housed other notable features including an audio track that would be played alongside a MIDI file during the game's last boss battle. This piece of music— composed by the series veteran composer Nobuo Uematsu—became known as "One-Winged Angel."

Uematsu has called his score for *FFVII* his "greatest harvest" in terms of creativity (Uematsu 1997). The soundtrack, despite being over four hours in length and consisting of 85 tracks, was composed in less than a year, as opposed to the two-year period that the game's predecessor *FFVI* had undergone (Gann 2006). Upon its release, the original soundtrack (OST) published by DigiCube spanned four CDs by itself. Similar to the other scores within the series, the soundtrack to *FFVII* contains many character leitmotifs, providing an audible representation of a character each time they are referenced in dialogue or appear on screen. As such, various tracks contain material or motifs used in other tracks, which helps the player to relate a piece of music to a character's actions.[1]

On April 10, 2020, Square Enix released *Final Fantasy VII: Remake*— the first part of a full, multipart remake of the original 1997 game.[2] This first installment—although a full 35–40-hour game—only makes up about eight hours of the original (Franzese 2020). This, though, is not a "remake" in the traditional sense as the narrative departs substantially from the original and a version of "One-Winged Angel" appears before the end, and a future comparison of the original and the remake (arranged by Masashi Hamauzu and Mitsuto Suzuki) would make for an intriguing study. It is therefore not unreasonable to suggest that *FFVII* is a fan favorite within the wider series of *FF* games, as it remains the best-selling *FF* game to date (Blake 2016). As each installment in the remake is released, they will undoubtedly be scrutinized to see how they differ from the original. Therefore, as "One-Winged Angel" is such a crucial element of the original version of *FFVII*—becoming almost synonymous with the game itself—it stands to reason that an analysis of the original track will prove invaluable to musicologists in the future. While there have been amateur forays into dissecting "One-Winged Angel" (Hatake52 2011), the present work applies a number of novel methodologies, including Schenkerian analysis and neo-Riemannian theory, to better understand this video game composition.

Plot

As with many RPGs, *FFVII* has a complex story that ties the traditional fantasy of the series with science-fiction elements. The player assumes the role of the principal protagonist Cloud Strife, and as they progress in the game, they

are eventually exposed to the principal antagonist, Sephiroth.[3] As the main vil-lain of the game, Sephiroth rapidly acquires greater and greater powers until the player must finally fight against him in the Final Boss Battle, as Sephiroth attempts to become a god. As such, the player must face two incarnations of him: "Bizzaro Sephiroth," accompanied by the track "Birth of a God," and then finally "Safer Sephiroth," accompanied by "One-Winged Angel,"[4] which relates to Sephiroth's appearance on screen: that of an angelic being but having a black wing in place of where his right arm would be.[5] The image of his form in this fight is somewhat ironic; while he is attempting to become a god, his monstrous form with his one wing makes him look more like a fallen angel, a reference perhaps to the one-winged demon Abezethibou in the pseudepigrapha "Testament of Solomon."

Context

"One-Winged Angel" combines orchestra with choir and falls across several genres of music. From the instrumentation alone, this would not be dissimilar to pieces from the Romantic period of western classical music. However, through the treat-ment of other musical elements, genres of Hollywood film scoring and rock can also be observed.[6] The differences in the PlayStation release and the Windows release of the game must be addressed, however, before conducting an analysis due to distinct differences between the timbral qualities of these versions. Although the PlayStation supported CDs and thus Redbook audio, *FFVII* did not go in the direction of a recorded CD-quality soundtrack, choosing instead to continue with MIDI as Uematsu had done for the *FF* games on the Super Nintendo Entertain-ment System (SNES). As such,

> the use of MIDI in the game meant that there could be more room for very dynamic music without having to loop endlessly [...] and it also freed up some of the CPU time for the extensive 3D graphics in the game. More importantly was that it allowed for quicker transitions between tracks.
>
> (Collins 2008: 69)

This is something that Uematsu has since gone on to confirm in person during an interview with Polygon.com, stating:

> Even though I had enough space to include vocals, they made it so the game took longer to load between scenes. And I didn't want to do that just for the music, with the game starting and stopping as you play. I didn't think that made sense. So I

gave up on that idea and made it work so all the sound would load when you first
booted up the game. I was particularly invested in that idea.

(Uematsu 2017: n.pag.)

Uematsu used a wide variety of samplers and other sound sources in the production
of the music for *FFVII*. According to the Video Game Music Instrument Source
Spreadsheet (V.I.S.S.)—a peer-verified spreadsheet of samplers found in video
game music using waveform and oscilloscope tools—sources for "One-Winged
Angel" in particular included the *InVision Lightware 1 Stratus* and *Akai S3000
Sound Library 2* (G-Boy et al. 2021). The Windows release, however, had mul-
tiple options for the music in the game:

1. Microsoft's General MIDI—if this was selected, no recorded choir would be
 heard (Humbert21 2012).
2. Creative Labs Sound Fonts, if the player had a Creative Labs AWE sound card
 (Square Enix Support Centre n.d.).
3. Yamaha's "XG SoftSynthesizer," which came bundled with the game.

As such, if option 1 was selected, players would have a vastly different sonic experi-
ence of this battle compared to the other options and the original PlayStation
release. Even so, despite the differences in timbral quality, "One-Winged Angel" is
regarded as a milestone within the *FF* series, as it was the first piece to consist of a
recorded choir singing to orchestral accompaniment. To this end, it can be argued
to be something of an interesting historical junction within video game music: a
piece that sits between MIDI-based soundtracks and those that feature recorded
music. The eight-person SATB choir—listed in the liner notes of the OST—con-
sists of the following:

- Sopranos: Matsue Fukushi, Minae Fujisaki
- Alto: Kazuko Nakano, Saki Ono
- Tenor: Toru Tabei, Daisuke Hara
- Bass: Toshizumi Sakai, Masashi Hamauzu

The Latin lyrics—according to the website Forgotten Memories—were taken from
the same medieval poetry featured in Carl Orff's *Carmina Burana*.[7] Based around
describing Sephiroth's anger and duality between his heavenly form and monstrous
nature, the lyrics can be found in the songs "Estuans interius," "O Fortuna" (the
line "*Sors immanis*" is found here), "Veni, veni, venias" and "Ave formosissima"
("*Gloriosa*" and "*Generosa*") (Ashmore 2007).[8] As will be shown below, the main
bulk of the choir sections are in D minor, which suits the burning rage that the

lyrics translate to, yet the section that starts *"Sors immanis, Et inanis"* ("Fate—monstrous and empty") is in the chromatic submediant key of Bb minor creating an interesting connection between the lyrics and the tonally unsettled key. The final section of the piece (before the repeat) is also notable for having an almost heaven-and-hell duality between the female voices and the male voices. Here, the soprano and altos sing *"Gloriosa, Generosa"* ("Glorious, Noble"), while the tenor and bass sing *"Veni, veni, venias, Ne me mori facias"* ("Come, come, O come, do not let me die"). This once again leads back to the angelic form with the demonic wing that Sephiroth now has.

Among the tracks of the OST, "One-Winged Angel" is the second longest piece in the game, with a runtime of 7:16.[9] It is not unreasonable to suggest that this was deliberate as the player would probably spend more time fighting this boss than any other opponent within the game, as had been done with "Dancing Mad," the final boss battle of *FFVI*.[10] Uematsu has stated that this piece was inspired by Bernard Herrmann's music from Alfred Hitchcock's *Psycho* (Frey 2015), and that this piece was intended to be a fusion of the musical styles of the Russian composer Igor Stravinsky and rock musician Jimi Hendrix (Tetsuya 2006). Nevertheless, Uematsu suggests that he did not fully achieve this goal until the encore of the 2006 video game music concert *VOICES: Music from* Final Fantasy, where an arrangement of "One-Winged Angel" was played that blended Uematsu's prog band "The Black Mages" with a live orchestra and choir. In an interview with James Mielke from the website 1UP.com,[11] Uematsu stated, "at that moment, I knew that was the complete 'One-Winged Angel.' So, I still think 'One-Winged Angel' is a rock piece" (Uematsu 2009: n.pag.).

Among several examples of why Uematsu regards "One-Winged Angel" as being in the rock genre are the following:

- The tempo marking—a typical rock-appropriate 120 crotchet beats a minute that remain unchanged for the entire duration of the piece.
- The time signature—with the exception of two-meter changes that are discussed below, the piece resides entirely in common time, a typical rock characteristic.
- The tonality—the piece begins in E minor—a typical key for rock musicians to play in due to the nature of a guitar's string tuning. The piece's second key—D minor—is also another more simplistic key for guitarists.

In order to perform an analysis of "One-Winged Angel" in more detail, a MIDI sequenced track was needed. This was achieved using the PC release of the game that when installed had much of the music in type-1 MIDI files. For "One-Winged Angel," the title of the file (as marked on the score) is "lb2.mid"—possibly standing for "Last Battle 2." This MIDI file was then imported into

Avid's *Sibelius 8.5* to transform it into standard notation. No markings such as slurs, articulation, or dynamics were imported and so those have been edited in by the author. Key signatures are based upon those listed in Square Enix's piano arrangement from the official *Final Fantasy VII Piano Collections* (Hamaguchi 2003) sheet music book that has been used as guidance. It should be noted that for clarity of reading in the examples below, some tracks have been labeled with the instrument that they are playing rather than the original track name and for other parts where instrumental sounds have changed half way through the track; extra staves have been added to show this. The original instruments used however are outlined in Table 2.1.

Being a sequenced MIDI track, various inaccuracies become obvious when viewing it as a notated score for performance, such as instruments being asked to perform outside of their pitch range. Nevertheless, when sequencing a MIDI file, such restrictions do not apply that allowed Uematsu (a self-taught musician, it should be noted) to compose in a symphonic style. This could also be linked to the time restrictions that Uematsu had, as mentioned previously. Despite all of this however, the mix is well balanced—no doubt in part thanks to other members of the audio staff—again listed on the OST liner notes, including the following:

- Sound programmer: Minoru Akao
- Sound engineer: Eliki Nakamura
- M.A. and recording engineer: Kenzi Nagashima
- Mastering engineer: Masaaki Kato

These roles are not atypical within soundtracks to many films and games, though it should be noted that, in addition to composing the score for *FFVII*, Uematsu is also credited with arranging and producing it. However, questions arise about Uematsu's timbral choices: the absence of any other instruments in the woodwind family save for the flute is a curious one, especially considering that Stravinsky—known for his complex wind-writing (Dunnigan 1994)—is listed as one of his influences. Suggestions as to why are as follows:

- The flute sound can be made to sound more prominent in the mix. As mentioned above, the mix is well balanced, allowing all parts to be heard.
- The flute is often used to culturally represent angels (Senol 2012: 592), as it is a soprano instrument. Therefore, it serves to underscore the *angelic* qualities of Sephiroth—no matter how twisted they have become.
- The timbral qualities of the oboe, clarinet, and bassoons played via MIDI are arguably too distinctive and would be more difficult to blend with the rest of the mix.

TABLE 2.1: List of instruments and additional information revealed when importing "lb2. mid" into *Avid Sibelius 8.5*.

Family	Instrument		Additional information
Woodwind	Flute		Upon playback, the flute part would change to a horn sound at m. 44, which is only stated as a hidden MIDI message at m. 36. As such, the marking of the instrument change has been edited in.
Brass	Horn I/II		
	Trumpet in Bb		Key of trumpet is likely automatically chosen by *Sibelius 8.5*.
	Trombone		
	Tuba		The tuba part became a violin sound at m. 110.
Percussion	Timpani		The timpani sound becomes first a piano sound at m. 68 and then a tubular bell sound at m. 123.
	Taiko drum		Upon importing, *Sibelius* showed the taiko drum on a five-line stave with the note registering at the pitch E–1. A 15vb symbol has been used during these sections.
	Orchestral percussion		Snare, rim-shot, bass drum, crash cymbal, splash cymbal, tubular bells.
	Piano		The piano part also swaps sound between a piano and a flute sound at m. 68 before returning to a piano sound at m. 106.
Vocal	Synth choir		
	Recorded choir		Vocal parts transcribed due to not being MIDI data.
Strings	Violin I	Labeled as ST 1–7 upon importing	Approximations of clefs/instruments within the strings have been made due to all tracks importing with treble clefs.
	Violin II		ST5 changed to timpani at m. 36 and a taiko sound at m. 106, ST6 from strings to timpani at m. 36, and ST7 from strings to taiko drum at m. 52.
	Viola		
	Cello		

Another curiosity is the lack of any non-orchestral instruments in the piece, particularly as Uematsu claims Jimi Hendrix as an influence. Expected instruments would include guitars, drum kit, or synthesizer, yet there is not one of these, save for the synth choir that mainly doubles the recorded choir. This is peculiar, especially considering that Uematsu uses synths in other pieces of the soundtrack. Additionally, upon importing the MIDI file into *Sibelius 8.5*, there was no indication of a double bass or bass guitar as part of the string section. While this may be an error in the program's importing of the file, a look at the two celli lines shows that neither of them plays at a particularly low pitch. The violin II line that adheres to the pitch range of a violin for the vast majority of the piece descends to a B2 at m. 91. As this is lower than a viola, this may suggest an unfamiliarity with stringed instruments. Also of note is the viola line itself, which is devoid of any musical material from mm. 36–121—the vast majority of the piece. Similar is the lack of material for the piano that when combined with the above observations perhaps shows Uematsu's limitations when it comes to conventional orchestration.

The piece is not in any strict form, instead being more of a fantasy. Uematsu himself reveals more as to why this is the case:

> With *Final Fantasy 6*, I had put a lot of effort into creating the boss tracks. And since I put a lot of effort in, they turned out really well and gained a nice reputation. After that, I was thinking, "OK, the normal approach won't exceed what I did for *Final Fantasy 6*" [...] So after that, I started—I would go into the office and just record a couple phrases that came into my mind. Like in the morning, I would come into the office and record the phrase that pops into my mind. And I just kept doing that for two weeks. And after two weeks, I had a lot of random phrases piled up. Then I took those as puzzle pieces and tried to line them up in an interesting order to make sense as a track. That was a totally new approach for me. [...] This was the only time I ever used that approach. It was almost like a gamble—it could have turned out great, or it could have turned out horribly.
>
> (Uematsu 2017: n.pag.)

This piecemeal approach suits a fantasy perfectly and contrasts with the battle and boss fight music that he had composed previously. Table 2.2 provides a suggested structure of "One-Winged Angel."

Interestingly, the three keys that Uematsu employs—Em, Dm, and B♭m—suggest a rock music idiom: if Em is the tonic, then Dm is the flattened seventh and B♭ is the tritone (a feature that underpins many of Uematsu's harmonic and melodic decisions in the piece[12]). Meanwhile, if Dm is the tonic, then Em is the supertonic and B♭ minor is the minor submediant.

TABLE 2.2: Structure of "One-Winged Angel."

Section	Time (min:sec)	Measures	Key	Notable features
A	0:00–1:09	1–35	Em	mm. 1–9: Intro passage. Occurs during opening cut-scene to fight. Start of "march ostinato."
				mm. 10–20: Player regains control. Direct continuation from before. Melodic material in brass. Fanfare figure at m. 15.
				mm. 21–35: 7/8 meter change for three measures. Transition passage.
			Dm	mm. 26–35: Continuation of march ostinato (with variation).
B	1:09–2:13	36–67	Dm	Loop point start. Recorded choir begins. Self-contained ternary form passage: (a) mm. 36–51: Introduction of "Sephiroth motif." High string notes acting as "echo stabs" to the soprano melody in choir.
			B♭m	(b) mm. 52–59: B♭m drone (B♭ + D♭) between cello, trombones, and violin II. Choir singing in octaves the motif first heard in the track "Those Chosen by the Planet."
			Dm	(a′) mm. 60–67: Repeat of second half of choir A section. Final two measures contain a chromatic transition back to Em.

(*Continued*)

Section	Time (min:sec)	Measures	Key	Notable features
C	2:13–3:21	68–105	Em	Instrumental section—new melodic material and key.
				mm. 68–79:
				Arpeggiated melody (6 + 6 measures)
				mm. 80–87:
				Alternating C$^7$-Em quaver/semiquaver melody (4 + 4 measures)
				mm. 88–91:
				Concluding section. Ends on dominant chord with addition of a C$^{\#}$ in the melody acting as a leading tone back to Dm for section D.
			Dm	mm. 91–105:
				Variation of previous melodic material with change of key. 3/8 for six measures. Snare drum roll crescendos and diminuendos.
D	3:21–4:01	106–25	Dm	Choir coda—resumes with new melody anchored around Dm. Use of "Sephiroth motif" with additional tubular bell chime. Loop end at the end of m. 125.

TABLE 2.3: Hit-points revealed upon importing "lb2.mid" into *Sibelius 8.5.*

Timecode	Measure.beat	Name
00:00'00.0"	1.1	lb2a
00:01'09.2"	36.1	loopStart
00:01'09.2"	36.1	lb2b
00:02'13.2"	68.1	lb2c
00:03'21.7"	106.1	lb2d
00:04'01.7"	36.1	loopEnd

Table 2.2 is supported when looking at the hit-points that are shown upon importing the MIDI file into *Sibelius 8.5*. According to Katie Wardrobe, "hit points (also known as time markers) are used to mark specific places in [a] score where action and events occur in the video" (2013: 5). While "One-Winged Angel" is not a piece to accompany a linear video, the hit-point markers do present an interesting layout of the structure in the game's implementation of the music. There are six in total, shown in Table 2.3.

The hit-points in Table 2.3 relate perfectly to the proposed structure outlined in Table 2.2, further enhancing the argument that "One-Winged Angel" does not fit into any standard western classical structure and is therefore a fantasy in multiple parts. The points "loopStart" and "loopEnd" are clear in their explanations, as is lb2a—the start of the piece. What is more interesting however are the lb2b, 2c, and 2d hit-points; these suggest that the piece is thought by the audio team to be split into multiple sections though there is no evidence that they relate to any direct action to the player in their fight against Sephiroth.

An argument could be made that the structure of this piece could exist in two parts—not a traditional binary structure that is related by key—but two parts nevertheless:

- Part 1 (mm. 1–36): This is a one-time-played introduction that moves the piece from Em to Dm through a series of disparate yet connected segments.
- Part 2 (mm. 37–125): An infinite loop that is centered around the choir sections until the completion of the battle with either Sephiroth defeating the player's party or the player defeating Sephiroth whereby the music undergoes a quick fade-out.

However, as will be shown below, the clear differences in melodic material, tonality, and other musical elements support the fantasy hypothesis.

Analysis

Section A: mm. 1–35

"One-Winged Angel" begins with a blaring militaristic march rhythm played in the lower brass, strings, and percussion: timpani, taiko drum, and rim-shot (see Example 2.1). The prominent on-beat accents in the quavers within the strings and brass double the percussion, while the alternating taiko drum-timpani crotchet beats are particularly distinctive.

Notice too that Uematsu employs the augmented fourth interval (or tritone) between the viola I and cello II parts, which is notable due to its historical notoriety as the "The Devil's Interval" (Kennedy 1996: 747). As Sephiroth is now a twisted angel in appearance, the use of this chord—and its respective connotations—is apt. Combined with the minor-seventh drone between the two cello parts, there is almost a continuous dissonance throughout, which is present throughout much of the first half of section 1. This harmonic interest provides a contextual link with one of Uematsu's inspirations. As stated above, Uematsu indicated that one of his

EXAMPLE 2.1: Nobuo Uematsu, *FFVII*, "One-Winged Angel," mm. 1–2 displaying the march ostinato with a clear 4–4 meter.

influences was Jimi Hendrix, and in particular Hendrix's song "Purple Haze."[13] The similarities between the beginning of "One-Winged Angel" and "Purple Haze" are obvious: both contain accents on each crochet beat, and both feature dissonant harmonies above a fundamental root. The chord in "Purple Haze" is sometimes referred to as the "Hendrix chord," though this is a misnomer: the Hendrix chord is more generally associated with an $E^{7\#9}$ chord, of which the tritone interval presented both in "One-Winged Angel" and "Purple Haze" is not the primary focus of the harmony (aside from being embedded within the dominant seventh chord itself). Instead, the influence potentially comes from another of Uematsu's inspirations—Stravinsky, most noticeably the "Augurs chord" from *The Rite of Spring*, as Tim Hanks (2011) of the band Los Doggies discusses.[14]

After the two-measure introduction, Uematsu provides a statement in the upper strings, which alternate between A and B^b—an interval of a semitone, which draws a relation to John Williams's leitmotif for the shark in the 1975 film *Jaws* (Spielberg 1974).[15] Of this infamous musical motif, Mervyn Cooke writes, "this motif—a simple pulsating semitone figure [...] serves not only to promote a sense of impending threat to the pursuers but can also suggest the panic of the pursued" (2008: 461). The humans battling against the shark in *Jaws* is easily mirrored here where the player faces off against Sephiroth, and the semitone in the strings is reinforced with the flutes' chromatic appoggiaturas leading from D to E, which is then repeated seven times. Further similarities can also be associated with Bernard Herrmann's score for "The Murder" in *Psycho*, which uses the upper strings a semitone apart to provide the notion of fear.[16] Even within this introductory passage of section 1, the use of the tritone can be found in several places, creating a deliberately unsettled sound. Take, for example, mm. 7–8: the piano part rapidly alternates between two broken chords, Em^7 and A^7 (omit3), suggesting a tonic-subdominant alternation[17]—and again in mm. 9^4–10^1 with the chromatic flourish linking the introductory subsection with the next.[18] This flourish occurs in an unexpected additional measure to the standard eight-bar phrases traditionally found in rock music, disrupting the sense of expectation that comes from this style. From here, a second subsection is heard during which the player regains control after the initial cut-scene to the battle. Within this subsection, several notable features stand out. Measure 10 contains the first notable melody within the piece, played in the brass. The drone-like accompaniment between the two cello parts (and initially the two violas) that was played in the introductory subsection continues, which supports the argument that this is one longer section compared to a series of disparate but related smaller sections. Once more, a tritone can be seen from the $F^\#$–C at the end of the phrase.[19] The decoration in the upper strings—which is then answered by the flute and horn—is shown in Supp. 2.10 and mirrors the

extended chord heard in the piano suggesting intention by Uematsu to harmonically link the two subsections.[20]

A new melodic idea begins in m. 15—a four-bar fanfare passage of triplet quavers played on the trumpet and violin II that gradually ascend chromatically in the upper strings and trombone before being answered by a descending two-bar response in the horn and viola.[21] This fanfare idea is not heard again, although rhythmically there are similarities with the melodic decoration to the choir melody played by the horns in section B.[22] Fanfares are typically defined as "a means of proclamation, such as a military signal" (Kennedy 1996: 241), and thus it works as a melodic idea early in the piece signaling the start of a new battle. As stated above, the player has not regained control from the cut-scene at this point, and therefore the music acts as an introduction. Nevertheless, although a new idea has been introduced, the two viola lines, which had previously been emphasizing a dissonant minor-second, are removed, leaving only the two cellos playing, which remain locked in their minor-seventh drone. This has a percussion-like quality to it due to the on-beat accents, leaving the fanfare to appear almost monophonic in texture. Notice too the tritone intervals heard again between the F# and C in measures 15^1 and 16^1. The C is the highest note before the pitch falls. Another tritone can then be heard again between the lowest note and the next highest note—the A# and E (m. 16^3 and m. 18^1, respectively).

While the music remains locked around E minor with the aforementioned E minor-seventh drone heard in the bass (along with the constant repetition of B and the brief instance of G in m. 15^2), hints of D begin to emerge here with accented dissonances on beats 1 and 3 evident in mm. 15 and 17. No other harmony is used to support the fanfare melody other than the drone, so ambiguity arises when trying to analyze two note chords. Nevertheless, certain assumptions can be made as shown in Example 2.2.

By m. 20, the aforementioned two-bar answering response occurs where the horn and viola play a rising arpeggio before descending through two chords—an E minor followed by a C# minor scale. With C# minor being a distant key to E minor, we would expect that this is in some way suggesting a modulation of some

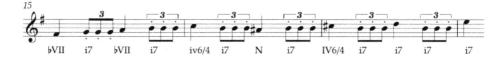

EXAMPLE 2.2: Nobuo Uematsu, *FFVII*, "One-Winged Angel," mm. 15–18. Harmonic analysis of the fanfare section showcasing the assumed harmony until the repetition of Em7 and the E in the soprano line.

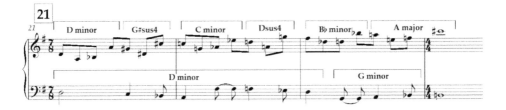

EXAMPLE 2.3: Nobuo Uematsu, *FFVII*, "One-Winged Angel," mm. 21–23.

description.[23] This then occurs at m. 21 where D minor is suggested. That said, with the amount of chromaticism that this subsection contains, it is understandable that the official piano arrangement does not mark a formal change of key to D minor until m. 26, suggesting that mm. 21–25 act as more of a transitionary passage (see Example 2.3). Notice how the bassline in particular descends through much of the D minor scale before ascending back through G minor—the subdominant—while the ascending melody line in the trumpet moves through a variety of different chords creating a sense of bitonality.

The section concludes however with just two tones—a B in the bass and a C# in the trumpets and celli creating dissonance that results in tonal ambiguity. The B in the bass is clearly in relation to E minor, being the dominant, yet the C# suggests it being the leading note of D minor—a point reinforced by the final four notes of the piece outlining a fairly definitive A major chord. An argument could be made that these two notes fit within the D melodic minor scale, yet as a traditional cadence point, the music defies convention. Uematsu does use this cadential gesture again, later in the piece (mm. 90–91) to move into D minor, suggesting that this is a conscious technique where even though there is not a traditional cadence the melodic writing partly implies this.

This ambiguous change in tonality is accompanied by a change in time signature—7/8—and a change in style as well, a key feature of transitory passages as suggested by Hepokoski and Darcy (1997: 115–54). The minor-seventh drone that had been underpinning the rest of the musical texture is replaced by a contrapuntal texture between an upper voice and an independent bass line. While the first cello plays throughout, the brass is employed in a measure-by-measure antiphony, and it is here that panning (along a stereo spectrum) becomes obvious for the first time.[24] It should be noted, however, that this panning does not give the player any sonic clues as to which of the player's party Sephiroth might attack.[25] This transitionary subsection's move to a more unusual time signature presents a small link to one of Uematsu's supposed inspirations. Take, for example,[26] the final piece of Stravinsky's *The Firebird* ballet—"Final Hymn." At rehearsal mark 167, there

is a change from 3/2 to 7/4 resulting in a major stylistic change at that point in the piece. Uematsu's approach is undeniably simpler—certainly the transcription compared to the score for *The Firebird* suggests as much, but a change of style in the piece is undoubtedly produced. Note as well in Stravinsky's *Firebird* how the 7/4 measures are subdivided into a 3/4 followed by two 2/4 measures.[27] One could suggest a similarity in Uematsu's music—three quavers around a similar pitch followed by a larger jump in each of the three 7/8 measures.[28]

Nevertheless, a continuation of the march ostinato from the introductory subsection still exists and carries on into the final subsection of section A albeit in the new key of D minor—that of the driving quaver passage, this time by the trombone and tuba that help to link the sections together.

The continuation section of section A (mm. 26–35) is where Uematsu strips away the melodic ideas introduced prior, as he provides a succession of blocked chords played by the flute, horn, trumpet, and the second violins/violas (played in octaves) reinforced with cymbal crashes. Each chord is played twice in succession, with strings playing the first statement, answered by the winds. Thus, a chord progression in the new key of D minor materializes over a D pedal tone: Dm → Cm → A → Ab → Dm → Ebm → F → B. Notice the tritone intervals between several of the chords: Ab to Dm, as well as F to B. This helps propel the harmony in unusual directions as the chords do not fall into a conventional scale or mode; instead the root notes of each chord fall into the more unusual D diminished scale. Interestingly, in looking closely at the six different chords, they include every note of the chromatic scale. While not all the chords above the D pedal are in root position, the voice leading—particularly notable in the flute—leads to another tritone between the A and D$^\#$ in mm. 34–35. Finally, the interval between the flute's D$^\#$ at m. 35—the most prominent note in the piece at this point due to its pitch—and the soprano note of the choir in m. 36 creates yet another tritone.

As this subsection does not conform to a traditional harmonic function, a simple PLR analysis used in neo-Riemannian theory provides insight as to the relationship between these chords, the results of which are shown in Table 2.4.

The results of this PLR analysis provide enough insight to draw several notable conclusions. First, these are not simple transformations and it is highly probable that Uematsu was aiming to pull the piece in unexpected directions. The number of P-R transformations found within this chord sequence is also interesting, especially considering that a tritone transformation is R-P-R. While it is not possible to say whether this was a conscious decision by Uematsu, it does show links between many of the chords in this section. Looking into the results further, we notice several ideas that have been used by other composers. Frank Lehman (2012: 39), for instance, states that John Williams uses R-P-R-P transformations—in a C and F$^\#$m oscillation—in the "Ark Theme" from *Raiders of the Lost Ark*,

TABLE 2.4: Neo-Riemannian results for the chord sequence in mm. 28–35. Columns two and three showcase the P-L-R transformations needed to move to the next chord. All chords are played above a D pedal (mm. 28–35).

Order of chords in sequence	Transformation(s)	Resultant chord per transformation
Dm	R-L-R-P	Dm → F → Am → C → Cm
Cm	P-R-P	Cm → C → Am → A
A	P-L-P-R	A → Am → F → Fm → Ab
Ab	R-P-R	Ab → Fm → F → Dm
Dm	P-R-P-L	Dm → D → Bm → B → Ebm
Ebm	P-R-L-R-P	Ebm → Eb → Cm → Ab → Fm → F
F	R-P-R-P	F → Dm → D → Bm → B
B		

an equally menacing track given the ark's nature within the film. A later paper by Lehman (2014: 8) suggests that the P-R-P-L transformation in Bernard Herrmann's "The Nautilus" from *The Mysterious Island* is used to denote mystery. Similarly, Lehman cites the L-P-R transformation (found in the Table 2.4 between A and Ab) as a way of quickly generating a chord with no common tones (2014: 8)—therefore introducing chromaticism that distorts the listener's perception. As such, even though the analysis did not yield any obvious results as to Uematsu's choice of harmonic progression during this subsection, there are still multiple examples within film music of similar transformations providing similar emotional affects as can be found in "One-Winged Angel."

Only the upper strings here have any real rhythmic interest as they play a fast chromatic passage in parallel major thirds between an A and a D#—another tritone. Due to the MIDI sonorities and the dynamic swells, this arguably sounds more like a sound effect than any form of melodic passage. The chromaticism adds tension to the section particularly against the triads mentioned above; however, the start of the rise and fall of each of these chromatic lines fall directly on the beat and, combined with the D pedal beneath, further reinforce the argument that this section is in D minor.[29]

As a final point, it should be noted that this subsection has the first appearance in the piece of a simple tonic triad; at no point until now has the piece been

harmonically stable. However, for the first time at m. 28, Uematsu provides a simple D minor chord, clearly established as tonic that provides a foreshadowing of the next choir-dominated section.

Section B: mm. 36–67

Measure 36 marks a clear new section within the piece, which is dominated by the recorded choir—this marks the first time within the entire *FF* series where a MIDI piece incorporates recorded vocals. The section itself fits into its own smaller modified ternary form (labeled in Table 2.2 as aba'). Also, of note are the two hit-points found here: "loopStart" and "lb2b."

The first—"loopStart"—is easily explainable. As with many tracks within video games, music would often be written so that it could loop: a byproduct of not knowing how long a player would take to complete a various action or event. Its corresponding "loopEnd" occurs at m. 125, making the previous section a one-time-only play-through. The "lb2b" hit-point is a little bit more curious. It appears that this hit-point refers to where the choir starts, possibly working with the audio engine to trigger the audio file. It was likely very surprising for players in 1997 to hear human voices during this track considering the rest of the sound-track only included artificial tones. Many reviews of the official soundtrack have since praised "One-Winged Angel" in particular for the inclusion of the choir for the lyric's atmospheric effect.

The strings accompany the choir almost in heterophony, with stabbing syn-copated chords leaping an octave higher adding a form of embellishment to the simpler vocal lines and arguably serving as a distraction from the ominous add-ition of the voices. Again, the use of a tritone interval is exploited at m. $36^{3.5}$ and other similar instances within the section between the notes D and G#.[30] This two-line Latin phrase *"Estuans interius, ira vehementi"* is followed by the game's principal antagonist's name—Sephiroth.[31] The rhythmic unison of the orchestra when the choir proclaims "Sephiroth," which I refer to as the "Seph-iroth motif," provides a distinctly foreboding atmosphere.[32] The accentuation of the three chords provides a "hook" in the listener's mind—the one lyric that non-speakers of Latin would understand is the name of the villain that has been built up toward throughout the game. It is important to note that the final syllable of "Sephiroth" lands on the D minor tonic chord, another brief moment of harmonic relief following a perfect authentic cadence (PAC), albeit somewhat delayed due to the bass (see Example 2.4). Notice too the prominent use of E^b in the bass as it descends toward the tonic, a Phrygian mode inflection that William Kimmel sug-gested has often been used to represent the appearance of death in western tonal music (Kimmel 1980).

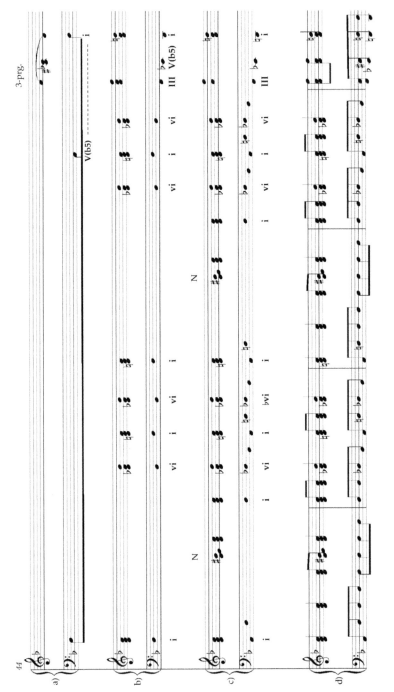

EXAMPLE 2.4: Nobuo Uematsu, *FFVII*, "One-Winged Angel." Schenkerian analysis of mm. 44–48 showing the delayed perfect authentic cadence.

Uematsu provides a countermelody in the horns at m. 44 (note: in the MIDI file, the flute has changed to a horn at this point), which adds a light polyphonic texture to the otherwise homophonic texture underneath. It is interesting to note that this is the first polyphonic writing since the second subsection in section A; the cross-rhythms between the horn's triplet quavers and rest of the ensemble's duplet-quavers provide a new more complex texture. Nevertheless, the triplet quavers in the horn part do not interfere with the straight quavers of the choir; in fact, it becomes apparent that the horn lines were written specifically so that the triplets occurred while the piano/choir held a crotchet beat eliminating any disruptive cross-rhythms. Two more instances of the "Sephiroth" motif are then heard interspersed by fanfares on the trumpets and horns—a subtle reference to the fanfare theme heard in section A.

As previously stated, section B exists in its own smaller modified ternary form. The contrasting (b) subsection begins at measure 52 and has a noticeable change of mood from the two halves that surround it: moving to the key of Bb minor— the chromatic submediant—and being notably quieter as well as containing less rhythmical movement within it.[33] This modulation is not entirely unexpected— Uematsu has used numerous Bb minor chords within subsection a (mm. 36–52).[34] The harmonic analysis reveals further uses of the tritone by Uematsu as part of the B$^{b\circ}$ chord, for example, at measure 52$^3$. Interestingly, for the first time within this piece, Uematsu recalls another piece from the *FFVII* score.[35] The track "Those Chosen by the Planet" (cephiros.mid in the MIDI file from the PC version) is first heard in game when Sephiroth learns the truth about his origins and contains almost the exact same motif—albeit with different instrumentation: strings, synth strings, and a synth choir—in addition to being played at a slower tempo.[36]

"Those Chosen by the Planet" is also used in "Birth of a God," which accompanies the preceding fight with Sephiroth in his "Bizzaro" form, further reinforcing this motif with his character. The use of the synth choir and synth in "Those Chosen by the Planet" and "Birth of a God," respectively, is strengthened considerably in "One-Winged Angel" with the use of the recorded choir—no longer akin to a faded echo, but now prominent and in the foreground. For the melody here, Uematsu uses just three tones—E, F, and Gb. Assuming beats two and four are the stronger beats here, the melody of these four measures can be reduced as follows.[37] This chromatic movement is reminiscent of mm. 3–4, clearly a technique favored by Uematsu to create tension. Also discovered is the use of a tritone once again between the Bb pedal and the E at the end of the second phrase. Notice that this reduction creates an inverted chromatic movement to the reduction found between mm. 36–37.[38] After this statement, Uematsu returns to the tonic with the a' subsection through a fanfare in the trumpet at m. 59 rounding off this small ternary form that then leads toward section C.

Section C: mm. 68–105

Measure 68 marks another hit-point—"lb2c." Here the choir is removed from the texture and the music reverts back to an instrumental section. The piece returns to E minor (although it should be mentioned that there is barely an A-natural at all in this section). This raises an interesting point; if the instrumental sections are predominantly in E minor and the choir sections are in D minor, then the concept of rising and falling between these two tonal centers could suggest an interesting contextual point. Choirs have long since been used to represent heavenly voices suggesting that "One-Winged Angel" might ascend in pitch when the choir sing. However, as Sephiroth is essentially a *fallen* angel, that descent to D minor merits this fall in pitch.

Within this section, various musical features heard earlier in the piece return. The march ostinato heard at the start of section A makes a reappearance as does the minor-seventh double-pedal drone (first between E and D and then between B and A). The new melodic material is based on an ascending E minor arpeggio with notable inclusions of the B^b tritone in m. 69 landing prominently on the first beat of the bar. This arpeggio figure is then shared between other parts of the orchestra—first in horn 2 and then in horn 1. It should be noted that when listening to the track, the horn 1 repetition is surprisingly quiet in comparison. This raises an interesting question as to whether Uematsu meant it as more like an echo than simple imitation.[39]

At m. 80, Uematsu pushes the chord sequence up a step from the dominant to the submediant (C major) although the added B^b in the trumpet and first violin parts and the added F# in the horn and violin Ib suggest a C^{7b5}—a chord containing two tritones. This subsection consists of a repeated four-bar phrase, consisting of a two-measure idea that Uematsu sequences up by semitone before repeating it all: the first two measures emphasize the note B^b, harmonized with a C^7 chord, and the second statement emphasizes B natural, harmonized by an E minor chord.[40] This chromatic oscillation between B^b and B is arguably a reference again to the piece's introduction. Note as well the slightly unusual placement of the cymbal crashes in the percussion part accenting the second and fourth beats along with the timpani—an idea found in rock music as the "backbeat" that further reinforces Uematsu's description of "One-Winged Angel" as a rock piece.

A concluding phrase occurs from mm. 88–91, which pushes the piece toward Dm for the final subsection of section C with a large amount of chromaticism. What is particularly interesting here is the inclusion of a low B in the lower strings (in addition to a B fanfare on the trumpet) and the high C# in the upper strings and flute—a return of the exact same interval used earlier in mm. 24–25. Here, Uematsu prepares the return to D minor by ending this section on an altered dominant chord, yet with a leading tone to the new key in the highest register.[41]

As the final subsection of section C begins, the piece changes key again to D minor with a formal key signature change, which is only cemented in mm. 106—the start of section D.[42] The harmony mostly oscillates between C^7 and $C\#^{o7}$, courtesy of a chromatic shift heard in violin IIb, naturally giving rise to a further tritone. Meanwhile, the melody draws heavily from mm. 80, with two descending semiquavers followed by an array of quavers.[43] This continuity is interrupted however with an unexpected change of time signature to 3/8 creating a waltz-like "oom-pah-pah" feel[44] as another nonfunctional harmonic sequence occurs: Dm–Cm–E^bm–Dm–Cm–Fm, which is not overly dissimilar from the chord sequence outlined in section A. Understandably, as these chords can be identified harmonically quite easily (i–vii–bii–i–vii–iii), there is not anything to be gained through PLR analysis as there was in section A. The section ends with a two-bar statement played twice at mm. 102–05. The first of the two phrases descend another tritone from a D in the bass to an A^b. The second moves from an extended B^b chord to an E^{b13} chord[45]. This E^b once again highlights Uematsu's consistent use of the Phrygian mode within his D minor sections as seen previously across this piece.[46]

Section D: mm. 106–25

The final section of the piece before it loops back to section B also has a hit-point to signify the reappearance of the choir. By doing so and preparing the loop, there is strength to the argument that D minor is the piece's home key: because of the choir's significance within the piece, and the fact that it is separated by instrumental sections before looping, the central focus, and thus tonal center, of this piece is D minor.

This section serves as a culmination of almost all the elements that Uematsu has employed within the piece. Here, Uematsu employs layering to gradually thicken the texture in four-bar phrases, beginning with a low and ominous atmosphere where the piano, male voices, and trombone play together in octaves, based around the tonal center of D and mainly moving up a semitone to E^b or down to $C\#$. While the former is another use of the Phrygian mode, the latter refers back to the importance of the $C\#$, now the leading tone within the melody. Four measures later, the first violins present high chords reminiscent of the stabs heard in the introduction, while the sopranos and altos join in the next phrase with an eight-crotchet countermelody, all of which is accompanied by the horns playing dissonant seconds. The section ends with the recognizable "Sephiroth" motif first presented in section D2 with the addition of two ominous tubular bell chimes—a clear reference to a funeral bell toll—and one that harks back to "Those Chosen by the Planet"[47] (see Example 2.5). The piece

then returns to m. 36/section B, at which point the music continues to loop until the battle is completed.

The legacy of "One-Winged Angel"

"One-Winged Angel" has been called Uematsu's "most recognizable contribution" to the music of the *FF* series (Mielke 2008: n.pag.). Since the release of *FFVII*, multiple versions of the piece have been released in print, live concert, recordings, and covers. As such, it is not unreasonable to suggest that with each additional arrangement of "One-Winged Angel" its legacy grows. On October 22, 1997, and later on February 23, 2005, Square Enix released a single-disk album titled *Final Fantasy VII Reunion Tracks*. This was a single-disk album, again published by DigiCube, and was never released outside of Japan in disk format (although the music has since been made available in digital format on the North American iTunes store). Although mainly just a selection of tracks from the OST, there were three tracks on the disk that had special orchestrations made for them and then subsequently recorded by an orchestra and choir. These were as follows:

- "Main Theme" of *FFVII*
- "Aeris's Theme"
- "One-Winged Angel"

In some versions of the album, there is an additional hidden pre-gap track consisting of an instrumental version of "One-Winged Angel" without the accompanying choir—a curious decision given that players of the Windows release of the game using General MIDI would not have heard the choir sing. Nevertheless, the decision to orchestrate these three tracks was critically well received and showed their popularity among fans of the game (Gann 2000). An arrangement of "One-Winged Angel" was also released on *Piano Collections: Final Fantasy VII*, released originally on December 3, 2003, and later on May 10, 2004. This piano collection was released in two parts: as piano sheet music completed by Shirō Hamaguchi and a CD recording of these arrangements performed by Seiji Honda.

The CGI sequel film *Final Fantasy VII: Advent Children* (Nomura [2005] 2006) also contained a new arrangement of "One-Winged Angel." This takes place during the film's climatic battle between Cloud and a newly resurrected Sephiroth. This piece has two versions: one for the original release titled "Advent: One-Winged Angel" and an extended version for the Blu-ray release of the film titled "Advent: One-Winged Angel—ACC Long Version." This version (and its slightly longer counterpart) featured a new orchestral arrangement accompanied—as

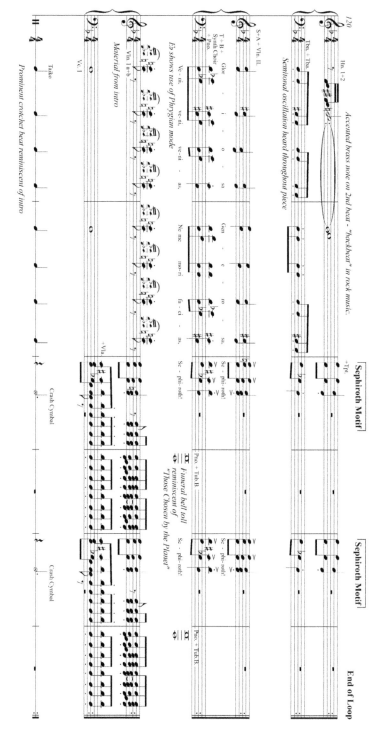

EXAMPLE 2.5: Nobuo Uematsu, *FFVII*, "One-Winged Angel," mm. 120–25. Schenkerian reduction showcasing the culmination of much of the musical material Uematsu has incorporated to this point. Annotations to score in italics.

in *VOICES: Music from* Final Fantasy—by The Black Mages.[48] The track was arranged by Shirō Hamaguchi and Kenichiro Fukui with new lyrics by Tetsuya Nomura.

Additional arrangements of "One-Winged Angel" were made for the following games:

- *Final Fantasy VII: Remake*
- *Crisis Core—Final Fantasy VII*
- *Dissidia Final Fantasy* (2008)
- *Dissidia 012 Final Fantasy*
- *Dissidia Final Fantasy* (2015)
- *Theatrhythm Final Fantasy*
- *Theatrhythm Final Fantasy Curtain Call*
- *Theatrhythm Final Fantasy All-Star Carnival*
- *Ehrgeiz: God Bless the Ring*
- *Kingdom Hearts/Kingdom Hearts II*

"One-Winged Angel" has also been performed in numerous concerts, often being performed as an encore. Uematsu is quoted as saying:

> I know that with every concert that we have, when we have the orchestra perform "One-Winged Angel," for some reason or another that's the one that has the biggest reaction, and everyone sort of expects that to be in a Final Fantasy concert. I still can't figure out why. I know that I pushed everyone to his/her limits, but then it worked out in the end.
>
> (Uematsu 2008: n.pag.)

Some but not all of these concerts are listed below:

- *20020220: Music from* Final Fantasy
- *More Friends—Music from* Final Fantasy
- *Distant Worlds: Music from* Final Fantasy
- *Distant Worlds: Music from* Final Fantasy *Returning Home*
- *Vanafest 2012*
- *A New World: Intimate Music from* Final Fantasy
- *Final Symphony*

Additionally, "One-Winged Angel" has been arranged by Jonne Valtonen as the first movement of a larger work titled *Final Fantasy VII Symphony in Three Movements*. This movement is titled "Nibelheim Incident," and the official program notes state:

Jonne Valtonen, the arranger and orchestrator of this symphony, uses the 3-note motif of Sephiroth throughout the first movement as an element of structural integrity. In the final phase of the movement "The One-Winged Angel" emerges in all its glory, before gradually distorting as all of the earlier themes of the movement are gradually built on top of each other. This distortion is a reflection of the internal chaos Sephiroth is feeling, as he becomes aware of his past. In the end of the movement things slow down. As Sephiroth is reborn, the familiar pulse is heard "in almost spiritual context," an apt description by Jonne Valtonen.

<div align="right">(Game Concerts n.d.: n.pag.)</div>

Where "One-Winged Angel" is performed in a concert setting, modifications to the original game's score are inevitable.[49] The sole woodwind line of a flute is without exception expanded to incorporate the whole woodwind section of a typical orchestra. The strings incorporate a double bass. Each part is typically expanded upon in order to contain more idiomatic writing for that particular instrument. More notable, however is that arrangers have always opted to finish the piece with a definitive ending rather than using the original track's loop point and fading—as the game does upon Sephiroth's defeat by the player where a fade-out occurs. Instead, the vast majority of linear arrangements make use of a four-bar ending that occurs after section D (without the repeat back to m. 36)—this was created originally for the orchestrated version of "One-Winged Angel" from the *Final Fantasy VII Reunion Tracks* released in 1997. For this CD, Uematsu is credited as the composer, arranger, and producer, while the recorded tracks were orchestrated by Shirou Hamaguchi; it is therefore likely that this four-bar ending can be credited to Uematsu. A piano transcription of this four-bar ending is provided below (Example 2.6).

All of the concert performances listed above save for *Final Symphony* make use of this ending in addition to the orchestrated versions used in both *Final Fantasy VII Reunion Tracks* and *Final Fantasy VII: Advent Children*. Notice again the

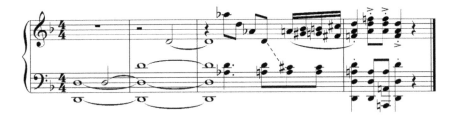

EXAMPLE 2.6: Nobuo Uematsu, *Final Fantasy VII Reunion Tracks* (CD), "One-Winged Angel" (transcription by author). Here we see a definitive ending in comparison to the infinite loop in the game, finishing with a final "Sephiroth motif."

distinct D–Ab tritone arpeggio in the penultimate measure—clear evidence that Uematsu based much of his harmonic language in this piece around this interval.

Conclusion and further thoughts

Since its release, *FFVII* has been both commercially and critically acclaimed, and to this day, critics suggest that it is "culturally significant and worthy of preservation" (Reynolds 2019). As one of the most memorable pieces within the game's score, "One-Winged Angel" is a curious piece despite its status as both a milestone for the series and the commercial success it garnered.

Although Uematsu's piecemeal approach of putting his ideas into a coherent order works in this instance, the net result is that, on first glance, no one idea is given time to develop. This complete change in the way that he had composed boss music, particularly after the success of "Dancing Mad" in *FFVI*, suggests a level of apprehension in writing this piece. Yet, a deeper analysis reveals that "One-Winged Angel" motivically references many previous tracks within the game, which ultimately ties these independent sections together into a coherent fantasy.

For the player, "One-Winged Angel" may be experienced as a relentless musical work: it is a fusion of highly contrasting styles—rock, a Romantic-style orchestra with a traditional choral style—and how they are brought together often works in unexpected ways. Its tonality is a constant duality between the D minor choir sections and the E minor instrumental sections where it is possible to argue that D minor is the tonal center due to the loop point, despite the fact that piece begins in E minor. While there are various dominant chords, Uematsu's main harmonic anchor seems to be the tritone. This interval appears numerous times, either within the melody or the harmony, and its unsettling nature—and colloquial name "The Devil's Interval"—fits perfectly with what is being represented in game. Ultimately, the purpose of the piece is to represent Sephiroth in his final "godlike" form. His role in the game's story is that of an almost unstoppable villain aiming to reshape the world in his vision, and he is relentless in that pursuit. The player cannot predict what will happen next in the music just as the player cannot predict what the character Sephiroth might do next in the game—a prime example being Sephiroth's most iconic move within this battle: the two-minute-long, un-skippable cut-scene move, "Supernova."[50]

Uematsu's claim of "One-Winged Angel" as a rock piece is not without support. Thomas B. Yee's 2020 article "Battle Hymn of the God-Slayers: Troping Rock and Sacred Music Topics in *Xenoblade Chronicles*" has a core argument that video game final bosses who proclaim to be a god have pieces of music that accompany them that are a fusion of rock and sacred music idioms. Although he does not refer

TABLE 2.5: Thomas B. Yee's (2020) proposed rock-and-sacred music topics found in "God-Slayer" tracks. Additional columns provided to show whether Yee's proposal is found in "One-Winged Angel."

Parameter	Rock topic	Present	Sacred music topic	Present
Texture	Monody (melody and accompaniment)	x	Counterpoint or homophony	x
Instrumentation	Drum set, electric bass, electric guitar		Solo voice, choir, organ	x
Melody	Active (syncopation, leaps possible)	x	Simple, stepwise	x
Harmonic rhythm	One chord per measure	x	One chord per beat	
Mode	Minor (when in video game battle themes)	x	Major	
Dynamic	Loud: *mf* to *ff*	x	Soft: *pp* to *mp*	
Tempo	Moderate to fast	x	"Exceedingly slow tempo"	

to "One-Winged Angel" directly, many of Yee's points can be seen within this piece. As explained at the beginning of this chapter, while Sephiroth is not quite a god in the game, this is his desire, and his physical form is partly angelic/demonic. Consider the tropes Yee proposes from both idioms, represented in Table 2.5.

As can be seen, Yee's proposed rock topics, in particular, are almost entirely met by Uematsu in "One-Winged Angel." The sole exception is instrumentation due to the lack of guitar and bass. Yet even here, in *FFVII*'s sequel *Advent Children*, these instruments would be introduced.

Finally, *Final Fantasy VII: Remake* should again be acknowledged. As explained previously, this is not necessarily a simple retelling of the story of the original game with newly updated visuals. Instead, perhaps it would be closer to call it a "reimagining." While many of the themes that Uematsu used within the original are kept, all have been newly arranged and additional material created by Masashi Hamauzu and Mitsuto Suzuki. At the time of writing, this has been suggested to be the first installment of a larger story; and while a new arrangement of "One-Winged Angel" is found within the game, it will be interesting to see—and hear—where and how the story and music develops from here.

NOTES

1. For further information on how Uematsu utilizes the leitmotif and other operatic conventions, see Thompson (2020).

2. It is also the first game in the series to be fully remade as compared to being simply remastered (as was the case with *FFVIII* and *X/X-2*).

3. See Supp. 2.1. Screenshot of Sephiroth in his "human" form shown in a flashback cutscene after Sephiroth destroys the village of Nibelheim.

4. It should be noted that there is one more stage afterwards, but it is impossible for the player to lose.

5. Supp. 2.2. Screenshot of "Safer Sephiroth" against the playable characters Cid (left), Red XIII (center), and Cloud (right).

6. This manner of musical fusion has become widely expected in fantastical boss battles within video games. For further discussion, see Yee (2020).

7. Uematsu uses a similar strategy in both *FFVIII* and *FFX*, but instead evokes the Latin language through anagrams and word puzzles, which results in an allusion to the lost language. See Powell and Dudley, this volume.

8. Due to copyright reasons, the full lyrics cannot be printed here. Nevertheless, many websites (including Ashmore 2007) feature both the Latin original and the English translation.

9. There is however only 4:01 of original material within the piece before the material loops. Further information is provided below.

10. However, the OST track time for "Dancing Mad" is significantly longer at 17:39.

11. This website has since ceased being updated, with many of its pages now resulting in "404 Not Found" error messages. It is however archived on internet archive Wayback Machine.

12. This is in contrast to the use of perfect fourths and minor thirds typically heard for the protagonists (Summers 2016).

13. See Supp. 2.3 for a transcription of Jimi Hendrix's "Purple Haze," introduction (transcription by author).

14. See Supp. 2.4 for a musical example of the "Augurs chord" from Igor Stravinsky's *Rite of Spring*.

15. See Supp. 2.5 for a musical example of *FFVII*, "One-Winged Angel," mm. 3–4 depicting the use of alternating semitones in the first and second violins, a similar technique to the main title to *Jaws*.

16. See Supp. 2.6 for the resultant chord that initiates "The Murder" in Bernard Hermann's *Psycho*.

17. See Supp. 2.7 for a musical example of *FFVII*, "One-Winged Angel," mm. 7–8. Note the tritone between the sixth and seventh semiquavers (E–B).

18. See Supp. 2.8 for a musical example of *FFVII*, "One-Winged Angel," mm. 9–10. The tritone (E–B) is used as a flourish into the second subsection of section A.

19. See Supp 2.9 for a musical example of *FFVII*, "One-Winged Angel," mm. 10–13. Notable tritone between F#–C (m. 112–13).

20. See Supp. 2.10 for a musical example of *FFVII*, "One-Winged Angel," mm. 12–14.

21. See Supp. 2.11 for a musical example of *FFVII*, "One-Winged Angel," mm. 15–18. Fanfare figure heard in the trumpet and violin IIb showcasing tritone intervals between the lowest and highest notes.

22. See Supp. 2.12 for a musical example of *FFVII*, "One-Winged Angel," mm. 44–46. Horn decoration to choir melody in section B, showing similarity to the rhythm of the fanfare in Example 2.2.

23. See Supp. 2.13 for a musical example of *FFVII*, "One-Winged Angel," mm. 19–20. Two-bar horn statement implying both E minor and C# minor.

24. See Supp. 2.14 for a musical example of *FFVII*, "One-Winged Angel," mm. 21–25.

25. See Supp. 2.2 for a visualization.

26. The edition of *The Firebird* referred to within this discussion is the 1982 Eulenberg version.

27. In the following bar, Stravinsky reverses this subdivision with two sets of 2/4 followed by a 3/4. This two-bar changing subdivision is then repeated for much of the remainder of the piece until m.175 where the meter changes to 2/2.

28. See Supp. 2.15. Igor Stravinsky, *The Firebird*, rehearsal 167 (the "Final Hymn"), displaying Stravinsky's change of meter to 7/4, similar to Uematsu's.

29. See Supp. 2.16 for a musical example of *FFVII*, "One-Winged Angel," m. 26, depicting the chromatic runs in parallel major thirds in the first violins. Note the tritone between A and D#.

30. Supp. 2.17 for a musical example of *FFVII*, "One-Winged Angel," mm. 36–39.

31. As this was the first time that any game in the *FF* series contained recorded vocals, this makes Sephiroth the first audibly named character in the series.

32. See Supp. 2.18 for a musical example of *FFVII*, "One-Winged Angel," m. 40, the first occurrence of the "Sephiroth motif."

33. See Supp. 2.19 for a musical example of *FFVII*, "One-Winged Angel," mm. 52–55.

34. See Supp. 2.20 for a musical example of *FFVII*, "One-Winged Angel," mm. 52–59, harmonic analysis.

35. Examples of this motif also exist in *Final Fantasy VII: Remake*. As explained above, while "One-Winged Angel" does not appear, this motif is heard within the opening scene to the game, again sung in Latin by a choir.

36. See Supp. 2.21 for a musical example of *FFVII*, "Those Chosen by the Planet," mm. 5–8. The "*Sors immanis, Et inanis*" vocal melody returns in "One-Winged Angel."

37. See Supp. 2.22 for a reduction of the melody of mm. 52–55 focusing on beats two and four, revealing chromatic conjunct movement heard above a B+D drone.

38. See Supp. 2.23 for a reduction of the melody of mm. 36^3–37^2 revealing a chromatic conjunct movement inverted when compared to Supp. 2.22 (accounting for transposition).

39. See Supp. 2.24 for a musical example of *FFVII*, "One-Winged Angel," mm. 68–72.

40. See Supp. 2.25 for a musical example of "One-Winged Angel," mm. 80–84, depicting the "chromatic slip" between the B and B.

41. See Supp. 2.26 for a musical example of "One-Winged Angel," mm. 90–91 (reduction), showing the return of a low B against a high C# just before a return to Dm.

42. As stated in the introduction of this chapter, the transcription has been done with the help of the official piano arrangement, and in that they change the key signature at this point.

43. See Supp. 2.27 for a musical example of "One-Winged Angel," mm. 92–93. The chromatic shift in violin IIb from C to C# changes the harmony from a C$^7$ chord to a C$^{#o7}$.

44. For further discussion on Uematsu's use of rhythmic and timbral oddities, readers should consult Chapter 5 of Plank (2018).

45. See Supp. 2.28 for a musical example of *FFVII*, "One-Winged Angel," mm. 102–05 (reduction). Note the tritone between the D and A in the bass.

46. For further discussion on Uematsu's use of the Phrygian as a motive of evil and villainy within *FFVI*, see Anatone, this volume.

47. This tubular bell is often used in final boss battles; here it foreshadows the final "impossible-to-lose" that follows the battle with Safer Sephiroth. For further discussion of the chimes' significance in *FFVI*, see Plank (2018).

48. The Black Mages was a Japanese instrumental rock band formed by Uematsu along with two other Square Enix composers: Kenichiro Fukui and Tsuyoshi Sekitowas. Uematsu acted as keyboardist, composer, and producer for the group.

49. For further discussion of the concertization of these pieces, the conundrum regarding the arrangement, and subsequent writing of "endings" within these pieces, see Greenfield-Casas, this volume.

50. See Supp. 2.29 for a screenshot of Sephiroth's iconic move "Supernova" that takes over two minutes in game to execute.

REFERENCES

Ashmore, Patrick D. (2007), "*Final Fantasy VII* Original Soundtrack Liner Notes Translation," Daryl's Library: Final Fantasy CDs, September 3, http://www.ffmusic.info/ff7ostliner.html. Accessed May 12, 2020.

Blake, Boston (2016), "*Final Fantasy 15* is Fastest Selling Game in the Series," Game Rant, December 1, https://gamerant.com/final-fantasy-15-fastest-selling/. Accessed May 12, 2020.

Collins, Karen (2008), *Game Sound: An Introduction to the History, Theory, and Practice of Video Game Music and Sound Design*, Cambridge: MIT Press.

Cooke, Mervyn (2008), *A History of Film Music*, Cambridge: Cambridge University Press.

Dunnigan, Patrick (1994), "Stravinsky and the 'Circus Polka,'" *Journal of Band Research*, 30:1, pp. 35–52.

Franzese, Tomas (2020), "How Long is *Final Fantasy VII* Remake? The Answer May Surprise You," Inverse, April 6, https://www.inverse.com/gaming/final-fantasy-7-remake-length-runtime-how-many-chapters. Accessed May 12, 2020.

Frey, Angelica (2015), "Video Game Music: Focus on Nobuo Uematsu," CMuse, March 21, http://www.cmuse.org/video-game-music-focus-on-nobuo-uematsu/. Accessed May 12, 2020.

Game Concerts (n.d.), "Final Symphony," http://www.gameconcerts.com/en/konzerte/final-symphony/. Accessed May 12, 2020.

Gann, Patrick (2000), "*Final Fantasy VII* Reunion Tracks," RPGFan, June 23, https://www.rpgfan.com/music-review/final-fantasy-vii-reunion-tracks/. Accessed May 12, 2020.

Gann, Patrick (2006), "*Final Fantasy VII* OST," RPGFan, June 17, https://web.archive.org/web/20180805021040/https://www.rpgfan.com/soundtracks/ff7ost/index.html. Accessed May 12, 2020.

G-Boy et al. (2021), "VGM Instrument Source Spreadsheet," V.I.S.S., https://docs.google.com/spreadsheets/d/1brPjhDt2pW3H1nfThFMHVldDX9qzPRXujVGGwTZfgN8/edit#gid=0. Accessed March 14, 2021.

Greening, Chris (2013), Nobuo Uematsu profile, VGM Online, http://www.mfiles.co.uk/video-game-music-history.htm. Accessed May 12, 2020.

Hamaguchi, Shiro (2003), *Piano Collections: Final Fantasy VII*, Tokyo: Digicube Publishing.

Hanks, Tim (2011), "How to Make a Musical Funny," Los Doggies, May 16, http://www.losdoggies.com/archives/2078. Accessed May 12, 2020.

HATAKE52 (2011), "Nobuo Uematsu: An Analysis of Three Pieces," Blogger, May 31, https://nobuouematsu-musicex.blogspot.com/2011/05/one-winged-angel.html. Accessed May 12, 2020.

Hepokoski, James and Darcy, Warren (1997), "The Medial Caesura and Its Role in the Eighteenth-Century Sonata Exposition," *Music Theory Spectrum*, 19:2, pp. 115–54.

Humbert21videos (2012), "*FFVII*: One-Winged Angel (Comparación PSF vs MIDI)," YouTube, August 13, https://www.youtube.com/watch?v=XkG6lCVfAVk. Accessed May 15, 2020.

Kennedy, Michael (1996), *Concise Dictionary of Music*, 4th ed., Oxford: Oxford University Press.

Kimmel, William (1980), "The Phrygian Inflection and the Appearances of Death in Music," *College Music Symposium*, 20:2, pp. 42–76.

Lehman, Frank (2012), "Reading Tonality through Film: Transformational Hermeneutics and the Music of Hollywood," PhD dissertation, Cambridge, MA: Harvard University.

Lehman, Frank (2014), "Film Music and Neo-Riemannian Theory," *Oxford Handbooks Online*, https://doi.org/10.1093/oxfordhb/9780199935321.013.002. Accessed September 26, 2021.

Lochner, Jim (2013), "9 Most Influential Film Composers," Film Score Click Track, March 9, https://filmscoreclicktrack.com/9-most-influential-film-composers/. Accessed May 15, 2020.

Mielke, James (2008), "A Day in the Life of *Final Fantasy*'s Nobuo Uematsu," 1UP, February 15, https://www.webcitation.org/6EFStLpY5. Accessed May 15, 2020.

Niebur, Louis (2010), *Special Sound: The Creation and Legacy of the BBC Radiophonic Workshop*, New York: Oxford University Press.

Nomura, Tetsuya ([2005] 2006), *Final Fantasy VII Advent Children Distance: The Making of Advent Children*, DVD, USA: Square Enix.

Plank, Dana Marie (2018), "Bodies in Play: Representations of Disability in 8- and 16-Bit Video Game Soundscapes," PhD dissertation, Columbus: Ohio State University.

Reynolds, Ollie (2019), "*Final Fantasy VII* Review," Switch Player, May 12, https://switchpla yer.net/2019/05/12/final-fantasy-vii-review/. Accessed May 12, 2020.

Senol, Ajda (2012), "Flute and Recorder in Art," *Procedia: Social and Behavioral Sciences*, 51:1, pp. 589–94, https://doi.org/10.1016/j.sbspro.2012.08.210. Accessed October 9, 2021.

Square Enix Support Centre (n.d.), "*Final Fantasy VII*: Knowledge Bass Search—[PC] Regarding Sound," Square Enix Support Centre, http://support.na.square-enix.com/faqarticle.php?kid= 54190&id=444&pv=20&c=5&sc=0&q=&page=0. Accessed May 12, 2020.

Summers, Tim (2016), *Understanding Video Game Music*, Cambridge: Cambridge University Press, https://play.google.com/store/books/details?id=gJXsDAAAQBAJ&hl=en. Accessed March 14, 2021.

Sutherland, Kenny (2005), "Elusions: *Final Fantasy 64*," Lost Levels, October, http://www.los tlevels.org/200510/. Accessed May 15, 2020.

Thompson, R. (2020), "Operatic Conventions and Expectations in *Final Fantasy VI*," in W. Gibbons and S. Reale (eds.), *Music in the Role-Playing Game: Heroes and Harmonies*, New York: Routledge, pp. 117–28.

Uematsu, Nobuo (2008), "A Day in the Life of Nobuo Uematsu," Thirdworldgamer, February 16, https://thirdworldgamer.blogspot.com/2008/02/1up-article-day-in-life-of-nobuo.html. Accessed May 15, 2020.

Uematsu, Nobuo (2009), interviewed by J. Mielke, "A Day in the Life of Nobuo Uematsu," *1Up*, https://youtu.be/t1QPNZ_bzlE?t=1578. Accessed May 12, 2020.

Uematsu, Nobuo (2017), "*Final Fantasy 7*—An Oral History by Matt Leone," *Polygon*, January 9, https://www.polygon.com/a/final-fantasy-7. Accessed May 12, 2020.

Wardrobe, Katie (2013), "Midnight Music," *Sibelius Film Scoring*, https://midnightmusic. com.au/wp-content/uploads/2013/05/Sibelius-Film-Scoring.pdf. Accessed May 12, 2020.

Yee, Thomas B. (2020), "Battle Hymn of the God-Slayers: Troping Rock and Sacred Music Topics in Xenoblade Chronicles," *Journal of Sound and Music in Games*, 1:1, pp. 2–19.

3

Changing Times:
The Diatonic Rhythms of Nobuo
Uematsu's *Final Fantasy* Battle Music

Ross Mitchell

Battle music in the role-playing game (RPG), and from the *Final Fantasy* (FF) series in particular, has received an enormous amount of attention from fans and scholars alike. For example, a quick search of *"Final Fantasy IV* battle theme" on YouTube brings up a myriad of fan-made videos that enshrine just this one theme: an extended version that repeats the loop for 15:30 minutes, a 39-minute comparison of every version of the theme from various ports of the game, and even a fan remake (SilentWeaponsIII 2011; Sschafi1 2011; Nintendo Complete 2015). Comments on the extended version of this theme range from nostalgic reflections like "if memories had a sound" (Hellslayer_1 2016: n.pag.) to a desire to accompany their daily lives with the theme—"I could listen to this all day [...] Until I'm done with work, then I would expect a victory theme" (myrddincrow 2014: n.pag.). The fact that battle music is so suffused with memories is reasonable when one considers that players likely spend a majority of the game listening to this music: battles make up a significant portion of gameplay within the RPG, and this incessant repetition can cause them to loom large in a player's memory.

Scholars have also produced a rush of intriguing work in recent years, such as Stephen Armstrong's (2019) observation of the "musicospacial stasis" that these themes work to generate. Building on ideas that came up during a Q&A at William Gibbons's 2015 presentation at the *North American Conference on Video Game Music*, Armstrong contends that "battle music is functional music," meaning "fans measure battle music by its psychological effectiveness, not by its sonic beauty." Armstrong further claims that musical parameters like harmonic stasis and "chaotic textures" have become generic norms that structure listener expectations for how a battle theme should operate. Aaron Price's work on Matoi Sakuraba's battle music reveals another norm, namely the use of syncopation to produce a sense of

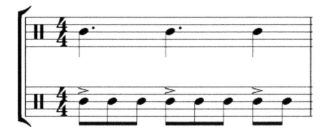

EXAMPLE 3.1: 3+3+2 as long and short tones.

"groove" (Price 2020). Price's observation that rhythm forms a key component of many battle themes is apt, as a complex and varied rhythmic language is one of the main tools that RPG composers use to ensure that their battle music remains exciting over the course of their many repetitions across a game.

The *FF* series has received a significant amount of musicological attention for its use of leitmotifs, simulation of voice, and evocations of nostalgia, but little focus has been assigned to its rhythms (Summers 2016; Cheng 2014; Kizzire 2014). This is understandable given that musicological study of rhythm has often lagged behind work on melody and harmony (McClary 1994). However, this series features a significant level of rhythmic variety that is worth studying, especially its use of "diatonic rhythm."

The framework of diatonic rhythm was created by Jay Rahn, and one key expansion is Mark Butler's application of this idea to electronic dance music (Rahn 1996; Butler 2006). Diatonic rhythms involve an odd number of attacks in a number of pulses divisible by four, such as dividing a 4/4 meter into eighth-note values of 3+3+2 (see Example 3.1) or two measures into values of 3+3+3+3+4 (see Example 3.2) (Butler 2006: 85). The sudden shorter beat (or beats) forms "a particular strategy for creating rhythmic interest" by generating an anticipation of the upcoming downbeat (Butler 2006: 85). Butler explains that the shorter beat at the end of the 3+3+2 rhythm "has an energetic quality of leading *to* the downbeat," and Rahn compares the shorter duple beats of diatonic rhythms to the half steps of a diatonic scale, hence the name "diatonic rhythm" (Butler 2006: 93, original emphasis; Rahn 1996: 80).

Drawing on psychological research, David Huron's book *Sweet Anticipation* discusses the impact of "strong feelings of anticipation includ[ing] the feeling that a chromatic tone should resolve to a diatonic neighbor" on a (presumably western-enculturated) listener's brain, claiming that "a slight amount of psychological stress will arise as each moment of possible resolution approaches" (2006: 306–07). I argue that a similar case can be made for duple beats placed at the end of

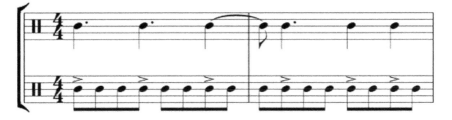

EXAMPLE 3.2: 3+3+3+3+4 as long and short tones.

a diatonic rhythm, meaning that the triple beats at the beginning form a stable "tonic" and the duple a "leading tone" that disrupts this stability. Given that scales based on variable sets of whole and half steps have different qualities, it seems only natural that there be some sort of measurable difference between various diatonic rhythms, such as 3+3+2 and 3+3+3+3+4. I contend that the *FF* series is an excellent place to investigate this issue as a result of Uematsu's frequent and varied usage of these rhythms.[1]

This chapter primarily focuses on the battle themes of the *FF* series, as diatonic rhythms most frequently appear in these exciting situations.[2] Across the franchise, I identify two primary ways Uematsu uses diatonic rhythms. The first, as a transitory tool, uses what Butler refers to as the "energetic quality of leading *to* the downbeat" as a means to create and direct tension toward a new passage (2006: 93, original emphasis). These transitions generally coincide with major structural shifts or the endings of battle theme loops and serve to propel the music forwards. The second kind is cyclical and involves structuring large sections around a repeating diatonic rhythm that may or may not be supported by the melody. This form is rare in the pre-PlayStation games, but becomes fundamental to nearly all of the battle themes from *FFVII* (1997) onwards.

Uematsu's frequent use of diatonic rhythms in combat situations is likely due to Butler's observation of their proclivity "for creating rhythmic interest," a sentiment that is echoed by other musicologists (Butler 2006: 85). Don Traut finds that diatonic rhythms form a key tool in constructing "hooks" in rock music by acting "to highlight certain portions of the song" in tracks as diverse as Billy Joel's "Don't Ask Me Why" and AC/DC's "Shoot to Thrill" (Traut 2005: 69).[3] Richard Cohn has observed their ability to "invite conflict, instability, confusion" in music as early as Beethoven's *Symphony No. 9* (1992: 195), and even Rahn's highly technical account makes reference to their "unique forward momentum" (1996: 71).[4] I must also note that this linkage of diatonic rhythm with scenes of battle is not unique to the *FF* series, and I have also observed similar use by Koji Kondo in "Chase Theme" from the opening cutscene to *The Legend of Zelda: Majora's*

Mask (2000) and by Junichi Masuda in the battle theme for *Pokémon Red and Blue* (1996).[5] However, Uematsu's use of this technique seems to be far more pervasive, varied, and consistent than these other composers.

Before moving on to my analysis, I must point out that Uematsu's *FF* music makes use of a very limited subset of diatonic rhythms. Under Rahn's original, mathematical definition of the concept, diatonic rhythm refers to odd-numbered rhythmic groupings that divide a square meter in a manner that is "asymmetrical," "maximally even," and "maximally individuated," which creates a large number of possible rhythms (Rahn 1996: 78–79).[6] Maximal evenness simply means that rhythmic strikes must occur "as evenly as possible," requiring that there be only two different kinds of relations between rhythms—2 and 3 (quarter and dotted quarter) or 1 and 2 (eighth and quarter) both meet this requirement—and that they be distributed through time as evenly as possible (Clough and Douthett 1991: 96). A helpful metaphor is that of a circle with evenly spaced points representing each pulse, such as a circle with eight points to represent the eighth notes of a 4/4 meter. The note attacks are placed on the points that correspond to their eighth notes, and there must be a minimal difference between the placement of the attacks (Figure 3.1). When dividing eight pulses into three attacks, 3+3+2, 3+2+3, and 2+3+3 are all maximally even because each of these arrangements creates the minimal possible contrast between beats. The rhythm 1+3+4 demonstrates why there must only be two beat values, as the highly asymmetrical difference between the 1, 3, and 4 necessarily prevents maximal evenness (see Figure 3.2). Even when there are only two beat values, a rhythm can fail to meet the criteria of maximal evenness if the distribution is imbalanced, such as 3+3+2+2+2 (see Figure 3.3). This rhythm is not maximally even (and therefore not diatonic) because the attacks in the first half are so much further apart than in the second half. A more balanced alternative is 3+2+3+2+2 (see Figure 3.4). One should also note that a diatonic rhythm must be "maximally even without being *absolutely* even," so if one were to divide eight pulses into four attacks of 2+2+2+2, then one has produced a rhythm that is totally even and therefore not diatonic (Butler 2006: 84).

Maximal evenness is a requirement of diatonic rhythms, but does not classify them as such in and of themselves, as these rhythms must also be maximally individuated. Maximal individuation requires that "each note within the pattern has a unique set of relationships with every other note" (Butler 2001: n.pag.). As an example, Butler explains that "in the 2+1+2+1+2 pattern, the third note occurs three pulses after the first note, one pulse after the second note, two pulses before the fourth note, and three pulses before the last note; no other note within the pattern has the same set of relations to its surrounding notes" (2001: n.pag.). Maximal individuation prevents diatonic rhythms from repeating particular patterns within themselves and partially explains their unique interest.

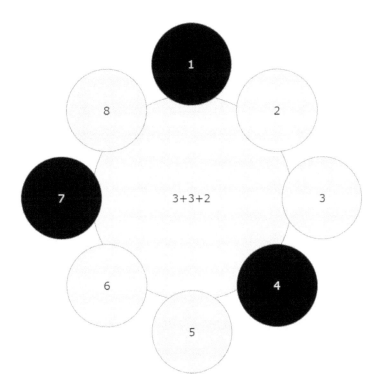

FIGURE 3.1: Clock diagram of 3+3+2 rhythm (maximally even, diatonic).

Even with the limited set of constraints that Rahn explores, he still finds 36 possible diatonic rhythms (Rahn 1996). However, he notes that his methods often do not reflect musical practice by stating that "what such precise numerical relations among types or kinds of things actually might sound like has not been as clear as the proof themselves. Other aspects of these rhythms, formulated just as mathematically, seem more directly connected to both perception and performance" (Rahn 1996: 79). He encourages application of this framework to musical repertoires for further study in order to rectify the gap between theory and practice.

One of these strange gaps between theory and practice is already apparent in my labeling of the rhythm in Example 3.2 as 3+3+3+3+4 instead of the seemingly more accurate 3+3+3+3+2+2 (Example 3.2). To be sure, a significant portion of the examples of this rhythm in various repertories features two short duple attacks at the end instead of one large one (Outlander, "Vamp"; Bon Jovi, "Have a Nice Day"; Uematsu, "Those Who Fight!"), so why are these two smaller attacks subsumed into one larger one? While Butler and Rahn do not explicitly treat this issue of labeling, I gather from their criteria that the issue comes down

FIGURE 3.2: Clock diagram of 1+3+4 rhythm (not maximally even, not diatonic).

to the requirement that a diatonic rhythm involve an odd number of attacks. 3+3+3+4 is sixteen pulses divided into five attacks, whereas 3+3+3+3+2+2 is sixteen pulses divided into six. I seek to problematize what I view as the excessively narrow restrictions of diatonic rhythm, and this odd-number requirement is one such culprit. When discussing this rhythm, I will label it according to the number of attacks present in the music.

Butler's work on EDM zeroes in on a small subset of diatonic rhythms that he finds occurring frequently in the repertoire: 3+3+2 and 3+3+3+3+4. He highlights how these rhythms are particularly useful tools for composers due to the fact that in a "whole note span, they will only align with quarter-note beats in two places—the upbeat and the downbeat" (Butler 2006: 93). This feature differentiates them from other diatonic rhythms that could also divide a square meter, such as 3+2+3, through a powerful "dynamic of returning to an orienting beat after an interval of rhythmic contrast" (Butler 2006: 93). Although these particular diatonic rhythms are two of the primary rhythms that Uematsu uses in the *FF* series, they are not the only rhythms that have this intensely forward-driven effect.

FIGURE 3.3: Clock diagram of 3+3+2+2+2 rhythm (not maximally even, not diatonic).

In Uematsu's *FF* music, one also encounters rhythms that bear a sonic *resemblance* to the diatonic rhythms that Butler examines but do not meet the mathematical requirements to be classified as such, therefore failing to meet the requirements of diatonic rhythms (Butler 2006: 83–84; Rahn 1996: 79). Examples include the 3+3+2+2 from "Don't Be Afraid" in *FFVIII* (1999), as well as the 3+3+2+2+2 found in "The Landing" (*FFVIII*) and "Hunter's Chance" in *FFIX* (2000). 3+3+2+2 is not a diatonic rhythm on several counts: it divides a total of ten pulses, a number that is not divisible by four; it contains an even (rather than odd) number of attacks; and is not maximally even. Similarly, while 3+3+2+2+2 may meet the first two requirements, it fails the evenness test by an even wider margin than 3+3+2+2.

Although these two rhythms each fail to meet some of the criteria of diatonic rhythm, I argue that they belong to the same category as 3+3+2 and 3+3+3+4 due to the significant resemblance of their intensely forward-driven sound. This rhythmic drive stems in large part from the "rhythmic leading tones" formed by the duple beats at the end of each cycle, a common trait that they all share. I argue for a new category of rhythms based on the properties of maximal

FIGURE 3.4: Clock diagram of 3+2+3+2+2 rhythm (maximally even, diatonic) (Rahn 1996: 78).

EXAMPLE 3.3: Nobuo Uematsu, *FFI*, mm. 1–2, pulsing motive that begins "Battle Scene."

individuation, asymmetry, and the placement of triple beats on the downbeat and duple beats on the upbeat of the measure or cycle. As my analysis shows, these are the most salient musical characteristics of this new category of rhythms that I call "propulsive rhythms." This new category would not replace or eliminate diatonic rhythms; instead, the two categories would form a Venn diagram where some rhythms belong on one side or the other, while a rare few belong to both (Figure 3.5). For purposes of clarity, I will use the term diatonic when speaking about rhythms that exclusively fall within that category, propulsive for those that only fit my new category, and diatonic/propulsive for the few that belong in both categories.

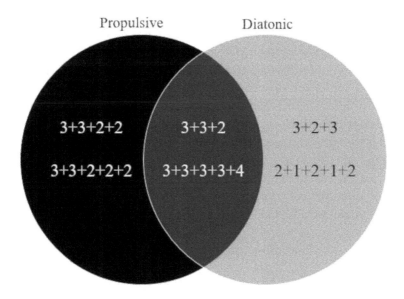

Propulsive Diatonic

3+3+2+2 3+3+2 3+2+3

3+3+2+2+2 3+3+3+3+4 2+1+2+1+2

FIGURE 3.5: Venn diagram illustrating the crossover between diatonic and propulsive categories.

Traditionally diatonic/propulsive rhythms in early battle themes

I begin my analysis with a prolonged investigation into the battle theme for the original *FF* (1987), as it encapsulates many of the strains of this chapter. I identify "surprise" as a major motivator for both the compositional and ludic aspects of the battles in this game, which is sensible in the context of the game's release.[7] Try for a moment to embody a player's experience the first time they hear this music. Especially for North American audiences, *FF* was one of the first games of its kind, and few players would have known about random encounters. They have just begun to play the game, having selected their party members and been dropped right outside of Coneria Castle[8] with little in the way of explanation. Surrounding the castle is a forest and grassland and, slightly further off, the ocean bordering the entire peninsula. It seems the very picture of a bucolic landscape. While walking through the fields and forests, the player character will suddenly disappear as the screen flashes and a vague but distorted sound effect plays. This noise is followed by a rising and dissonant arpeggio that fades away to a pounding bass ostinato as goblins materialize on one side of the screen and the player's party on the other (see Example 3.3). Although today this trick seems so routine as to elicit no real affective response from the average gamer, in 1987/90 this first ambush would likely have been quite shocking. Uematsu would naturally need to follow this

dramatic introduction with appropriately intense music, and diatonic/propulsive rhythm is one of the primary tools he uses in order to generate this excitement.

This track features both the transitory and cyclical variants of diatonic/propulsive rhythms in order to generate this tension and therefore provides a helpful introduction to Uematsu's rhythmic style. After the arpeggio and pulsing bass, the battle theme proceeds in three sections, labeled A, Transition, and B, each of which follows a different rhythmic construction.[9] The A section constitutes the primary theme and is rhythmically square, mainly relying on a chromatic melody in order to create tension. The middle of the theme is a brief transition based on the 3+3+2 diatonic/propulsive rhythm, and the B section is a secondary theme in a looping rhythm that functions as a conflict between 3+3+3+3+4 and 2+3+3+3+3+2. I will focus on the transition and B section due to their dynamic rhythmic construction.

Transitory propulsive rhythm in *FFI*

After the A section, the transition enters with the pulse 1 and 2 lines both producing little "stabs" of syncopated sound by placing a quarter-note rest between each eighth note, creating the first of the series' diatonic/propulsive rhythms, a 3+3+2.[10] This moment comes as an explosion of energy as the pulse shifts from a strict 4/4 to the forward drive of the 3+3+2 rhythm, while the sudden triple division at the start of the diatonic/propulsive rhythm creates a sense of mid-air suspension. The figure crashes onto a dominant harmony on the duple beat before a brief arpeggio in eighth notes leads into a repeat of the motive. The sudden return to the 4/4 meter with the rising arpeggio interrupts the propulsive rhythm's explosion of forward motion, causing a slight stalling of rhythmic tension. Uematsu interestingly avoids this technique in future battle themes by having transitory diatonic rhythms drive directly into new passages, which may mean that he found it less effective than desired.

The most unique aspect of this particular rhythm is that it does not start on the downbeat like one would normally expect it to; instead, Uematsu opted to begin the 3+3+2 on beat 2 of m. 11. This displaces the duple beat, which would normally land on beat 4, to the downbeat of the next measure. I find this choice useful in this situation for two primary purposes. First, placing the greatly emphasized first attack of the 3+3+2 on the weak beat 2 creates a sense of syncopation that is further emphasized by the sudden triple divisions.[11] This placement also creates a "double downbeat" on beats 1 and 2 of m. 11, generating further rhythmic interest. Second, it reconfigures the downbeats of mm. 12 and 14 so that instead of being the moment of resolution they become the culmination of the tension. This allows the diatonic/propulsive rhythm to transition smoothly into the next section's unique metrical construction.

Cyclical propulsive rhythm in *FFI*

The B section of this battle theme features metric dissonance: pulse 1's line follows a 3+3+3+3+4 pattern but the triangle wave's line follows the pattern of 2+3+3+3+3+2.[12] Crucially, these metrical cycles do not begin at the same time: although their 3's and 2's line up, each has a different sense of where the downbeat is. The triangle wave's phrase begins with the 4/4 meter, but just like the prior transitory passage, pulse 1's melody begins on beat 2 and carries over through beat 1 of the next measure with a tie. The location of the triangle wave's downbeat is also troubled by the octave leaps that create phenomenal accents in sync with pulse 1's sustained pitches (e.g., the third and sixth eighth notes in m. 15).[13] These phenomenal accents produce a double downbeat similar to that of the transition every two measures as the rhythmic cycle repeats, generating a significant amount of rhythmic excitement for a melodic phrase that in reality moves quite slowly and exclusively by step. This passage demonstrates that diatonic/propulsive rhythms can serve as powerful tools to produce tension within battle music because the music does little else to produce said tension; the harmonies are quite simple and change slowly, and the melody moves slowly in predictable rising and falling steps.[14] Here we see Uematsu using a cyclical diatonic/propulsive rhythm in order to produce excitement and tension in a way that contrasts with the more typical methods in the A section. This usage of diatonic/propulsive rhythm to energize a slow melody later becomes a central aspect of his style in the *FF* series.

FFIII and a growing focus on diatonic/propulsive rhythm

Uematsu did not utilize diatonic or propulsive rhythm in the battle music of *FFII* (1988), but in *FFIII* (1990) we see another method of diatonic metrical conflict while also making overt his influence from hard rock and heavy metal.[15] One of the major additions to all of this game's battle themes is a drumkit playing in the background at all times, for which Uematsu frequently writes rapid figurations on upbeats in order to propel the music forward. A clear example of this is in the beginning of *FFIII*'s standard battle theme, which resembles the *FFI* theme with its rising arpeggio and pulsing bass motive, except now each beat is accented by a bass drum.[16] On the upbeat of 3, the drumkit plays six sixteenth-note hits that lead into another bass drum hit right as the melody comes in on the downbeat.[17] The sudden shift to a faster pace on the upbeat is reminiscent of Uematsu's use of diatonic/propulsive rhythms, but in a strictly duple context. This particular theme lacks any diatonicism in the rhythms, but still reflects Uematsu's focus on the upbeat as a place of rhythmic tension.

The new drumkit makes for a drastic change in rhythmic construction for the final boss track aptly titled "This Is the Last Battle" by providing a constant 3+

3+2 background to the nearly universally duple melody until the two parts finally come together at the end of the loop.[18] After the brief, tremolo-laden introduction, the A section enters in straight eighth notes whose emphases clash with the 3+3+2 of the drums and bassline.[19] The level of rhythmic interest is much higher than in the prior battle themes, thanks to this metric dissonance, and reaches a pinnacle in the last eight measures before the end of the loop. Here, pulses 1 and 2 suddenly shift to match the 3+3+2 of the drums, briefly releasing the tension of the metrical dissonance for just one measure while generating the uninhibited forward drive of their diatonic/propulsive rhythms. They then return to a square 4/4 structure for one measure, then back to the 3+3+2 for two more.[20] The sudden rhythmic alignment of all three pulses generates significant momentum toward the 4/4 bar, reinforcing the arrival on the downbeat, though the drumkit remaining in 3+3+2 retains the tension of the metrical dissonance.

This specific use of diatonic/propulsive rhythm resembles the 3+3+2 passage in *FFI* in its transitory purpose, as it propels into the repeat of the loop, though in comparison it maintains more momentum and generates more rhythmic interest as a result of the weaving of metrical dissonance and diatonic rhythms. Uematsu's choice to infuse this theme with so much rhythmic tension highlights this theme's placement as the climax of the entire game, as this particular theme marks the first time that an *FF* game had a specific track devoted to the final battle. *FFI* had only one battle theme for the entire game; *FFII* had normal and boss battle themes, but *FFIII* was the first time that Uematsu wrote a theme dedicated to *one* specific fight. Going forward, Uematsu often worked to infuse boss and especially final boss themes with more tension than the standard battle themes, and "This Is the Last Battle" reflects the importance of diatonic/propulsive rhythms in generating this tension.

1990s standardization of diatonic/propulsive rhythm technique

Following the Nintendo Entertainment System era of *FF*, Uematsu's rhythmic writing underwent several changes, including a greater focus on the 3+3+3+3+2+2 rhythm and a general abundance of diatonic/propulsive rhythms in his battle themes that increased further during the PlayStation era. *FFIV* (1991), *FFV* (1992), and *FFVI* (1994) all feature propulsive rhythms in many of their various battle themes, but due to the immense similarity in their technique, I focus on the boss theme from *FFIV* titled "Fight 2" as the primary example of transitory propulsive rhythm. This track marks the first occurrence in the series of the 3+3+3+3+2+2 rhythm used in such a way while also resembling many later uses of the rhythm. Although cyclical propulsive rhythm is a central aspect of the track "The Decisive

Battle" from *FFVI* (and a minor part of "Exdeath" from *FFV*), I choose instead to focus on "Those Who Fight!" from *FFVII* as it is more representative of Uematsu's typical usage of this technique.

Transitory propulsive rhythms

"Fight 2" recalls "Battle Scene" from *FFI* in its melodic contour, general rhythmic patterns, and its use of a propulsive rhythm to enact a major transition. Like most battle themes in the series, the track features an AB structure, but unlike *FFI*, the propulsive rhythm does not serve as a bridge between the sections, but instead comes at the end of the track and transitions back to the beginning of the loop.[21] Leading up to this moment, during the B section the electric bass part begins playing a 3+3+2 rhythm against the prevailing duple meter, raising the level of rhythmic tension and foreshadowing a more overt propulsive rhythm. This foreshadowing comes to fruition at the end of the B section with the upper parts and drums "stabbing" a 3+3+3+3+2+2 rhythm right before the transition back to the beginning of the loop.[22] Just like the equivalent moment in *FFI*, the sudden shift to a triple division creates an explosion of energy and a sense of mid-air suspension that demands resolution back into a stable meter. The electric bass also continues to generate rhythmic interest by creating metric dissonance against the prevailing 3+3+3+3+2+2 pulse with its own 3+3+2+3+3+2 rhythm, ratcheting up the tension even further. As opposed to the 3+3+2, the extra time that it takes for the 3+3+3+3+2+2 to occur (sixteen pulses instead of eight) creates more opportunities for contrasting parts to create such metrical dissonance. A similar example of the electric bass providing metrical contrast to the 3+3+3+3+2+2 rhythm occurs in the standard battle theme in *FFVI*, where the electric bass plays an exceedingly irregular (and not diatonic or propulsive) 3+3+1+2+3+2+2 rhythm against the 3+3+3+3+2+2 rhythm at the end of the loop.[23] Uematsu does not use this technique every time he writes a transitory 3+3+3+3+2+2 rhythm (*FFV*, "Exdeath"; *FFVII*, "Birth of a God"), but the ability of the 3+3+3+3+2+2 rhythm to allow for greater degrees of metric dissonance remains a strong argument for its prevalence in Uematsu's middle-late battle themes.

"Fight 2" is the prototype of Uematsu's use of transitory propulsive rhythms, as from this point forward he stops using 3+3+2 for such passages and instead almost exclusively relies on 3+3+3+3+2+2. Examples include the "Exdeath" battle theme from *FFV*, "Battle 1" from *FFVI*, and "Birth of a God" from the fight against Bizarro-Sephiroth in *FFVII*. A typical occurrence is in mm. 61–64 of "Birth of a God," where a prevailing duple meter suddenly shifts to two cycles of 3+3+3+3+2+2.[24] This rhythmic shift coincides with a dramatic change in texture, generating suspense before launching the music into a powerful and rhythmically

stable statement of the villain Sephiroth's theme. Here Uematsu uses the transitory propulsive rhythm as a tool to intensify a climactic moment of the penultimate combat track in the game. In general, Uematsu's typical use of transitory propulsive rhythm involves ending a section with the 3+3+3+3+2+2 rhythm in order to generate rhythmic interest and propel the music forward, usually for the purpose of ending a loop but also occasionally in order to highlight climactic moments.

Cyclical propulsive rhythms

With the release of *FFVII*, cyclical propulsive rhythms became the de facto standard of *FF* battle themes. Although the boss track "The Decisive Battle" from *FFVI* preceded its use of an incessantly repeating 3+3+3+3+2+2, that track primarily featured the propulsive rhythm in its electric bass part, while the melody does not adhere to it. *FFVII*'s "Those Who Fight!" ultimately became the track to set the template for the majority of future battle themes: a melodic *and* harmonic structure that is irrevocably tied to the pattern of a propulsive rhythm that loops for most or all of the themes.

"Those Who Fight!" differs drastically from prior battle music in the series in its introduction and rhythmic structure.[25] For the first time in the series the introductory arpeggio and pulsing bass motive are absent, and the 3+3+3+3+2+2 rhythm simply explodes onto the soundscape the moment a player triggers a battle. The violins and snare drum play straight eighth notes, but heavy accents from the trombones and percussion divide the pulse into the 3+3+3+3+2+2 propulsive rhythm.[26] In one of his more adventurous moves, Uematsu immediately works to undermine this overall pulse through melodic action: in the second measure, the violins play a brief melody beginning on the upbeat to beat 2 that shifts their pulse to 3+3+4+2+2+2 in direct metric conflict with the trombones continuing the 3+3+3+3+2+2 rhythm.[27] Although the violins do strike on the second eighth note of m. 2, which seems to imply a continuation of the 3+3+3+3+2+2 rhythm, this attack fails to feel metrically accented due to the immediate leap downward to C that begins the next melody. The placement of this melody in this exact spot recontextualizes what had been a clear 3+3+3+3+2+2 pulse into 3+3+4+2+2+2 and generates metric dissonance against the trombones that continue the original pulse.

In the next metric cycle (mm. 3–4), Uematsu uses orchestration to recreate this effect on a more dramatic scale by having the entire brass section forcefully attack the 2+2+2 portion of the 3+3+4+2+2+2 propulsive rhythm. Like the violins in m. 2, the trombones' attack on the second eighth note of m. 4 loses its accented status as a result of the powerful emphasis of the 2+2+2 portion of the 3+3+4+2+2+2 propulsive rhythm. This propulsive rhythm generates rhythmic interest by taking an established pulse and upsetting it immediately; the extra dynamic force

of the entire brass section emphasizing the 2+2+2 portion of the rhythm lends a significant amount of weight to the "leading tone" portion of the meter. The harmonies in this passage also reinforce this part of the meter; in m. 2, the duple portion of the 3+3+3+3+2+2 features a move to the unstable lowered seventh, while the enharmonically equivalent Eb minor triad in m. 4 contains the uncomfortable pitch a half-step above the tonic. With this introduction to "Those Who Fight!," Uematsu focuses a significant amount of compositional energy on the duple portion of each rhythmic cycle, reinforcing the rhythmic propulsion with harmony and orchestration in order to generate a cycle with significant forward drive.

The A section that enters in m. 9 conforms exactly to the looping 3+3+3+3+2+2 rhythm and continues to generate a cycle of tension of alternating intensity in the same manner as the introduction.[28] The melody derives a sense of striving from its rising contour and through the way that it shifts to new instruments with each successively higher statement—first horns, then trumpets, then violins and flutes. In spite of the accented rhythm pulsing in the background, Uematsu imbues this melodic statement with a surprising smoothness. This melody uses the tension produced by the rhythmic accents on the upbeats in order to drive forward smoothly into the next portion of the theme, which is fairly typical of Uematsu's use of this specific propulsive rhythm. However, this smooth continuity is not always present in his most rhythmically focused tracks, as I demonstrate below.

This occurrence of cyclical propulsive rhythm is simpler than its use in *FFI*, as it does not contain the metrical dissonance of the 3+3+3+3+2+2 against the 2+3+3+3+3+2; it is actually more representative of Uematsu's typical technique for writing with cyclical propulsive rhythms. A myriad of tracks feature the cyclic 3+3+3+3+2+2 rhythm as a primary compositional ingredient, including "The Decisive Battle" from *FFVI*, *FFVIII's* boss theme "Force Your Way," "Battle Theme" from *FFX* (2001), and many of the post-Uematsu scores, such as "Blinded by Light" from *FFXIII* (Masashi Hamauzu 2010), and *FFXV's* "Stand Your Ground" (Yoko Shimomura 2016).

Although all of these themes use a rhythm that can be relabeled to fall under Rahn's criteria of diatonic rhythm, Uematsu occasionally uses rhythms that *cannot* meet Rahn's criteria of a diatonic rhythm yet function very similarly. The 3+3+4+2+2+2 from the introduction to "Those Who Fight!" is one example, but that particular rhythm was only a deviation from an overall pulse to create a dynamic moment. Rhythms that more closely follow Uematsu's standard cyclical diatonic/propulsive rhythm technique but *do not* qualify as diatonic include the 3+3+2+2 and 3+3+2+2+2 in *FFVII*, *FFVIII*, and *FFIX*, and the consistency of their technique lends support for my contention that a new category of "propulsive rhythm" is necessary.

Challenges to diatonic rhythm

I begin with *FFVIII*'s standard battle theme "Don't Be Afraid," which is centered around a cyclical 3+3+2+2 rhythm. This rhythm may at first glance seem to meet the requirements of diatonic rhythm, as it is maximally individuated and asymmetrical, but the two issues are that it is not maximally even (see Figure 3.6) and does not divide a square meter. All of the rhythms that Rahn and Butler work with divide a number of pulses that is divisible by four—either eight, twelve, or sixteen—but "Don't Be Afraid" exists within a ten-pulse sequence (Rahn 1996; Butler 2006). While this may seem to indicate a possible revision of the criteria for diatonic rhythms rather than the creation of my new partially overlapping category, this need becomes clearer below as I incorporate the 3+3+2+2+2 rhythm that also acts similarly to 3+3+2 and 3+3+3+3+2+2.

"Don't Be Afraid" foregrounds its rhythm from the opening measure by first presenting only the underlying pulse with no discernable melody.[29] The drumkit,

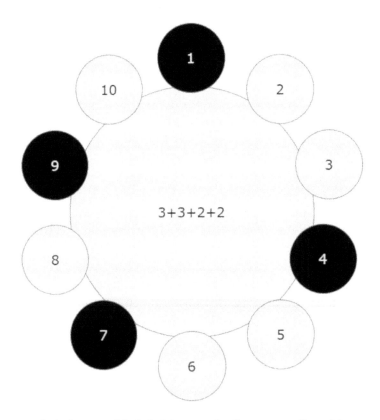

FIGURE 3.6: Clock diagram of 3+3+2+2 (not maximally even, not diatonic).

cello, and violins clearly emphasize the 3+3+2+2 rhythm with accents on each of the beats, and the percussion continues to do so throughout the entire track.[30] The melody that enters in m. 9 incorporates the 3+3+2+2 rhythm to create a series of one-bar phrases in call and response that all emphasize the underlying pulse, and the result is a fast-paced and energetic melody.[31] The B section of the track relies even more heavily on the rhythm to generate tension, as the new melody moves slowly—primarily by a dotted half and whole note with some quarter-note passing tones—and the harmony continues to change only once per measure with a static bassline.[32] Amidst this slow-moving texture, the 3+3+2+2 rhythm continuously pounds away in the background and even grows in intensity over time as Uematsu gradually adds timpani and chimes to the percussive hammering of the cycle. The chimes in particular emphasize the rhythmic contrast by only striking on the first duple beat, emphasizing the switch from triple to duple divisions. Overall, although this battle theme focuses more intensely on rhythm than prior tracks, it produces a similar level of tension through similar means.

"Don't Be Afraid" uses its rhythm in a manner similar to prior battle themes based on cyclical diatonic/propulsive rhythms, such as "The Decisive Battle" (*FFVI*) and "Those Who Fight!" (*FFVII*), even though its rhythm is not diatonic. The key factor that generates this resemblance is the duple beats at the end of each measure, which serve to propel the music forward and demonstrate the relative importance of this specific portion of the meter. These various rhythms are tied together more by the placement of duple beats following triple beats than theoretical constructs like maximal evenness. Additionally, the compositional uses of rhythms such as 3+3+2 resemble 3+3+2+2 more than they do other diatonic rhythms, such as 3+2+3, which Uematsu never uses in order to generate the forward motion that the former rhythms are so adept at creating.

The balance of triple and duple beats in the 3+3+2+2 rhythm is worth considering, as while it produces an effect of forward motion similar to the previously discussed rhythms, it also has its own distinctive characteristics. The diatonic/propulsive rhythms 3+3+2 and 3+3+3+3+2+2 both have the same ratio of triple and duple beats—75 percent triple and 25 percent duple—but the 3+3+2+2 is 60 percent triple and 40 percent duple.[33] One could imagine this rhythm as having been produced by taking the 3+3+2 and adding an extra two-pulse upbeat. This extension of the meter does not only lengthen the less stable duple section, it also seems to have the effect of causing the rhythmic cycle to stand on its own as a musical idea. Instances of 3+3+2 and 3+3+3+3+2+2 in Uematsu's *FF* music nearly always coincide with a recognizable melodic or harmonic musical idea; the rhythm typically only stands on its own as a background to produce metrical conflict (*FFIII*).

However, in "Don't Be Afraid," we first see Uematsu use the rhythm *itself* as the central musical motive, both by beginning the piece with the bare rhythm and

by making it the primary focus of the B section. This newfound individuality of the rhythm also has the effect of structuring the piece as a series of one-bar phrases rather than the smooth and continuous melody in 3+3+3+3+2+2 found in "Those Who Fight!" The closer-to-even ratio of 60–40 percent results in a rhythm that more clearly stands on its own, both as a musical idea and a means of structuring phrases. This argument is supported by the only other instance of the 3+3+2+2 in the series, *FFXIII's* "Saber's Edge" (Masashi Hamauzu), which also begins with a bare rhythm and has a melody that progresses in one-bar phrases until it eventually leads into a main theme that uses the 3+3+2+2+2 rhythm. This new rhythm also does not meet the requirements of diatonic rhythm, but its unique usage in three PlayStation-era tracks provides further support for my category of propulsive rhythms.

Heightened ludic tension and the 3+3+2+2+2 rhythm

FFVIII and *FFIX* each contain tracks that not only serve as battle music but also demarcate special extended gameplay sequences—"The Landing" in *FFVIII* and "Hunter's Chance" in *FFIX*. "The Landing" plays during the Siege of Dollet sequence, in which the protagonists experience their first taste of war as part of their exam to become SeeD mercenaries, while "Hunter's Chance" accompanies Zidane's participation in the Festival of the Hunt. Both of these unique game-state cues involve traversing a large but self-contained area and fighting repeated battles during a period of heightened tension in the narrative—a full military invasion in *FFVIII* and a thrilling competition in *FFIX*. Interestingly, the musical scoring for both of these ludic highpoints shares much in common while differing from the usual accompaniment for the series.[34] Instead of each area having an ambient track that transitions into the standard battle theme when the player encounters enemies, these segments each have a discrete backing track that plays at all times, including a seamless continuation into the battles. The traditional victory theme is also notably absent from the battles, likely in order to maintain the continuity of these two themes.

Going beyond the unique aspects of their placement in their respective games, "The Landing" and "Hunter's Chance" also greatly resemble each other in their use of a cyclical 3+3+2+2+2 propulsive rhythm and their melodic contour. After their brief introductions, each track moves into a primary theme that hits both of the 3's of the meter and also has a lighter attack on the final eighth note of the 3+ 3 grouping that leads into quarter-note strikes on each of the 2's of the 2+2+2.[35] In fact, these melodies are so similar that the most significant difference between them is that the duple portion of the propulsive rhythm descends in "The Landing" but rises in "Hunter's Chance." Uematsu also treats each melody as a sequence that

is varied in both pitch and instrumentation in order to create a sense of dynamic action and prevent the loop from getting stale.

One could argue that these themes are more focused on melody and sequences than rhythm, but there are moments in each track that prove rhythm's centrality. "The Landing" features a variation on the theme that lacks melody; it is primarily the drumkit and synth outlining the 3+3+2+2+2 rhythm, while the cellos play an ascending line on the duple beats.[36] Even more convincing is a passage early in "Hunter's Chance" that drastically cuts the orchestration down to just the piano and percussion hammering out the propulsive rhythm.[37] The most melodic figure is the piano, which simply plays ascending and descending arpeggios on the triple groupings but strikes low C's on the duple beats. Interestingly, the music that immediately precedes this is a rhythmic contrast of four measures in pure 6/8, and this passage manages to feel like a return to home even without the melody. This rhythmic recapitulation demonstrates how central the 3+3+2+2+2 rhythm is to these tracks.

I contend that the presence of specifically the 3+3+2+2+2 propulsive rhythm in both of these tracks is no coincidence and stems from the unique situations that Uematsu was scoring. Recall that, according to Rahn's theorization of diatonic rhythm, 3+3+2+2+2 does not meet the requirements because it is not a maximally even division of twelve pulses into five attacks (see Figures 3.3 and 3.4). However, I argued above that it bears a significant resemblance to the diatonic/propulsive rhythms 3+3+2 and 3+3+3+3+4 in the way that it propels the music forward, a fact that both of these tracks demonstrate. However, there exists one crucial difference from those diatonic rhythms that makes it uniquely suited to these two situations—the "asymmetrical symmetry" of its beats. The two diatonic/propulsive rhythms each have triple sections followed by a duple beat, but in both of them the triple passage accounts for 75 percent of the total cycle and the duple for only 25 percent.[38] The rhythm 3+3+2+2+2 features two sections that are equal in length but unequal in the size of their division: two symmetrical halves divided asymmetrically.[39] The primary result of this difference is that the duple portion no longer constitutes solely the upbeat but instead contains a period of relatively rapid forward motion when compared with the triple half. This perfectly even alternating speed of beats is excellently suited to producing a cyclic pattern of constant tension that lengthens the upbeat to match the stable part of the meter; it is an endless alternation between explosive triple beats and fast-moving duples. Returning to "The Landing" and "Hunter's Chance," this rhythmic structure enables Uematsu to produce a recurrent cycle of tension *without true release* that can be easily varied over a lengthy period of time through simple transposition or changes in instrumentation.[40] The lengths of the tracks also serve to underscore this point; most *FF* battle themes have a roughly one-minute loop, whereas "The

Landing" goes on for 4.36 minutes and "Hunter's Chance" lasts 3.48 minutes before repeating. This structure perfectly matches the ludic situation that he scored in both games—a lengthy period of uninterrupted tension.

The PlayStation era of *FF* has one more widely known track that focuses intensely on the 3+3+2+2+2 rhythm—"Jenova Complete" from *FFVII*. The placement of this track differs from "The Landing" and "Hunter's Chance," as it is dedicated to one of the final boss fights instead of being spread out over an extended segment. Although this may seem to bring doubt to my conclusions about the rhythm's usefulness in matching those two prior ludic segments, I do not see why the rhythm cannot be well suited to extended play as in those situations *and* as a more standard boss fight theme. One does not rule out the other, though I stand by my assertion that the asymmetrical symmetry of this rhythmic cycle is uniquely suited to extended variation in a way that the 3+3+2 and 3+3+3+3+2+2 are not. "Jenova Complete" demonstrates the usefulness of the 3+3+2+2+2 rhythm for tracks that rely heavily on sequences and changes in instrumentation, as its compositional methods are highly similar to the other two tracks.

One key difference between "Jenova Complete" and "The Landing/Hunter's Chance" is the immediate foregrounding of the rhythm over the melody that results from its orchestration-focused structure. Like the other tracks, "Jenova Complete" continuously plays the 3+3+2+2+2 and varies the instrumentation over time, but in this case the music begins as straight rhythm with little melody. A percussive metallophone outlines the rhythmic cycle, while the oboe plays mostly F's in constant eighth notes to confirm the pulse at both levels.[41] Like the "rhythmic recapitulation" in "Hunter's Chance," there is no true melody here and the importance of the rhythm is foregrounded. From this point onwards the track gradually adds melodic fragments through layering that eventually build up to the full melody near the end of the 1:58 loop, meaning that rhythm is so central to this track that the listener only hears the complete melody for roughly one-fourth of its duration. While in "The Landing/Hunter's Chance" this rhythm creates a constant and predictable push and pull of tension, in this case, the 3+3+2+2+2 rhythm works like a backdrop for Uematsu to incessantly repeat while he added in textural layers in order to create a track of constant rising intensity.

There is also a rhythmic aspect to the way in which Uematsu adds layers that highlights the importance of upbeats in his works, which ties back to Butler's observations about diatonic rhythms and their "dynamic of returning to an orienting beat after an interval of rhythmic contrast" (2006: 93). In the opening bars of the track, the triple portion of the meter is left unadorned and melodic fragments play only over the latter, duple half. This dynamic and textural emphasis already makes the duple portion seem accented, but this emphasis goes even further with the cello fragment on the final duple beat of the meter. In mm. 2, 4, 6, and 8, the

cellos play two slurred eighth notes with a heavy accent on the final beat of the cycle, lending weight and importance to the beat that most resembles a traditional upbeat. Much later, when the full melody plays, this emphasis shifts backward one beat so that the final two duple beats of the cycle are heavily emphasized by a loud synth sound in a high register.[42] Both of these variations draw attention to the ending of a looping metrical cycle and generate rhythmic tension that propels the music forward into the coming downbeat.

A focus on the upbeat

This dramatic emphasis of the upbeat is a core component of Uematsu's *FF* battle music and the key that links together the rhythmic structures in all of these tracks. Whether he is using the 3+3+2 rhythm as a transitory tool between sections or the 3+3+2+2+2 in order to create a symmetrical loop of alternating forward motion, the contrast between slow downbeats and fast upbeats is what drives the music forward. His favored ratio is 75 percent stable, 25 percent unstable, but tracks like "Don't Be Afraid" and "The Landing" demonstrate that ratios of 60–40 or even 50–50 have their own unique uses. I would now like to point back to one of the most iconic musical cues in the *FF* series, which was featured prominently in the battle themes through *FFVI*, and reprised in *FFIX*—the pulsing bass motive from Example 3.3. Notice that this motive spends 75 percent of the measure on the tonic and 25 percent on the unstable seventh, its structure perfectly mirroring the 3+3+2 and 3+3+3+3+4 rhythms that Uematsu would use later in the track. Emphasis of the upbeat as a method of generating rhythmic interest is a crucial part of Uematsu's style, regardless of the presence of explicit diatonic/propulsive rhythms.

FFIX's main battle theme "Battle 1" weaves all of these strands of diatonic/propulsive rhythm and upbeat emphasis into a poetic whole, which is fitting given that it marks the end of an era. It was the last *FF* on the PlayStation, the end of series creator Hironobu Sakaguchi's involvement with the series, and the last time that Nobuo Uematsu worked as sole composer for an *FF* game. The game encapsulates this series of endings by nostalgically looking back at what came before in many regards, from its return to a medieval setting to the characterization of *FF*'s black mage through Vivi, and the music is no exception.[43]

After *FFVII* and *FFVIII* had diverged from the standard formula by abandoning the once-traditional opening arpeggio and pulsing bass, *FFIX* brings them back and makes them more central than ever before. From the start, Uematsu expands this motive from two bars to six, decorating it with strings that accentuate the beats and build tension. However, this focus on nostalgic elements does not mean that Uematsu was unwilling to incorporate new ideas in this theme. Immediately

after the pulsing bass motive, he generates a significant amount of rhythmic energy through a propulsive rhythm he has not yet used: 3+3+2+2+2+2, which is heard most prominently in the melodic lines.[44] The most unique aspect of this rhythm is that it does *not* fit within the prevailing 4/4 meter and requires one bar of 3/4 in order to place the following downbeat properly. The use of metrical change is atypical within Uematsu's battle themes, and the resulting shift in downbeat placement makes the meter difficult to track. I refer to this effect as a "metrical breakdown," because for a brief moment the music seems to lose its rhythmic grounding. Uematsu immediately follows this 3+3+2+2+2+2 rhythm with the more traditional transitory propulsive rhythm 3+3+3+3+2+2 at mm. 9–10 in the trumpet part, but given that it begins on the out-of-place downbeat, even this familiar rhythm serves to create more instability. By the end of m. 10, the duple beats drive toward some sort of arrival, which Uematsu delivers with the first ever return to the pulsing bass motive in the franchise.[45] This abnormal return to the opening foreshadows an immense focus that Uematsu places on this motive throughout the entire A section of this theme.[46] The pulsing bass motive recurs every two measures in the A section; and this is the only instance in which this opening motive returns at the end of the repeat with the exception of *FFIV*. Excluding this motive from *FFVII* and *FFVIII* demonstrates the push into uncharted waters that the developers strove for. By returning to and emphasizing the motive in *FFIX,* Uematsu capitalizes on the feeling of nostalgia inherent within the game.

The pulsing bass motive is not the only upbeat-focused aspect of *FFIX*'s battle theme: within the A section, Uematsu alternates each of those two-bar phrases with two measures of a melody in the 3+3+2 rhythm.[47] This decision ensures that every measure of this passage contains an emphasis of the upbeat either melodically or rhythmically, resulting in a rhythmic structure that resembles the cyclical propulsive rhythms of earlier games without relying on making the rhythm explicit at all times. Uematsu creates a seamless chain made of links that are both melodic and rhythmic, treating both musical aspects as interchangeable so long as they emphasize the upbeat.[48]

The beginning of the B section at m. 31 continues the upbeat emphasis with a cyclical 3+3+2 rhythm in both melody and accompaniment, but the melody in the first four measures (mm. 31–34) has one unique feature that sets it apart from Uematsu's typical use of diatonic/propulsive rhythms. He typically uses the final duple beat as a means to drive toward a downbeat, but here Uematsu frustrates that desire by ending the first part of the phrase on beat 4 of m. 31.[49] The sudden sustained F on beat 4 of m. 31 draws attention to itself while simultaneously feeling unresolved, somewhat akin to the way that *FFI*'s transitory 3+3+2 ended on the 2, but without the displacement. The fact that m. 32 also lacks an attack on the downbeat in either of the melodic instruments (trumpet and French horn) serves to

further undercut the release of this rhythmic tension. Measures 33–34 feature the trumpet repeating the same motive a step higher, while the horn accompanies in a rising 3+3+2 rhythm, capitalizing on the tension thus far produced. The second half of this phrase is simpler, with 3+3+2 rhythms in the electric guitar melody and percussion accompaniment that lead directly into the next phrase.

The second half of the B section plays with the trumpet, French horn, and electric guitar motives from the first half in a sequential chain of 3+3+2 rhythms that release their tension onto long sustained notes. Similar to the way in which the A section links together phrases by alternating the 3+3+2 rhythm with the proportionally similar pulsing bass motive, the 3+3+2 rhythm here serves as a constant link between the parts as various melodies bounce between instruments. Meanwhile, the electric bass, guitar, and percussion play a cyclical 3+3+2 rhythm that reinforces the pulse and continues it once the melody transitions into tied whole notes. The final measure of the loop features a combination of cyclical and transitory techniques through the use of several low drums that heavily pound out one final 3+3+2 rhythm, using orchestration to weight the rhythmic energy toward the end of the section. *FFIX*'s battle theme weaves together both of Uematsu's upbeat-focused techniques to create a track that perfectly encapsulates his rhythmic style.

Conclusion

The rhythms of Uematsu's *FF* battle music place an immense focus on the upbeat as a site for generating rhythmic excitement. Whether they are working as transitions between sections or as a cycle of constant tension, these rhythms support Butler's contention that rhythmic contrast that comes into focus on the upbeat forms "a particular strategy for creating rhythmic interest" (2006: 85). This conclusion seems quite sensible, as these tracks accompany moments of ludic strife and excitement and must naturally be exciting in order to fulfill their purpose. Beyond this rather plain conclusion, these rhythms reveal gaps in existing scholarship on rhythmic categorization through their misfit with the existing category of "diatonic rhythm." Although Uematsu makes frequent use of rhythms that belong to the diatonic category, he only ever uses a small portion of them. Furthermore, the rhythms found in tracks such as "Don't Be Afraid" and "Hunter's Chance" produce remarkably similar effects to the diatonic rhythms that Uematsu prefers while *not* falling into this existing category. This phenomenological and technical resemblance leads me to the conclusion that a new, partially overlapping category must be made, a category I call "propulsive rhythm."

My work is more suggestive than conclusive, and I am certain that future refinements will need to be made in order to fully delimit this new category of

rhythm. With that disclaimer, I propose this new rhythmic category with the criteria of maximal individuation, asymmetry, and dividing a number of pulses into two clear sections—first one of triple beats, then one of duple beats. The 3+3+2+2+2 rhythm meets all of these criteria by being maximally individuated, the size of the beats being asymmetrical, and dividing twelve pulses into a group of two 3s and three 2s. This set of criteria would also allow the tying in of rhythms with an odd number of pulses, such as 3+2+2, possibly read as the meter 7/8, which absolutely could not be diatonic because of the odd number of pulses. I design propulsive rhythm as a category with purposely broad requirements due to the unmistakable sonic resemblance that rhythms share when they begin with triple beats and end in duple beats.

I have come to these criteria based upon the use of propulsive rhythms in Uematsu's music but also from hearing the same rhythms produce similar effects in a wide variety of musical works as diverse as "The Number of the Beast" by Iron Maiden (3+3+3+3+2+2+2+2), "I Don Quixote" by Mitch Leigh (3+3+2+2+2), and "Shape of You" by Ed Sheeran (3+3+2). The most salient feature of a propulsive rhythm is the sense of suspension produced by the triple beats that then shifts to intensive forward motion with the duple beats. They are a highly effective tool for crafting rhythmic excitement and a sense of forward motion, and Uematsu's frequent inclusion of these rhythms in his battle music serves to underscore this ability. These rhythms have become a central aspect of *FF* battle music, as memorable (if maybe implicitly) as Chocobos or the Warriors of Light. One could think of them as one of the most powerful pieces of materia that Uematsu and later composers use to craft thrilling musical accompaniment to on-screen clashes: a veritable musical limit break.

NOTES

1. I address the ambiguity surrounding 3+3+3+3+4 and 3+3+3+3+2+2 below.

2. Will Gibbons (2017) explores the idea that most Japanese RPGs (JRPGs) organize their soundtracks around "location-based cues" and "game-state cues." He cites online RPG soundtrack critic Patrick Gann's concept of the "eight melodies template" that many JRPGs work from, involving four musical cues that play according to the player's current location—"(1) castle, (2) town, (3) field, and (4) dungeon—and four cues based on ludic events—(1) introductory title screen [...] or opening expository cut scene, (2) the end of the game [...][,] (3) the standard combat state, and (4) the final battle." He contends that while most JRPGs contain far more than eight tracks, most or all tracks will fall into one of those categories; for example, a game may have a unique theme for each town, but you will never hear those themes when in battle. He claims that one primary purpose of location- and game-state cues is "aurally indicating the nature (and relative safety) of each setting."

Gibbons also provides a long quote from Gann that succinctly summarizes generic norms for some of these cues: "[T]he castle theme is always written in a Baroque contrapuntal style, the field music is more romantic, and the battle music is always frantic and intentionally dissonant" (Gann cited in Gibbons 2017: 418).

3. Traut's account does not exclusively work within the framework of diatonic rhythm, instead preferring to explore "recurring accent patterns" that involve some degree of syncopation (Traut 2005: 60). However, although he includes nondiatonic patterns like 3+4+4+5 and 3+4+5+2+2 in his table of such patterns in rock music, it is key to note that the body of his paper focuses most intensely on the 3+3+2 and 3+3+3+3+2+2 rhythms (his chart of 150 songs that feature such accent patterns also contains 30 examples of 3+3+2 and 32 of 3+3+3+3+2+2). He shows a particular interest in the 3+3+3+3+2+2 rhythm, which he claims "is often repeated extensively as the main groove, or 'vital drive' of a particular song" and goes on to argue that "despite its repetition, its unique structure commands attention and hooks the listener" (Traut 2005: 70).

4. Cohn (1992) primarily focuses on "metrical complexes," or the multiple ways that a span of pulses can be divided. He uses the example of a six-pulse span being interpretable as either the meter of 6/8 or 3/4 as his primary example and explores the dramatic results that happen when such interpretations can clash. Although this work is not directly related to diatonic rhythm (and was written four years before Rahn defined the term), he does hypothesize certain metrical divisions—such as 3+3+2—and find them to be syncopated in a manner that produces rhythmic tension.

5. One probable reason for the ubiquity of the 3+3+2 rhythm in video game music lies in the technical means of sound production on 1980s and 1990s hardware. When using an eight-step sequencer, 3+3+2 is the closest one can get to a truly even triplet, and 3+3+3+3+4 is simply that pattern doubled (as if producing quarter-note triplets). With the NES and SNES, there was the possibility of hardcoding durations in hexcode in order to produce durations outside of the sequence, such as Koji Kondo's "Overworld Theme" in *Super Mario Bros.* (1985), which featured true duple eighth notes contrasting with true triplets (McAlpine 2019: 123). However, doing so was both time- and labor-intensive, and many composers opted instead to use interfaces like the Family BASIC or proprietary software that included sequencers for convenience.

6. When I use the term "square meter," I am referring to a meter that contains a number of pulses that divide evenly by four. Although the most common diatonic rhythms in both popular and media score music fit into a 4/4 meter (eighth-note pulses divided into 3+3+2 or sixteen divided into 3+3+3+3+4), Rahn's original conception of diatonic rhythm allowed for diatonic rhythms in the meter of 3/4. For example, twelve pulses divided into 2+2+3+2+3 is a diatonic rhythm because it takes a total number of pulses that is divisible by four and divides it by an odd number in a way that is maximally even and maximally individuated. See Rahn (1996).

7. Building on Gibbons's work on location- and game-state-based cues, Alan Elkins's presentation at the *2020 North American Conference on Video Game Music* explores the formal

structure of phrases in town and field cues in JRPGs. He identifies two main formal structures, the period and sentence, that have each historically been associated with particular musical and affective qualities. Elkins identifies a "sense of motion" and "continuation function" inherent to the sentence, in contrast to the more self-contained period. He finds that the location-based cues for town themes have a strong tendency to use periods in order to accentuate the feelings of safety, whereas the more adventurous field locations frequently have sentential structures that imbue them with a sense of constant forward motion. In such a context, the lack of cadential closure provided by sententially structured field themes acts to create a restless state that is then interrupted at random by an enemy encounter. I contend that the surprise generated by triggering the battle music cue is heightened by Elkins's observation of field music's sentential structure. See Elkins (2020).

8. "Coneria Castle" is the name used in the 1990 US release; it was translated to "Castle Cornelia" in subsequent rereleases including *Final Fantasy Origins* (PlayStation 2002) and *Final Fantasy I & II: Dawn of Souls* (Game Boy Advance 2004).

9. See Supp. 3.1 for a formal structure of "Battle Scene" from *FFI*. Sections featuring diatonic and/or propulsive rhythm are in black here and elsewhere.

10. See Supp. 3.2 for a musical example of the 3+3+2 transitory section from *FFI*'s "Battle Scene."

11. When I refer to a syncopation here, I am conceptualizing the meter as cut time (2/2) due to the rapid pace of the quarter note pulse.

12. See Supp. 3.3 for a musical example of the B section from *FFI*'s "Battle Scene."

13. My use of "phenomenal accent" refers to "any event at the musical surface that gives emphasis or stress to a moment in the musical flow" (Lerdahl and Jackendoff 1983: PP). Lerdahl and Jackendoff specify that unlike the common-practice accent mark, a phenomenal accent need not necessarily involve a change in dynamics, as their category allows for "attack points of pitch-events, local stresses such as sforzandi, sudden changes in dynamics or timbre, long notes, leaps to relatively high or low notes, harmonic changes, and so forth" (Lerdahl and Jackendoff 1981: 485).

14. The simple harmonies of this passage are typical for an RPG battle system. He contrasts the "fast tempo, driving bass lines, [and] chaotic textures with lots of surface noise" with "the harmonic content—one of the musical elements usually considered primary in musical analysis—[which] is often rather threadbare, filled with the simplest of cliches," an observation that rings true for the extremely basic i–iv$^{6/4}$–i–V loop found here. Also of note is the two-pitch bassline that could have been absolutely devoid of tension, but uses the octave leaps in the 2+3+3+3+3+2 rhythm as the sole tool for generating tension. See Armstrong (2019).

15. Although *FFII*'s battle themes do not contain any diatonic rhythms, this does not mean that Uematsu tried nothing new or exciting. *FFII*'s battle themes are filled with unique and memorable timbres placed in structurally crucial junctures that call attention to them. In the standard battle theme, the transition from the A section to the B section (mm. 11–15) features a crescendo that crashes onto staccato stabs on dominant harmony that drop away to make room for a strange, glittery instrument. The dramatic buildup followed by the

solo texture creates an immense focus on this instrument. Additionally, the game's boss battle music (a first for the series) uses rapid trills to make melody notes sound unstable and shimmery, as if the very pitches are breaking apart at the seams.

16. See Supp. 3.4 for the opening measures from *FFIII*'s "Battle 1."

17. The specific percussion sounds used here might be easily mistaken for synths due to an idiosyncrasy of the NES's APU (audio processing unit), because they partially are. The NES had five audio channels available—two pulse generators, a triangle-wave generator, a noise channel, and a 1-bit sampler—with the noise channel primarily being used for percussion. Given that the noise channel can only produce one white noise sound at a time, composers frequently mixed the noise with pitch-bent tones in the pulse or triangle-wave generators in order to achieve the desired effect, as in the "Title Theme" to *Hero Quest* (1991) (Todd 2012). In *FFIII*'s standard battle theme, this is the effect that Uematsu uses in order to produce the sound of descending toms. See Collins (2008) and McAlpine (2019).

18. See Supp. 3.5 for a formal structure of "This Is the Last Battle" from *FFIII*.

19. See Supp. 3.6 for a musical example of *FFIII*, "This Is the Last Battle," A section.

20. See Supp. 3.7 for a musical example of *FFIII*, "This Is the Last Battle," B section's closing material.

21. See Supp. 3.8 for a formal structure of "Fight 2" in *FFIV*.

22. See Supp. 3.9 for a musical example of *FFIV*, "Fight 2," closing propulsive rhythm.

23. See Supp. 3.10 for a musical example of *FFVI*, "Battle 1," mm. 36–37.

24. See Supp. 3.11 for a musical example of *FFVII*, "Birth of a God," mm. 63–66.

25. See Supp. 3.12 for a formal structure of "Those Who Fight!" from *FFVII*.

26. See Supp. 3.13 for a musical example of *FFVII*, "Those Who Fight!," mm. 1–4.

27. 3+3+4+2+2+2 is not a diatonic rhythm due to the fact that it contains three different pulse values, 2, 3, and 4, and these cannot be maximally even. However, it does meet my criteria for propulsive rhythm because it begins with triple beats and then transitions to duple for the remainder.

28. See Supp. 3.14 for a musical example of *FFVII*, "Those Who Fight!," mm. 9–14 (primary theme).

29. See Supp. 3.15 for a formal structure of "Don't Be Afraid" from *FFVIII*.

30. See Supp. 3.16 for a musical example of *FFVIII*, "Don't Be Afraid," mm. 1–3.

31. See Supp. 3.17 for a musical example of *FFVIII*, "Don't Be Afraid," mm. 9–12 (A section).

32. See Supp. 3.18 for a musical example of *FFVIII*, "Don't Be Afraid," mm. 25–27 (B section).

33. See Supp. 3.19 and Supp. 3.20 for an illustration of this balance.

34. Earlier *FF* games included similar ludic highpoints, but the treatment of the music differs significantly. In *FFVI*, for instance, the track "Protect the Espers" plays continuously through multiple similar ludic segments, such as the "Battle of Narshe" and during the party's escape from the Magitek Facility. While these appearances resemble the use of "The Landing" and "Hunter's Chance" in that "Protect the Espers" plays without interruption in and out of battle, the fact that this track is reused makes those segments less unique than the Siege of

Dollet or the Festival of the Hunt. It is the very uniqueness of "The Landing" and "Hunter's Chance" that highlights their significance. I should also note that there is one example of a track that uses a propulsive rhythm in *FFVI* and only appears once in the required game-play—the underwater journey that Sabin, Cyan, and Gau take through the Serpent Trench. ("The Serpent Trench" is also used when traveling through the caves from the basement of Figaro Castle to the Ancient Castle during the exploration of the World of Ruin, but this is a side quest that is not required for the game to proceed. Furthermore, "The Serpent Trench" is interrupted by battle music while exploring the caves, while the track is uninterrupted during the underwater journey.) "The Serpent Trench" is an atypical presentation of Uematsu's use of cyclical propulsive rhythm in spite of featuring the standard 3+3+3+3+2+2 rhythm due to its slow tempo and lack of sharp percussive sounds. Most likely chosen to match the underwater setting, the instruments used in this track feature soft and reverb-laden timbres that do not affectively match what one would expect from a battle theme, but quite effectively capture the sense of an underwater journey. This example more closely resembles "The Landing" and "Hunter's Chance" due to its appearance during only one segment of the game (unless the player chooses to walk significantly out of their way to travel through the trench again), though the underwater affect dilutes the sonic similarity.

35. See Supp. 3.21 for a musical example of *FFVIII*, "The Landing," mm. 15–18, 3+3+2+2+2 melody. For a musical example of *FFIX*, "Hunter's Chance," mm. 9–12, 3+3+2+2+2 melody, see Supp 3.22.
36. See Supp. 3.23 for a musical example of *FFVIII*, "The Landing," mm. 62–65 depicting rhythmically focused variation.
37. See Supp. 3.24 for a musical example of *FFIX*, "Hunter's Chance," mm. 25–28, depicting rhythmically focused variation.
38. See Supp. 3.19 and Supp. 3.20.
39. For an illustration of this balance, see Supp. 3.25.
40. One of the more famous examples of the 3+3+2+2+2 rhythm is Leonard Bernstein's "America" from the musical *West Side Story*, and this particular example also uses this rhythm to swap in and out aspects of the "orchestration." Throughout "America," a group of female immigrants sings against a group of male immigrants about the virtues and failings of living in the United States, alternating between the two groups with each cycle. The boisterous tone of the song is certainly aided by the cyclic pattern of tension that I described in all three *FF* examples, and the rhythm is long enough to allow one group to make a complete statement before the other takes over.
41. For the sheet music for Nobuo Uematsu, *FFVII*, "Jenova Complete," mm. 1–4, see Supp 3.26. The official OST sheet music for "Jenova Complete" is also in 6/8 but notated with all durations half the length as in my example; that is, an eighth note in my example is a sixteenth note in the OST. I chose to base my notation on an eighth-note rather than sixteenth-note pulse because I find the music easier to read at this scale.
42. See Supp. 3.27 for a musical example of *FFVII*, "Jenova Complete," mm. 81–84.

43. For a deeper discussion into the role that nostalgia and the Black Mages play in *FFIX*, see James L. Tate, this volume.

44. See Supp. 3.28 for a musical example of *FFIX*, "Battle 1," mm. 7–10, depicting the metrical breakdown through change of meter.

45. See Supp. 3.29 for a musical example of *FFIX*, "Battle 1," mm. 15–18 (A section).

46. For a formal structure of "Battle 1" from *FFIX*, see Supp 3.30. The form of this track is slightly ambiguous, and one could argue that what I have labeled as the B section could be split into two eight-bar sections. I chose not to interpret the form this way because the A section (a repeated eight-bar phrase) ends on a conclusive cadence, but the first eight-measure phrase of the B section ends on a weak half cadence that feels incomplete. Additionally, the second eight-bar phrase of the B section shares the same thematic material of the first phrase, creating a cohesion between them that cannot be ignored.

47. See Supp. 3.29.

48. Uematsu also increases the metric dissonance of the pulsing bass motive on each of these two-bar returns by having the synthesizer play a 3+ (long tone) tail to the melody that hints at the 3+3+2 diatonic/propulsive rhythm in contrast to the duple 2+2+2+2 of the bass.

49. See Supp. 3.31 for a musical example of *FFIX*, "Battle 1," mm. 31–34 (B section).

REFERENCES

Armstrong, Stephen (2019), "Sounding the Grind: Musicospatial Stasis in Classic RPG Battle Themes," *North American Conference on Video Game Music*, The Hartt School, CT, May 31.

Butler, Mark J. (2001), "Turning the Beat Around: Reinterpretation, Metrical Dissonance, and Asymmetry in Electronic Dance Music," *Music Theory Online*, 7:6, https://www.mtosmt. org/issues/mto.01.7.6/mto.01.7.6.butler.html. Accessed October 15, 2021.

Butler, Mark J. (2006), *Unlocking the Groove: Rhythm, Meter, and Musical Design in Electronic Dance Music*, Bloomington: Indiana University Press.

Cheng, William (2014), *Sound Play: Video Games and the Musical Imagination*, New York: Oxford University Press.

Clough, John and Douthett, Jack (1991), "Maximally Even Sets," *Journal of Music Theory*, 35:1, pp. 93–173.

Cohn, Richard L. (1992), "The Dramatization of Hypermetric Conflicts in the Scherzo of Beethoven's Ninth Symphony," *19th-Century Music*, 15:3, pp. 188–206.

Collins, Karen (2008), *Game Sound: An Introduction to the History, Theory, and Practice of Video Game Music and Sound Design*, Cambridge: MIT Press.

Elkins, Alan (2020), "Musical Form and Gameplay Context in the Japanese Role-Playing Game," *North American Conference on Video Game Music* (held online), June 13.

Gibbons, William (2015), "Navigating the Musical Uncanny Valley: *Red Dead Redemption*, *Ni no Kuni*, and the Dangers of Cinematic Game Scores," *North American Conference on Video Game Music*, Ft. Worth, TX, January 17–18.

Gibbons, William (2017), "Music, Genre, and Nationality in the Postmillennial Fantasy Role-Playing Game," in M. Mera, R. Sadoff, and B. Winters (eds.), *The Routledge Companion to Screen Music and Sound*, Abingdon: Routledge, pp. 412–27.

Hellslayer_1 (2016), "Comment: Let's Listen: *Final Fantasy IV* (SNES)—Random Battle Theme (Extended)," YouTube, https://www.youtube.com/watch?v=50rom7BtG8s. Accessed July 19, 2020 [no longer available].

Huron, David (2006), *Sweet Anticipation*, Cambridge: MIT Press.

Kizzire, Jessica (2014), "'The Place I'll Return to Someday': Musical Nostalgia in *Final Fantasy IX*," in K. Donnelly, W. Gibbons, and N. Lerner (eds.), *Music in Video Games: Studying Play*, New York: Routledge, pp. 183–98.

Lerdahl, Fred and Jackendoff, Ray (1981), "On the Theory of Grouping and Meter," *The Musical Quarterly*, 67:4, pp. 479–506.

Lerdahl, Fred and Jackendoff, Ray (1983), *A Generative Theory of Tonal Music*, Cambridge: MIT Press.

McAlpine, Kenneth (2019), *Bits and Pieces: A History of Chiptunes*, New York: Oxford University Press.

McClary, Susan and Walser, Robert (1994), "Theorizing the Body in African-American Music," *Black Music Research Journal*, 14:1, pp. 75–84.

Myrddincrow (2014), "Comment: Let's Listen: *Final Fantasy IV* (SNES)—Random Battle Theme (Extended)," YouTube, https://www.youtube.com/watch?v=50rom7BtG8s. Accessed July 19, 2020.

Nintendo Complete (2015), "*Final Fantasy IV* Battle Themes: 4 Different Versions—NintendoComplete," YouTube, June 7, https://www.youtube.com/watch?v=TW51r7RUrl4. Accessed July 19, 2020 [no longer available].

Price, Aaron (2020), "From Grinding to Grooving: An Investigation of Motoi Sakuraba's RPG Combat Music," *Music and the Moving Image* (held online), NYU Steinhardt, June 13.

Rahn, Jay (1996), "Turning the Analysis Around: Africa-Derived Rhythms and Europe-Derived Music Theory," *Black Music Research Journal*, 16:1, pp. 71–89.

SilentWeaponsIII (2011), "Let's Listen: *Final Fantasy IV* (SNES)—Random Battle Theme (Extended)," YouTube, November 2, https://www.youtube.com/watch?v=50rom7BtG8s. Accessed July 19, 2020 [no longer available].

Sschafi1 (2011), "*Final Fantasy IV*—Battle Theme [Remastered]," YouTube, February 13, https://www.youtube.com/watch?v=AK0QeunxLx0. Accessed July 19, 2020.

Summers, Tim (2016), *Understanding Video Game Music*, Cambridge: Cambridge University Press.

Traut, Don (2005), "'Simply Irresistible': Recurring Accent Patterns as Hooks in Mainstream 1980's Music," *Popular Music*, 24:1, pp. 57–77.

Todd, Patrick (2012), "NES Audio: Triangle Kick Drum," Retro Game Audio, March 8, https://retrogameaudio.tumblr.com/post/18991395931/nes-audio-triangle-kick-drums. Accessed July 2, 2020.

PART 2

NIBELHEIM

4

Thus Spake Uematsu:
Satirical Parody in the Opening Sequence
to *Final Fantasy VI*

Richard Anatone

Longtime fans of the *Final Fantasy* (*FF*) franchise collectively acknowledge the significance, both from a narrative and musical perspective, of *FFVI*.[1] As the last game for the Super Nintendo of the series, it marked a dramatic shift away from the high-fantasy medieval aesthetic that had become established as the norm for the title. The use of steam-powered machines and weaponry was indeed a radical change for those familiar with the "Tolkienesque fantasy world" long established by *Dungeons and Dragons*[2] as the model for RPGs. This ultimately set the stage for the next two games in the series, which became more futuristic with each installment (Holleman 2019b: 6).

To reflect this dramatic aesthetic shift, the introduction to *FFVI* contains an unsettling aura, especially when compared to its predecessors. Each of the first five games is imbued with an overall sense of optimism, which is imparted to the player through the use of bright colors and harmonies immediately presented when the game is turned on: the first three games in the series released for the Nintendo (*FFI–III*) all begin with a bright blue screen depicting the backstory for the player as they prepare for their upcoming adventures, while the Super Nintendo's *FFIV* and *FFV* begin the game with black screens depicting the game's title in a translucent and tinted blue font. Musically, Nobuo Uematsu's famed "Crystal Prelude" accompanies the introductions for the first four games in the series,[3] while *FFV* displays its title screen accompanied by an optimistic statement of the game's cyclic theme,[4] complete with major tonalities announced by trumpet fanfare.

Now, consider a player in 1994 who has just brought home a copy of *FFVI*. As soon as our hypothetical gamer turns on the power switch, they are shown a black screen with white font depicting the title, completely devoid of music.

When this screen fades, the player is then shown a video that descends upon a blackened sky, with storm clouds, and intermittent lightning strikes. Adding to the suspense, the only music that the player is "greeted" with is a church organ playing a dissonant stack of six notes, each a perfect fourth apart.[5] Finally, an ominous choir thunderously chants two notes unintelligibly, "sung" on top of two radically dissonant harmonies. What follows is not the expected (or by this point, unexpected!) "Crystal Prelude," but rather a dissonant piano prelude full of chromatically planed seventh chords, played with rich rubato. Indeed, this seems more like a warning than the expected greeting, as if to say "abandon all hope, ye who enter here."

An attentive player who is familiar with the previous games and their accompanying music may experience conflicting emotions and thoughts while experiencing this brief but powerful sequence. It is not a stretch to suggest that our hypothetical gamer may be awestruck, confused, and perhaps a little apprehensive about what is to come: awestruck, because the introduction is visually impressive; confused, because it is a complete contrast to what is expected visually, musically, and narratively when compared to the rest of the games in the series. And of course, this foreboding title screen would certainly justify someone being apprehensive about what is to come. However, a *truly* attentive player would perhaps be more intrigued and excited, especially if this person, in addition to being well versed in the *FF* series, was also familiar with music in the traditional western canon, literature, and philosophy.[6] This is because the entire opening sequence that I have described is not simply different from the previous games, but it is riddled with layers of irony for the attentive gamer to decipher. From the first note sounded in the organ to the final note sung by the choir, Uematsu satirically parodies Richard Strauss's famous introduction to *Also Sprach Zarathustra*, and quotes himself, further enhancing the introduction while foreshadowing what is to come.

Taking a multifaceted approach, I examine the various levels of irony and symbolism within Uematsu's "Omen." After briefly discussing the introduction to both Nietzsche's and Strauss's *Thus Spake Zarathustra*, I turn to several character analyses to draw a parallel between the Übermensch as seen by Nietzsche and the Gestahlian Empire in *FFVI*. Taking a heuristic approach to "Omen," I apply theories of semiotics asserted by Robert Hatten, Linda Hutcheon, and Esti Sheinberg, arguing that "Omen" is both a satirical parody of Strauss's nature motive and Uematsu's own recurring compositional "rising fourth" motive. This complicated ironic introduction is also saturated with symbolism and, as I reveal, reflects accurately the antithesis of Nietzsche's Übermensch and foreshadows the horrors committed by the Gestahlian Empire.

Nietzsche and Strauss's Zarathustra

Although Strauss's work is set "freely" after Nietzsche, there are several program-matic interpretations upon which most scholars agree, especially regarding the piece's introduction. The famous nature motive, a term coined by Hans Merian (Williamson 1993: 3), comprising the trumpet's rising C-G-C gesture is stated three times, answered in turn by a bombastic fanfare, each with its own unique cadence. Labeled "Sonnenthema," or "sun theme" by the composer himself (McQuiston 2013: 157), most agree that this musically represents the prologue of Nietzsche's eponymous novel. To be sure, the first words Zarathustra proclaims in the novel are to the sun: "Thou great star! What would be thy happiness if thou hadst not those for whom thou shinest!" (Nietzsche 1997: 3). Strauss scholar John Wil-liamson states, "From this famous passage, most commentators have isolated the sunrise, illustrated in the trumpet calls and C major cadence of the first twenty-one bars, as indicative of the work's feeling for nature, its relationship to landscape, though they have seldom felt the need to go further" (1993: 57).

Strauss's "feeling for nature" has become one of the most iconic musical intro-ductions in the world of popular culture, thanks in part Stanley Kubrick's use in his *2001: A Space Odyssey*. In her book *We'll Meet Again: Musical Designs in the Films of Stanley Kubrick*, Kate McQuiston writes, "Strauss' contemporary Gustav Mahler had relied on the overtone series and wide spacing of orchestral ranges to evoke nature in his first symphony, premiered in 1889. Strauss combined notions of nature and fanfare in the opening of *Zarathustra* seven years later" (2013: 157). Indeed, the opening nature motive and the first E that initiates the triumphant fanfare all outline the naturally occurring harmonic series in C major. It therefore seems logical to begin the work in C major, as it is the only key without any acci-dentals and all of the notes within the key signature are natural. The thunderous tonic and dominant affirmation in the timpani simply add weight to the already exuberant fanfare.

Yet, Strauss's introduction does more than simply depict the sunrise in Nietzsche's novel; it successfully imparts the same sense of grandiose optimism found in Zarathustra's proclamations regarding the Übermensch. As McQuiston writes, "[the musical introduction] might, for Strauss, also speak to the enormity of—and ultimate triumph over—philosophical questions Friedrich Nietzsche poses in his eponymous writing" (2013: 158). Combining the natural with the fanfare in this introduction reinforces Nietzsche's theory regarding the quest for the Übermensch as the natural step in evolution: that it is natural for us to overcome our innate personhood and become to the Übermensch what "ape is to man." This is made clear in Zarathustra's prologue, as he proclaims to the people:

I teach you the Superman.[7] Man is something that is to be surpassed. What have ye done to surpass man? [...] What is the ape to man? A laughing-stock, a thing of shame. And just the same shall man be to the Übermensch: a laughing-stock, a thing of shame.

(Nietzsche 1997: 6, original emphasis)

A semiotic look at the underlying symbolism inherent within the trumpet's opening gesture seems to confirm McQuiston's statement regarding the "enormity of—and ultimate triumph over" certain philosophical questions. While space does not permit an entire discussion of Charles Peirce's tripartite theories of the sign, it is helpful to identify the sign qualities surrounding the rising C-G-C nature motive. Icons are defined according to their likeness to their referent; likenesses may fall under the realm of shared qualities, properties, or similar structure (Hatten 1994: 258). This opening motive is therefore musically iconic, in that it rises just as the sun rises. Although it may be simplistic (and also common sense!), this is especially useful when searching for meaning in the introduction to *FFVI*.

The nature motive's iconicity is not the only semiotic interpretation that bears fruitful meaning: the abstract quality of the ascending gesture itself lends to further discussion. While application of Peircean terminology would probably consider the "rising gesture" as a rhemic qualisign (a sign with abstract potential),[8] Robert Hatten's views on the encultured correlations surrounding ascending musical gestures are most relevant to the present discussion. According to Hatten, "[o]ne can easily imagine how 'yearning' might correlate with 'upward' motions, since upward motions are iconic with 'reaching,' and 'reaching' relates to yearning through metaphors such as 'reaching for higher existence'" (1994: 57). It is especially interesting that Hatten concludes this thought referring to "higher existence," as a parallel may be drawn to the philosophical ideas inherent within Nietzsche's writing, and, by connection, Strauss's nature motive. Of particular interest is Nietzsche's own admission in *Ecce Homo* of being the opposite of the heroic type:

I cannot remember ever having exerted myself, I can point to no trace of struggle in my life; I am the reverse of a heroic nature. To "will" something, to "strive" after something, to have an "aim" or a "desire" in my mind—I know none of these things from experience.

(1911: 50)

If the Übermensch is the ultimate being that, through evolution, man strives to become, then Strauss's introduction to *Zarathustra* of an ascending gesture rooted

in the naturally occurring overtone series—a blend of the natural and fanfare—is entirely logical from a semiotic perspective.

Gestahl and Kefka's Übermensch

Kefka Palazzo gets a bad rap. One simply needs to read the scholarship surrounding *FFVI*, spend a few moments reading blog posts, or even peruse through YouTube comments to realize that the majority of fans see Kefka as one of the most evil (if not, *the* most evil) villains within the game franchise. Granted, Kefka does commit some of the most heinous acts perpetrated against the citizens of the World of Balance: he sets fire to Figaro Castle; he poisons the people of Doma Castle; he murders General Leo in cold blood; he murders his liege Emperor Gestahl to usurp the throne; he absorbs the power of the Magi statues to destroy the world, which he nearly does—twice. Scholars have analyzed this character and his associative music in many different ways. For example, Kylie Prymus approaches Kefka's personality and actions through the lens of different philosophers with an emphasis on Foucault and Nietzsche, ultimately concluding that labeling Kefka as evil, mad, or even irrational may be too simplistic of a view.[9] Approaching Kefka from the perspective of disability studies, Dana Plank (2018) conducts musical analysis of his leitmotif as well as other associative musical themes, demonstrating what she refers to as Uematsu's "musical markers of insanity." Still, others like Pierre Maugein view him through the lens of victimhood, as Kefka *was* Gestahl's first experiment with Magitek technology. Maugein writes:

> A classic flashback, as used for Sephiroth in *Final Fantasy VII*, could have been utilized to evoke [Kefka's] formative experiences; however, it is a lowly NPC in Vector who mentions who he was before. As if, despite his importance to the plot, he was outside the story, even the world, no more than a regular guy who turned bad. This is exactly what assists in understanding him. Unlike the instinctual enemies of prior installments in the series, Kefka is fundamentally unexceptional [...] He acts for himself, impelled solely by a madness which is connected to the trauma he suffered.
>
> (2018: 78)

As the NPC from Vector states, "That guy, Kefka? He was Cid's first experimental Magitek Knight. But the process wasn't perfected yet. Something in Kefka's mind snapped that day…!"

There seems to be so much scholarship surrounding Kefka's psyche that Emperor Gestahl is somewhat overshadowed by Kefka's heinous actions. True, Kefka may be the character carrying out all of these violent acts, but for the first

half of the game, he simply seems to be carrying out Emperor Gestahl's orders. Aside from the parallels between the Gestahl Empire and the Nazi party under Hitler, it is the emperor's desire to be worshipped *himself* that leads him to his own demise. This is made evident right when Kefka betrays Gestahl atop the Floating Continent and murders him in cold blood: the last words Gestahl utters are, "There'll be no one to worship us" right before Kefka tosses him off of the floating island after exclaiming, "What a worthless excuse for an emperor!"

Regardless of the scholar or the villain in question, one finds a common thread within the bulk of analysis: Nietzsche, nihilism, and the Übermensch. The search for the "superman" seems to be an underlying theme for the empire in *FFVI*; perhaps more interesting is the dynamic shift from Emperor Gestahl's ambitions for creating the Übermensch through eugenics and its realization with Kefka's rise to godhood. After questioning whether Kefka is truly an Übermensch, Prymus ultimately concludes that he is not, writing that,

> Nietzsche wanted more than what Kefka could offer mankind. The Übermensch he described might initially resemble Kefka, but ultimately it shows him to be a *false prophet*. The real Übermensch is capable not only of overthrowing God and the old morality, but of overcoming *nihilism* as well.
>
> (Prymus 2009: 31, emphasis added)

And nihilism is indeed what we see in Kefka, especially in the second half of the game: while his poisoning of Doma Castle may have been strategically effective as Prymus argues, once he amasses the power of a god, he becomes purely nihilistic and aims to destroy the world—a failed Übermensch.

Ominous beginnings

While the introduction to Strauss's tone poem combines nature and the fanfare to reflect a world of man's natural triumphs over the age-old philosophical questions in beautiful harmony, we see that within the world of *FFVI*, this combination results in a dissonant dichotomy as a result of the *unnatural* creation of Magitek technology. This is reflected no more clearly than within the opening sequence to *FFVI*, which is formally most complex in terms of organization and structure, at least compared to previous games in this franchise's history. This is largely due to the fact that the introduction to the game consists of five different consecutive scenes before the player begins to take control of the gameplay: the opening title screen, a backstory played over various vignettes, the dialogue between Wedge and Biggs (with Terra present), and the opening credits. According to the official soundtrack, the music

that accompanies all of these scenes falls under the same track titled "Omen," which runs just over four minutes in length on the OST. Perhaps, in an attempt to simplify things, the original sound version for piano released by Doremi in 1994 splits this entire track into two different pieces, titling them "Opening Theme #1" and "Opening Theme #2." Nevertheless, "Omen" contains several smaller sections within it, each with an important notable musical statement.[10] The analysis that follows relates to section 1, which consists of the satirically parodic statement of the introduction to Richard Strauss's *Also Sprach Zarathustra*.

"Omen" as parody

In her dissertation *Bodies in Play*, Dana Plank suggests that the introduction to "Omen" seems to be an allusion to Strauss's *Zarathustra*, stating, "[T]his track is *extremely* reminiscent of Strauss' dramatic introduction—the slow whole notes leading to a huge descending semitone gesture. All that is missing is the timpani" (2018: 281, original emphasis). Plank's remark suggests that "Omen" is both parodic and satirical of Strauss's famous introduction: parodic in that Uematsu imitates Strauss's introduction; satirical in its timbral distortion (among others). While I address the satirical nature of "Omen" in length below, it is important to briefly discuss parody as a separate technique of irony.

According to Esti Sheinberg, "parody is simultaneously a text and a meta-text [...] Parody is characteristically based on elements of imitation, which it modifies by the insertion of incongruous critical and/or polemical components" (2000: 141). In this sense, parody consists of two significant features: (1) its imitation of pre-existing works, and (2) its use as satirization device. However, parody is more than simply imitation for the sake of humor or satire; Linda Hutcheon's book *A Theory of Parody: The Teachings of Twentieth-Century Art Forms* provides an exhaustive look into parody as an independent structure, separate from satire. Perhaps her most significant contribution to our understanding of parody, according to Sheinberg, is her term *trans-contextualization*, "which describes not only the transfer of a subject from its original context to a new one, but also the incongruity, or the 'ironic confrontation,' within the new entity" (2000: 152). Sheinberg provides a visualization of Hutcheon's process, which is shown in Figure 4.1.

Due to its close relationship to satire, Hutcheon provides definitions of both satiric parody and parodic satire; more relevant to the present discussion, however, is satirical parody, which occurs "if the chosen items [to parody] possess some similar qualities and/or provide a semantic link between their former and new contexts" (Sheinberg 2000: 103).[11] As an example of satirical parody, Sheinberg provides an in-depth analysis of Debussy's "Golliwogg's Cakewalk," in which

FIGURE 4.1: Hutcheon's concept of trans-contextualization as the driving force of parody (Sheinberg 2000: 152).

Debussy parodies Wagner's "Tristan Chord" throughout the rag in a distorted and humorously dysfunctional manner. Here, the "yearning" motive of Wagner's dramatic music is structurally distorted and recontextualized in a lighthearted rag—a style used for light entertainment.

Uematsu's "Omen" is thus both a satirical parody of Richard Strauss's introduction to *Zarathustra* and Uematsu's own rising fourth motive that he frequently employs in many of his *FF* soundtracks. The result, as I discuss below, is a complicated, symbolically rich, and ironically dense musical introduction that not only serves to foreshadow musical and narrative aspects of the game but also serves as commentary *to* the music and narrative within the game. Within ten measures of music, Uematsu tells us everything we need to know about the next 40 hours of gameplay—as well as a few thought-provoking ideas on Strauss and his own compositional skills!

Satirical distortion in "Omen"

There exists a vast amount of theories on the structure and meaning of irony. Sheinberg sums up irony thusly:

> In spite of the vast amount of literature covered and the large span of time between the classical and modern writings, there are no major differences between the theories that are presented. They all speak about "saying one thing while meaning another," and all stress the aesthetic importance of a correct interpretation of the message by discovering the "intended" or "true" meaning behind the ostensible one.
>
> (2000: 34–35)

One of the major traits of irony is its satirical function, which is always combined with its dissimulatory characteristics (Sheinberg 2000: 34). And if irony is essentially boiled down to "saying one thing while meaning another," then we can see how "Omen" is an ironic statement through both its parodic and satirical nature. As parody, "Omen" recontextualizes a well-known musical introduction into a new presentation. However, it is its satirical nature that accounts for its musical distortions, which I address below.

Satire, as a form of irony, "relies on a given set of norms, and uses ridicule, *often in an aggressive manner*, to indicate actual instances of failure to match their standards" (Sheinberg 2000: 70, emphasis added). The most relevant satirizing techniques involve some type of structural distortion, which include: (1) the removal of an essential component of the satirized object, (2) the insertion of a new component, and (3) the replacement of one or more of the object's characteristic components.[12] Sheinberg states that satirical exaggeration "is a kind of distortion in which certain characteristics that are to be perceived as deficient [...] are exaggerated and thus highlighted" (2000: 107). Among these exaggeration techniques are qualitative exaggeration (a subject's characteristics are satirized) and quantitative exaggeration (through repetition or through an accumulation of characteristics) (Sheinberg 2000: 109).[13]

Many of these techniques are evident in Uematsu's introduction to *FFVI*. As a primarily consonant introduction comprising an ascending line with a subsequent fanfare and affirmation, *Zarathustra*'s introduction includes all of the musical signifiers that lie on what Sheinberg refers to as the culturally favored realm of the spectrum.[14] Uematsu, however, begins "Omen" by removing and replacing Strauss's key timbral components that are responsible for such optimistic interpretation (see Example 4.1). Although "Omen" begins with an ascending gesture, Uematsu strips away every instrument that Strauss uses, save for the organ. In addition to this timbral distortion, Uematsu replaces every instrument that plays the fanfare with an unintelligible choir sound. As Plank mentions, the organ is as much a symbolic instrument for Kefka as it is a signifier for religious music;[15] the use of organ and choir here foreshadows Kefka's eventual rise to godhood, and by removing the brass timbre, he removes any semblance of fanfare.[16]

Uematsu's use of timbre alone is not the only distortion worth investigating, although it certainly is a starting point. The very rising gesture that initiates *FFVI* is, itself, riddled with layers of irony. Rather than beginning with a consonant rising three-note gesture like Strauss, Uematsu exaggerates and distorts this statement to pure dissonance: a series of five notes in quartal harmony, totaling six notes. Seasoned fans of the *FF* series will likely recognize this recurring "rising fourth" musical motive in Uematsu's language and may even associate it as a symbol of evil, or at the very least, peril. While I address this motive and its

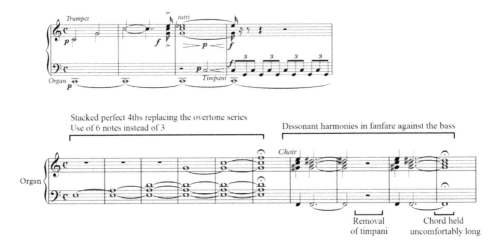

EXAMPLE 4.1: (top) Richard Struass, *Thus Spake Zarathustra*, introduction (reduction); (bottom) Nobuo Uematsu, *FFVI*, "Omen," mm. 1–10.

musical symbolism within earlier *FF* games elsewhere, its use *here* is significant for a number of reasons.[17] First, Uematsu exaggerates both Strauss's three-note nature motive and also his own "rising fourth" motive, which typically consists of only four notes. Second, his choice of pitch collection is of particular interest: by beginning with an E instead of the C that initiates Strauss's introduction, Uematsu ultimately concludes his rising gesture with a purely white key cluster (E-A-D-G-C-F) that implies the Phrygian collection—the darkest diatonic mode that still contains a perfect fifth above its tonic. This results in a use of the same notes, but a different *rotation* of the C major scale implied in the nature motive of *Zarathustra*, thereby providing a dark reflection, or shadow, of Strauss's famous introduction.

Structural symbolism: Foreshadowing Emperor Gestahl and Kefka

From a structural perspective, the use of six notes allows for Uematsu to conclude the gesture a compounded minor second higher from which he begins, creating an E-F dissonance, further implying the Phrygian tonality. The Phrygian tonality is of particular significance, as it foreshadows Emperor Gestahl's own musical associativity: Emperor Gestahl's own leitmotif, as well as "Catastrophe," and "Troops March On" (itself a variation on his leitmotif) reside in the Phrygian. Approximately ten pieces within the soundtrack reside primarily in the Phrygian mode, and many others move to the Neapolitan harmony for means of expression;

approximately 28 percent of the game's soundtrack rely on these harmonies.[18] Thus, the Phrygian mode, as implied in the opening of "Omen," becomes a harmonic motive in the game, symbolically referring to the horrors committed by the Gestahl Empire. It is for this reason, among others addressed below, that I see the rising gesture and its implicit Phrygian harmony as belonging to Emperor Gestahl, which is eventually usurped by Kefka.[19]

Further distortion within this introduction is evident in the "fanfare" itself; I use the term "fanfare" loosely because, devoid of any brass timbre and consonant and/or perfect intervals, it contains virtually no characteristics of a fanfare. Harmonically speaking, the fanfare progression consists of an fmM7–fm7$^{b5}$ in place of Strauss's CM–cm statement following the nature motive (although the fm7$^{b5}$ is enharmonically reinterpreted). Thus, Strauss's consonant fanfare is replaced by a two-note dissonant choir chant played twice in succession: while the second chord is held for three seconds the first time, the listener is exposed to the dissonant chord cluster for an uncomfortable six seconds during the second statement, with no tonic-dominant affirmation that was present in Strauss's timpani and hardly any visual movement on the screen.[20] Though applying traditional Roman numerals to this phrase may not yield fruitful analysis, there are some significant structural attributes inherent within this ten-measure phrase: in addition to the implied Phrygian modality exhibited between the E and F in the rising gesture, the Phrygian mode is also implied through voice exchange between the outer voices between m. 6 and the downbeat of m. 7, at which point the choir chant, associated with Kefka, is stated. As this voice exchange also marks the shift from Gestahl's rising motive to Kefka's chant motive, it takes on symbolic meaning, as it represents the exchange in power dynamic that occurs halfway through the game when Kefka murders Gestahl on the Floating Continent and assumes the role of godhood.

Additionally, the rise in the bass from E to F foreshadows the final fight against Kefka in "Dancing Mad": although "Dancing Mad" begins with a C Phrygian modality, the music ascends by half step to D flat at the "Second Tier" of the battle, announcing Kefka's ascension into godhood. Although Kefka, himself, does not appear until the "Fourth Tier" of the battle, it is within the "Second Tier" where the organ enters to accompany the choir; here, Uematsu provides musical motives associated with Kefka.[21] Thus, the rising semitone becomes symbolic of Kefka's ascent to godhood.

While the structurally ascending step in the bass foreshadows Kefka's ascent into godhood, the "once-fanfare-now-choir chant" stated at m. 7 of "Omen" foreshadows Kefka's musical associations through its descending melodic step, which is used prominently in three of Kefka's associative themes: his eponymous leitmotif, "Dancing Mad," and "Fanatics."[22] Dana Plank's discussion of Kefka's leitmotif provides a wonderful analysis of topics and motives therein; for the present discussion,

however, the point of interest lies at the climax of the last phrase before looping back to the A section: at this point, we hear a descending semitone played in the melodic layers, foreshadowing further instances of the prominent use of this descending gesture.[23] This motive is expanded further in "Dancing Mad: Tier 1" in both the organ introduction and within what could be considered a "transition" section at mm. 43–46 (see Example 4.2).[24] In the former, Uematsu unites both the ascending and descending step together in the organ; in the latter, the descending semitone is the exclusive melodic gesture sung by the choir. Within the second tier, Uematsu makes almost exclusive melodic use of these two gestures (see Example 4.3).[25]

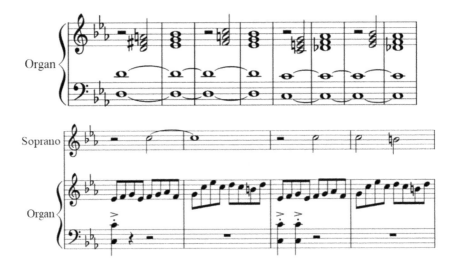

EXAMPLE 4.2: Nobuo Uematsu, *FFVI*, "Dancing Mad: Tier 1," mm. 21–28 (top) showing prominent use of the ascending and descending step; mm. 43–46 (bottom) showing prominent use of the descending step.

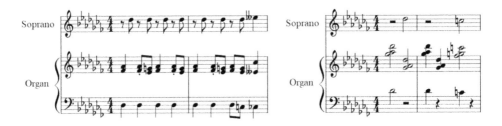

EXAMPLE 4.3: Nobuo Uematsu, *FFVI*, "Dancing Mad: Second Tier," the first phrase (left) and second phrase (right).[26] Here, the only melodic motive used in the soprano consists of a rising and falling descending semitone.[27]

EXAMPLE 4.4: Nobuo Uematsu, *FFVI*, "Fanatics," mm. 1–8. Note the parallel fifth motion in the voice, reflecting the religious nature of the cult. It should be noted that the rhythmic activity of the tambourine and bass drum is increased to eighth notes at m. 5.

It is within "Fanatics," however, where Uematsu brilliantly synthesizes all of these musical ideas through the process of developing variation.[28] In the second half of the game, we are eventually witness to a Cult of Kefka: a brainwashed collective that chants praise to Kefka out of fear that he will destroy them with his dreaded "Light of Judgement." The music accompanying this scene contains each of these important motivic associations: the rising perfect fourths from "Omen" are replaced with rising minor thirds, creating a fully diminished seventh chord built on E^b, resulting in the further dissonant octatonic scale. This introduction, which functions as dominant to A^b, leads directly to a choir that chants a melody comprising ascending and descending steps around a fixed pitch, all of which is accompanied by a Phrygian bassline centered around A^b (see Example 4.4).

Doubly satirical: Satirizing Emperor Gestahl

There is more to musical satire, however, than simply exaggerating or distorting known musical traits in a mocking and aggressive manner. As Sheinberg writes:

Musical satire must be bound to norms. Therefore, more than any other kind of musical irony, musical satire depends on musical norms, i.e. musical styles and musical topics. Musical satire, thus, is concerned with the assessment of certain phenomena, musical ones or their semantic, against a musical aesthetic, and/or ethical set of norms, and with the implied demand for their rectification [...] *In such cases, the satire's target can be either the failure to comply with the musical norms of the specific style or the musical set of norms itself* [...] *Since many musical units correlate with more than one semantic unit, they can be used to connect two different sets of values.* Thus, by satirizing a musical characteristics that correlates with an unpreferred value within a certain set of norms, while also correlating with another value that is preferred in another set of norms, a *double satirical goal can be achieved*: directly, the specific characteristic is satirized as unpreferred within the original set of norms; in addition to that , and entirely different set of norms, within which the semantic correlative of the same musical unit is preferred, is satirized too, albeit indirectly.

<div align="right">(2000: 76–77, emphasis added)</div>

While the goal of satire may be to aggressively ridicule instances of failure to match particular standards according to Sheinberg, her statement above reveals the true potential for satire: to satirize *two distinct sets of norms*. As an example, she provides the march in Shostakovich's "Happiness" from his op. 79 *From Jewish Folk Poetry*: within one set of norms, the use of full orchestra playing *fortissimo* correlates with the "vanity" and "pomposity"—the unpreferred pole of the ethical and aesthetic axes, respectively—and therefore falls within the unpreferred pole of the musical axis. A completely different set of norms, however, would see the same musical characteristics of the full orchestra playing *fortissimo* fall under the "preferred" pole of the ethical and aesthetic axes, correlating with communism and populism, respectively. Therefore, as Sheinberg discusses, through the use of exaggeration within his orchestration and dynamics, Shostakovich directly satirizes the vanity of the song's narrator while indirectly satirizing communism and populism.[29]

Within the introduction to *FFVI*, we see a similar doubly satirical phenomenon, although it deviates slightly from Sheinberg's description (see Figure 4.2).[30] This is because Uematsu is not simply criticizing a set of norms seen in Strauss's introduction—*he is also parodying the musical statement itself*, albeit satirically.[31] The very structure of Uematsu's musical statement contains stacked dissonance, hinting toward atonality through its purely clustered harmony. Under the set of norms "A," this sonorous cluster correlates with "distortion" and "unnatural" within the aesthetic value-axis and also with "egotism" and "guilt" within the ethical value-axis. Consequently, Uematsu's use of exaggerated dissonance falls within

FIGURE 4.2: Adaptation of Sheinberg's model demonstrating the level of satire within "Omen" to understand the rising fourth motive as a parody of Strauss's nature motive.

the unpreferred pole of the musical value-axis. Within this set of norms, Strauss's consonant nature motive correlates positively with "humility" and "innocence" under the ethical axis and "beauty" and "natural" under the ethical and aesthetic axis, respectively. However, under a *different* set of norms "B," the use of stacked dissonance may be seen more favorably and may correlate more positively on the ethical with "complexity" and on the aesthetic axis with "sophistication." Indeed, Strauss's reliance on the overtone series may correlate with "simple-mindedness" and "banality" from a compositionally critical perspective, while Uematsu's radically distinct harmony, dissonant as it may be, may correlate more favorably with "complexity" and "sophistication."[32]

What results is a doubly satirical musical occurrence: directly, Uematsu's stacked fourth motive is satirized as unpreferred within one set of norms, "A," while indirectly it is satirized as preferred under an entirely different set of norms, "B." Through the use of exaggeration and harmonic distortion, Uematsu directly satirizes its ethical and musically aesthetic correlative: the simple-mindedness and banality inherent within Strauss's nature motive. Indirectly, and perhaps even more interestingly, he satirizes the arrogance, egotism, guilt, and even unnatural scientific practices of Emperor Gestahl himself, which are further ethical and aesthetic correlatives of the same musical statement.

Doubly satirical: Uematsu satirizes Uematsu

Although Uematsu's introduction is a satirical parody of Strauss's introduction to *Zarathustra*, the distortion process results in Uematsu's rising perfect fourth gesture—itself a motive that exists within Uematsu's own musical language.[33] As a completely independent motive found within his own musical language in his soundtracks to prior installments of *FF*, Uematsu further satirizes and parodies *himself* with his introduction to "Omen," which, as I discuss, involves a completely different set of norms.

As a recurring motive in his compositional toolbox, Uematsu began using the "rising fourth motive" (and slight variations on it) in 1990s release of *FFIII*, released for the Nintendo (see Table 4.1). Save for "Vegies of Gysahl" and *FFVI*'s battle music, the motive is typically reserved as a brief, subtle introductory passage to a more significant melodic statement. Additionally, the rising fourth motive is usually found in a rock setting and accompanies plot devices with more negative connotations: with the exception of "Vegies of Gysahl," which is a lighthearted melody that accompanies the village of Gysahl where chocobos are raised,[34] and "The Airship Blackjack,"[35] every instance of the rising and descending fourth motive is found in battle music or, as in the case of "Baron Castle" and "Omen,"

TABLE 4.1: Instances in which Uematsu uses his "rising 4th" motive and motives related to it. It should be noted that, although the motive is found in later FF games (e.g., "Birth of a God" from FFVII), this table only contains instances prior to and including FFVI.

Game title	Track title	Modality	Tempo and duration of notes within rising motive[36]	Characteristics	Musical function
FFIII	"Vegies of Gysahl"	G Lydian	♩ = 112 Sixteenth notes	Four notes, rising perfect fifths	Within B section, played subtly after musical phrase in triangle wave
FFIV	"Baron Castle"	F Aeolian	♩ = 108 Eighth notes	Two sets of descending perfect fourths[37]	One-measure lead in to the four-measure introduction to the theme proper
FFIV	"Final Battle"	G Aeolian	♩ = 172 Half notes	Five notes, rising perfect fourths	Four-measure lead in to the cyclic theme's statement played in a rock setting
FFV	"Battle Theme"	A Aeolian	♩ = 162 Half notes	Four notes, rising perfect fourths	Two-measure introduction to main theme played on top of traditional Uematsu "pulsing bass" battle motive in a rock setting
FFV	"The Fire-Powered Ship"	E♭ M/E♭m	♩ = 136	Four notes rising, each with quartal harmony played beneath	Two-measure introduction to main theme played on top of dominant pedal

Game title	Track title	Modality	Tempo and duration of notes within rising motive[36]	Characteristics	Musical function
FFV	"Exdeath's Castle"	C Lydian-Dominant	♩ = 123	Four notes, rising perfect fourths	Two-measure introduction to the main theme played on top of chromatically descending V7 chords
FFVI	"Omen"	E Phrygian	♩ = 80 Whole notes	Six notes, rising perfect fourths	The entire musical statement, unaccompanied, followed by a two-note choir fanfare
FFVI	"Battle Theme"	A Phrygian	♩ = 168 Quarter notes	Four notes, rising perfect fourths	Played subtly in strings after A section's first complete phrase, played in a rock setting
FFVI	"Mt. Koltz"	A♭ Lydian[38]	♩ = 146 Whole notes	Four notes, rising fourths	Four-measure introduction on a Neapolitan pedal to the main theme in a rock setting
FFVI	"The Airship Blackjack"	C Major	♩ = 145 Half notes	Four notes, rising perfect fourths	Two-measure introduction to main theme on top of a pedal tone in a rock setting

scenes that imply or foreshadow antagonists within the game's story, or, at the very least, some form of danger, as is the case with "The Fire-Powered Ship."[39] Lastly, with the exception of "Vegies of Gysahl," "Mt. Koltz," and "The Airship Blackjack," the primary underlying harmonies within the track are darker, mostly residing in the Aeolian or Phrygian mode.

Returning to "Omen," we see a variety of satirizing techniques that Uematsu applies to his own rising fourth motive. Structurally, he exaggerates the number of notes by increasing the expected four notes to a total of six.[40] He also exaggerates the duration of each note, using whole notes and playing the passage at 80 beats per minute. Through this technique, as well as the removal of critical elements of the motive's surrounding environment (like the rock band setting and its obligatory driving bass line), Uematsu not only distorts the motive's typical presentation but also, more importantly, draws further attention to the motive as the *only* musical statement on which to focus our attention, rather than using it simply as a short introductory passage to a more substantial musical theme. Furthermore, he tonally distorts the expected quartal harmony: four notes in quartal harmony, dissonant as they may be, still contain tonal attributes. For instance, E-A-D-G, as well as its A-D-G-E and compacted A-D-E-G rotation, may be interpreted as a seventh chord with a dissonant fourth (a "sus 4") above its root. However, a series of six notes in quartal harmony results in a sonic cluster of pure saturation that is virtually unintelligible from a traditional and tonal harmonic perspective.[41]

Viewing the introduction to "Omen" through the lens of self-satire and parody, we see yet another occurrence of a satirical phenomenon with an entirely different set of norms than when seen as a satirical parody of Strauss's *Zarathustra* (see Figure 4.3). Under the set of norms "A," the rising gesture correlates with "graciousness" and "conscientiousness" within the ethical axis and with "recognition" and "symbolism" within the aesthetic value-axes. As a recurring musical device, Uematsu pays what is typically known as "fan service" to his own fans by shining more attention on this typically overshadowed melodic statement: a gracious and subtle nod to his overly attentive fan(atic)s. Those who understand the motive's association with negative connotations in previous installments of the game will also recognize its symbolic attributes. Consequently, the rising fourth gesture falls under the preferred pole of the musical value-axis. Under an entirely different set of norms "B," this same musical phrase may fall within the unpreferred pole of the musical axis as a result of its relationship to its unpreferred correlatives: "limited creativity" and "laziness" under the ethical axis as well as "unoriginality" and "pedestrianism" within the aesthetic axis; one could argue that the use of the same material repeatedly over the course of every game is the result of a lazy composer who is entirely unoriginal.

117

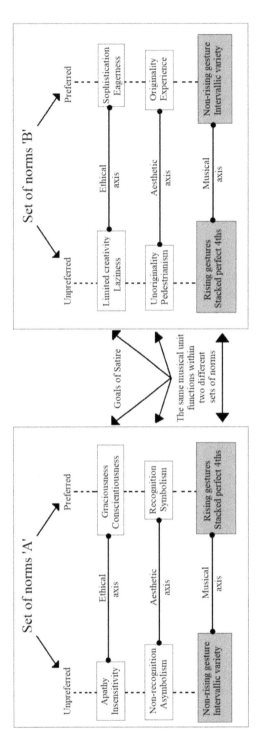

FIGURE 4.3: Depiction of the level of satire within "Omen" to understand the rising fourth motive as a parody of Uematsu's own compositional tool.

The result of this passage is a brilliantly laughable instance of self-depreca-
tion. Directly, Uematsu satirizes the rising fourth motive as unpreferred under
the set of norms "B" while indirectly satirizing the same musical motive as pre-
ferred under the set of norms "A." By removing all other musical characteristics
like the rock music setting and heightening our attention to this rising motive,
he satirizes the motive's simplicity and constant reoccurrence through its ethical
and aesthetic correlatives: "limited creativity," "laziness," "unoriginality," and
"pedestrianism." However, under a different set of norms "A," Uematsu satir-
izes the same motive as preferred but only to those attentive fans who understand
Uematsu's musical language intently. Secretly, Uematsu tells us that unoriginality
and limited creativity are meaningless if you know how to do it correctly: as the
old adage goes, "good composers borrow, great composers steal"—even from
one's own self.

The ultimate irony: The rise and fall of the Gestahlian Empire

It is apparent that there is much more to Uematsu's introduction than a simple par-
odic statement of Strauss's iconic nature motive: there is an abundance of musical
and narrative symbolism within his ten-measure introduction, all of which sup-
port the complex interwoven web of parody and satire embedded in his ironic
utterance. And yet, something still seems to be amiss: Even though "Omen" is
a structurally distorted satiric parody of Strauss's nature motive, it retains its
ascending motion, which is arguably its most distinct characteristic. However,
the visual accompaniment to "Omen" is the *reverse* of Nietzsche's imagery: while
Zarathustra's prologue depicts a sunrise, the entire introduction to "Omen" is cen-
tered around a *descending* moving image—not a sunset per se but a direct inversion
of the ascending motion inherent within the sunrise. Because of this, Sheinberg's
depiction of the concept of "trans-contextualization" seen in Figure 4.1 does not
fully depict what occurs at "Omen." In other words, the nature motive is not only
distorted, but rather it is at odds with its new surroundings—*not* from an aes-
thetic perspective, as distorted harmonies accurately depict the distorted visual
imagery—rather, the now-distorted ascending nature motive is incongruous with
the *descending* video sequence. True, "trans-contextualization" implies that the
original object is now incongruous with its new surroundings, but it is a bit more
complex in this situation.

We must not forget that "Omen" is also a satirically parodic statement
of Uematsu's own four-note rising motive. The four-note rising gesture not
only undergoes structural distortion in "Omen," but its new musical appear-
ance is at odds with its new musical surrounding, as it is now the sole focus

of our musical attention. As the four-note rising fourth motive is already similar to the nature motive in that they both rise, we see that both motives endure structural distortion and are trans-contextualized into a new environment with which the new distorted motive is congruous aesthetically, but incongruous *visually*. The result is a doubly satirically parodic statement of these similar gestures—which culminates in an unaccompanied rising fourth gesture of six notes at odds with its new environment at the introduction of *FFVI* (see Figure 4.4).

Is Uematsu's music truly incongruous with the visual imagery? On the surface, it certainly seems that way: an ascending musical gesture that sonically intensifies and a descending video sequence of a stormy sky seem to be, at the very least, out of sync with one another. However, further scrutiny reveals a hidden meaning— a beautiful irony—within this introduction (see Figure 4.4). For as one ascends through a series of perfect fourths, one actually *descends* through a series of perfect fifths. And while the former may be incongruous with the video sequence, its hidden and implied descending motion is perfectly suitable for this video depiction. The descending quintal harmony is thus a hidden reflection of the ascending gesture—a looming musical gesture that is hidden in plain view that warns us of what is to come (see Figure 4.5).

Could this be the hidden meaning within "Omen"? I certainly believe it is. Uematsu could have used *any* stacked intervallic series for his introduction, including a series of six notes in quintal harmony. Such a collection would have certainly been dissonant, although quintal harmony is arguably brighter than quartal harmony. This may be the result of two factors: (1) a perfect fifth is consonant, while a perfect fourth is dissonant against a given root; and (2) quartal harmony implies the Phrygian mode, while quintal harmony implies the brighter Ionian and the major pentatonic collection. However, there seems to be something more poignant in Uematsu's introduction in addition to its Phrygian implication. For if ascending motions are correlated with "yearning" and "aspiration," then perhaps their hidden descending gestures are their negative reflection. And if perfect fifths are associated with nature and God due to its consonance within the harmonic series, as well as their distance spanning seven semitones, then perhaps perfect fourths may be correlated with its opposites: the unnatural and the (d)evil in humanity. To be sure, Uematsu's exaggerated ascending motion that initiates *FFVI* seems to represent an emperor who continues to reach higher and higher toward godhood for his own evil ambitions, defying nature and Nature's God—ultimately leading to his own downfall, as foreshadowed in the voice exchange that takes place at the distorted choir fanfare. Indeed, Gestahl's twisted ambitions in conjunction with his manipulation and distortion of nature through Magitek research, eugenics, and human

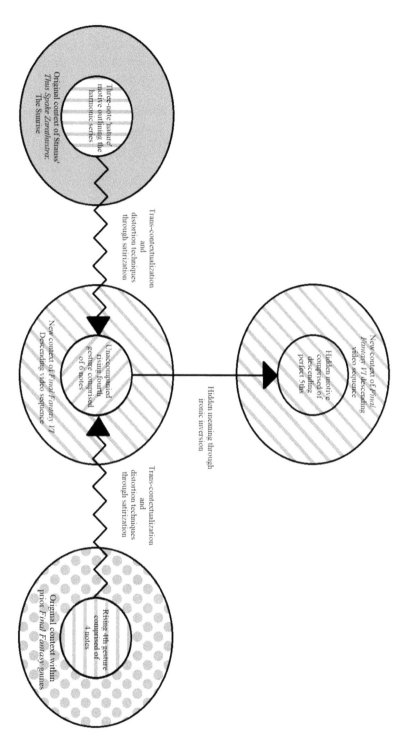

FIGURE 4.4: The fully realized ironic statement of the introduction to "Omen." On the bottom, the satirical parody of both Strauss's nature motive and Uematsu's rising fourth motive are distorted and recontextualized, resulting in ascending musical gesture that is incongruous with the descending video sequence. The ironic inversion of the rising fourth motive results in a descending fifth motion, which is perfectly suitable for its video accompaniment, revealing the hidden meaning behind the introduction: foreshadowing the rise and fall of the Gestahl Empire.

FIGURE 4.5: The hidden meaning within *FFVI*'s "Omen." A gesture that rises in perfect fourths (left) creates a sonic dissonance, while its hidden reflection is a gesture comprising *descending* perfect fifths, which depicts a power-hungry Emperor Gestahl, hell-bent on global domination.

experimentation ultimately result in both his downfall and the rise and fall of the failed *Übermensch* Kefka, who ends up being just another nihilistic villain who needs to be put down.

Conclusion

FFVI marks a break of tradition in many ways from the previously established medieval- and Renaissance-based narratives of its predecessors. But it also marks a significant moment in Uematsu's career: it is within *FFVI* where Uematsu's ability to exploit compositional conventions typically found in role-playing games is on full display. To be sure, Uematsu's earlier score to *FFIV* marks the beginning of his experimentation with these conventions: within *FFIV*, Uematsu provides multiple aesthetic transformations of the game's cyclic theme throughout the game—a technique found in most all genres.[42] Additionally, it is within *FFIV* where Uematsu represents multiple characters with their own character themes, although very few endure any type of meaningful transformation.[43] And remarkably, Uematsu's troping of musical topics for the use of foreshadowing a future narrative event occurs in *FFIV*.[44]

However, I would argue that it is within *FFVI* that these conventions realize their full potential. Here, Uematsu provides primary leitmotifs for fourteen protagonists and two antagonists, as well as multiple secondary (and tertiary!) transformations for various characters.[45] The game's cyclic theme also endures a much more complex transformation through a gradual tropological shift heard over the course of the entire game.[46] Additionally, as I have demonstrated here, Uematsu foreshadows significant characters and events that the player has not yet been introduced to, while satirically parodying a well-known nineteenth-century tone poem, an iconic Kubrick film, *and himself*—all before the player even hits a button on the controller![47] Through satirical parody, Uematsu simultaneously engages with traditional musical repertoire, philosophy, and popular culture—as well as himself—thus rewarding attentive players' various levels of literacy. These players will likely draw connections with Strauss, Kubrick, and Nietzsche and may ultimately form their own theories about the game before even witnessing its opening sequence that describes the fabled War of the Magi. Fans familiar with Uematsu's use of the rising fourth motive in games prior may even chuckle to themselves as they hear such an exaggerated statement of an otherwise mundane musical idea. This level of interaction with players demonstrates a truly attentive composer who treats the fans with the utmost respect and affection and who rewards them for their years of dedicated fan service. In sum, it depicts a composer who cares deeply for his craft and, perhaps more importantly, about the players.[48]

We can garner much from Uematsu's treatment of this iconic introduction to *FFVI*. The musical symbolism and cohesion through developing variation are perhaps the soundtrack's greatest characteristics, as Uematsu creates a seemingly endless collection of unified melodies, which is ultimately reflected in the game's narrative of an allied resistance united against a tyrannical empire. While it may be unlikely that players will pick up on all of these musical characteristics upon the first, second, or even tenth hearing, we can nevertheless learn much through our analysis of the soundtrack to *FFVI*. Composers seeking subtle ways of unifying their own soundtrack may turn to the methods discussed in this chapter. Arrangers and performers interested in telling and retelling their favorite stories may investigate motivic symbolism within other soundtracks to enhance their musical dramas,[49] and scholars may combine similar analytical methods presented here to aid in that process. Indeed, the level of detail in his compositional process may be one of the reasons that the soundtrack has received so much attention since the game was released in 1994. That "Omen" foreshadows significant musical elements and plot devices through such brevity, symbolism, and humor demonstrates Uematsu's artistic cognizance and serves as an example for musicians and fans everywhere.

NOTES

1. Although it may go without saying, because it was the third game of the franchise to be released in North America, it was released there as *FFIII*. Here, I use the title *FFVI* to avoid confusion with other games in the series.

2. Patrick Holleman provides a detailed overview of roots that RPGs share with *Dungeons and Dragons*. See Holleman (2019).

3. While the melody that accompanies the introduction to the NES games is referred to as the "Prelude" in official soundtracks and the "Crystal Theme" in many fanbases, I refer to the opening arpeggiated harp prelude as the "Crystal Prelude" in this chapter to avoid confusion between this theme and other prelude or prologue music used within the franchise.

4. Several scholars and composers, including Winifred Phillips (2014), refer to the cyclic theme of video games as the *Idée Fixe*. I use the term "cyclic theme" in this chapter, as I feel that the term *Idée Fixe* has too strong of a connotation with Berlioz's *Symphonie Fantastique*.

5. As I will discuss throughout this chapter, the rising fourth motive is one of the most significant motives used in all of Uematsu's compositional language. Within *FFVI*, it is interestingly a satirical parody of both himself and Strauss's *Also Sprach Zarathustra*.

6. William Gibbons addresses the problematic term "classical music," especially from the perspective of video game music studies. See chapter 1 of Gibbons (2018).

7. As this is a direct quote from a translation, I keep "Superman" here, although it is widely known that he is speaking of the Übermensch.

8. Bribitzer-Stull provides a very useful description regarding Peirce's tripartite theory of sign and its application of leitmotifs. See Bribitzer-Stull (2015).

9. Prymus ultimately concludes that he must be stopped because of his actions, but labeling Kefka as "evil" or "mad" is perhaps an oversimplification. See Prymus (2009).

10. See Supp. 4.1 for a table that breaks down the subsections of the game's opening sequence.

11. Sheinberg discusses examples of nonsatirical parody as well, but I do not address that here, as it does not relate to my current topic. See Part IV of Sheinberg (2000).

12. For an in-depth overview of these satirizing techniques, consult Chapter 5 of Sheinberg (2000).

13. For a detailed description of these different exaggeration techniques, see Sheinberg (2000).

14. See Supp 4.2 for a chart that compares the culturally favored characteristics within Strauss's *Zarathustra* with the culturally disfavored characteristics within Uematsu's "Omen."

15. It is also worth mentioning that the organ is often used in video games, as in film, in other symbolic ways. See Gibbons (2010) and Plank (2018 and 2019).

16. The fact that this statement comes back during "Dancing Mad" makes this all the more symbolic. See Plank (2018).

17. I have addressed this rising fourth motive as symbol for evil at a number of conferences, including the *2019 North American Conference on Video Game Music*, *2019 National Conference of the College Music Society*, and the 2019 regional conference of the Society of Composers Inc. See Anatone (2019).

18. See Supp. 4.3 for a table that displays tracks within *FFVI* that use Phrygian and Neapolitan harmonies.

19. Additionally, the player does not see Kefka as a potential primary antagonist until well into the game. For the first half of the game, Gestahl is set up to the primary villain that must be defeated.

20. The fact that this music accompanies a fairly uneventful introduction suggests further satirical parody of Stanley Kubrick's use of the music in his introduction to *2001: A Space Odyssey*. Although space does not permit me to address this here, it is certainly another layer of irony worth investigating.

21. See Supp. 4.4; the opening bars of both the first and second tier of "Dancing Mad" make use of prominent semitone motives.

22. Jessica Kizzire provides a detailed formal analysis of Kefka's associative themes and their influence on the leitmotifs of villains in subsequent installments of the series; see Kizzire, this volume.

23. See Supp. 4.5. Plank's comment that the choir's two-note gesture is one of obsession that "does not lead anywhere" reflects her discussion regarding Kefka's obsessive and destructive personality. See Plank (2018).

24. The term "transition" is used loosely, but if applying the theories put forth by Hepokoski and Darcy's *Sonata Theory*, it contains rhetorical functions typically reserved for transitions

like the increased tempo and surface rhythmic activity. See Chapter 6 of Darcy and Hepokoski (2006).

25. It is worth noting that the gesture played in the organ is itself related to the three-note rising motive (B-C-D) heard at the beginning of "Dancing Mad," which is first heard in "Catastrophe" and hints at the Phrygian mode. Plank (2018) suggests that this rising motive seems to represent magic in general.

26. While different scores use different key signatures for the second tier, I use all flats to emphasize the tonic D flat minor in the key signature—other scores use a key signature of three or four flats and use an F flat or even an E natural as an accidental within the phrase, which does not reinforce the D flat minor chord as being the tonic.

27. The fact that the rest of "Dancing Mad" resides in the theoretical key of D flat minor—with its nonexistent key signature of B-E-A-D-G-C-F—further reinforces the idea that Kefka is a *theoretical god*, or even a *nonexistent Übermensch*!

28. This is but one example of Uematsu employing the process of developing variation to create cohesion within this soundtrack. This example of "Fanatics" demonstrates how it is used to unify multiple tracks with each other (i.e., "Omen," "Kefka," "Dancing Mad," and "Fanatics"). Additionally, Uematsu employs the process to create cohesion *within* individual tracks. "Locke's Theme," for example, utilizes only a few motives throughout the A section, which Uematsu combines to create the transition and then inverts to create the B section. The resulting B material is then further employed throughout many other tracks as a short recognizable motive that takes on its own symbolic meaning regarding the tragic backstory of each protagonist. See Anatone (2019).

29. Sheinberg's analysis is much more in-depth than my brief description of her work here. See Sheinberg (2000).

30. The chart presented is based on Sheinberg's own theories. Here, I apply those theories to Uematsu's music using her graphic description. See chapter 4 of Sheinberg (2000).

31. The structure of parody and its relationship to these multiple satirical phenomena will be addressed further below.

32. This is not to say that I, personally, find Strauss's nature motive to be simple-minded and banal. I am merely addressing the satirical effect through Uematsu's (possibly unintended!) compositional techniques and the potential criticism regarding the simplicity inherent within the nature motive.

33. Space does not permit me to go into depth of Uematsu's various recurring musical motives and their symbolic potential from a Peircean perspective. I have elaborated on a variety of his recurring motives, including this rising fourth motive as well as the "tragic" motive elsewhere. See Anatone (forthcoming).

34. It should be mentioned that "Vegies of Gysahl" uses ascending perfect fifths, instead of fourths, suggesting that Uematsu associates stacked fourths more negatively than a series of stacked perfect fifths.

35. It is worth noting that "The Airship Blackjack" is the *only* instance of the rising fourth motive being used in a positive setting. Considering that the airship is the only way that the player can defeat the villains, it is perhaps fitting that this theme transforms the motive's negative connotation into one that is more optimistic and set in the major, albeit ambiguous, tonality. Additionally, this track also quotes "Gau" and the game's own cyclic theme at the start of the B section, so the self-quotation of the rising fourth motive seems to fit right in.

36. Tempo and duration of notes for all of these examples have been taken from the Doremi original sound version scores for solo piano.

37. Here, Uematsu separates both sets of descending fourths by a perfect fifth, resulting in the following notes: D-A-E-B-F-C-G-D.

38. It should be noted that this track is harmonically ambiguous. Although the melody seems to suggest tonic-dominant phrasing at the four-measure level (outlining C minor and G Lydian modalities), the A-G bassline suggests A Lydian instead of C minor. Regardless, the rising fourth harmony is built on A-D#-G-C, resulting in the more dissonant $Am^{7(\flat5)}$ chord.

39. It is also worth noting that "The Fire-Powered Ship" contains topical (and timbral) similarities with "The Red Wings" from *FFIV*. The triplet fanfare rhythms, wide-ranging trumpet melody, heavy percussion, and oscillation between tonic major and minor modality recall the dark militant "antihero" trope. See Atkinson (2018) for a discussion on the antihero trope in *FFIV*.

40. It does seem interesting that Uematsu chooses six notes, given the symbolic meaning regarding the devil, especially considering that the perfect fourth also spans six notes. To make matters even more interesting, a more literal translation of "Gestahl" is "Gastra," which is numerically represented as "66" using the system A=1, B=2, C=3, and so on. Although this is likely pure coincidence, I would feel remiss had I not exhausted all potential symbolism inherent within this introduction.

41. See Supp. 4.6 for a complete list of satirizing techniques employed in this example.

42. Even 8-bit games like *Castlevania* (NES 1986) and *Super Mario Land 2: Six Golden Coins* (Game Boy 1992) contain multiple transformations of the game's cyclic theme. While the first three *FF* titles do not transform the game's cyclic theme in meaningful ways, it became a common technique in subsequent games beginning with *FFIV*.

43. Most notably, Golbez's theme endures multiple transformations, while a substantial tropological transformation of the Red Wings' theme occurs once Cecil becomes a Paladin. See Atkinson (2018).

44. As Atkinson discusses, the "Airship" theme subverts typical "soaring" musical characteristics, which foreshadows its use as a vehicle to explore the underground of the earth. See Atkinson (2019).

45. Ryan Thompson discusses Wagnerian operatic convention with specific attention paid to various leitmotifs in this game. See Thompson (2020).

46. As I suggest, Terra's true leitmotif is not her self-titled track, but rather, it is the unique B section contained *within* her self-titled track, which organically develops over each subsequent treatment of the games' cyclic theme. This is the result of his "blurring of the boundaries" between the game's cyclic theme and a character's leitmotif, which he first attempted in *FFV* (Lenna's leitmotif quotes a fragment of the game's cyclic theme). See Anatone (2020).

47. As space does not permit me to discuss, the piano prelude that follows the ten-measure opening sequence of "Omen" contains further motivic and symbolic meaning for other elements of the game. Additionally, as it is a subversion of Uematsu's oft-used "Crystal Prelude," there arises a tropological shift once players finally hear the "Crystal Prelude" in the Narshe classroom. See Anatone (forthcoming).

48. James L. Tate discusses this broader approach to "interaction" within the frame of van Elferen's ALI model through the lens of nostalgia. See James L. Tate, this volume.

49. For instance, *Final Fantasy VI: Symphonic Poem (Born with the Gift of Magic)* is but one "retelling" of the events from *FFVI*; the symbolic meaning presented throughout is simply icing on the cake for listeners. For a discussion on how arrangements of these works may help tell the story from a different perspective, see Greenfield-Casas, this volume.

REFERENCES

Anatone, Richard (2019), "(Omen)ous Motives: Structural Unity and Developing Variation in Nobuo Uematsu's *Final Fantasy VI* Soundtrack," *Society for Composers, Inc.*, Commerce, TX, April 11–13.

Anatone, Richard (2020), "Rethinking the Idée Fixe and Leitmotif in Role-Playing Video Games: A New Methodology of Interpretation and Analysis," *Music and the Moving Image*, NYU Steinhardt, May 28–31, https://www.youtube.com/watch?v=UP9mVr8Ojw8. Accessed July 11, 2020.

Atkinson, Sean (2018), "Tropes and Narrative Foreshadowing in *Final Fantasy IV*," *North American Conference on Video Game Music*, Ann Arbor, MI, January 13–14, https://www.youtube.com/watch?v=2xJFkQoBhjA&t. Accessed September 26, 2021.

Atkinson, Sean (2019), "Soaring through the Sky: Topics and Tropes in Video Game Music," *Music Theory Online*, 25:2, https://mtosmt.org/issues/mto.19.25.2/mto.19.25.2.atkinson.php. Accessed September 26, 2021.

Bribitzer-Stull, Matthew (2015), *Understanding the Leitmotif: From Wagner to Hollywood Film Music*, New York: Cambridge University Press.

Darcy, Warren and Hepokoski, James (2006), *Elements of Sonata Theory: Norms, Types, and Deformations in the Late-Eighteenth-Century Sonata*, New York: Oxford University Press.

Gibbons, William (2010), "Blip, Bloop, Bach? Some Uses of Classical Music on the Nintendo Entertainment System," *Music and the Moving Image*, 2:1, pp. 40–52.

Gibbons, William (2018), *Unlimited Replays: Video Games and Classical Music*, New York: Oxford University Press.

Hatten, Robert (1994), *Musical Meaning in Beethoven: Markedness, Correlation, and Interpretation*, Bloomington: Indiana University Press.

Holleman, Patrick (2019), *Reverse Design: Final Fantasy VII*, New York: CRC Press.

Hutcheon, Linda (2000), *A Theory of Parody: The Teachings of Twentieth-Century Art Forms*, Chicago: University of Illinois Press.

Maugein, Pierre (2018), *The Legend of Final Fantasy VI* (ed. N. Courcier and M. El Kanafi; trans. ITC Traductions), Toulouse: Third Éditions.

McQuiston, Kate (2013), *We'll Meet Again: Musical Design in the Films of Stanley Kubrick*, New York: Oxford University Press.

Nietzsche, Friedrich (1911), *Ecce Homo* (trans. A. Ludovici), London: T.N. Foulis.

Nietzsche, Friedrich (1997), *Thus Spake Zarathustra* (trans. T. Common), Ware: Wordsworth Editions.

Plank, Dana (2018), "Bodies in Play: Representations of Disability in 8- and 16-Bit Video Game Soundscapes," PhD dissertation, Columbus: Ohio State University.

Prymus, Kylie (2009), "Kefka, Nietzsche, Foucault: Madness and Nihilism in *Final Fantasy VI*," in J. Blahuta and M. Beaulieu (eds), *Final Fantasy and Philosophy: The Ultimate Walkthrough*, Hoboken, NJ: John Wiley & Sons, pp. 20–32.

Sheinberg, Esti (2000), *Irony, Satire, Parody, and the Grotesque in the Music of Shostakovich*, Burlington: Ashgate.

Thompson, Ryan (2020), "Operatic Conventions and Expectations in *Final Fantasy VI*," in W. Gibbons and S. Reale (eds), *Music in the Role-Playing Game: Heroes and Harmonies*, New York: Routledge, pp. 117–28.

Williamson, John (1993), *Strauss: Also Sprach Zarathustra*, Cambridge: Cambridge University Press.

5

That Tune Really Holds the Game Together: Thematic Families in *Final Fantasy IX*

Sean Atkinson

The music of the *Final Fantasy* (*FF*) game series has been long regarded by fans as some of the most memorable and beloved in video games.[1] This is supported by the numerous video game music live concerts that feature music from the game, especially those tracks composed by Nobuo Uematsu: *Distant Worlds*, a concert series of music from the *FF* series, continues to have regular performances across the globe.[2] These concerts combine Uematsu's music, scored for full orchestra, with images and video from gameplay. Even among more "traditional" concert-music listeners, Uemastu's music is highly rated, sometimes even more so than Beethoven or Mozart (Gibbons 2018: 163).

While the music continues to be popular among fans, the games themselves have had a more tumultuous journey. Beginning with *FFIV* (1991), the series' setting gradually moved forward in time, with *FFVIII* (1999) taking place in the distant future. This alienated many long-time fans who knew the series best for its focus on settings in medieval or Renaissance time periods. The mechanics of gameplay had also become more complicated as the series continued, further driving people away. *FFIX* marked a turning point in the game series: the narrative returned to a clearly medieval setting and the way players interacted with the game was simplified compared with immediately previous titles in the series. Uematsu emphasizes the medieval environment right from the start with the game's title track, "The Place I'll Return to Someday," written in a pre-Baroque contrapuntal style played by recorders. The style and the timbre of the instruments help transport the player back in time and set the stage for a story in a medieval time period (Kizzire 2014).

FFIX's soundtrack boasts over 100 separate musical tracks, though not all of them are truly unique tunes. Uematsu's clever reworking and refashioning of

a core set of tunes, or thematic families as I call them, throughout the game not only adds a layer of cohesiveness to gameplay, but also demonstrates the narrative potential of topics and their associated tropes inside the closed system of a role-playing game soundtrack. This chapter, therefore, examines the music of *FFIX* through the lens of topic theory: that is music's ability to draw a listener to a variety of extramusical references. The tunes that come back during the course of the game, though altered in even the most subtle of ways, create thematic families that can provide vital narrative threads for players, enhancing the interactive nature of video game play.[3]

To begin, I briefly define musical topics and tropes as they occur in western art music, highlighting their usefulness in previous analyses of music in *FFIV* and *VI*. I then define thematic families by examining two large families in the music of *FFIX*. The "Vivi's Theme" family not only represents the character Vivi, but also more broadly represents evil in the game. The "Melodies of Life" family connects the character Dagger to other characters in the game through both spiritual and romantic ties. Close analysis of both thematic families demonstrates the complex narrative that can emerge through the topical manipulation of themes.

Musical topics and tropes

Before beginning a discussion of the music in the game, a set of working definitions is in order. Topics, as I will refer to them in this chapter, are those musical objects that reference some extramusical thing or idea. I adopt Robert Hatten's definition that topics in music are "a complex musical correlation originating in a kind of music [...] used as part of a larger work" (1994: 294). In other words, topics are music styles or characteristics that are contained within a piece of music that connect with something outside of the music itself. For example, the use of a horn sounding a melodic perfect fifth is often associated with the hunt as the use of that timbre in that melodic configuration is reminiscent of how horns were used outdoors as a signaling device during actual hunting events. Although classical topics (those musical markers like the hunt that were codified and used extensively by classical composers) have been explored extensively by Hatten, Leonard Ratner (1980), Raymond Monelle (2006), and Kofi Agawu (1991), among others, topic theory has moved well beyond the confines of the classical period and can be a useful mode of inquiry into any genre in which those topics occur.

Tim Summers briefly discusses the topical roles that are present in an earlier incarnation of the series, *Final Fantasy VI*:

The valiant Locke, for example, has a theme that includes standard signifiers of heroism (secure major harmony, rising fourth gestures, military percussion and topic, etc.), communicating and asserting his role in the game's story. Terra's mournful theme, by contrast, mirrors the tragic life events she experiences (minor mode, slow tempo, sustained pitches, ornamented melody, bittersweet excursion to relative major). The theme for the secretive assassin-for-hire, Shadow, clearly references Ennio Morricone's music for the Sergio Leone films featuring the "Man with No Name." The music signifies the role that the character plays in the game's narrative.

(Summers 2014: 207)

Summers views the use of topics as one of many analytical avenues for the discussion of video game music: "Analysing the musical-rhetorical gestures and musical signs in games helps to understand the ways in which musical meanings are configured and re-configured in games" (2016: 40). And it is this reconfiguring of musical meanings that leads to the narrative potential of musical tropes. Tropes are, in Hatten's definition, "a manipulation of a topic through the juxtaposition of contradictory or unrelated types" (1994: 170). Altering a topic by direct correlation with another topic or event in a significant moment can change the meaning of the topic, leading to a trope of that topic. And the other topic or event need not be solely musical, as David Neumeyer illustrates in his application of topics and tropes in film music (Neumeyer 2015). Kizzire demonstrates this topic-to-trope transformation, though she does not refer to it as such, in her discussion of the pre-Baroque title music for *FFIX* mentioned above. The uses of "The Place I'll Return to Someday" in later tracks "not only appeal to an idealized past, but do so in conjunction with nostalgic events that occur diegetically" (Kizzire 2014: 191). The combination of the topic with significant narrative events in the game creates a powerful trope that helps reinforce the nostalgic aspects of the game.

Musical topics and tropes can also have a direct effect on the narrative unfolding of the game. In a previous study of the music from *FFIV*, I show that the manipulation of a musical topic can have the effect of foreshadowing future narrative events (Atkinson 2019). The airship theme from *FFIV* would be expected to contain musical elements associated with flight, or more accurately soaring through the sky by magical or fantastical means. But instead, Uematsu's music for the airship is missing many of the important markers of soaring, which include overt references to the Lydian mode, consistent upward melodic leaps, and ascending stepwise motion. In fact, the most prominent melodic motions within this airship theme are descending. A trope, therefore, emerges from the juxtaposition of unrelated material, a visual depiction of soaring through the sky with music

that is largely counter to the well-established musical topic. This musical trope participates in the narrative and helps foreshadow the eventual use of the airship underground, an unexpected role for such a vehicle.

This type of topical manipulation goes beyond the similar idea of leitmotif. Graham Hunt breaks down several leitmotivic transformations found in Wagner's Ring Cycle, specifically in the third opera *Siegfried* (Hunt 2007). Starting with David Lewin's analysis of transformations within the opera, Hunt shows that certain manipulations of the *Vahalla* leitfmotif can be read as corruptive, matching the known actions in the narrative of the corruption of the item itself.[4] And John Williams famously folded the Imperial March into Anakin's theme in episode 1, giving audiences a subtle reminder of who he will become.[5] The important difference between such leitmotivic use in opera or film and in video games is the interactivity of video games. Attentive viewers of a Wagenrian opera or a sci-fi film will likely pick up on and appreciate such musical transformations, adding a complexity to their involvement with the experience of watching. But a player in a game might hear such transformations and act on them, altering the narrative for that player to some extent. A common and simple example is the "hurry up" trope in which the music in a platforming game (*Super Mario Bros.*, for example) doubles in tempo as an aural indication that time to complete the level is running out. The new tempo also increases tension for the player, changing the way they interact with the game.[6]

Thematic families

Nobuo Uematsu, like many composers of RPGs or other long-format games, is known for reusing themes throughout a game's soundtrack, helping to create a cohesive environment over the span of a game that can take many tens of hours to complete (and rarely completed in one sitting). Karen Collins discusses the ways in which composers can manipulate themes to create variability, extending what she calls the "shelf life" of the music and allowing the music to "be more responsive to the player and to the narrative/image" (2008: 147). Specifically, she identifies ten ways in which a composer might alter a theme to increase its longevity among which are tempo, pitch, rhythm/meter, volume, timbre, and form. And indeed, Uematsu brings back several themes in various guises in *FFIX*, many of which are altered in the manner Collins discusses. For example, as will be discussed below in more detail, the theme "Eye to Eye" reoccurs frequently, and in one case, the meter, timbre, and form are all altered to better suit the current situation. Above all, Collins notes that these alterations, and the context in which they are found, "are developments that distinguish games from linear

media composition" (2008: 147). In other words, manipulation of a single theme in multiple ways is more common and expected in video game music than in music written for television or movies.[7]

In discussing the music in *FFIX*, I focus on two of the most prominent thematic families, each of which is introduced early in the game and contributes to a large portion of its soundtrack. The presentation of these themes in different configurations and narrative situations leads to complex interpretations of meaning. The "Melodies of Life" thematic family consists of two motivically similar themes: the first is the game's overworld music, "Crossing Those Hills," and is used as the game's main theme.[8] The other theme, "Song of Memories," while only appearing sporadically throughout the gameplay, is united with the first theme in the game's dramatic conclusion. The second thematic family, which I call the "Vivi's Theme" family, has a bifurcated function: while clearly a reference to Vivi, one of the game's protagonists, it also comes to represent part of an evil conspiracy to rule the world. In addition to "Vivi's Theme," this family includes the themes "Limited Time," "Black Mage vs. Black Mage," and "Black Mage Village."[9] Subtle changes to these themes over the course of the game create tropes, altering the theme's original meaning and helping to contribute to the game's narrative events.

The story of *FFIX* centers around the characters Dagger (also known as Princess Garnet, though Dagger is the name she chooses for herself) and Zidane. Dagger is the princess of the Alexandria kingdom; her mother, Queen Brahne, is secretly plotting to take over the world. Zidane is a member of a group of bandits that is hired to kidnap Dagger and take her to the neighboring kingdom of Lindblum, but much to Zidane's surprise, Dagger welcomes being kidnapped, as she was planning to run away to warn people about her mother's actions. This marks the beginning of Dagger and Zidane's romantic relationship, which continues to develop throughout the game. Additionally, Dagger is a summoner, having the power to call on powerful monsters that can help during battles; summoners are quite rare, as Eiko, a young girl that Dagger meets about halfway through the story, is the only other summoner in the game.

Another important character in the game is Vivi, a black mage with no memory of who he is or where he has come from. Players are introduced to Vivi very early in the game; in fact, he is the second playable character in the game. Eventually, it is discovered that part of Queen Brahne's plot to take over the world directly involves Vivi: he was created by Brahne and her villainous friends as a prototype weapon. He eventually learns that he is one of hundreds of black mages that make up an army of magical soldiers to do her bidding. Over the course of the game, players learn of Vivi's relationship not only to this evil plot but also to the very fabric of the game world itself.

"Vivi's Theme" thematic family

"Vivi's Theme" is the first theme within his thematic family that players encounter in the game and contains three different sections rolled into a single track. A transcription of the first two sections of the theme is shown in Examples 5.1 and 5.2. The first two sections, which I refer to as α and β, respectively, are quite similar as they share two common features, the first of which is a progression that alternates between harmonies a fifth apart in their respective keys. Both α and β consist mostly of tonic-dominant movement, although β employs a minor dominant and alternates more quickly than α. The second common feature of these two sections is the varied use of a single eighth note with two sixteenth notes. This idea, motive *x*, helps define a subtle difference between these similar sections. As shown in Example 5.1, α introduces motive *x*, consisting of an eighth note followed by two sixteenth notes. While β, shown in Example 5.2, also prominently features *x*, it begins with its retrograde, which I call \overline{x}. This difference not only helps distinguish this section from α but also factors into future reappearances of "Vivi's Theme" throughout the game.

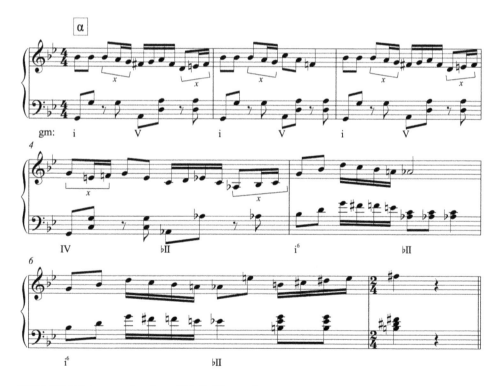

EXAMPLE 5.1: α section from "Vivi's Theme."

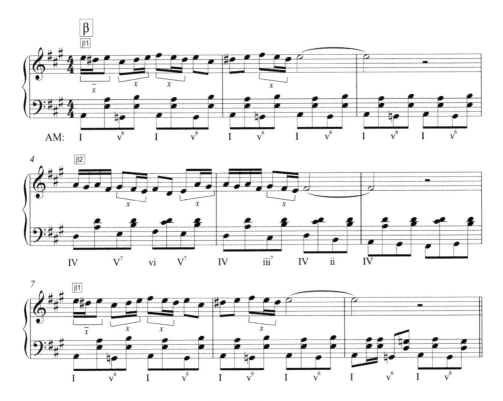

EXAMPLE 5.2: β section from "Vivi's Theme."

The phrasing within each of these sections is also important to note. α consists of a four-measure parallel phrase followed by a three-measure transition that leads into β. All of α functions comfortably in G minor as discussed above, including the bII Neapolitan harmony before and during the transition. β is actually made up of two subsections: β1, which is three measures long and features motive *x* at the beginning, and β2, which follows immediately and is also three measures long. Harmonically, β is more adventurous than α. While β1 subtly suggests A major as a tonal center with its alternations between A major and E minor harmonies, β2 is tonally more ambiguous: the emphasis on D major suggests at least a tonicization of D, but the E^7 harmonies function more like passing harmonies than as dominants yearning to resolve to an A major tonic. Reading the β section is the key of A major, then the progression I-IV-I in moving from β1-β2-β1 is suggestive of a blues or pop/rock influence. The track "Black Mage Village," which occurs later in the game, will both help resolve this tonal ambiguity and introduce a clear rock-inspired setting based on the β section.

The end of "Vivi's Theme" serves several important functions. First, it unites several features of both α and β, including a more homogenous use of both motive

x and \overline{x}. It also acts to bring the entire cue to a close and facilitates the loop to the beginning. But the relevance of the end of "Vivi's Theme" to other themes later in the game seems to be rooted more in the harmonic and topical elements than in reoccurring musical motives. The section begins with a playful use of F Lydian, appropriate for Vivi's youthful character. But just before the transition back to the beginning, a military snare drum enters along with a strong Phrygian modal reference, foreshadowing the Queen Brahne's use of the black mages as her own personal dark army.

In-game uses of "Vivi's Theme" thematic family

"Vivi's Theme" plays a dual role in the course of gameplay: it acts as both the theme for the Kingdom of Alexandria (where the events of the game begin) and as a theme for Vivi, a young and naïve black mage just starting a journey of discovering who he really is and what his destiny will be. With the need to act in diverse ways, the multiple sections inside of "Vivi's Theme" cast it as unique among other cues in *FFIX* that tend to be more cohesive and homogenous. The theme also helps to set the stage for how important he is to the narrative of the game.

Players first encounter "Vivi's Theme" a few minutes into gameplay. Controlling Vivi, players must navigate their way through the town of Alexandria, attempting to see a traveling acting troupe.[10] Players will likely spend a good amount of time in this area, as basic control functions and dynamics of game play are introduced. Additionally, figuring out a way to see the performance is a small puzzle in itself, and first-time players may need time to figure out how to proceed. The variety offered in "Vivi's Theme" helps to make the loop of this music more interesting.

The next time a player encounters something from "Vivi's Theme" is during an encounter with a group of black mages that are operating an airship bound for Alexandria. The cue "Limited Time" is heard here, featuring a slowed version of the α section.[11] Additionally, the texture features recorders in a contrapuntal learned style, which is quite similar to the game's opening music, "The Place I'll Return to Someday." These adaptations of "Vivi's Theme" are meaningful for two reasons: First, using the α section on an airship bound for Alexandria, which lacks its own unique theme, further ties it to "Vivi's Theme." Second, the sense of nostalgia imparted to the player at this moment is quite strong. By presenting "Vivi's Theme," already strongly associated with Alexandria, in the same musical style as "The Place I'll Return to Someday," the player is reminded of Alexandria (which lacks its own unique theme), a location in the game that serves both as a metaphorical home for the player (as the action in the game starts there) and a literal home for Vivi (his creation was ordered by the queen of Alexandria).[12]

Though the ship is initially bound for Alexandria, Zidane changes course and heads for the neighboring kingdom of Lindblum. Immediately after this, an enemy named Black Waltz No. 3 appears and tries to stop them and return Dagger to Alexandria.[13] In a cut scene known as "Black Mage vs. Black Mage," this enemy attacks and kills the black mages who are trying to defend Vivi and his friends. The music in this cut scene is a slow and intimate melody played in the piano that begins with a rhythmically augmented presentation of the β section's \bar{x} motive.[14] This motive's presence here further ties Vivi to the story of the black mages and how he figures into this particular plot of the game. Of particular importance is that both "Limited Time" and "Black Mage vs. Black Mage" omit the playfulness found in the original "Vivi's Theme" and are replaced by a sense of sorrow and introspection as Vivi watches the black mages die and he questions his own existence.

Probably the most clear and extensive reuse of "Vivi's Theme" occurs when Vivi and his friends enter Black Mage Village, a settlement filled with black mages who, like Vivi, were created by Queen Brahne as she built her army. These black mages, however, defected from her growing army. It is at this point in the story that Vivi learns the disturbing news that the black mages in the village all have a limited life span of about one year before they suddenly die (or "stop" as is said in the game). The music is a driving rock version of the β section of "Vivi's Theme" (Example 5.2) though the order is reversed: β2 is the first subsection heard, followed by β1.[15] It is also important to note the differences in the implied pitch centers in "Black Mage Village" compared to its counterpart. Though I have analyzed the harmonies of the β section of "Vivi's Theme" in A major (see Example 5.2), this is not the only possible reading. Specifically, the music of β2 outlines a D major triad in the melody, and several D major triads act as harmonic support. β2, therefore, expresses a strong D Lydian modality in contrast to the A major sections that surround it. In "Black Mage Village," an A pedal underscores the entire track, though the D-centered pitch material from the original β2 remains unchanged. The ambiguity of D Lydian and A major from "Vivi's Theme," already a strong allusion to the ambiguity felt by Vivi himself, is strengthened in "Black Mage Village."

The thematic family created by "Vivi's Theme" results in a network that, while unsurprisingly centers on Vivi, reveals his connections to other black mages in the story as well as his connection to Alexandria. The α section seems to be most closely tied to Alexandria itself: its initial presentation in "Vivi's Theme" occurs there, and "Limited Time," its slower and more intimate variation styled similarly to the game's opening title music, is first heard when the group is headed back to Alexandria. The β section seems to exclusively relate to Vivi's connection to the other black mages, reinforcing his origin story and his importance to the narrative: recall that we first reencounter the β theme during the "Black Mage vs.

FIGURE 5.1: Connections within "Vivi's Theme" thematic family.

Black Mage" cutscene with Black Waltz No. 3, a more advanced and powerful version of the black mages. Additionally, the first section of "Black Mage Village," where Vivi's closest relatives live, focuses on the β section. And though the harmonic ambiguity of the β section is heightened during "Black Mage Village," the reordering of the subsections (β2 then β1) is perhaps a more subtle nod to the difference between Vivi and the black mages. Vivi is, after all, special in his role in the larger narrative. Figure 5.1 illustrates the connections in "Vivi's Theme" between Vivi and various locations and characters. Solid lines represent connections that involve the α theme, while dotted lines represent connections using the β section.

The "Melodies of Life" thematic family

The "Melodies of Life" thematic family consists of two themes referred to as "Eye to Eye" (the same theme as heard in the song's overworld track "Crossing Those Hills") and the "Song of Memories" on the official sound track (OST).[16]

EXAMPLE 5.3: "Eye to Eye" theme from *FFIX*.

"Eye to Eye" is first heard in its normative, unabridged form about an hour into gameplay and is featured during the first extended conversation between Garnet and Zidane.[17] Shown in Example 5.3, the theme itself presents many aspects of a singing style, including a prominence of stepwise melodic motion, simple rhythms, and a clear homophonic texture. Consequently, these traits of the theme point to the "centrality of comprehensibility" found with the singing style (Day-O'Connell 2014: 254). Divided into two phrases, the melodic range of the first phrase stays largely within the opening major sixth interval, the one exception being the F5 in m. 7. This sets up the second phrase's use of higher pitches, though the overall range of the theme remains just one octave. The second phrase also features a descending melodic line with several notes repeated. This, along with the opening interval of a sixth, is a defining motive for the "Melodies of Life."

"Song of Memories" is rhythmically more active than "Eye to Eye," but still retains the singing style and the limited range of "Eye to Eye." The texture, however, is worth noting. When players first encounter this theme, it is diegetically: as Dagger sings alone on the rooftop, Zidane, controlled by the player, ventures off to find her. As such, the monophonic texture of the solo voice is quite different from anything else heard in the game up to this point.[18] Shown in Example 5.4, the first phrase of "Song of Memories" features a prominent leap of a minor sixth, reminiscent of the opening major sixth leap in "Eye to Eye." Immediately after the leap, the line descends with a similar pattern of repeated notes heard in "Eye to Eye." The second phrase also features this descending pattern with repeated notes and ultimately ends on the tonic scale degree approached from above, just as in "Eye

EXAMPLE 5.4: "Song of Memories" theme from *FFIX*.

to Eye." These motivic similarities allow these themes to coexist, sharing similar features while still remaining distinct tracks.

Structurally, "Eye to Eye" takes the form of a sixteen-bar contrasting period. The first phrase ends with a half cadence on a suspended V⁷; the second phrase is a continuation of the first before moving to a closure on a repeated plagal motion (iv–I–IV–I). The plagal motion here is accentuated due to the use of modal mixture (arrival on minor iv in m. 12) and the repeated plagal motion itself. This ending, without a more definitive authentic cadence, still behaves like a period, but is harmonically weakened by the plagal ending.

The phrase structure of the "Song of Memories" is also a period. The first phase ends in a half cadence and the second phrase ends with authentic cadence, making this a more convincing period than "Eye to Eye." The first phrase features a hint of plagal motion as ii moves to ii⁴/² (bass line 2→1) before the half cadence. The second phrase contains an internal harmonic expansion in mm. 8 and 9, initiated by a move to ♭VII before finally arriving on V⁷ then I. Interestingly, the hint of plagal returns here as the V⁴/³ to I mimics the bass line 2→1 in the first phrase. The overall harmonic pacing of the "Song of Memories" is faster than "Eye to Eye," with the former averaging about two harmonies per bar as opposed to the latter's one harmony per bar. And though they are both periods, the "Song of Memories" harmonic structure strongly suggests a parallel phrase structure, different from the contrasting structure of "Eye to Eye."

Despite the harmonic and structural differences between these themes, the motivic similarities, sparse as they might be, unite them as a thematic family long

141

before they are literally joined together in the game's finale in the track titled "Melodies of Life." By the time a player encounters the "Song of Memories" for the first time, they will have heard "Eye to Eye" in several different contexts, including as the game's overworld music, ensuring a familiarity to the player. The upward leap of a sixth followed by a descending line with repeated notes is now a familiar sound, and though a player might not connect the two themes immediately, it nonetheless sets the stage for their synthesis at the end of the game. But before these themes come together in the end, they are altered and used in several scenarios that both enrich the scenes they accompany and build deeper meaning into the themes themselves.

In-game uses of the "Melodies of Life" thematic family

In general, instances of "Eye to Eye" tend to correspond with references to Dagger's present and her relationship with other characters. This theme, featured in at least ten other tracks including the overworld music, manifests in many places throughout game, contributing to its sense of "presentness" in Dagger's life.[19] When "Eye to Eye" is heard, it is often in the form of what I call a variant. Variants are presentations of the theme with topical variations that alter some aspect of the theme's meaning. I consider "Crossing Those Hills" to be a neutral example of the "Eye to Eye" theme upon which to compare its variants. The variants I engage with below do not make significant changes to the music as shown in Examples 5.3 and 5.4; however, some variants end differently and those differences are noted when present. Otherwise, variants should be assumed to be melodically and harmonically identical to the original themes.

The "Romantic" variant, which is heard in the theme's namesake "Eye to Eye," is strongly associated with the romantic relationship between Dagger and Zidane. When the theme is heard in this context, the texture is lush and romantic, featuring a string accompaniment with the melody played on flute, complete with a drawn-out and highly chromatic introduction. Although this melody is in the delicate singing style, the piece is overall solid and well supported through its accompaniment. The emphasis on the plagal motions at the end of the theme is perhaps a nod to Dagger's mysterious past, as motions toward the subdominant are inward and retrospective, as opposed to motions toward the dominant that are more driving and forward-looking.[20] The Romantic variant is also the first time that the complete theme is heard, accompanying a scene in which Dagger reveals her true identity as the princess of Alexandria to Zidane (though he already suspected as much), beginning their relationship and strongly connecting the tune to their budding romance.

The "Escape" variant positions the "Eye to Eye" theme within the hero topic, emphasizing brass and percussion in the style of a march. Andrew Haringer cites several eighteenth- and nineteenth-century writers who associate the hero with the military, especially the battlefield use of trumpets and drums (Haringer 2014: 198). This hero music combines well with the action at that time: a quick cutscene from early in the game (known as "Garnet Jumps") in which Dagger, followed by Zidane, must swing on a long decorative rope in order to escape from Steiner, the leader of the Knights of Pluto, who is trying to bring Dagger back to her evil mother, Brahne. The music, reminiscent of the swashbuckling adventures of an Errol Flynn film, clearly situates Dagger as the hero, a character fully in charge of her own destiny despite Zidane's inaccurate impressions that she is a helpless princess. Importantly, this variant also omits the second phrase of the theme, eliminating the repeated plagal motion and any retrospective effect it may create.[21] A trope begins to emerge in this cutscene as it becomes clear that Zidane's mistaken impression of Dagger as a damsel in distress is shattered by not only her actions in saving herself but also from the clear hero topics in the music as well. The hero topic confirms Dagger as a strong female lead, reinforcing her position as a central character in the game.[22]

The "Summoner" variant, a track called "Eiko's Theme," helps to connect Dagger and Eiko, a character that is introduced about halfway through the game. Eiko, like Dagger, is a summoner who can call on monsters to help during the game's numerous battles. Dagger and Eiko are also the last known of their kind, which further enhances the bond between the two. In this variant, a simple guitar-strummed accompaniment in a lazy swing eliminates any romantic aspects of the theme. "Eiko's Theme" also contains no melody, but simply the harmonic accompaniment of "Eye to Eye," and is reminiscent of "Yuffie's Theme" from *FFVII*.[23] Like Eiko, Yuffie is the youngest playable character in that game too. Clearly no longer a theme between two lovers, "Eiko's Theme" transforms to suit the purpose of aligning with this young character while also maintaining a strong bond with Dagger. The plagal motions are read here to connect Eiko with Dagger's past, in which she too was a young girl coping with her summoner powers in much the same way Eiko is in the present.

Figure 5.2 illustrates these character relationships supported and enhanced by "Eye to Eye." The diagram illustrates two aspects of the theme; one is the connection between characters, and the other is the topic and/or trope created by the interaction of music and media. Character relationships are represented with arrows and labels of the music that unites them. Topics and tropes are indicated for both the relationships between characters and the characters themselves. Dagger acts as the focal point of this theme, signaled not only by the two relationships represented by the theme, but the heroic qualities of the Escape variant elevate Dagger

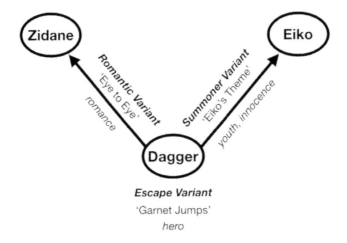

FIGURE 5.2: The "Eye to Eye" theme and its role in defining relationships with Dagger.

to a position of prominence in the diagram. She is not just another character but a crucial character at the center of the action.

Uematsu uses the "Song of Memories" theme much less often than "Eye to Eye," giving it an elusive quality. The theme first appears early in the game when Zidane hears the song but cannot track down the source. Later, he hears the tune again and discovers that Dagger herself is singing it.[24] I call this the "Wordless" variant as Dagger sings the tune with a neutral "la" syllable with no accompaniment. Adding to this theme's elusiveness, Dagger admits that she does not remember when she learned it or where it came from. The song comes from Dagger's mysterious past of which she has no memories, and like "Eye to Eye," this theme's plagal references provide an opportunity for introspection into Dagger's past.

Other than these brief moments when Dagger sings the theme, it is only heard once more before the end of the game as accompaniment for a cutscene after Dagger is made the new queen of Alexandria. The "Coronation" variant is a simple piano arrangement, very similar to the music shown in Example 5.4, except for the end of the second phrase, which ends on an open-ended dominant harmony.[25] The dominant ending here might suggest a contemplative moment on Dagger's future, a stark contrast to the theme's connection to her unknown past, alluded to through the use of plagal motion; it is this temporal conflict that drives the connections between variants of the "Song of Memories." Figure 5.3 illustrates these connections, but unlike "Eye to Eye," where the connections were between Dagger and other characters, the connections here are with Dagger and her own past and future. Dagger's present self interfaces with the past through singing the

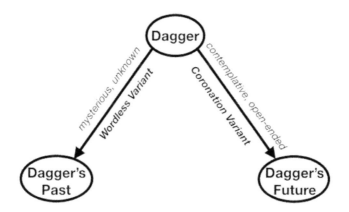

FIGURE 5.3: The "Song of Memories" theme and its connection between Dagger's past, present, and future.

"Song of Memories," and she contemplates her future via the Coronation variant after she is made queen of Alexandria.

For the majority of the game, players hear and understand "Song of Memories" and the "Eye to Eye" theme as two separate yet motivically connected melodies. "Eye to Eye" becomes one of the primary melodies of the game and likely the tune most players will remember. However, this, along with "Eiko's Theme," specifically links Zidane and Dagger's romantic relationship and Dagger and Eiko's spiritual relationship, respectively, while the "Song of Memories" theme relates to Dagger alone. More importantly, Dagger lies at the center of both themes, which is why the music of the game's finale becomes so powerful.

The ending of *FFIX* features roughly 30 minutes of cutscenes and additional dialogue after the final boss fight. In the final moments, Zidane—whose fate was left unknown after the fight—makes a surprise appearance in Alexandria, much to Dagger's delight and relief. It is after this that players, for the first time, hear both "Eye to Eye" and "Song of Memories" as sections within a single song, "The Melodies of Life," complete with lyrics (in Japanese or English depending on which version of the game is being played). It becomes clear in this setting that the "Song of Memories" theme was always intended to be the second half of a larger song. Before the song plays, Dagger asks how Zidane survived after the battle. He simply says, "I had to live. I didn't have a choice. I wanted to come home to you. So, I sang your song. Our song." It is here that Uematsu's musical plan is fully realized: Dagger and Zidane were always destined to be with each other, and Uematsu drops musical evidence of this all throughout the score. Not only is "Eye to Eye" a symbol of their romance, but "Song of Memories," a symbol of Dagger's past and future, is now declared by Zidane to be "our song," connecting him to Dagger in a timeless romance.

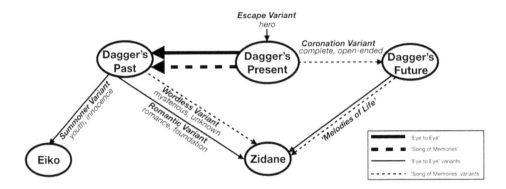

FIGURE 5.4: The complete "Melodies of Life" thematic family.

Looking at Figure 5.4, it then becomes clear that the "Melodies of Life" (both the song and the thematic family) centers on Dagger. Both "Eye to Eye" and "Song of Memories" reference Dagger's past. Though "Song of Memories" does this more directly through the game's narrative, "Eye to Eye" does so through subtle use of plagal motion. The variants of "Eye to Eye" connect Dagger romantically with Zidane and spiritually with Eiko, a character that likely reminds Dagger of a younger version of herself and of her mysterious past. The Wordless variant of "Song of Memories" connects Dagger to Zidane as he is the only one who acknowledges the song during the game. So even though Zidane and Dagger meet in Dagger's present, the musical connections between them extend into her past. But the thematic connections also reveal that Zidane is part of Dagger's future, as the combining of the themes in the "Melody of Life" coincides with the reunion of Dagger and Zidane on screen. The topical play of the melodies heightens all of these connections. The heroic features of the Escape variant give the player an early sign that Dagger is not only central to the story but also not a stereotypical princess who needs rescuing. And the Romantic variant cements Dagger's relationship to Zidane.

Furthermore, the form of the "Melodies of Life" is important as well. The song is in AABA, or 32-bar song form, a standard form in popular music.[26] The left side of Table 5.1 shows the thematic content of the song as it corresponds to the form. Instead of "Eye to Eye" returning as the final statement of A, "Song of Memories" is substituted. This is different from what we hear in "Crossing Those Hills" (the overworld theme), which is also in an AABA form. The right side of Table 5.1 highlights that the final A is simply a restatement of "Eye to Eye." Players, familiar with this formal layout from popular music and primed by hearing "Crossing Those Hills" throughout most of the game, are likely to be surprised at the appearance of "Song of Memories" during "Melodies of Life," further heightening the dramatic effect of its presence.

TABLE 5.1: Formal layouts of "Melodies of Life" and "Crossing Those Hills."

Formal section	"Melodies of Life"	"Crossing Those Hills"
A	"Eye to Eye"	"Eye to Eye"
A	"Eye to Eye"	"Eye to Eye"
B	Sequential contrasting material	Sequential contrasting material
A	"Song of Memories"	"Eye to Eye"

It is important to reiterate that the interactions within the "Melodies of Life" thematic family go beyond just playing the appropriate theme whenever certain characters are on screen or mentioned (a more basic leitmotivic role). Indeed, the themes and the game's final song play an important role in the story itself. In addition to the connections discussed, the game's music is largely nondiegetic, but "Song of Memoires" is different in that Dagger sings it and Zidane acknowledges it. A common device, especially in film and television, is for music to transcend the boundary between diegetic and nondiegetic. Typically, music will begin in one domain, and through an audio and/or visual cue, viewers understand that what was diegetic is now nondiegetic or vice versa. In this case, "Song of Memories" is only ever heard during gameplay as diegetic music. The convergence of diegetic and nondiegetic music in "Melodies of Life" is yet another remarkable event in the game's conclusion. The lyrics of the "Song of Memories" theme are also telling:

> A voice from the past, joining yours and mine,
> adding up the layers of harmony.
> And so it goes, on and on,
> melodies of life, to the sky beyond the flying birds,
> forever and beyond.

It is literally a song from Dagger's past, joining with Zidane's voice to become their song in the present and beyond. The thematic family as illustrated in Figure 5.4 provides musical connections that mirror and support the game's narrative, tracing Dagger's relationships with other characters and with her own past, present, and future.

Conclusion

The function of video game music varies widely from game to game and among video game genres. Collins discusses many of these functions in detail, including

diegesis and the level of interactivity a player has with the music. Arcade games tend to sonically value the concept of lives, while console games tend more toward the concept of health (Collins 2008: 136–37). Most readers are familiar with the "Hurry up" trope common in most platform games, where an increased tempo indicates that time is almost up and a life is at risk. And players of RPGs like *The Legend of Zelda* are familiar with the "beeps" that accompany a low health. These sonic elements are unique to games and are only possible in an interactive environment, but their role in the game is largely utilitarian. These are simple sonic cues that relay important information about status in the game and contribute in a small way to the overall narrative of the game as experienced by the player.

Approaching video game music through the lens of thematic families and observing the network of topics and tropes that emerge reveals not only the efficiency of reusing tunes in a game but also the meaningful impacts that can be generated through careful manipulation of those themes. And the interactive nature of games themselves allows these connections to play an important role in the experience of the game. The popularity of Uemastu's music in this game might itself stem from careful reuse of themes. Writing about the soundtrack as a whole, internet user TheShroud13 notes that it "features some of Uematsu's most colourful and characterized pieces, simultaneously maintaining more motivic unity than any work he created before or after it" (TheShroud13 n.d.). While the music of *FFIX* may not be the most motivically unified game soundtrack that Uematsu wrote, it is nonetheless a thematically tight score that still manages to create variety, and through that variety, Uematsu provides vital insights into the characters and their relationships.

NOTES

1. A review from a passionate fan on the now-defunct Square Enix Music Online is just one example: https://www.squareenixmusic.com/reviews/theshroud13/ff9.shtml. Accessed December 13, 2021.

2. For a detailed discussion on the concretization of video game music, see Stefan Greenfield-Casas's chapter in this book.

3. James L. Tate explores the use of recurring motivic fragments from previous installments of *FF* in *FFIX*, as well as their ability to conjure nostalgia in the player-listener. See James L. Tate's chapter in this book.

4. Hunt uses neo-Riemannian transformations to demonstrate that the distorted *Vahalla* motive matches closely with the ending of the *Tarnhelm* motive, reinforcing the corrupting influence of the magical object.

5. Frank Lehman extensively documents this connection and many other thematic connections in the music from the *Star Wars* films (Lehman 2020).

6. Julianne Grasso discusses this affect and other affects of tempo changes in the overworld music on the way a player interacts with the game (Grasso 2018).

7. For example, Collins mentions that in *The Legend of Zelda: Twilight Princess*, the pitch of the music rises with each successful strike of his sword (2008: 148). Such manipulation of motives highlights the kinds of transformations that are unique to video games.

8. The melody heard during "Crossing Those Hills" is one of the most used melodies in the game's soundtrack. For example, the track "Garnet's Theme" is heavily based on both the melody and formal structure as "Crossing Those Hills." Though the "Melodies of Life" thematic family largely describes the relationships that Garnet/Dagger has with others, I do not discuss "Garnet's Theme" specifically in this article, as the track is heard only once in the game and references Garnet alone. Richard Anatone (2020) discusses the complexities that can arise when a character's theme is also an *ideé fixe* in the game.

9. See Supp. 5.1 for a table that describes the themes in each thematic family that I consider.

10. In the scene immediately prior to controlling Vivi, players learn that the acting troupe is really a ruse designed to distract people from a plot to kidnap Princess Garnet. This part of the plot will be discussed in more detail in the next section on "The Melodies of Life."

11. See Supp. 5.2 for a transcription of the first few measures of "Limited Time."

12. This is an example of a connection between the title music and later events in the game that Kizzire does not discuss explicitly, as the tune is not being recalled but rather the style and instrumentation. The effect, though, is the same, which raises the question of what constitutes a nostalgia trope in the context of this game and in game studies in general.

13. A highly entertaining musical pun accompanies this moment as well. As the name of the enemy implies, players have previously encountered a Black Waltz No. 1 and No. 2 prior to this battle. Once Black Waltz No. 3 is defeated, Zidane comments, "I think that was the last one." After Steiner questions how he could know that for sure, Zidane replies, "He said 'Waltz,' right? Don't you think No. 3 would be the last one?"

14. See Supp. 5.3 for a transcription of the first few measures of "Black Mage vs. Black Mage."

15. See Supp. 5.4 and Supp. 5.5 for transcriptions from "Black Mage Village"; shortly after the release of *FFIX*, Uematsu formed a band with fellow Square Enix composers Kenichiro Fukui and Tsuyoshi Sekito. This group, which played progressive rock arrangements of Uematsu's music from the *FF* series, was called The Black Mages (VanBurkleo 2009).

16. "Eye to Eye" has also been labeled as "Stolen Eyes." "Song of Memories" is also known as "Garnet's Song," but should not be confused with "Garnet's Theme," which is a variant of "Eye to Eye."

17. Timings on gameplay will vary from player to player and are therefore approximations.

18. This track also features the only live recording in the game, performed by Emiko Shiratori. At this point in the game, the tune has no lyrics and is simply sung on a neutral "la" syllable.

19. In addition to the overworld music ("Crossing Those Hills"), the melody from "Eye to Eye" can be found in the tracks "Mistaken Love," "Memories of that Day," "At the South Gate

Border," "Daughter of Madain Sari," "Dagger's Recollection," and "Eiko's Theme," and "Birth of the New Queen." "Garnet's Theme" is the one exception to the use of this theme as representative of Garnet's current self, as it is used during a flashback scene. However, that scene is a remembrance of her life as young princess being educated by Professor Tot. Most references to Garnet's past musically involve the "Song of Memories."

20. The first snippet of this theme is heard at the very beginning of the game, immediately after players see a daydream in which Dagger is on a small boat in a large body of water during a storm. The implication here is that Dagger is remembering something from her past, but something she cannot fully reconcile.

21. Hatten briefly discusses the long history of this marked relationship (1994: 43). This is, from what I have observed, the only diegetic music in the game (other than the music that accompanies the various stagings of plays within the game).

22. The "Damsel in Distress" trope in video games is well documented in the video series "Tropes vs. Woman in Video Games" by Anita Sarkeesian (2013).

23. In an alternate version of "Eiko's Theme" that was released on the *Final Fantasy IX Plus* album, bell-like sounds fill in the missing melody. Reminiscent of Montessori bells, this melody, if it had been used in the game, would further describe the youthfulness of Eiko's character.

24. This is, from what I have observed, the only diegetic music in the game (other than the music that accompanies the various stagings of plays within the game).

25. This might be a common element in cutscenes for this game and in JRPG cutscenes in general. A half-cadential ending helps to propel the action forward and to soften the transition between video recording and interactive gameplay.

26. "Melodies of Life" was released as a single in Japan on August 2, 2000 (Shiratori).

REFERENCES

Agawu, Kofi (1991), *Playing with Signs: A Semiotic Interpretation of Classic Music*, Princeton, NJ: Princeton University Press.

Atkinson, Sean (2019), "Soaring through the Sky: Topics and Tropes in Video Game Music," *Music Theory Online*, 25:2, http://mtosmt.org/issues/mto.19.25.2/mto.19.25.2.atkinson.html. Accessed July 3, 2020.

Collins, Karen (2008), *Game Studies: An Introduction to the History, Theory, and Practice of Video Game Music and Sound Design*, Cambridge: MIT Press.

Day-O'Connell, S. (2014), "The Singing Style," in D. Mirka (ed.), *The Oxford Handbook of Topic Theory*, Oxford: Oxford University Press, pp. 238–58.

Gibbons, William (2018), *Unlimited Replays: Video Games and Classical Music*, Oxford: Oxford University Press.

Grasso, Julianne (2018), "Action and Affect in the Boundaries of Music: A Case from *Super Mario World*," *Society for Music Theory Annual Meeting*, San Antonio, TX, November 1–4.

Haringer, Andrew (2014), "Hunt, Military, and Pastoral Topics," in D. Mirka (ed.), *The Oxford Handbook of Topic Theory*, Oxford: Oxford University Press, pp. 194–213.

Hatten, Robert (1994), *Musical Meaning in Beethoven*, Bloomington: Indiana University Press.

Hunt, Graham (2007), "David Lewin and Valhalla Revisited: New Approaches to Motivic Corruption in Wagner's Ring Cycle," *Music Theory Spectrum*, 29:2, pp. 177–96.

Kizzire, Jessica (2014), "'The Place I'll Return to Someday': Musical Nostalgia in *Final Fantasy IX*," in K. J. Donnelly, W. Gibbons, and N. Lerner (eds.), *Music in Video Games: Studying Play*, New York: Routledge, pp. 183–98.

Lehman, Frank (2020), "Complete Catalogue of the Theme of Star Wars: A Guide to John Williams's Musical Universe," https://franklehman.com/starwars/. Accessed July 3, 2020.

Monelle, Robert (2006), *The Musical Topic: Hunt, Military, and Pastoral*, Bloomington: Indiana University Press.

Neumeyer, David (2015), *Meaning and Interpretation of Music in Cinema*, Bloomington, IN: Indiana University Press.

Ratner, Leonard (1980), *Classic Music: Expression, Form, and Style*, New York: Schirmer Books.

Sarkeesian, Anita (2013), "Damsel in Distress: Part 1, Tropes vs Women in Video Games," YouTube, https://www.youtube.com/watch?v=X6p5AZp7r_Q. Accessed June 21, 2019.

Shiratori, Emiko (n.d.), "Biography," *Emiko Shiratori*, http://emikoshiratori.woodgreen.jp/biography/index.html. Accessed January 9, 2020.

Summers, Timothy (2014), "From Parsifal to the PlayStation: Wagner and Video Game Music," in K. J. Donnelly, W. Gibbons, and N. Lerner (eds.), *Music in Video Games: Studying Play*, New York: Routledge, pp. 199–216.

Summers, Timothy (2016), *Understanding Video Games*, Cambridge: Cambridge University Press.

TheShroud13 (n.d.), "*Final Fantasy IX* Original Soundtrack: Review," Square Enix Music Online, https://www.squareenixmusic.com/reviews/theshroud13/ff9.shtml. Accessed June 21, 2019.

VanBurkleo, Meagan (2009), "Nobuo Uematsu: The Man Behind the Music," GameInformer, https://web.archive.org/web/20090601154539/http://gameinformer.com/News/Story/200905/N09.0527.1612.59659.htm?Page=3. Accessed January 7, 2020.

6

A Link between Worlds: The Construction of Nostalgia in Game Music and *Final Fantasy IX*

James L. Tate

Nostalgia in music and video games

Nostalgia is a positive emotional experience that is typically epitomized by the recall of memories of the self within social contexts (Batcho 2007). As such, its understanding is particularly relevant to both musicology and ludology. Furthermore, with regard to the effect that video game music has on the player-listener, music's ability to invoke affective emotions is well documented; there exists an extensive body of research and academic literature into the effect that music has on nostalgia. Barrett et al. (2010) have written extensively on this subject, drawing upon previous research by LaBar and Cabeza (2006). Additionally, Barrett and Janata (2016) cite Trost et al. (2012) in stating that emotions characterized by positive valence have been shown to increase brain activity in limbic and media prefrontal areas. Barrett et al. (2010) also note that familiarity with nostalgia-invoking stimuli has been shown to predict the strength of music-evoked nostalgia. Barrett and Janata's study builds upon this existing body of research and determines that personalized music selections evoke nostalgia, as observed via MRI scans. Given that such a solid body of well-conducted empirical evidence exists to support the impact that music has on nostalgia, a foundation has been established for composers to attempt to evoke this emotion through music.

To demonstrate the use of nostalgia in *Final Fantasy* (*FF*) *IX*, I examine the use of musical quotation and allusion of musical cues from earlier games within the series. I then examine how player control over a soundtrack allows players to create their own nostalgic cues affective to their own experiences. To examine the process of how nostalgia influences the audience–composer relationship, I then

| A perceived 'golden age' or 'classic' period in a canon of work defined by common aesthetic and narrative themes is formed. | Expanse of time in which material that deviates from themes and general aesthetic of 'classic' period in some way is published. | Demand for 'classic' material becomes significant. Release of material that has a notable use of thematic and aesthetic aspects of 'classic' period. |

FIGURE 6.1: My own generalized model of how conditions for a demand for nostalgia are created and how artists respond to them.

adapt van Elferen's ALI analytical model (2016) that examines the relationship between affect, literacy, and interaction.[1]

The process through which nostalgia develops is illustrated by the diagram shown in Figure 6.1. With this diagram, we can ascertain how the demand for nostalgia culminated in the implementation of nostalgic themes in *FFIX*. The first six games within the *FF* series employed a medieval aesthetic, although *FFVI* added a "steampunk" atmosphere to the narrative. The seventh and eighth installments into the series deviated from this tradition, perhaps in tandem with a next-generation console, introducing a more modern and even futuristic environment to the game, which was further supported by the vastly improved audio and musical capabilities of the Sony PlayStation over its predecessors. Thus, many fans considered the ninth entry into the series as a "return to its roots," embracing a medieval setting with a narrative involving crystals not seen since *FFV* (1992). Indeed, the developers of the game even stated in interviews that their goal was to evoke a sense of nostalgia for the player (Nix 2000). In a previous examination of how music is used in *FFIX*, Jessica Kizzire notes the juxtaposition of elements that results in the marriage of technological progression with nostalgic elements from previous games, stating that "designers carefully balanced progressive technology and a complex narrative with recognizable elements from earlier games" (2014: 186). While these recognizable elements are demonstrated in more overt devices such as narratives, themes, world design, and artwork that reference earlier games in the series, it is the compositional techniques that Nobuo Uematsu employs that are of the most interest in the context of this chapter.

My discussion of nostalgia in *FFIX* expands on Kizzire's research, which argues that Uematsu draws upon musical signifiers of western Renaissance music such as contrapuntal textures and the use of the recorder in his title theme for *FFIX*, "The Place I'll Return to Someday." When these signifiers exist in conjunction with the cultural coding of listener expectations as to what western Renaissance music

sounds like, they evoke an image of the past that is at odds with the steampunk, futuristic, and more modern settings and narratives of the two predecessors in the series. This contrast serves as a clear signifier that the game establishes a nostalgic fantasy setting that "returns to its roots." At this point, the above diagram for nostalgic process becomes useful when adapted to this particular situation.

Kizzire's argument for nostalgia, while mentioning that it is formed from listener expectations, places an emphasis on signifiers and cultural coding, as opposed to the composer's use of musical quotation due to his awareness of the affective experiences of the player-listener. She demonstrates that nostalgia can be induced unto listeners via composition by explicitly focusing on Uematsu's awareness of musical aesthetics used in traditional fantasy settings, such as the use of recorders and modal counterpoint. Her argument notes this "deviation" period in the above diagram, arguing that "The Place I'll Return to Someday" transports the listener from the dystopian and futuristic settings of *FFVII* and *FFVIII* to a simpler, idealized image of the past via the listener's musical literacy with musical tropes associated with the Renaissance period.

In many cases, instances of quotation within the soundtrack are rather obvious to someone familiar with the *FF* series. My analysis differs from that of Kizzire's in that I focus upon Uematsu's use of self-quotation as opposed to use of Renaissance tropes to evoke nostalgia. Applying Juslin and Västfjäll's BRECVEMA model (2008) for the emotive impact of music, Kizzire's analysis of music and nostalgia in *FFIX* can be said to fall under the definition of evaluative conditioning.[2] That is to say that she discusses the elicitation of nostalgia as a result of learned responses pertaining to the relation between Renaissance music and fantasy settings. My analysis instead falls into the category of episodic memory: where emotional responses are induced because of the listener's association of the musical cue with an experienced event. I examine the inclusion of nostalgic cues in compositions as opposed to the reference of culturally conditioned cues, which is central to Kizzire's analysis.

Finally, the question is raised: why is the study of nostalgia of particular importance? What is the significance of Uematsu's response to the demand for a "return" to the game's roots? To answer this, we can point out both nostalgia's cultural and economic importance. Within the context of video games, nostalgia is a booming market: the video game industry is heavily reliant on legacy titles such as *Super Mario Bros.*, *FF*, *The Legend of Zelda*, *Metal Gear Solid*, *Sonic the Hedgehog*, *Elder Scrolls*, and *Pokémon*, among others. It would not be unreasonable to suggest that Nintendo would not be as successful a company if it did not have such a strong canon of legacy titles. Furthermore, it is economically viable to remaster or even remake games onto different ports. Examples of this include both the PlayStation Store and Steam's extensive software library of older games for download, as well as Nintendo games being ported from console to handheld formats.

The market for retro gaming is phenomenal and driven by nostalgic, positive memories of youth. I have demonstrated elsewhere that the average modern gamer, being 35 years old, would have been in their early adolescence when some of the "great" canonized games were released back in 1994. With this gap of approximately twenty years in mind, it is then possible to predict when nostalgic demand for a product will again develop.[3]

This attitude of nostalgic purchasing also occurs in the collection of other media, such as vintage albums or classic movies, all due to a desire to reconnect with the past (McFerran 2012).[4] Culturally, nostalgia has a significant impact on arts. When examining top-grossing concert tours, one notices a single constant: these lists are dominated by legacy acts[5] (Allen 2016). Additionally, compilation albums and the remastering of back catalogs of legacy musicians continue to be a commercially successful venture for both record labels and artists. Artists frequently receive critical praise for "returning to their roots"; an excellent example of this was the critical and fan reaction to Metallica transitioning from the *Load/ReLoad* and *St. Anger* albums to a more "classic" thrash metal style seen in *Death Magnetic*.[6] This relationship between artist and target audience is something of which we must be mindful: where artists rely financially on their fanbase, their works must to a degree fulfill the desires of that fanbase.

Adaptation of van Elferen's ALI model

In an effort to analyze immersive experiences within video games, van Elferen (2016) developed the "ALI model," which considers the convergence of musical affect, literacy, and interaction and how they contribute to the experience of immersion in games. This model examines which music-specific experiential phenomena afford musical involvement to the player and analyzes how they are executed within "sound play." I propose that the same factors in van Elferen's ALI model be used to analyze the demand for nostalgia that defines the relationship between audience and composer (see Figure 6.2).

Van Elferen defines "affect" as "the personal investment in a given situation through memory, emotion and identification" (2016: 34). Nostalgia, by its very definition, is an affective process that can accompany autobiographical memories.[7] It is unsurprising, then, that within psychological literature, music has been irrefutably demonstrated to evoke nostalgia (Barrett 2016). According to van Elferen, affect is both a vital part of the musical experience (in that listening to music stirs emotions, connotations, and identifications), as well as a determining factor in the attribution of personal and collective meanings to music. While van Elferen discusses the importance of past experiences and identification to analyze "affective"

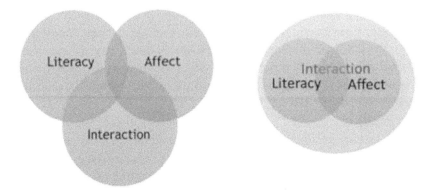

FIGURE 6.2: Van Elferen's ALI model (left) and my modification of the same model (right).

immersion in video games, I discuss affect to analyze the inclusion of *musical cues* with awareness of the potential past musical experiences of the intended audience. I believe this is of particular importance: while nostalgia can be evoked by salient music (Barrett et al. 2010), I examine explicitly the intentional inclusion of nostalgic cues in music.

The second factor adapted from van Elferen's ALI model is that of musical literacy, which is also relevant when discussing nostalgia. The expectations that the player-listener has developed from their experiences of the composer's previous material may inform the composer's decisions to use nostalgic cues. Van Elferen cites Roepke for a definition of literacy: "[H]abituated practices of media engagement shaped by cultural practices and discourses" (van Elferen 2016: 36). From this definition, we can determine that players who have engaged with the media would have the aforementioned expectations that contribute to the conditions for the development of nostalgic demand.

The final factor of van Elferen's ALI model is that of interaction, which she defines as the connection between player actions and the soundtrack, mentioning that this connection is even more powerful in audio-driven games that place a primacy on audio over visuals in terms of game mechanics. Interaction is particularly important for two reasons. First, player interaction with texts creates affective experiences, which may contribute to future conditions where nostalgia is to be inferred.[8] Second, in a somewhat more indirect and more "meta" way from what van Elferen describes, audience interaction with the composer informs the composer of the audience's desires. A player's interaction and agency in a game is what progresses gameplay and defines the player's experiences, which contributes to their literacy and affective experiences of the text. Furthermore, players can interact with game music through discourse within social circles and the wider

gamer culture in which canons of games and their soundtracks develop. It is the result of these interactions with the music and community that the prerequisite "golden age" for nostalgia develops as a result of canonization.

However, as Collins notes, the term "interaction" or "interactivity" is somewhat problematic within video game music, as it can refer to the listener interacting *with* music (2008: 3). Collins cites Manovich in regard to this issue, stating, "[a]ll classical, and even more so modern, art is 'interactive' in a number of ways. Ellipses in literary narration, missing details of objects in visual art, and other representational 'shortcuts' require the user to fill in missing information" (2001: 56). Collins states that the term "interactivity" is indeed appropriate in the context of video game analysis because the physical processes of input into a game can constitute interactivity. Collins (2008: 3) paraphrases Cameron (1995: 33–47) to define the term "interactivity" within the context of the game industry as "to refer not to being able to read or interpret media in one's own way, but to physically act, with agency, with that media." It is this definition of "interactivity" that I use with this chapter.

The way interaction is used for analyzing nostalgic cues differs slightly from van Elferen's use of ALI to analyze game immersion. Where van Elferen's model presents affect, literacy, and interaction as three overlapping circles in a Venn diagram, I propose a modified model where interaction plays a more intertwined role when using it to analyze nostalgic cues. While interactive input helps to immerse the player in a game, interaction defines affective experiences and literacy in this context and, as a result, may be best represented as seen in Figure 6.2.

When used to analyze nostalgia, the ALI model I have adapted hybridizes emphasis on the composer's intentions and the text, with the affordance of meaning to the player-listener, in contrast to imposing meaning on them. This is a particularly helpful model to use, as it demonstrates a communication between a composer and their target audience without disregarding the player-listener. I utilize this versatility of the ALI model throughout this chapter to examine the player experiences that create the conditions for nostalgic cues.

Self-quotation and intertextuality as a means to evoke nostalgia

Although there are several techniques that Uematsu uses to evoke nostalgia within *FFIX*, I identify self-quotation as his primary technique. This concerns the quotation of musical cues, phrases, and "musemes" (or "motives") from previous installments in the *FF* series. By applying van Elferen's ALI model to specific musical cues, it is possible to examine how listener affect, literacy, and interaction result in nostalgic sentiment being experienced by the listener. Given the intention of

the developers to return to the series' roots, it is feasible that Uematsu's awareness of his audience's musical literacy informs his use of self-quotation for nostalgic purposes. First, Uematsu uses "in-references"[9]: musical gestures and motifs that those well acquainted with his musical style will recognize. He is likely aware of the affective experience that longer-standing fans of the series have had—they have experienced his previous work autobiographically in their own past. Second, Uematsu is likely aware that his fans have a degree of literacy with his music: they are informed of his compositional style and what to expect in a *FF* game (Nix 2000). His use of reoccurring "stock" musical gestures such as the rising fourth motive[10] or his use of ragtime music within a fantasy setting are just two examples of Uematsu's style. Finally, Uematsu exploits the interaction his audience has with his music: knowledgeable players can trigger certain musical tracks in the game simply by performing the required task associated with the musical cue. This can involve traveling to a particular town, engaging in combat within the game, or triggering a specific event within the game's narrative. The convergence of these factors allows a composer to evoke nostalgia to a receptive audience familiar with earlier textual experience. Figure 6.3 demonstrates the contribution of ALI factors to the process in which the composer reacts to nostalgic demand.

One should note, however, that when discussing this compositional technique of targeted nostalgic evocation within the context of Uematsu's work, it is important to realize that *FF* games are not serialized; they rarely refer to other games in the series, and they contain their own narrative. For example, *FFII* (1988) is not the sequel to *FF*. Exceptions exist where particular games have an expanded universe around them, but these do not coincide with other game worlds in the series (e.g., the many games within the universe surrounding *FFVII*, such as *Dirge of Cerberus* [2006] and *Crisis Core* [2007]). Because of this, each installment in the series has an entirely new and original soundtrack that exists in the narrative world of the game that it accompanies. While some plot devices and musical themes may exist as overarching structures that unify the *FF* series as a whole, such as the "Chocobo" themes, the recurring "Prelude," and the staff roll themes, the music within each game is almost entirely self-contained, referential only to its own world and does not reference previous games. Due to this seemingly strict adherence to creating entirely new material within a game, it is of particular significance that Uematsu should quote his previous work within the soundtrack to *FFIX*. As mentioned above, Uematsu typically avoids reusing all but a handful of musical cues associated with the series within his *FF* soundtracks. To support this claim that the soundtrack to *FFIX* draws upon previous installments purposefully, I utilize a series of case studies to demonstrate motivic links to *FFIX* from his earlier works. To deconstruct these cues and examine how they are used, I present a series of musical quotation forms that Uematsu uses in the *FFIX* soundtrack.

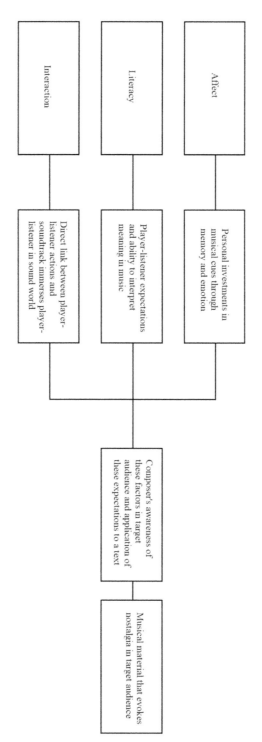

FIGURE 6.3: A flowchart in which I demonstrate how the ALI factors converge to evoke nostalgia.

Types of musical quotation

Musical quotation exists in multiple forms, all of which vary depending on the extent that the musical material is quoted. The meaning that could be afforded to the listener therefore varies depending on what type of quotation is used. Notably, in a discussion on Charles Ives's use of quotation, Christopher Ballantine considers its semantic connotations and how it "communicates the attitude of an original occasion" (1979: 168). This is particularly important because, whether or not it is intentional, Uematsu achieves this by quoting himself throughout *FFIX*. The effect on the listener is that they are indeed transported to that "original occasion" upon hearing the music. But it is important to note that quotation does not necessarily have to be a direct transportation of musical syntax; the "attitude" and semantic connotations of music as described by Ballantine can be transplanted as well. To provide a system of categorizing and demonstrating direct transplantations of syntax, or semantic connotations, we can look at the work of Goodman (1974), who identifies two primary forms of musical quotation that exist: direct quotation and stylistic allusion

Direct quotation

Direct quotation is the citation of a "syntactic replica of quoted expression" from a particular piece of music (Bicknell 2001: 185–87). Bicknell notes that Howard (1974) and later Goodman (1978) argue that direct quotation must fulfil the requirement of "containment," in that the quoted phrase is "contained" within its transplantation when the passage bears similar if not the same auditory properties to the original. However, as I discuss, the amount of musical material that a composer directly quotes may change the semantic interpretation for the listener; a short musical fragment may not carry the same interpretative weight as a complete musical phrase. As such, I expand on the notion of direct quotation, further subcategorizing it into *musematic*, *discursive*, and *variant* quotations.

Musematic quotation

The need for musematic quotation as a separate subcategory of direct quotation is due to the fact that a museme (or "motive") is the smallest fragment of musical meaning. Additionally, the definition of direct quotation as "a syntactic replica of quoted expression" is inadequate to account for the fact that a museme can be transplanted out of its original phrase and cadence, yet still carry musical meaning with it. This is evident when comparing the five-note motive that initiates

Rachmaninov's *Rhapsody on a Theme by Paganini* with the first measure of Paganini's Caprice no. 24.[11] Here, we see the five-note museme from Paganini's famous caprice being transplanted into the introduction to Rachmaninov's variations. The initiating five-note museme that initiates *Rhapsody*, while not a full quotation of Paganini's original phrase, still carries musical meaning and structure through its quotation. When this phrase is heard, a sense of familiarity is afforded to the listener, who with literacy of the two musical texts can recognize that Paganini's Caprice no. 24 is being quoted, without the need for the entire phrase to be quoted.

Discursive quotation

The definition of discursive repetition adheres to Goodman's original definition of quotation as a syntactic replica of the original phrase—there is no alteration to the phrase as there is in variant quotation, and it is not quoted "out of context" as it is in musematic quotation. In regard to the actual syntax of the quotation, discursive quotation will almost invariably be transplanted with the cadence that existed within its source material; in isolation, the music still "makes sense" and does not necessarily require the musical environment from which it was transplanted to do so. All tonal and harmonic relations between the transplanted notes remain intact. An exemplification of this process can be observed if we draw our attention back to the example of Rachmaninov's *Rhapsody*: while musematic quotation occurs when the sixteenth note figure is quoted out of context, the quotation is evidently discursive when Rachmaninov finally provides the entirety of Paganini's phrase. While at first glance the boundaries between discursive and musematic repetition may appear blurred, an important distinction can be drawn in the significance of quoting an entire phrase of music as opposed to a single "cell" of music. A helpful analogy here would be comparing the quotation of a complete sentence of speech to a short phrase from the same sentence. To go back to musical terms, discursive repetition involves transplanting a phrase of music with its cadences, harmonic motion and signposting, and resolutions intact, while musematic repetition varies in that it does not need to necessarily adhere to a phrase-like structure.

Variant quotation

Variant quotation is perhaps the broadest and most versatile of the three subcategories of direct quotation for two reasons: first, the degree in which variations may occur within a phrase differ greatly, and second, this type of quotation is applicable to the variation of both musemes and complete phrases. Continuing with the example from Rachmaninov's *Rhapsody on a Theme of Paganini*, we see

this technique employed in his eighteenth variation: while the entire composition is a series of variations of a quoted theme, the fame of this variation is perhaps in part due to its stark contrast to the previous variations, with its inverted melodic contour, as well as its more lyrical and sentimental nature.[12] We can see that the musical "source code" still exists within this quotation, even with its inverted melody. While the transplanted music is invariably altered, there is still a measure of information that links it back to its source material (in this case, the melody), and indeed, the entire tone is an inversion of the original material. Within this quotation, a sense of familiarity and perceptual link is maintained, so that the listener can recognize the relationship between the original and altered quotation, be it implicit or explicit, while sensing that some type of variation has been applied. This is the crucial factor that separates variant quotation from other forms of direct quotation, as the musical "DNA" has been quoted without being a replica of musical syntax as defined by Goodman and Howard.

Stylistic allusion and the musical paraphrase

Stylistic allusion refers to the quotation of a piece of music's sonority and/or semantic equivalency, or the lifting of textural elements.[13] This is in opposition to simply and directly quoting musical phrases. It is, in a sense, a pastiche of another piece of music. Here, Goodman uses the term "indirect quotation" using the analog of paraphrasing within grammar: two sentences could be constructed of different words, but still carry the same meaning. This comparison particularly elucidates how stylistic allusion differs from direct forms of quotation. Goodman argues that transpositions and variations within music are not musical paraphrases, in that they carry syntactic rather than semantic meaning with their relationships between their notes and patterns; an example of this would be the aforementioned Paganini quotation in Rachmaninov's *Rhapsody on a Theme of Paganini*. Stylistic allusion therefore involves a situation where musical meaning or sonority is alluded to without the transplantation of a phrase. One example of this is the song "Sowing the Seeds of Love" by Tears for Fears, which semantically quotes the Beatles (particularly "I Am the Walrus") by imitating the voice of John Lennon, 1960s production styles, and using similar harmonic devices used by The Beatles. Other examples include Steel Panther's "Party All Day," an allusion to Bon Jovi through the use of similar melody and instrumentation, and Kington Wall's "Shine on Me," an allusion to Pink Floyd's "Shine On You Crazy Diamond."

To illustrate his point of "musical paraphrase," Goodman considers the phrase "John affirmed that the clouds are full of angels" against the paraphrase "the clouds are full of angels." The original meaning that the clouds are full of angels

is retained within the paraphrase without quoting the syntactic structure of an agent stating that the clouds are full of angels, thus resulting in a semantic quotation—the meaning of the phrase has been quoted, without quoting the phrase verbatim. In a musical context, this form of semantic quotation is found with the use of musical tropes and meaning, particularly those of semiological or ecological perception theories. With these types of quotation identified, it is now possible to analyze the elements of Uematsu's compositions that utilize self-quotation by first identifying what musical cues are evocative of his previous work.

Black Mages: The Mysidian theme linked to FFIX

Perhaps one of the most iconic images from the early *FF* series is that of the "Black Mage," a character present throughout the first five games in the series, but notably absent in the sixth, seventh, and eighth installments. As part of the development team's aim to realize their goal of creating a game that fulfilled fan desires for nostalgic themes, the black mage returned in *FFIX*.[14]

To analyze this musical link between *FFIX* and the earlier games, we must first ask "how does Uematsu musically represent the Black Mage?" To answer this question, let us revisit "Mystic Mysidia," the theme for the mage town of Mysidia from *FFIV*. It is worth noting that this was the first installment in the series where black mages were given their own musical theme. As such, Uematsu directly quotes a museme from "Mystic Mysidia" in "Vivi's Theme" in *FFIX*. This is particularly significant, as the playable character Vivi is a black mage whose artwork, aesthetic, and gameplay are heavily drawn from previous incarnations of the Black Mage class in the *FF* series. Furthermore, Vivi's theme is subject to motivic development later in the game, within the track "Black Mage Village."[15]

Mystic Mysidia

From the onset of "Mystic Mysidia," we are immediately greeted by a staccato quaver note rhythm ostinato between D and A on a MIDI approximation of a marimba and bass guitar. This is where we begin to hear how Uematsu characterizes the Black Mage, an eccentric yet brilliant figure—someone with a mind chaotically darting between ideas, in contrast to the more "ordered" motifs we hear often associated with other characters or locations within game. While a rather simple I-V-I is heavily outlined in the ostinato, this simplicity projects attention onto this unusual choice of percussion that stands out to the listener. This musical characterization of eccentricity is by no means unique to "Mystic Mysidia" for

Uematsu however. The use of "quirky" percussion to signify madness and "oddity" is utilized in Palom and Porom's theme from *FFIV* and in "What?" from the soundtrack to *FFVI*. In a discussion of musical markers that Uematsu uses to signify madness,[16] Dana Plank notes that Uematsu utilizes a "sparse and open" texture characterized by the marimba and the cuica, a Brazilian friction drum that creates a whooping noise[17] (2018: 257–59). Notably, the melody in "Mystic Mysidia" is antiphonal in nature, and we can hear this, along with the driving quaver rhythm, alluded to in "Vivi's Theme" (see Example 6.1).

"Vivi's Theme" begins with wide, intervallic leaps within the driving quaver rhythm, a stylistic allusion to the opening ostinato from "Mystic Mysidia." There is however a difference: where "Mystic Mysidia" imbues a strong sense of tonality via the perfect fifth in its ostinato, the quaver rhythm in "Vivi's Theme" features a much more discordant tonality: a harmonic tritone that moves back and forth

EXAMPLE 6.1: Nobuo Uematsu, "Mystic Mysdia," *FFIV*, mm. 1–6 (top); Nobuo Uematsu, "Vivi's Theme," *FFIX*, mm. 1–6 (bottom).

between a whole tone. The ensuing whole tone inflection reinforces Vivi's lack of identity: where "Mystic Mysidia" musically represents a sense of belonging for the mage community, the tonal ambiguity in "Vivi's Theme" suggests a character who has yet to discover who he is, or a place he can call home. Indeed, the concept of discovering a sense of self, belonging, and finding a home is a prominent narrative theme in *FFIX*.

Arguably the most significant similarity between these two tracks is a variant quotation of the six-note museme played on the marimba in m. 2 from "Mystic Mysidia," which initiates the main melodic material for "Vivi's Theme" at m. 5. This museme is the most identifiable cue that exists between the two tracks, and as a variant (although almost direct) form of quotation, it provides a strong link between these two games. Additionally, and more importantly, this museme returns throughout *FFIX*, most notably in the theme "Black Mage Village." This, in a sense, creates a musical lineage: "Mystic Mysidia" begets "Vivi's Theme," which in turn begets "Black Mage Village."

"Black Mage Village"

Within the narrative of *FFIX*, Vivi searches for others like him and eventually finds a village populated by his kin; Uematsu reflects this within the music for the village. Within the D section of "Black Mage Village," Uematsu quotes "Vivi"s Theme" as if to signify that Vivi has finally found a place that he can call home: Vivi's theme finally exists in a tonal environment, and the connection between Vivi and black mages is finally resolved. However, as "Vivi's Theme" quotes "Mystic Mysidia," the theme "Black Mage Village" in turn establishes another connection between the village of mages in *FFIX* with the village in *FFIV* through the heavy use of musical quotation.

The first thing we hear in "Black Mage Village" is completely anachronistic for both the settings of *FFIV* and *FFIX*. The largely traditional instrumentation heard throughout most of *FFIX* is eschewed in favor of a synth rock ensemble, as can be observed by the instrumentation in Example 6.2 (notably, however, the instrumentation of "Black Mage Village" is foreshadowed via the use of a heavily syncopated hi-hat in "Vivi's Theme"). The track utilizes synthesizers and organs more closely associated with progressive rock music from the 1970s and 1980s, which is a notable feature of Uematsu's work.[18] Despite the obvious anachronism of the instrumentation and style that "Black Mage Village" carries within it, a genealogy exists that spans "Mystic Mysidia" through "Vivi's Theme" and "Black Mage Village"; this is most notable through the same six-note museme present in all three themes. The connection between "Mystic Mysidia" and "Black Mage

EXAMPLE 6.2: Nobuo Uematsu, *FFIX*, "Black Mage Village," mm. 38–48.

Village" is further reinforced through Uematsu's use of the cuica; as a particularly unusual instrument to be found in even Uematsu's compositions, its inclusion is significant. Given the context in which it originally exists within "Mystic Mysidia," its stylistic allusion as a hocket in "Black Mage Village" is no coincidence. While quotation from "Mystic Mysidia" serves as a powerful exemplar of Uematsu's method of inducing nostalgia in the listener, the *FFIX* soundtrack is rich with other examples of this compositional technique.

"Mount Gulug"

There are many other examples from *FFIX* in which Uematsu relies on self-quotation from previous games. One such example lies within the "Mount Gulg" theme within *FFIX*.[19] Here, we see an instance of direct quotation as opposed to stylistic allusion: the theme is entirely quoted from "Mount Gulug" in the original *FF* game (see Example 6.3).[20]

These highlighted sections demonstrate the two primary themes heard within "Mount Gulug" and its quotation in *FFIX*. By merely looking at the similarity of the names of the two compositions, this quotational link is clear.

EXAMPLE 6.3: Nobuo Uematsu, "Mount Gulug," *FFI*, mm. 2–9 (top); Nobuo Uematsu, "Gulug Volcano," *FFIX*, mm. 6–9 (middle); Nobuo Uematsu, "Gulug Volcano," *FFIX*, mm. 18–21 (bottom).

While the musical syntax and dialogue is conserved, the use of the pan flute[21] represents a major variation from the original.[22] Because of the visibility of the quotation in this context, an extremely clear affective link between the two games is created.

Character themes in FFIX

Another instance in which *FFIX* refers to earlier games in the series is through the use of playable characters, who themselves allude to characters from earlier in the series. Consequently, this is also heard in their respective musical themes, as

it is yet another opportunity for Uematsu to apply this compositional technique. One such example is found in Zidane, who shares many similarities with Locke, a protagonist from *FFVI*: both Zidane and Locke are thieves who utilize the same in-game abilities and have similar art designs, personalities, and relationships with the female love interest within the games. Additionally, both characters experience some form of unrequited love.

These similarities are reflected in Uematsu's use of allusion and quotation in their respective character themes. Both of these characters' eponymous themes feature a march section with a brighter tonality, reflecting the cheerful, good-natured "swashbuckler" archetype that both of these characters project. Similarly, both themes are contrasted with mournful section in a darker mode, reflecting that these are both characters who are actually rather troubled underneath their happy-go-lucky exteriors. These personal troubles are further exploited through similar transformational techniques: for instance, while "Forever Rachel" is a mournful transformation of "Locke's Theme," "Zidane's Theme" is aesthetically transformed in "Unrequited Love" in a similar fashion (see Examples 6.4 and 6.5).[23] Thus, Uematsu reinforces the character similarities between Zidane and Locke through both stylistic allusion and similar transformational procedures.

Further instances of both character and musical stylistic allusion occurs between Amarant and Shadow from *FFVI*. Both characters are portrayed as "lone wolves" who, through their adventures, finally realize the value of companionship. Similarly, they are both represented as a "ninja" class in their

EXAMPLE 6.4: Nobuo Uematsu, "Locke's Theme," *FFVI*, B section, mm 17–20 (top); "Forever Rachel," *FFVI*, mm. 1–4 (bottom).

EXAMPLE 6.5: Nobuo Uematsu, "Zidane's Theme," *FFIX*, mm. 61–68 (top); "Unrequited Love," *FFIX*, mm. 1–8 (bottom).

respective games with very similar traits: quick, physical fighters, with the ability to throw items at their foes. The similarities in Amarant's character to Shadow are reinforced by the stylistic allusion of Shadow's theme.[24] The most prominent similarities between these two tracks are the use of the downtempo, the triple meter/swung shuffle feel, sparse timbres, and, most notably, the use of the Dorian mode.[25]

An additional significant quotation in *FFIX* for the purposes of this case study is the direct quotation of the opening of the battle themes from *FFI–VI*.[26] Although this opening bass riff (and occasionally the accompanying gesture at the beginning) is used for every battle theme in *FF*'s 2D "classic" era, Uematsu omits this introduction for the battle themes in *FFVII* and *VIII*. Due to the six-year gap in terms of game development between *FFVI* (1994) and *FFIX* (2000), a hunger for nostalgia would certainly have developed, and the inclusion of this riff in the *FFIX* battle then is certainly a nod to earlier games. The fact that this iconic bass riff is

present throughout almost all of the A section instead of being "sidelined" to the introduction only strengthens this argument.[27]

Finally, and perhaps most strikingly, two other direct quotations of *FF* tracks exist diegetically as Easter eggs within *FFIX*: "Rufus's Welcoming Parade" from *FFVII* is heard as in-game music played by an orchestra if the player views an optional cutscene. Additionally, "Doga and Unei" from *FFIII* can be heard through an in-game gramophone in *FFIX* after the completion of a lengthy optional side-quest.[28] The inclusion of such Easter eggs, while not a compulsory part of the plot every player-listener would experience, serves to reinforce the theme of nostalgia in *FFIX*.

Analyzing the inference of nostalgia from these cues

Now that these cues have been isolated, van Elferen's ALI model can be applied to analyze how these instances of quotation contribute to the invocation of nostalgia. First, regarding musical affect, we know that player-listeners familiar with music from previous *FF* games would have experienced these musical cues in the past. To put the ALI model to use, we can examine the process for how nostalgic cues are inserted into the text. For the purposes of illustration, it is helpful to refer back to the ALI diagram used by van Elferen and my modified version (Figure 6.2).

The aspect of "interaction" in regard to how communities react to works also serves a supplementary role: interaction with games and music is vital to how affect and literacy develop. Through interaction with previous games and the wider community, affective experiences develop, which informs the literacy with the *FF* series. This ultimately informs expectations of how *FF* games are aesthetically designed. The interaction within a community and discussion with peers creates a consensus of what constitutes the "classic" period within the series. In the case of *FF*, this includes the first five installments of the series from the 2D era on the NES/SNES ports. This perception of the "classic" period then creates nostalgic demand for a return to aesthetic and narrative themes of the earlier games after a period of time elapses during which there has been a significant departure from features of the "classic" period, be it music, visual styles, or gameplay mechanics. The affect factor of ALI comes into play at this point. Uematsu is likely aware of the experiences that contribute to this discussion of what constitutes a "classic" period. The player-listener who is likely to have played earlier *FF* games will have heard at least a few of those quoted tracks such as "Mystic Mysidia," "Mount Gulug," or "Locke's Theme," which would contribute to their affective experience.

At this point of the ALI model, musical literacy comes into play. The ability for the player-listener to recognize these cues consciously or subconsciously with

varying degrees of familiarity is the next step in this process. If the player-listener were to hear "Vivi's Theme" while playing *FFIX*, and had fulfilled the requirement of affectively experiencing the theme's source material, one may perhaps recall when they heard this and have affective, positive associations from where they recognize the music. For the player-listener, the ability to recognize cues and conventions within *FF* music fulfills that second criterion for the process of the nostalgic composer–audience relationship: expectations of an audience informing the music of the composer. From here, the conditions are met for which the composer can then demonstrate an awareness of his or her target audience, knowing it is likely that they have experienced this material. It is from this awareness that Uematsu placed these nostalgic cues from quotations within his soundtrack, which finally results in the invocation of nostalgic sentiment in many of those playing *FFIX*.

Conclusions

The research presented allows us to reach multiple conclusions: first, the economic benefits along with a cultural demand for a "return to roots" have been demonstrated to have varying degrees of influence over the composition of musical material. *FFIX* serves as an excellent case study, as it covers both issues of nostalgia pertaining to music within the *FF* series and video game music in general. However, this self-referential means of invoking nostalgia is not merely related to the music of *FFIX*; it may be extrapolated to other media formats, such as musicians recording albums that have a similar aesthetic to older material or Easter eggs in films that reference previous material.

There currently seems to be a rather postmodern zeitgeist toward nostalgia: remakes of classic retro games are becoming increasingly common, with *The Legend of Zelda: Link's Awakening*, *World of Warcraft: Classic*, and *Pokémon: Let's Go* as some of the most recent 2018/19 releases. Furthermore, old intellectual properties are still used and remain bestsellers, in the case of *Pokémon*, *Mario*, *Legend of Zelda*, and *FF* titles. While the continued success of these titles can in part be owed to the power of their brands, it is not unreasonable to suggest that nostalgia is a significant contributory factor to their success. While understanding how audiences experience nostalgia developed on their own affective experiences with previous works can have financial benefits for composers, the adaptation of van Elferen's ALI model presented in this chapter can have wider ramifications for the understanding of nostalgia. We can use the ALI model as a framework to identify what contributes to, and what triggers, nostalgia to inform studies on video games and the wider arts in general. This is particularly evident in the popularity of recent video game remasters/remakes, such as the *Crash Bandicoot*, *Spyro The Dragon*, the *Ratchet and Clank* series, and *Final Fantasy*

VII: Remake. Outside of video games, we see this with Disney's projects of creating live-action remakes of their animated catalog, or the pulling power established musicians still have in the box office.

Finally, the concept of affective triggers being inserted into music can raise many other issues other than financial or creative ones: just as music can result in the recall of positive memories, it likewise has the capacity to recall negative memories too. It is not inconceivable that music could potentially be a trigger for post-traumatic stress disorder, by the mechanism of a listener associating a certain piece of music or sonority with a negative experience that can then result in flashbacks. Contrarily, the study of music as therapy for those suffering psychological maladies like PTSD or dementia may benefit from the study of nostalgia's relationship with music. The arts are without exception, ubiquitous within all human cultures, whether we notice it or not; as nostalgia and arts often go hand in hand, the inflection of nostalgia in arts has wide, overarching consequences in how arts and media are experienced. The power for nostalgia to influence the content of art, as well as the experiences of the consumers/observers, makes the study and understanding of nostalgia all the more critical for anyone who holds a stake within the arts. And jointly, due to this prevalence of nostalgia and its impact on arts and arguably many aspects of human life, the study, understanding, and exploitation of nostalgia is very much an open field that demands more study.

NOTES

1. Van Elferen's ALI model is designed to analyze how an audience interacts to video game music via musical affect—how a listener experiences emotion while listening to music; musical literacy—how the listeners' past experiences determine literacy and some kind of expectations of music; and interaction—how the listener interacts with music, be it directly or indirectly, and consciously or unconsciously.

2. The BRECVEMA model details eight ways in which music is experienced emotionally: brain stem response (how the physical properties of sound affect a listener); rhythmic entrainment (how music influences a body rhythm in the listener); evaluative conditioning (how a listener associates music with a particular stimuli they have experienced); emotional contagion (how a listener feels emotion expressed within music); visual imagery (how a listener experiences music due to visual images associated with the music); episodic memory (how the listener associates music with a past event); musical expectancy (how a listener experiences emotion due to music fulfilling or violation of the listener's expectations of a piece of music); and aesthetic judgment (how the listener judges and individually values a piece of music).

3. This was a presentation I delivered at the *Ludomusicology 2017* conference proceedings. When discussing an "average" year of a canonized game, it is important to consider an

average that adds or subtracts a few years, as this would capture a cohort of gamers of a particular generation, who are likely to share many similar and homologous experiences of growing up in that era. It is notable that many titles from this period, such as *Pokémon*, *Super Mario*, *FF*, and *The Legend of Zelda*, continue to be immensely popular series, but remakes and remasters of titles released in the 1990s cement the idea of a canon of "great" games from this period.

4. McFerran cites research conducted by Clay Routledge into video game nostalgia and makes the link between collecting old software and the culture of buying vintage albums, or watching classic movies. Routledge then goes on to mention that nostalgia for retro gaming is less of a fondness for a particular title but more of a general emotional cue for fulfilling and happy experiences of youth.

5. Note that "legacy act" is not a term used by Allen; I use it to describe artists that are typically associated with previous eras, but still retain immense popularity and are able to continue to draw large revenues from touring.

6. *Load*, *ReLoad*, and *St. Anger* were met with mixed reviews, scathing reviews, and derision from fans and critics alike. In some cohorts of metal fans, Metallica was seen to have "sold out," in that the band sacrificed authenticity and their identity as part of a metal "tribe" to achieve commercial success. *Death Magnetic* was considered by many fans and critics to be a "return to form," in that it musically resembled much of their earlier work before the release of *Load* (1996).

7. In addition to this claim, Hepper et al. (2012) performed a series of experiments to describe nostalgia as a combination of cognition and affect, recalling autobiographical experiences with often a positive "rosy glow." Wildschut et al. (2006) in a study on nostalgia found that negative affect was the most common elicitor of nostalgia. Cavanagh et al. (2015) in a literature review, as part of a study on nostalgia, collated a series of studies that heavily suggest that nostalgia is indeed an affective process associated with autobiographical memories.

8. In this context, I use "texts" to refer to the general game itself.

9. The term "in-reference" is something I use to describe references to information that only a certain group would understand and that have little or no meaning to people outside this group. A more prosaic example would be the use of the "Cid" character in the *FF* series. The significance of using this name would be lost on a newcomer to the series, but likely carries greater meaning for experienced fans.

10. For further discussion of the symbolic meaning behind the recurring "rising fourth" motive, see Anatone, this volume.

11. See Supp. 6.1 for these examples.

12. See Supp. 6.2.

13. For further discussion regarding Uematsu and the use of stylistic allusion in his music for antagonists within the series, see Kizzire, this volume.

14. See Supp. 6.3 for a chart that displays the different Black Mages throughout the series.

15. For further discussion on Vivi's theme and its relationship to other musical themes regarding the Black Mages within *FFIX*, see Atkinson, this volume.

16. Plank discusses madness within the context of Kefka, in how he is portrayed as a deranged, psychopathic villain. Another, darker, and more sinister musical characterization for madness as noted by Plank utilizes a fragmented, discordant structure that contains multiple meter changes, as is the case with "Dancing Mad," which contrasts the rigid tonicity, stripped-back instrumentation, and robotic rhythm of music Uematsu uses to characterize "oddity." See Plank (2018).

17. I am grateful to Gregg Rossetti, who was able to confirm this instrument as a cuica. His complete instrument transcription of the *FFIV* soundtrack is available on his YouTube channel. See VGM Transcriptions (2018).

18. In fact, regarding the musical literacy of Uematsu's target audience, an expectation of music that lacks the readability of conventional film scoring is fulfilled through this type of instrumentation, especially those familiar with his own rock band, aptly named "The Black Mages."

19. "Mount Gulg" and "Mount Gulug" are inconsistently translated, with "Gulg," "Gulug," "Gurugu," and "Gurgu" interchangeably used. In this chapter, I use the more consistent translations "Gulg" when referring to *FF* (1987) and "Gulug" for the incarnation in *FFIX* (2000).

20. The instrumental oscillation between the tonic and the VII in the introduction, which implies the Mixolydian mode, is consistent with Uematsu's previous outputs that utilize rock music.

21. The use of a pan flute is significant. As an indigenous instrument, these are used to represent the more primal world of "Summoners" and the four elemental fiends, which hark back to early *FF* plot devices. This "primal" family has its own sound world represented by indigenous instruments, in tracks such as "Eternal Harvest," "Conde Petie," "Mount Gulug," "The Four Medallions," and "Ruins of Madain Sari."

22. Due to the extreme technical restrains in sound production in video games in 1987, it would be dangerous to discuss whether or not Uematsu intended to have any stylistic illusion in terms of instrumentation and texture from games this early on. It cannot be ascertained whether or not "Mount Gulug" in *FFIX* or other similar tracks were intended to be a truer representation of what the composer's vision was for the track, with the technical limits of the original game removed. For this reason, I believe it is best to focus on other musical elements that can be transplanted between games without being subject to change due to technical limits.

23. Additionally, Uematsu uses developing variation in "Locke's Theme" to link the A section with the B section, resulting in the new B theme. Moreover, the melodic material in the B theme is further exploited in other characters' leitmotifs throughout the soundtrack, musically unifying the protagonists allied against the empire. See Anatone (2019).

24. See Supp. 6.4 for a comparison of Shadow's theme and Amarant's theme.

25. Notably the use of whistling in "Shadow's Theme" alludes to Spaghetti Westerns scored by Ennio Morricone, further reinforcing the signifying of the "lone wolf" trope, due to this being a frequent stock character in these films.
26. See Supp. 6.5.
27. For further discussion on Uematsu's battle music in the *FF* series, see Mitchell, this volume.
28. This is particularly significant due to the gramophone being an antique associated with playing records from the past—the fact that music from past games played diegetically within this instrument is significant.

REFERENCES

Allen, Bob (2016), "Madonna Extends Record as Highest-Grossing Solo Touring Artist: $1.31 Billion Earned," Billboard, March 23, http://www.billboard.com/articles/columns/chart-beat/7271843/madonna-extends-record-highest-grossing-solo-touring-artist. Accessed September 19, 2020.

Anatone, Richard (2019), "(Omen)ous Motives: Structural Unity and Developing Variation in Nobuo Uematsu's *Final Fantasy VI* Soundtrack," *Society for Composers, Inc.*, Commerce, TX, April 11–13.

Ballantine, Christopher (1979), "Charles Ives and the Meaning of Quotation in Music," *Musical Quarterly*, 65:2, p. 168.

Barrett, Frederick, Grimm, Kevin, Robins, Richard, Wildschut, Tim, Sedikides, Constantine, and Janata, Petr (2010), "Music-Evoked Nostalgia: Affect, Memory, and Personality," *Emotion*, 10:3, pp. 390–403.

Barrett, Frederic and Janata, Petr (2016), "Neural Responses to Nostalgia-Evoking Music Modeled by Elements of Dynamic Musical Structure and Individual Differences in Affective Traits," *Neuropsychologia*, 91:1, pp. 234–46.

Batcho, Krystine (2007), "Nostalgia and the Emotional Tone and Content of Song Lyrics," *American Journal of Psychology*, 120:3, pp. 361–81.

Bicknell, Jeanette (2001), "The Problem of Reference in Musical Quotation: A Phenomenological Approach," *Journal of Aesthetics and Art Criticism*, 59:2, pp. 185–87.

Cameron, Andy (1995), "Dissimulations: Illusions of Interactivity," *Millenium Film Journalm*, 28:1, pp. 33–47.

Cavanagh, Sarah, Glode, Ryan, and Opitz, Philipp (2015), "Lost or Found? Effects of Nostalgia on Sad Mood Recovery Vary by Attachment Insecurity," *Frontiers in Psychology*, 6, pp. 1–2.

Collins, Karen (2008), *Game Sound*, Cambridge: MIT Press.

Goodman, Nelson (1978), *Ways of Worldmaking*, Indianapolis, IN: Hackett Publishing.

Hepper, Erica, Ritchie, Timothy, Sedikides, Constantine, and Wildschut, Tim (2012), "Odyssey's End: Lay Conceptions of Nostalgia Reflect Its Original Homeric Meaning," *Emotion*, 12:1, pp. 102–19.

Howard, V. A. (1974), "On Musical Quotation," *Monist*, 58:2, pp. 294–306.

Juslin, Patrik and Västfjäll, Daniel (2008), "Emotional Responses to Music: The Need to Consider Underlying Mechanisms," *Behavioral and Brain Sciences*, 31:5, pp. 559–75.

Kassabian, Anahid and Jarman, Freya (2016), "Game and Play in Music Video Games," in M. Kamp, T. Summers, and M. Sweeney (eds.), *Ludomusicology: Approaches to Video Game Music*, Sheffield: Equinox Publishing, pp. 117–19.

Kizzire, Jessica (2014), "'The Place I'll Return to Someday': Musical Nostalgia in *Final Fantasy IX*," in K. J. Donnelly, W. Gibbons, and N. Lerner (eds.), *Music in Video Games: Studying Play*, New York: Routledge, pp. 193–98.

LaBar, Kevin and Cabeza, Robert (2006), "Cognitive Neuroscience of Emotional Memory," *Nature Reviews Neuroscience*, 7:1, pp. 54–64.

Manovich, Lev (2001), *The Language of New Media*, Cambridge: MIT Press.

McFerran, Damien (2012), "Crippled by Nostalgia: The Fraud of Retro Gaming," Eurogamer, http://www.eurogamer.net/articles/2012-09-12-crippled-by-nostalgia-the-fraud-of-retro-gaming. Accessed September 19, 2020.

Medina-Gray, Elizabeth (2016), "Modularity in Video Game Music," in M. Kamp, T. Summers, and M. Sweeney (eds.), *Ludomusicology: Approaches to Video Game Music*, Sheffield: Equinox Publishing, pp. 53–56.

Nix, Mark (2000), "The *Final Fantasy IX* Team Spills All," IGN, https://uk.ign.com/articles/2000/09/21/the-final-fantasy-ix-team-spills-all. Accessed January 26, 2020.

Plank, Dana (2018), "Bodies in Play: Representations of Disability in 8- and 16-Bit Video Game Soundscapes," PhD dissertation, Columbus: Ohio State University.

Roepke, Martina (2011), "Changing Literacies: A Research Platform at Utrecht University," May, https://mmroepke.files.wordpress.com/2010/03/cl-working-paper-1-voor-boekje.docx. Accessed September 19, 2020.

Schuman, Howard and Scott, Jacqueline (1989), "Generations and Collective Memories," *American Sociological Review*, 54:3, pp. 359–81.

Summers, Tim (2016a), "Analysing Video Game Music: Sources, Methods, and a Case Study," in M. Kamp, T. Summers, and M. Sweeney (eds.), *Ludomusicology: Approaches to Video Game Music*, Sheffield: Equinox Publishing, pp. 8–29.

Summers, Tim (2016b), *Understanding Video Game Music*, Cambridge: Cambridge University Press.

Tate, James L. (2017), "High Scores: Canonisation within Ludomusicology," *Ludomusicology 2017*, Bath Spa University, April 21.

Trost, Wiebke, Ethofer, Thomas, Zentner, Marcel, and Vuilleumier, Patrik (2012), "Mapping Aesthetic Musical Emotions in the Brain," *Cerebral Cortex*, 22:12, pp. 2769–83.

Van Elferen, Isabella (2016), "Analysing Game Musical Immersion: The ALI Model," in M. Kamp, T. Summers, and M. Sweeney (eds.), *Ludomusicology: Approaches to Video Game Music*, Sheffield: Equinox Publishing, pp. 32–52.

VGM Transcriptions (2018), "*Final Fantasy IV* (SNES) 1991: Mystic Mysidia (a Unique Town Theme)—Transcription," YouTube, September 23, https://www.youtube.com/watch?v=CccGRi9TDvY&list=PLrVe1vyUW6Eem-9el40b3nNQ2tvLhIqH8&index=26. Accessed September 27, 2020.

Wildschut, Tim, Sedikides, Constantine, Arndt, Jamie, and Routledge, Clay (2006), "Nostalgia: Content, Triggers, Functions," *Journal of Personality and Social Psychology*, 91:5, pp. 975–93.

Wilson, Janelle (2014), *Nostalgia: Sanctuary of Meaning*, Duluth: University of Minnesota Libraries Publishing.

PART 3

THE LUNAR WHALE

7

Penultimate Fantasies:
Compositional Precedents in Uematsu's
Early Works

Alan Elkins

When Nobuo Uematsu first started composing music for Square—then a fledgling software developer working out of a computer café in Yokohama (Fujii 2005)—he considered it a side job, a supplement to his work at a local music rental company (Mielke 2008). In reality, it was the start of a long and successful career; Uematsu remained with Square for nearly two decades, scoring many of the titles that brought about the company's meteoric rise to prominence. Uematsu's music has practically become synonymous with the Japanese role-playing game (RPG), and his soundtracks for the *Final Fantasy* (*FF*) series are some of the best-loved works in the genre.

His early soundtracks, however, have remained relatively obscure. During his first few years at the company, prior to the release of *FF*, Uematsu composed music for thirteen games published by Square (see Table 7.1).[1,2] Although a few of these early works share the role-playing heritage of *FF*, most of them belong to other genres, including graphical adventure games and arcade-style action titles (side-scrolling platformers, 2D shooters, etc.). Some of these titles were released exclusively for Japanese personal computers (such as the *NEC PC-8801* and the *Sharp X1*) in limited quantities and are relatively unknown in the West.

In some respects, these early soundtracks are strikingly different from Uematsu's more famous works. The RPG soundtracks differ considerably in tone—both from *FF* titles and from each other—while the music for the action titles draws much of its inspiration from genre-specific conventions. The earliest menu-based adventure games barely contain any music at all, with tracks for only the title and ending screens. Nevertheless, some aspects of these soundtracks carried forward into the early *FF* entries, and discussing them is essential to attaining a complete perspective on Uematsu's compositional development.

TABLE 7.1: A list of titles for which Nobuo Uematsu composed soundtracks leading up to the release of *Final Fantasy*. Unless otherwise noted, all titles were released only in Japan.

Original release date	Game	Platform	Notes
April 30, 1986	*Cruise Chaser Blassty*	NEC PC-8801; NEC PC-9801; Sharp X1turbo	Co-composed with Takashi Uno
July 8, 1986	*Alpha*	NEC PC-8801; NEC PC-9801; Sharp X1; FM-7	
September 18, 1986	*King's Knight*	Famicom, MSX	Updated for the NEC PC-8801mkII SR and Sharp X1 as *King's Knight Special* (1987); released in the United States in 1989
December 15, 1986	*Suishō no Dragon*	Famicom Disk System	
March 12, 1987	*Tobidase Daisakusen*	Famicom Disk System	Released in the United States as *3D Worldrunner* in 1987
April 3, 1987	*Apple Town Story*	Famicom Disk System	
May 1, 1987	*Hao-kun no Fushigi na Tabi*	Famicom Disk System	Developed by Carry Lab; released in the United States as *Mystery Quest* in 1989
June 6, 1987	*Genesis: Beyond the Revelation*	NEC PC-8801; NEC PC-9801	
June 10, 1987	*Aliens: Alien 2*	MSX	
July 24, 1987	*Cleopatra no Mahō*	Famicom Disk System	
August 7, 1987	*Highway Star*	Famicom	Released in the United States as *Rad Racer* in 1987, then in Europe in 1988

Original release date	Game	Platform	Notes
December 1, 1987	*Nakayama Miho no Tokimeki High School*	Famicom Disk System	Co-composed with Toshiaki Imai[3]
December 7, 1987	*JJ: Tobidase Daisakusen Part II*	Famicom	
December 18, 1987	*Final Fantasy*	Famicom	Ported to the MSX2 in 1989; released in the United States in 1990

In this chapter, I examine three ways in which Uematsu's earliest game soundtracks relate to his work on *FF*. I begin by discussing the placement of Square's first RPGs in the overall landscape of the early Japanese RPG. I argue that the stylistic contrasts between these soundtracks and Uematsu's later works may be partly attributed to differences in theming and gameplay style from Square's later role-playing titles. Next, I demonstrate how some of Uematsu's soundtracks for early action-oriented titles share more in common with *FF* than his early RPG music, owing to musical features that were able to cross genre boundaries more easily. Finally, I demonstrate how Uematsu's underscoring for important plot moments in graphical adventure games parallels similar techniques found in the early *FF* titles.

First fantasies: Square and the early Japanese RPG landscape

Prior to the release of *FF*, Square developed three RPGs internally, all of which were scored by Uematsu: *Cruise Chaser Blassty* (1986), *Genesis: Beyond the Revelation* (1987), and *Cleopatra no Mahō* (1987). *Cruise Chaser Blassty*, a science-fiction RPG in which players battle against giant robots ("mecha") in outer space, adopts the first-person perspective of early dungeon crawlers like *Wizardry* (Sir-Tech 1981) and employs simple, menu-based one-on-one combat. *Genesis: Beyond the Revelation*, while also science-fiction-themed, draws heavily on western religious themes and uses an overhead perspective similar to the computer RPG *Ultima* (California Pacific Computer Company 1981), with combat taking place on an isometric grid. *Cleopatra no Mahō*, with its Egyptian theming, adopts a framework closer to the Enix's 1983 graphical adventure game *Portopia Renzoku Satsujin Jiken* (Altice 2015) while adding RPG-style combat

and character development. All three games differ considerably from *FF* in setting and gameplay mechanics, which may account for many of the stylistic differences from Uematsu's later works.

Although science-fiction elements were not unheard of in RPGs in the mid 1980s, the mecha theming of *Cruise Chaser Blassty* was far more common in anime. The player and enemy mecha designs for *Blassty* were, in fact, the work of Mika Akitaka, who worked on the series *Mobile Suit Gundam ZZ* the same year (4Gamer.net 2014). The game's soundtrack, a collaboration between Nobuo Uematsu and Takashi Uno, further underscores the anime connection; the music for the main theme, which is also used at the beginning of battles, more closely resembles the opening and ending themes of 1980s mecha-themed anime and sentai television shows.[4] While it may seem like an unusual choice to reuse the title screen music for battle sequences in an RPG, it was common for sentai shows to reprise their theme songs at the beginning of battle scenes. The primary melodic line moves mostly in eighth notes (the fastest moving value for most of the track) and is heavily syncopated—features that were common in the vocal parts of anime opening themes. The instrumental timbre in this track resembles the synthesizers used in many rock-based 1980s anime theme songs, owing to the fact that PC-8801's sound chip employs the same FM synthesis technology found in synthesizers like the Yamaha DX-7. Portions of *Blassty*'s main theme bear a striking resemblance to "Ai wo Torimodose," the original opening theme to *Hokuto no Ken*, written a couple of years earlier.[5]

Uematsu's soundtrack for the PC-8801 release of *Genesis: Beyond the Revelation* highlights its western religious theming through the use of somber organ music in some of its tracks. One such track plays when the player enters any of the game's churches, while another plays on the title screen and during the ending sequence. References to Christianity and Judaism play a central role in the game's progression; for instance, toward the end of the game, players travel to the town of Jerusalem after defeating a final boss named Satan. By contrast, western religious elements, while not entirely absent from the *FF* series, are far less pronounced than in *Genesis* and do not play a significant role in the soundtrack.

Even if Uematsu had wished to emulate organ timbres in the earliest *FF* entries, this would have been difficult to do within the limitations of the Famicom/NES sound chip. When the series moved to the Super Famicom/Super NES, with its more advanced sound hardware, Uematsu used the organ again, but to a different effect. The organ in *Genesis*, with its more reserved electronic timbre, represents a safe space for the player, contrasting with the dissonant music for Satan's home base (the final boss's lair). On the other hand, the organ in 16-bit *FF* entries, which employs a fuller sound closer to a "principal chorus" setting on a large cathedral organ, tends to be associated with major villains—for instance, Golbez's theme in

FFIV (1991) ("Golbez, Clad in Darkness") and the music from the final encounter with Kefka in *FFVI* ("Dancing Mad").[6,7]

The Egyptian theming of *Cleopatra no Mahō* informs most of its music.[8] Nearly every track incorporates what Serge Gut calls "L'Échelle à double seconde augmentée" ("the scale with two augmented seconds"), of which he outlines two forms (Gut 2000); both forms have an augmented second between scale degrees 6 and 7, while the other augmented second is between either scale degrees 2 and 3, or 4 and 5.[9] Although Uematsu's music for *Cleopatra* occasionally deviates from these pitch collections, the connection to the long-standing practice of associating Middle Eastern music with these scales is still audibly apparent.[10] Such theming is rare in the *FF* series, and thus the soundtrack to *Cleopatra* has little in common with Uematsu's later work.

The battle theme is one of the few tracks that do not employ an augmented scale—it outlines a whole-tone collection instead—but this, too, differs from Uematsu's practice in the *FF* series. The theme is shockingly brief, lasting less than three seconds before looping. Similarly, the battle theme to *Genesis*, although somewhat longer (about fourteen seconds), is still less than half the length of a typical *FF* battle theme, featuring a higher degree of tonal and metric instability than most of Uematsu's later battle music.[11] The brevity of these themes is perhaps a product of the games' combat mechanics: in both titles, the player controls the actions of a single character with limited attack options, often simply trading blows with enemies until someone dies. A battle in *Cleopatra* can often be finished in less than ten seconds; the longer, more complex battles of the *FF* series, on the other hand, would have required longer battle themes to minimize aural repetition over a longer span of time.

It is important to keep in mind that at the time Uematsu begin writing game soundtracks, there was relatively little precedent for the style of RPG that *FF* would come to represent. Some early Japanese RPGs incorporated elements from turn-based American releases like *Wizardry* and *Ultima*, while others adopted a real-time, action-oriented style. Settings ranged from standard sword-and-sorcery fantasy worlds to the less typical modern apartment complex in *Danchizuma no Yūwaku* (Koei 1983). The resulting differences in structure of these early RPGs meant that the gameplay contexts that became standard for *FF* and its progeny (towns, overworld and dungeon exploration, separate battle screens, etc.) were not always present, even in sword-and-sorcery titles. *Dragon Slayer* (Falcom 1984), for instance, takes place entirely within a dungeon, while *Hydlide* (T&E Soft 1984) lacks towns and discrete battle screens.

In turn, the musical features that tended to characterize these contexts in later Japanese RPGs were less clearly delineated during the genre's infancy. At first, it was rare for these titles to contain any original music at all; the few early Japanese

RPGs that even had music relied mostly on monophonic renditions of existing compositions. For instance, a session of *Dragon Slayer* opens with an excerpt from Antonín Dvořák's *Slavonic Dance* in E minor (Op. 46, No. 2), while *Hydlide* borrows several themes from nineteenth-century works, including "Farandole" from Georges Bizet's *L'Arlesienne Suite No. 2* and the hunter's chorus from Carl Maria von Weber's *Der Freischutz*.[12] This was due in part to the hardware limitations of early Japanese home computers; some machines available in the early 1980s, such as the first model of the NEC PC-8801, only supported a single channel of sound ("PC-8800 series" 2019).

By 1985, multichannel sound chips had become more widespread in Japanese PCs, and more developers had begun to support them. *Xanadu* (Falcom 1985), the second entry in the *Dragon Slayer* series, was among the first major Japanese RPGs to have a substantial original soundtrack, which was composed by Toshiya Takahashi.[13] The game uses separate background music for towns, dungeons, and boss fights, short tunes for enemy encounters and victory, and two ending themes. However, there is limited stylistic differentiation between different gameplay contexts, as several of these tracks—the town, dungeon, battle, and first ending track—are based on the same theme, "La Valse Pour Xanadu," with the battle music being merely a sped-up version of the dungeon music.[14] The boss music has the most distinct stylistic identity, employing stark dissonances and mixed metric groupings[15] in a manner similar to Uematsu's battle theme for *Genesis*.[16]

Xanadu was an important milestone for the Japanese RPG, but it was *Dragon Quest* (Enix 1986) that would indicate the future direction of the genre, both in terms of gameplay and music. Released around the same time as *Blassty*, Koichi Sugiyama's soundtrack differentiates more clearly between town and dungeon music than *Xanadu*, contrasting the cheery, major-mode town theme with a dissonant, mysterious dungeon theme that slows and lowers in pitch every time the player descends a floor. The overworld theme, a melancholy minor-mode tune with occasional Dorian inflections, occupies a tensional midpoint between the town and dungeon themes, while the battle music is more frenetic than the other three themes with its rapid flourishes and unstable sense of tonality.[17] The musical delineation between gameplay contexts is much clearer than in *Xanadu*, and Japanese RPGs that adopted the basic template of *Dragon Quest* would often articulate the musical differences between town, overworld, dungeon, and battle in a similar fashion.[18]

While Uematsu's compositional style is distinct from Sugiyama's, his soundtracks for the early *FF* titles more closely parallel the overall layout of the *Dragon Quest* soundtrack than his own early efforts in the genre, owing to similarities in overall gameplay structure between the two series. The aforementioned differences in theming between Square's first RPGs and *FF*—science-fiction and Egyptian, as opposed to sword-and-sorcery fantasy—further contributed to the differences

between their soundtracks. This is not to say, however, that Uematsu's later work is entirely unrelated to his earliest compositions; certain musical features seen in the early *FF* entries would find precedent, curiously enough, from Uematsu's work outside of the RPG genre.

From action to RPG: Stylistic precedents in other genres

Although Square is known mostly for titles like *FF*, RPGs actually constituted a minority of their output during the first few years of their existence. A larger portion of their early catalog consisted of platforming, shooting, and racing games—genres that were popular in arcades and on the Famicom. Uematsu composed soundtracks for six such games during his first two years at Square: *King's Knight* (1986), *Aliens: Alien 2* (1987), *Tobidase Daisakusen* (1987, released in the United States as *3-D Worldrunner*), *Hao-kun no Fushigi na Tabi* (1987, released in the United States as *Mystery Quest*), *Highway Star* (1987, released in the United States and Europe as *Rad Racer*), and *JJ: Tobidase Daisakusen Part II* (1987). Some of these soundtracks are stylistically dissimilar to *FF*, while others contain musical features that appear frequently in Uematsu's later work.

Some of Uematsu's action game soundtracks followed the conventions of their respective genres, having relatively little to do with his early work on RPGs. For instance, *Hao-kun no Fushigi na Tabi*, a fantasy-themed platformer, along with both *Tobidase Daisakusen* and *JJ*, 3D shooter-platformer hybrids, adopt characteristics typical of platformers in their main level music, invincibility themes, and death cues. As with titles like *Super Mario Bros.* (Nintendo 1985) and *Takahashi Meijin no Bōken Jima* (Hudson 1986—released in the United States as *Adventure Island*), the main level themes of *Tobidase* and *JJ* are brisk, upbeat, major-mode tunes in simple duple or quadruple meter. The invincibility theme in both games features the typical increase in tempo and/or rhythmic energy above that of the level music; the invincibility music from *JJ* also consists entirely of what Philip Tagg refers to as a *shuttle*—an oscillation between two chords (Tagg 2014: 16)[19]— that makes a striking comparison to the analogous theme in *Super Mario Bros.* (see Example 7.1). The death themes of *Tobidase* both contain a falling gesture, a typical way of mimicking a protagonist's off-screen descent upon losing a life, while *Hao-Kun* adopts the practice of quoting a cadential figure from the main level music, as seen in *Super Mario Bros.* and *Takahashi Meijin no Bōken Jima*.[20]

The "game over" themes of *Tobidase* and *JJ* make a particularly strong contrast to the analogous themes in the *FF* series. As Andrew Schartmann notes in his discussion of the *Super Mario Bros.* soundtrack, Koji Kondo intended for his death and "game over" tunes to encourage players to try again rather than convey a sense

EXAMPLE 7.1: The invincibility themes of *JJ* (by Nobuo Uematsu, top) and *Super Mario Bros.* (by Koji Kondo, bottom), which both contained a heightened sense of energy and repeating two-chord shuttle. (The two chords in *JJ* repeat in the second half of the loop.)

of "You're done for!" (Schartmann 2015: 98). *Tobidase* and *JJ* convey a similar light-heartedness in their game over music—perhaps too much so, as those tracks are almost indistinguishable in affect from the level victory music when taken out of their original gameplay context. In the *FF* series, on the other hand, death is a much weightier affair; the heroes' failure to save the world is accompanied by a slow lament (see Example 7.2). Uematsu had used similarly elegiac game over music in *Cleopatra no Mahō*—a rare instance of common ground with Uematsu's later RPG soundtracks.

Independent of the conventions of particular game genres, several of Uematsu's action game scores contain blues-inspired tracks: the ending to *Highway Star* uses

EXAMPLE 7.2: The starkly contrasting "game over" themes of *Tobidase Daisakusen* (top) and *Final Fantasy II* (bottom), reflecting the stylistic characteristics of their respective game genres.

a standard twelve-bar blues progression, while the bonus stages in *JJ* use a truncated variant. The ending music of *Tobidase*, as well as the "game over" and level ending music of *JJ*, also incorporates stylistic elements of blues. Uematsu had also used blues-style music in the simulation title *Apple Town Story* (1987), an adaptation of Activision's *Little Computer People* (1985); the game involved issuing requests to a little girl in a three-story house, who would sometimes play classical or blues music at the piano. Although blues music is almost completely absent from the early *FF* titles, the party leader in *FFIII* can play a blues-inspired piece ("Swift Twist") at the piano in the pub at Amur.

While some of Uematsu's action game soundtracks are quite different from his later work, there are two titles—*King's Knight* and *Aliens: Alien 2*—which contain important precedents to musical elements found in *FF*. Some of these elements were taken directly from previous action titles, while others represented an evolution of those musical techniques.

Heroic fanfares in King's Knight

King's Knight was Square's first fantasy-themed game and the first such title Uematsu would score, although it bears little resemblance to *FF* in terms of gameplay. It instead follows the basic template of vertically scrolling shooters like *Xevious* (Namco, 1982) and *1942* (Capcom, 1984), with the player controlling a humanoid character on the ground rather than an aircraft or spaceship; in this sense, it more closely resembles Sega's obscure arcade title *Mister Viking* (1984) or Konami's *Knightmare* (1986) for MSX home computers. In each stage the player controls one of four characters—a knight, a wizard, a monster, or a thief—blasting through terrain to acquire the power-ups necessary to finish the final stage, in which the player controls all four characters at once.

When the player successfully completes one of the first four stages, they are greeted with a victory theme in compound meter featuring chordal arpeggiations; a similar theme appears before the final stage (where the player is instructed to "Find the Princess!"), which reprises after successful defeat of the final boss (Example 7.3a). The stage-clear music of *Tower of Druaga* (Namco, 1984), another fantasy-themed action game, contains the same features and ends with an Aeolian progression (bVI-bVII-I) over a tonic pedal (Example 7.3b). The inclusion of at least two of these three features—chordal arpeggiations, compound meter (or prominent triplet rhythms), and a concluding Aeolian progression (or variant thereof)—was a common compositional strategy for end-of-level victory themes (and to a lesser extent, pre-level music) in video game music of the 1980s.

190

EXAMPLE 7.3: The pre-/post-level music for the final stage of *King's Knight* (top) and the "level clear" music from Junko Ozawa's soundtrack to *Tower of Druaga* (bottom), which both contain musical features associated with heroic fanfares.

This variety of pre- or post-level "heroic fanfare" was not limited to fantasy-themed titles, as the end-of-level music for *Super Mario Bros.* demonstrates.[21] The potential of this idea to cross boundaries of genre and theming made it easy for Uematsu to import it into the *FF* soundtrack; the best-known instance of this is from the game's iconic post-battle victory music that appears in most of the series' mainline entries.[22] Similar techniques also appear during other important moments, such as the acquisition of key items or additional companions.

"Now with Dungeons": The underworld aesthetic of King's Knight Special

In 1987, Square released an adaptation of *King's Knight* for the PC-8801mkII SR and Sharp X1 called *King's Knight Special*. This version added a total of twelve dungeons interspersed throughout the first four stages (three per stage),

which adopted a top-down perspective similar to the action RPG *Hydlide*.[23] The twelve new themes that Uematsu wrote for these areas have what may arguably be the strongest connection to his early *FF* music, as they define the template on which many of the *FF* dungeon themes were based.[24] Most of the twelve dungeon themes suggest a minor tonality (occasionally the harmonies are too dissonant or ambiguous to clearly establish a key) and feature static or repetitive harmonies; most of them feature exact repetition of one or more formal sections, and half of them also employ two-chord shuttles at various hierarchical levels relative to the main loop.

To differentiate between shuttles at different hierarchical levels, I draw upon Andrew Schartmann's taxonomy of loops and modules in Famicom/NES music (Schartmann 2018), which in turn builds upon and refines Karen Collins's taxonomy of loop hierarchy (Collins 2007). Schartmann defines four levels of hierarchy for loops (exact repetitions of material in one or more voices)[25] in Famicom/NES music. The macroloop operates at the highest level of structure, referring to "the longest repeating section of a piece that is also substantial in length relative to the piece as a whole"[26] (Schartmann 2018: 117). A mesoloop occurs when a large section of the form, or module,[27] repeats. A microloop is "any substantial repeated passage (typically two or more measures in length) within a module," while a nanoloop is a repetition on a smaller scale, such as a short ostinato pattern in a single voice (Schartmann 2018: 117–19). Figure 7.1 summarizes Schartmann's taxonomy within a single hypothetical music track (although in practice it is uncommon for all four levels of loop to actually appear in the same track). This taxonomy may be also applied to harmonic shuttles operating at any of these levels of form. Therefore, I define a macroshuttle as a repeated two-chord pattern that lasts the entire length of a macroloop. A single iteration of a mesoshuttle lasts the length of a module, while an iteration of a microshuttle lasts the length of a substantial subsection of a module (i.e., at least two measures); a nanoshuttle occurs at a still smaller level.[28]

Shuttles below the level of the macroloop most often appear within the first module, although they may appear elsewhere. In most shuttles, the two chords last for the same duration; this is not always the case, however, as demonstrated by the music for Kahn Cave (Example 7.4). The macroloop contains two modules with an "ab" segmentation, the second of which is a slightly modified transposition of the first. The first module is repeated, but the second is not; as a result, the second chord lasts half as long as the first, so the chord changes in this track form an *asymmetrical macroshuttle*.

Exact repetition of modules, as well as repetitions within modules, occur frequently in the dungeon music for *King's Knight Special*—more often than in most of the music Uematsu had written up to this point. Nine of the twelve dungeon

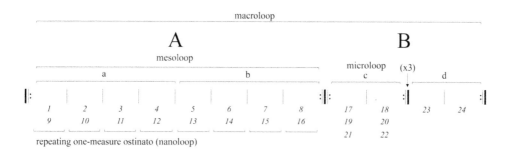

FIGURE 7.1: Summary of Andrew Schartmann's taxonomy of loop hierarchy. Measure numbers are calculated separately upon repeat (so, e.g., the second iteration of mm. 1–8 is renumbered as mm. 9–16).

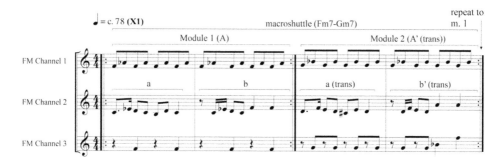

EXAMPLE 7.4: Nobuo Uematsu, *King's Knight Special*, music for "Kahn Cave."

themes contain exact repetitions of modules or portions of modules; a subset of these contains exact repetitions of every module. In some cases, short repeated ideas may be nested within a larger repeated section, as in the music for Rin Castle.[29]

A basic summary of the form for each of the twelve dungeon themes, with prominent shuttles and chord loops marked, is provided in Table 7.2.[30] All of these themes feature some degree of harmonic stasis, shuttling, or exact repetition, with only two exceptions. The first is the music from Val Labyrinth, which is very obviously derived from Edvard Grieg's "In the Hall of the Mountain King" from the incidental music to *Peer Gynt*. Grieg's material has been reworked to form a parallel period—the only dungeon theme to contain this type of phrase structure—followed by a short turnaround. The other exception is the music from Beth Tower, which consists of a pair of phrases ending with clear half cadences.[31] This theme has more harmonic direction and variety than any of the other dungeon themes; it is also remarkable for being the only major-mode dungeon theme in the entire

TABLE 7.2: A formal summary of each dungeon theme in *King's Knight Special*. Capital letters represent modules; lowercase letters represent smaller thematic units. Reused letters reflect returning melodic material; "(trans)" shows a repeat of earlier material at a different level of transposition (exact or near-exact), while an apostrophe ("prime" marking) reflects some other alteration. Measure numbers assume all examples to be in 4/4 according to the metronome marking given.

Area/BPM	Form			Shuttles/chord loops
Rin Castle	A	B	C	Mesoshuttle (A—2 mm./chord)
156 BPM (X1)	‖: a a a (trans) a (trans):‖: b b':‖ c c' d:‖			Nanoshuttle (B—1 beat/
124 BPM (PC-88)	1-4	9-10	13-16	chord; breaks off before end
	5-8	11-12		of module)
Kahn Cave	A	A' (trans)		Macroshuttle (asymmetrical,
78 BPM (X1)	‖: a b:‖ a (trans) b' (trans):‖			between A and A')
	1-2	5-6		
	3-4			
Beth Tower	HC	HC		N/A
156 BPM (X1)	A	B		
	‖ a a' ‖ b b':‖			
	1-8	9-16		
Town of Shirnas	A	B		Four-chord harmonic
156 BPM (X1)	‖ a a' a a" ‖ b ‖: c c':‖			nanoloop (A–2 beats/chord)*
124 BPM (PC-88)	1-8	9-10 11-12		
		13-14		
Val Labyrinth	HC	PAC		N/A
156 BPM (X1)	A	A'		
	‖ a a' ‖ a a":‖			
	1-4	5-8		
Tyron Palace	A B A' B			N/A
156 BPM (X1)	‖: a:‖: b:‖: a':‖: b:‖			
	1 3-4 7 9-10			
	2 5-6 8 11-12			

Area/BPM	Form			Shuttles/chord loops
Boltax Forest 156 BPM (X1)	A ‖: a a':‖: b b':‖: b (trans) b' (trans):‖ 1-2 3-4	B 5-8 9-12	B (trans) 13-16 17-20	Macroshuttle (asymmetrical, between A+B and B') four-chord loop (all sections—two measures per iteration)
Zak Valley 78 BPM (X1)	A ‖: a a':‖: a (trans) a' (trans):‖ 1-2 3-4	A' 5-6 7-8		Macroshuttle (between A and A')
Ghoul Lake 156 BPM (X1) 156 BPM (PC-88)	Intro ‖: (ostinato alone):‖: a a':‖: b b':‖ 1-2 3-4	A 5-6 7-8	B 9-16	Two-measure ostinato repeats for the entire track
Ghost Ship Jibuji 78 BPM (X1)	A ‖: a a':‖: b:‖ 1-4 5-8	B 9-10 11-12		Microshuttle (A–1 m./chord)
El Island 156 BPM (X1)	PAC A ‖ a a' a b ‖ c c' c b' ‖ a a' a b:‖ 1-8	IAC B 9-16	PAC A' 17-24	Nanoshuttle (A and A'–1 m./chord; breaks off before end of module)
Nest of Belforn 156 BPM (X1)	A ‖: a a':‖: a (trans) a' (trans):‖ a a' a b:‖ 1-4 5-8	A (trans) 9-12 13-16	A' 17-24	harmonic macroloop (Gm, Cm, Gm)—one chord per large formal section

game. These differences stem from the fact that the Beth Tower music is essentially a reworking of the original overworld music from *King's Knight*, which bears an entirely different set of characteristics from the music written for dungeons.

Many of Uematsu's dungeon themes for the early *FF* entries contain similar features to those found in *King's Knight Special*. The music for the Flying Fortress from the first game, for instance, opens with a nanoshuttle and features exact repetition of each of its two modules (Example 7.5).[32] Themes for other gameplay contexts, on the other hand, tend to contain less repetition and adopt different

formal strategies; for instance, several of Uematsu's town themes, such as the one from *FFII*, open with a parallel period—an option that, aside from the aforementioned Val Labyrinth example, he almost never employed in dungeon music.[33]

Not all of Uematsu's dungeon themes adopt the strategies favored in *King's Knight Special*, however; the music for the "Temple of Chaos" from the original *FF*, for example, employs a sentential structure in which the end of the basic idea is altered upon repeat.

On the whole, *FF* dungeon themes do not employ exact repetition of their modules quite as often as in *King's Knight Special* and tend to be more harmonically and melodically varied. Relatively speaking, though, the majority of *FF* dungeon themes contain a higher degree of repetition than the themes for towns, overworld exploration, and so on.

Aliens: Alien 2 and other boss encounters

Aliens: Alien 2, a side-scrolling platformer loosely based on the movie of the same name, features several tracks that share many features in common with the dungeon music for *King's Knight Special*, and in turn with the dungeon themes from *FF*. The background music for the second, third, and fourth stages, which take place in an abandoned complex, feature minor-mode or dissonant/ambiguous harmonies and frequently employ exact repetition of modules. Shuttles and internal repetition are also common—the music for stage 2, for instance, features a mesoshuttle in its opening module and near-exact repetition of two-measure segments in the second module.[34] The boss music at the end of each stage contains many of these same features.

For action games other than *Aliens: Alien 2*, Uematsu tended to employ this combination of techniques during boss encounters or in areas containing them. The underground and stage 5 themes from the original *King's Knight*—the former of which also underscores mini boss fights, and the latter of which also underscores the battle against the final boss—contain a significant amount of internal repetition and shuttling;[35] the same holds true of the opening module of the boss music from *JJ*. Such repetition-heavy tracks were commonplace in contemporaneous boss music, and given the similarities between these themes, it is plausible to conclude that Uematsu's early style of dungeon music has its origins in the boss music of early action titles. As Uematsu would continue to write dungeon music for *FF*, he would modify his strategy, often taking a slower tempo and tending toward longer loops, although he continued to employ many of the techniques first seen in *King's Knight Special*.

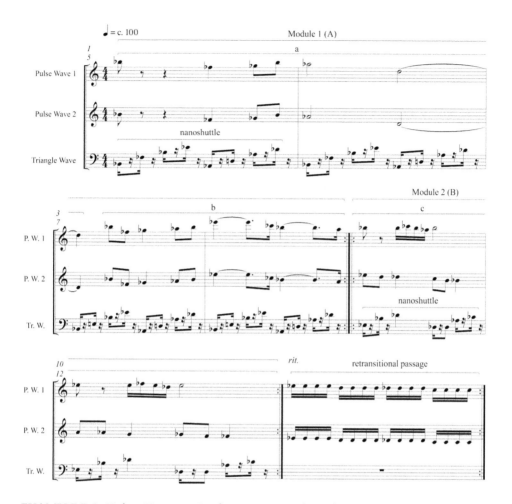

EXAMPLE 7.5: Nobuo Uematsu, *Final Fantasy*, music for "Flying Fortress," which contains a degree of internal repetition comparable to the dungeon themes of *King's Knight Special*. The two-sonority nanoloops in the triangle wave can be seen as akin to the shuttles of previous examples, even though the pulse waves do not participate in the harmonies the triangle wave outlines.

Emotional underscoring in the graphical adventure game

The first video games Square released were graphical adventures—titles in which players interacted with the world by typing or selecting commands and watching the game's narrative play out through still images. Prior to *FF*, Square released five such titles: *The Death Trap* (1984), *Will: The Death Trap II* (1985), *Alpha* (1986), *Suishō no Dragon* (1986), and *Nakayama Miho no Tokimeki High School* (1987).

The first two of these precede Uematsu's tenure at the company, while Uematsu scored the music for the other three.

Square's first three graphical adventures were released at a time when music was far less common in Japanese computer games. *The Death Trap*, which pre-dates the appearance of advanced sound hardware on those platforms, contains no music at all, while *Will: The Death Trap II* used a single musical track for the title and ending screens.[36] Uematsu's soundtrack for *Alpha*, written around the same time as the music for *Blassty*, also consists of a lone track for the title and ending sequences, with only sound effects occurring during gameplay.

Uematsu's soundtrack for *Suishō no Dragon*, a Famicom Disk System title, is also quite brief, consisting of only two tracks—one for the title screen, and one for the ending. While the title music has little in common with *FF*, the ending music, which plays when the protagonist is reunited with his friend Cynthia, resembles a couple of tracks in *FFIII* that underscore emotional moments. The opening portion of the track begins with a lonely melody in a mid-to-high register, floating above chordal arpeggiations in eighth notes. The same texture appears in *FFIII* when the player leaves the floating continent on which they start and discovers the desolate, flooded world below and when they discover a shipwreck and its two survivors.[37]

Although the specific emotional import of these tracks differs, they reflect an aesthetic that separated *FF* from other Famicom games at the time. Chris Kohler notes that Hironobu Sakaguchi, who pitched the original idea for *FF*, wanted to move away from the cute, colorful nature of most Famicom games in favor of a "serious, adult, *sabishii* (lonely)" style, and that Sakaguchi had specifically asked Uematsu to make the soundtrack contrast with that of *Dragon Quest* (Kohler 2016: 87–88). That being said, the ending of *Suishō no Dragon* demonstrates that emotional underscoring was not new to Uematsu when he began work on *FF*.

Some of the strongest comparisons to Uematsu's *FF* soundtracks come from *Nakayama Miho no Tokimeki High School* (1987). Released a few weeks before *FF*, it was Square's first direct collaboration with Nintendo and a forerunner to the "dating sim" subgenre of adventure games. The game features Miho Nakayama, a teenage Japanese pop idol, who has concealed her identity and transferred to the protagonist's high school. By performing the correct actions, the protagonist can become friends with Miho and will eventually have the opportunity to date her.

At certain points in the story, Uematsu uses diminished sonorities to underscore moments of dramatic tension, oscillating between two related musical ideas in a short loop. One such event first occurs during the scene where the player discovers Miho's true identity from a photograph that the player's brother took; another plays when the player shows the photo to Miho, causing her to become upset

with the player. Similar music occurs in several scenes of *FFII* and *III* as well—for instance, during a scene in *FFIII* where the player's party is trapped in the nest of the dragon Bahamut and scrambles for a place to hide before he returns.[38]

There are also several tracks in *Tokimeki High School* that share common musical features with the stylistic types Uematsu used for particular gameplay contexts (town, dungeon, etc.) in *FF*. Toward the middle of the game, the protagonist has a conversation with Miho after being stood up by her and attempts to clear up a misunderstanding about a situation with another girl; the music that accompanies this scene (Example 7.6) is very similar in affect and texture to Uematsu's game over music for the *FF* series, most notably from the second game (compare with Example 7.2b). The music that plays during the final date with Miho in the café, with its arpeggiated accompaniment and slow tempo, resembles many of Uematsu's town themes; the music for the village of Ur in *FFIII* is especially similar in its harmonic and melodic profile.[39] The looping portion of the music for the "good ending," in which Miho escapes on a motorcycle away from a frenzied mob, uses accompanimental figures similar to Uematsu's peppier exploration themes, such as the overworld and ship travel music from the original *FF*.[40]

Given that *Tokimeki High School* and the original *FF* were released around the same time, it is not certain which tracks were composed first, or whether the two soundtracks were written in tandem. In an interview with Satoru Iwata, former president of Nintendo, Hironobu Sakaguchi, mentions that a contingent from Square went to Nintendo's headquarters in Kyoto *after FF* was completed to finish work on *Tokimeki High School* (Sakaguchi and Sakamoto 2010). However, since Uematsu was not responsible for programing the music—that was the responsibility of Toshiaki Imai[41]—Uematsu may have finished the *Tokimeki High School* music earlier. Whatever the case, some of the features discussed

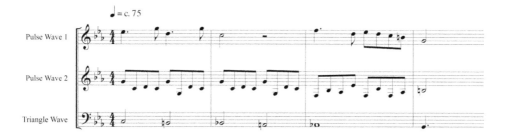

EXAMPLE 7.6: Nobuo Uematsu, *Nakayama Miho no Tokimeki High School*, the music during the apology scene with Miho (0:00–0:11). The slow tempo, minor mode, and texture strongly resemble Uematsu's "game over" music for *FFII* (see Example 7.2).

above did not first appear in *FF* until its sequel, so it is likely that at least some of the musical ideas first seen in *Tokimeki High School* informed Uematsu's later work.

Conclusion

Nobuo Uematsu's earliest game soundtracks, while relatively little known today, were an important step in the development of his compositional style. While his early RPG soundtracks do not have much in common with *FF*, given how different those games were in structure and theming, his soundtracks for action titles contained musical elements that were flexible enough to cross genre boundaries, such as his fanfares for pre- and post-level music from *King's Knight*. The harmonically static, repetition-heavy dungeon music for *King's Knight Special* anticipated his use of similar compositional strategies in the early *FF* entries, and their use in the level and boss music from *Aliens: Alien 2* arguably forms a stylistic link between his early dungeon themes and the boss music of early action titles. Uematsu's work in the graphical adventure genre contains a number of parallels to his early *FF* soundtracks—the aspects of a *sabishii* ("lonely") style in *Suishō no Dragon*, the use of diminished sonorities for dramatic tension in *Tokimeki High School*, and so on—and while some of the tracks from *Tokimeki High School* might have been written after the music from the original *FF*, they contain some stylistic elements that would not resurface until *FF*'s sequels.

In the wake of *FF*'s success, Square shifted its focus as a developer and soon become known as one of the foremost producers of Japanese RPGs. Uematsu's compositional output changed accordingly; he began writing longer soundtracks (and fewer of them), and with only a handful of exceptions, he composed exclusively for RPGs. Some aspects of his early style began to fall away, although his focus on a single genre did not mark a complete break from his early works. A survey of Uematsu's early compositional output shows that while Square's RPG classic was not his "final fantasy," neither was it his first; his earliest soundtracks would lay the groundwork for the music his fans have come to know and love.

NOTES

1. Dates for Famicom cartridge releases are taken from *Family Computer Magazine* (1991); dates for Famicom Disk System releases are taken from *Family Computer Magazine* (1989). Remaining release dates are taken from Video Game Music Preservation Foundation (2019). All dates are for the first platform listed; conversions for other platforms listed were often released later.

2. Throughout this chapter, Japanese words in video game titles are rendered in the modified Hepburn romanization system. Japanese loanwords from English, however, retain their English spellings (so *Final Fantasy*, e.g., would not be rendered *Finaru Fantajī*).

3. Claims to Imai's role as a co-composer seem to trace to a screen in the game that displays the names of several programmers who worked on the game, which includes the listing "MUSIC T. IMAI." However, it is possible that, as with Square's other early Famicom titles, Imai only served as sound programmer and did not write any of the music himself; in fact, a string of text in the game's ROM specifically credits him as such: "SOUND&ANIM PROG BY IMAI TOSHIAKI" (Video Game Music Preservation Foundation 2015).

4. The "sentai" genre of Japanese television shows involves a team of transforming superheroes, usually differentiated from one another by the color of their outfit, who work together to fight evil. Western audiences are most likely to be familiar with this genre through franchises such as *Voltron* and *Mighty Morphin Power Rangers*, which repurposed content from existing Japanese television shows for western consumption.

5. See Supp 7.1. Many thanks to my friend Chaz Holley for pointing out this similarity.

6. The association of the church pipe organ with antagonists has precedent in horror films as early as the 1930s; for a more detailed discussion, see Plank (2019a).

7. In addition to the church organ timbres associated with Golbez and Kefka, Uematsu also uses a Hammond organ-style timbre in a portion of the final section of "Dancing Mad" and the opening of the battle with Gilgamesh in *FFV* ("Battle at the Big Bridge"). Given the presence of bass guitar and drum set, these sections obviously carry a stronger association with progressive rock than with western sacred music.

8. For a more detailed discussion of exoticism in *Cleopatra no Mahō*, see Plank (2019b). Plank renders the name of the game as *Cleopatra no Ma Takara*; the discrepancy arises from two possible readings of the final character of the Japanese title. The Japanese-language resources that I have consulted provide the pronunciation *Mahō*, which I have adopted here.

9. See Supp. 7.2.

10. See Supp. 7.3.

11. See Supp. 7.4. The irregular metric groupings in the second half of the *Genesis* battle theme are uncharacteristic of most of Uematsu's battle themes for the *FF* series, although the 3+3+3+3+2+2 grouping structures in the first half do resurface in his later work. For a more detailed discussion of Uematsu's use of this rhythmic grouping in battle music, see Ross Mitchell's chapter in this collection.

12. As with many early video games, the usage of Western classical compositions in *Dragon Slayer* and *Hydlide* was probably driven by practical concerns (allowing the developers to implement music quickly in the absence of a dedicated composer) rather than for any extramusical significance. For more on this practice, see William Gibbons's discussion of *Captain Comic* in Gibbons (2009).

13. A second scenario to *Xanadu* was released the following year; it featured a substantially longer soundtrack by Yuzo Koshiro and Takahito Abe.

14. See Supp. 7.5.

15. It is possible to render this example in 4/4 time with the final sixteenth note acting as a reiteration of the original pickup; doing so, however, would obscure the metric divisions suggested by the three-note groupings beginning in m. 4.

16. See Supp. 7.6.

17. See Supp. 7.7.

18. William Gibbons identifies four additional contexts for musical cues in a typical Japanese RPG: castles, the final boss fight, title/opening cutscene music, and endgame (victory/credits) music. For a more detailed discussion, see Gibbons (2017).

19. Tagg refers to a repeated pattern of more than two chords (usually three or four) as a chord loop (2014: 16). This is not to be confused with Andrew Schartmann's use of "loop" (discussed later in this chapter), which refers to exact repetitions of material in at least one voice (but usually in all voices). I will generally use "loop" in Schartmann's sense, although in the handful of instances where I invoke Tagg's definition, I use the phrase chord loop to differentiate it from Schartmann's use.

20. See Supp. 7.8.

21. See Supp. 7.9. For additional examples of similar pre- and post-level fanfares in non-fantasy action titles; see: *Xevious*, pre-level music; *Star Jacker* (Sega 1983), pre-level music; *Exed Exes* (Capcom 1985), post-level music; *Twinbee* (Konami 1986), pre-level music; *Yume Kōjō: Doki Doki Panic* (Nintendo 1987), stinger from grabbing a crystal ball; and *Takahashi Meijin no Bōken Jima*, world clear theme.

22. See Supp. 7.10.

23. Since *King's Knight Special* has never received an official English translation, all translations of dungeon names in the following section are my own.

24. Nine of these themes appear to be exclusive to the Sharp X1 version of *King's Knight Special*; the PC-8801mkII SR version only includes three of them during gameplay, reusing themes for multiple dungeons. The Sharp X1 version also features additional music over a logo screen that is absent from the PC-8801mkII SR version.

25. Schartmann usually uses "loop" to refer to exact repetitions of all voices in a passage, although his example of a nanoloop applies to a single voice only. See Schartmann (2018: 116–20).

26. Schartmann adds the latter criterion to account for instances where most of the track is nonlooping, with only the final module being looped. He cites the title screen music of Hirokazu Tanaka's soundtrack to *Metroid* (Nintendo 1987) as an example.

27. I depart slightly from Schartmann in that I do not require the normative module to last eight measures. Schartmann's default assumption of an eight-measure module works well for the music he is analyzing, most of which comes from the mid-to-late years of the Famicom's lifespan (1987–92); and in cases where an apparent module is shorter, his theory allows for the presence of *reduced modules* that do not adhere to eight-measure norms. However, for the shorter tracks present in earlier games (and even in some titles from 1987), the largest

formal divisions for a track might be at the four-measure level (or, rarely, at lower levels) and may not cleanly follow Schartmann's taxonomy of reduced modules. Also, the question of how and when to determine measure boundaries in transcribing video game music poses problems for a theory that relies on numbering measures—an issue that Schartmann does not address in detail. For a solution to this issue in popular music, see DeClercq (2016). Because of this, I determine my labels from the highest clear segmentation boundaries in situations where eight-measure divisions might not prove meaningful; in the case of the dungeon themes from *King's Knight Special*, the highest level of repetition structure below the macroloop informs my module boundaries. This means that my four-measure mesoloops would qualify as microloops in Schartmann's taxonomy; otherwise, my usage of these terms aligns with Schartmann's.

28. A shuttle at a particular level will often appear within its corresponding loop type; by definition, this is always true of macroshuttles (since a two-chord progression spanning the entire macroloop will inevitably repeat) and almost always true of mesoshuttles (since a two-chord progression spanning the length of a nonrepeating module is no longer a shuttle unless the following module contains the exact same progression). However, this is not necessarily the case for microshuttles or nanoshuttles, where a two-chord pattern may accompany blocks of material that are similar (but not exactly repeated). For instances of this phenomenon, see Supp. 17j and Supp. 17k.

29. See Supp. 7.11. If one accounts for the common-tone-diminished seventh chords on the third beat of each measure, one could also argue for an additional layer of shuttling nested within the chord of the marked mesoshuttle (following the motivic brackets on the second staff).

30. For more detailed formal diagrams of the twelve dungeon themes, see Supp. 7.12.

31. See Supp. 7.13.

32. One could make a case for hearing a macroshuttle between the two main modules here, although the presence of the retransitional measure at the end of the loop potentially undermines this reading. Also, while shuttles are purely a harmonic phenomenon, the contrast in melodic material between the two sections leads me to hear the two modules as separate sections with contrasting pitch centers rather than as part of a large-scale oscillation.

33. There are numerous examples of parallel periods in the opening modules of Japanese RPGs from the 1980s and 1990s. Examples from Uematsu's output include the town themes for Amur and the Village of the Ancients from *FFIII* and the town theme for the World of Balance ("Kids Run through the City") from *FFVI*.

34. See Supp. 7.14. If the second module repeated, it would contain another mesoshuttle between two subsets of a whole-tone collection; however, a two-chord pattern must repeat to qualify as a shuttle according to Tagg's definition. That being said, the two halves of the second module still express the motivic parallelism typical of shuttles at higher levels of structure in video game music.

35. See Supp. 7.15.

36. The lone track for *Will: The Death Trap II*, whose composer is not credited in-game, seems to be the only piece of music written for a Square title prior to Uematsu joining the company.
37. See Supp. 7.16.
38. See Supp. 7.17.
39. See Supp. 7.18.
40. See Supp. 7.19.
41. Based on an examination of the source code of Square's Famicom output, the Game Developer Research Institute credits Toshiaki Imai as the programmer of the sound driver used in every Square title up to *FF*; Hiroshi Nakamura is credited for the sound driver in the company's latter-day Famicom/NES titles (Game Developer Research Institute 2019).

REFERENCES

4Gamer.net (2014), "Project EGG de 'Cruise Chaser Blassty (PC-8801)' ga Haishin Kaishi," May 2, https://www.4gamer.net/games/008/G000896/20140502092/. Accessed July 11, 2020.

Altice, Nathan (2015), *I Am Error: The Nintendo Family Computer/Entertainment System Platform*, Cambridge: MIT Press.

Caplin, William (2013), *Analyzing Classical Form: An Approach for the Classroom*, New York: Oxford University Press.

Collins, Karen (2007), "In the Loop: Creativity and Constraint in 8-Bit Video Game Audio," *Twentieth-Century Music*, 4:2, pp. 209–27.

DeClercq, Trevor (2016), "Measuring a Measure: Absolute Time as a Factor for Determining Bar Lengths and Meter in Pop/Rock Music," *Music Theory Online*, 22:3, https://mtosmt.org/issues/mto.16.22.3/mto.16.22.3.declercq.html. Accessed July 11, 2020.

Family Computer Magazine (1989), Special Issue: "Disk Writer Kakikae Game Zen Catalogue," 5:12.

Family Computer Magazine (1991), Special Issue: "5 Gatsu 10 Ka Tokubetsu Famicom Rom Cassette All Catalogue," 7:9.

Fujii, Daiji (2005), "The Birth of 'Final Fantasy': Square Corporation," *Okayama Economic Review*, 37:1, http://eprints.lib.okayama-u.ac.jp/files/public/4/40488/20160528032115939560/oer_037_1_063_088.pdf. Accessed July 11, 2020.

Game Developer Research Institute (2019), "Famicom/NES Sound Driver List," April 27, http://gdri.smspower.org/wiki/index.php/Famicom/NES_Sound_Driver_List. Accessed July 11, 2020.

Gibbons, William (2009), "Blip, Bloop, Bach? Some Uses of Classical Music on the Nintendo Entertainment System," *Music and the Moving Image*, 2:1, pp. 40–52.

Gibbons, William (2017), "Music, Genre, and Nationality in the Postmillennial Fantasy Role-Playing Game," in M. Mera, R. Sadoff, and B. Winters (eds.), *The Routledge Companion to Screen Music and Sound*, New York: Routledge, pp. 412–27.

Gut, Serge (2000), "L'Échelle à double seconde augmentée: Origines et utilisation dans la musique occidentale," *Musurgia*, 7:2, pp. 41–60.

Kohler, Chris (2016), *Power-Up: How Japanese Video Games Gave the World an Extra Life*, Mineola: Dover Publications.

Mielke, James (2008), "A Day in the Life of Nobuo Uematsu," 1UP, February 15, https://web.archive.org/web/20130207080524/http://www.1up.com/features/final-fantasy-composer. Accessed July 11, 2020.

Plank, Dana (2019a), "From the Concert Hall to the Console: Three 8-Bit Translations of the Toccata and Fugue in D Minor," *Bach*, 50:1, pp. 32–62.

Plank, Dana (2019b), "The Penultimate Fantasy: Nobuo Uematsu's Score for *Cleopatra no Ma Takara*," in W. Gibbons and S. Reale (eds.), *Music in the Role-Playing Game: Heroes and Harmonies*, New York: Routledge, pp. 76–96.

Sakaguchi, Hironobu and Sakamoto, Yoshio (2010), interviewed by Satoru Iwata and Iwata Asks, https://www.nintendo.co.uk/Iwata-Asks/Iwata-Asks-Metroid-Other-M/Iwata-Asks-Yoshio-Sakamoto-Hironobu-Sakaguchi/1-A-23-year-old-Connection/1-A-23-year-old-Connection-218000.html. Accessed July 11, 2020.

Schartmann, Andrew (2015), *Koji Kondo's Super Mario Bros. Soundtrack*, New York: Bloomsbury Academic.

Schartmann, Andrew (2018), "Music of the Nintendo Entertainment System: Technique, Form, and Style," PhD dissertation, New Haven, CT: Yale University.

Tagg, Philip (2014), *Everyday Tonality II: Towards a Tonal Theory of What Most People Hear*, New York: Mass Media Scholars Press.

Video Game Music Preservation Foundation (2015), "Nakayama Miho no Tokimeki High School," October 25, http://www.vgmpf.com/Wiki/index.php?title=File:Idol_Hotline_-_Nakayama_Miho_no_Tokimeki_High_School_-_FDS_-_Credits.png. Accessed July 11, 2020.

Video Game Music Preservation Foundation (2019), "Nobuo Uematsu," July 16, http://www.vgmpf.com/Wiki/index.php/Nobuo%20Uematsu. Accessed July 11, 2020.

Wikipedia (2019), "PC-8800 Series," July 16, https://en.wikipedia.org/wiki/PC-8800_series. Accessed July 11, 2020.

8

Music and Narrative Experience in *Final Fantasy XIV: A Realm Reborn*

Stephen Tatlow

Final Fantasy XIV: *Before* A Realm Reborn

Any discussion of *Final Fantasy (FF) XIV* must begin with the story of a creative failure. Originally released in 2010, the game at this time was met with highly critical reviews from fans, critics, and players. In a "post-mortem" of the game at the *2014 Game Developers Conference*, game designer Naoki Yoshida offered three central reasons for the negative reception: (1) a lack of experience in the design of massively multiplayer online role-playing games (MMORPGs) among the developers, (2) an "unhealthy obsession" with graphical quality, and (3) an unrealistic approach to addressing issues in the core design philosophy of the team (Yoshida 2014).

Role-playing games (RPGs) and MMORPGs have many superficial similarities. Both utilize character progression (e.g., characters gaining levels or accessing more powerful items throughout the game) as a core gameplay mechanic. As such, both typically offer branched, nonlinear narratives that focus on character development. RPG players expect increasingly large and detailed worlds to explore, and these are often a cornerstone of MMORPGs. Other game mechanics such as inventory management, character abilities, and quests are also shared. However, MMORPGs differ from traditional RPGs, such as earlier installments in the *FF* franchise, in several important ways.

First, MMORPGs are designed to be played socially: players form communities to share tips and tricks, to trade items, and to better facilitate collective play. Developers are expected to provide challenges for these communities: areas of the game accessible only when working with others, or that pose a challenge only surmountable by a "party" of characters with different specialties. While "parties" of characters are used within traditional RPGs, MMORPGs place the additional

challenge of cooperation on the shoulders of players, given that designers expect that each member of the party is another human being.

Second, MMORPGs exist within a persistent, shared world. In most traditional RPGs, the game enters stasis when players step away because the player has either closed or paused the game. Players cannot force an MMORPG to enter stasis: the world continues irrespective of whether or not they are connected ("logged in"). Other players are free to develop their character and progress their own individual stories without the input of any specific player. While traditional RPGs can easily make the player into "the" hero, MMORPGs place tens of thousands of players into a single shared world, participating within the same epic tale. This creates an immediate conflict: tens of thousands of players cannot be simultaneously "the" hero. Instead, players of MMORPGs are simply "a" hero among a cast of tens of thousands.

It is not clear exactly why *FFXIV* was unsuccessful, but it is likely that these differences between RPGs and MMORPGs were the cause of some of the creative difficulties hinted at by Yoshida in 2014 that led to broader difficulties with the reception of the game. It is particularly notable that *FFXIV* was one of the first *FF* games to include large-scale multiplayer elements: some multiplayer elements to the *FF* franchise were introduced in *FFII* (1988) where the game was programed to allow a second player to control some characters within the party during combat. Some initial exploration of large-scale multiplayer games can be found in the same team's work on *FFXI* (also known as *Final Fantasy Online*) in 2000.

However, this work may not have provided much relevant experience. While *FFXI* was released as an MMORPG, the historic conceptualization of the genre during the development of *FFXI* was very different to the design of modern MMORPGs during the development of *FFXIV*. For example, contrary to the design goal of a genre-defining virtual shared world, the technical limitations of the PlayStation 2 console required low hard-coded limits on concurrent player counts to be introduced to *FFXI* to ensure that players retained adequate levels of hardware performance at the desired level of graphical fidelity. Further, while there is less than a decade between the releases of *FFXI* and *FFXIV*, the MMORPG genre was redefined by the release of four major titles in the interim: *Runescape 2* (Jagex, 2004), *EVE Online* (CCP Games, 2003), *Second Life* (Linden Labs, 2003), and *World of Warcraft* (Blizzard Entertainment, 2004). Each of these titles established new standards for the design of MMORPGs and contributed to radical changes within the genre—some suggesting that the release of *World of Warcraft*, in particular, led the genre "away from innovation towards shameless imitation" (Messner 2017: n.pag.). Some elements of design are shared between *FFXI* and *FFXIV*. However, these radical shifts in the genre identity of MMORPGs make it seem unlikely that Square Enix had significant experience designing and

implementing the MMORPG systems used within *FFXIV* before they began work on the game around 2008.

Perhaps further evidencing a potential lack of experience was the lack of focus on in-game elements of *FFXIV* that players considered central to their enjoyment of the genre in 2010. Server instability was a consistent issue: players would constantly lag, disconnect, and desynchronize from one another. Client instability was also an issue, with players reporting crashes, "blue screens of death," and infuriatingly slow user interfaces. Multiplayer elements of the game remained significantly limited despite the shift to (typically more powerful) PC hardware—a maximum of twenty other players were visible on the screen, which prevented complex social communities from emerging as seamlessly as in other contemporary MMORPGs such as *Tera* (Bluehole Studio, 2011) or *Rift* (Trion Worlds, 2011). Alongside these technical problems, players also criticized many gameplay elements, such as a poorly designed real-time combat system, repetitive quests, poorly designed user interfaces, the lack of an auction house, and the tedium of being forced to repeatedly traverse boring (and often seemingly obnoxious) areas to make any progress.[1]

No matter the cause, the consequences of these problems were severe. By the beginning of 2011, Square Enix was facing a significant problem: *FFXIV* was becoming one of their biggest failures among critics and fans alike. And as a title within one of their largest popular franchises, this criticism meant it was likely contributing to what Square Enix reported as "extraordinary" financial losses during the period (Griffiths 2013).

To salvage something from the years of work that went into the development of *FFXIV*, and to restore the trust of fans of the franchise, Square Enix took the unusual step of rebooting the game in 2013, resulting in the creation of *Final Fantasy XIV: A Realm Reborn* (hereafter referred to as *Realm Reborn*). This was not a remake or a sequel—players of *Realm Reborn* do not experience similar or reimagined narratives to those of *FFXIV*, nor is the narrative continuous to events of *FFXIV*. According to the game canon, the world was destroyed and created anew. In practical terms, this meant that many of the game assets were updated and reused, but in new contexts and with updated implementation.

Problems surrounding musical crediting in A Realm Reborn

Unfortunately, not all the original creative team for *FFXIV* were available to work on *Realm Reborn*. This has some substantial consequences for the music of *Realm Reborn*. Most notably, Nobuo Uematsu was working on other projects during the eighteen-month development process for *Realm Reborn*. Masayoshi Soken, the

sound director for both development processes, is credited as providing much of the additional music for *Realm Reborn*. However, the exact boundaries between Soken's work and Uematsu's work are not clear.

Official credits for *Realm Reborn* place the majority of the credit in the hands of Soken. In particular, soundtrack releases credit Soken with the composition of nearly all tracks.[2] However, a closer examination suggests that this depiction is not representative of Uematsu's influence: much of the musical material for *Realm Reborn* utilizes music from *FFXIV* (e.g., "Primal Judgement"[3] appears in both *FFXIV* and *Realm Reborn*) or draws heavily upon Uematsu's existing canon of music for the *FF* franchise. "Battle Theme 1.x"[4] appears in *Realm Reborn*, credited to Soken, yet is clearly a version of "Battle Theme"[5] from Uematsu's score for *FFII*. The two versions share the same melody, the same underlying chords, the same musical structure, and the same implementation system within their respective games. While the version credited to Soken in *Realm Reborn* does have some changes, it is "only" an arrangement of the "Battle Theme" found in *FFII* credited to Uematsu. We can imagine that the process for creating the version found in *Realm Reborn* might even have started with the original MIDI tracks created by Uematsu being loaded into the contemporary audio workstations used by Soken. Similarly, "Eorzea de Chocobo"[6]—credited to Soken on the 2014 release of the *Realm Reborn* soundtrack—shares the same melody, chords, structure, and implementation as the "Chocobo" themes created by Uematsu for use throughout other installments of the *FF* franchise.[7]

There are many other examples of Uematsu's influences throughout the music of *Realm Reborn*. Soken stated in interviews that his composition process often included imagining how Uematsu's music for *FF* could be arranged or reimagined for *Realm Reborn* (Plante 2017) and, more broadly, that "the music of *Final Fantasy* belongs to Uematsu" (Williams 2018: n.pag.). Further, Uematsu returned to the creative team by 2014 to provide additional original music for updates to *Realm Reborn*. Uematsu also provided additional music for all expansion packs released for the game to date. While some information can be found from official credits, it is clear that official credits are only part of the complete story of the music of *Realm Reborn*. Video game music, rather like cinematic music, is often a collaborative process in which creative participants are not always fully credited. Hidden from the credits of OSTs and other resources is the relationship between composers, sound directors, game designers, and other members of the creative team. Composers of video game music must consider how their music will be implemented within the game.

Much of the content of this chapter discusses those rules of implementation— given that Soken was the sound director for both games, how much credit should we give to Uematsu? The answer to this is impossible to know, but it seems likely that given his extensive experience working on other projects, Uematsu will have

contributed to discussions surrounding the implementation of music in *FFXIV*. The underlying principles of the rules in *FFXIV* seem to remain fundamentally unchanged in *Realm Reborn*: while the game is no longer widely available and experimentation could not be conducted, surviving gameplay footage did seem to suggest that at least the broad strokes of the same rules were present. Soken clearly did extensive work to further develop *Realm Reborn*, but this work was undoubtedly influenced and shaped by Uematsu during their collaborative work on *FFXIV* and presumably during the transition into *Realm Reborn*. The work of Uematsu is also visible in the current-day development of *Realm Reborn*: he has contributed credited tracks to every expansion for the game.

The exact details of their collaboration may never be completely understood. Creative freedoms enjoyed by experienced composers such as Uematsu make it hard to pinpoint the exact boundaries of the collaborative process of composing for game. Given Uematsu's experience, it is hard to believe that he did not have an active voice in the process of implementation. Similarities in the implementation of music in *FFXIV* and *Realm Reborn* are also clear. We can presume, therefore, that the influence Uematsu had on the complex rules of *FFXIV* was a key part in the realization of those same rules by Soken in *Realm Reborn*. Uematsu is clearly a key figure within the music of *Realm Reborn*: Uematsu's music for *FFXIV* appears throughout *Realm Reborn*; Uematsu has been approached on several occasions to further contribute music to the game; and Soken draws many inspirations from Uematsu's music. Uematsu clearly forms part of the experience of music within *Realm Reborn*.[8]

Realm Reborn has received several major expansions since the 2013 reboot. Unlike the complicated relationship between *Realm Reborn* and *FFXIV*, these expansion packs are direct sequels to *Realm Reborn*, continuing and developing the narrative within the game. The research explored in this chapter was conducted during the early part of 2019, at which point only two expansion packs had been released: *Heavensward* (2015) and *Stormblood* (2017). Major content releases (e.g., expansion packs) and minor content releases (e.g., patches) continue to be released on a regular schedule (Table 8.1).[9]

This chapter examines a problem specific to music within MMORPGs: while single-player games create a multiplicity of virtual worlds specific to each player, MMORPGs take place within a singular, persistent virtual world. All players, no matter their playtime or progression through the game narrative, are placed within shared virtual locations. Individual player narratives are chronologically asynchronous: players experience the designed narrative at different times—often days, months, or even years apart. Therefore, while users engage simultaneously within the same virtual space, their specific virtual *experiences* may be drastically different.

TABLE 8.1: Installments of games within the *FFXIV* franchise.

Title	Notes
Final Fantasy XIV (2010)	Original release
Final Fantasy XIV: A Realm Reborn (2013)	"Replacement" release. Released on PC and PS3 in 2013, PS4 in 2014 and for OSX in 2015
Final Fantasy XIV: Heavensward (2015)	First expansion pack
Final Fantasy XIV: Stormblood (2017)	Second expansion pack
Final Fantasy XIV: Shadowbringers (2019)	Third expansion pack, unreleased at time of research

In instances where users engage in shared social experiences, their individual musical experience may differ; this results in musically asynchronous experiences among the players and therefore different affective responses. The world of *Final Fantasy XIV: A Realm Reborn* primarily encounters asynchrony where players may emotionally experience *specific narrative* events differently from one another (i.e., because of the methods used for implementing musical material). Where players are placed within the context of a *shared narrative* within the shared virtual world, they may become more easily aware of the contrast in musical material between users (e.g., they may experience the same shared narrative event with an alternate musical accompaniment, preventing them from sharing an emotional affect in the supposedly shared narrative moment). As the MMORPG genre focuses on shared player experiences, the philosophical question is raised: can music aid players in developing a social, shared approach to play?

To understand how the game approaches the scoring of multiplayer experiences, I first explore how music is integrated into the game's single-player experiences. I examine how musical cues are used narratively and how they are implemented within a dynamic music engine to create a specific player experience in the interactive world. I then examine the nature of specific player experiences within video game play to establish how potential problems could emerge within multiplayer experiences: what concerns must developers and composers consider in multiplayer games, and what techniques can be used to avoid them? Lastly, I examine the methods used specifically within Square Enix's *Realm Reborn* that accommodate and address the potential difficulties in the generation and support of an exciting collective experience for players sharing their virtual world.[10]

Audial cues in A Realm Reborn

Within video games, we understand that music underlies and accompanies the action visible on screen "not [as] a redundant echo of other aspects of the game [...] but a central part of the audiovisual experience of interacting with the video game" (Summers 2016: 6–7). Within *Realm Reborn*, the music is no different, forming an ever-present accompaniment to every activity found throughout the game. The range of activities within *Realm Reborn* is extensive: players take on the role of an adventuring denizen in the realm of Eorzea, requiring them to embark on a journey across continents to battle an evil empire and prevent the destruction of the fragile society of free peoples. This central narrative is formulated by "storyline" quests that, once completed, allow players to progress to new areas to find new opportunities for gameplay. Players are further encouraged to provide assistance to other nonplayer characters (NPCs) they meet along the way. These additional narratives can be singular narrative events (e.g., "side-quests"), randomized quests (e.g., "levequests" or "guildleves"), or replayable narratives (e.g., "dungeons") that offer tangible rewards or the satisfaction of uncovering secrets within the virtual world.

The central narrative of *Realm Reborn* integrates video sequences throughout the storyline. However, these sequences in *Realm Reborn* are often disconcertingly quiet. For example, halfway through the opening video sequence that all new players experience, both voiceovers and music are suddenly removed, leaving the player in an eerie silence with only the occasional audible sound effect. This sudden and occasionally jarring change is the result of a move between the two types of cutscenes found within *Realm Reborn*: *video cutscenes* and *text cutscenes*.[11] Video cutscenes are voiced by voice actors, with music and sound effects aligned to action, while text cutscenes are unvoiced: players must click through subtitles with music and sound effects aligned as "best guess" estimates of player's reading speed by the sound director. The practical difficulties of "best guess" alignment in text cutscenes pose a number of issues for aligning music, sound, and visuals together and create several unfortunate moments where the elements do not present a unified audiovisual experience for the player, in what Hooper describes as "audiovisual incongruence" (2018: 131–33).

The creative decisions behind designating video cutscenes and text cutscenes are also incredibly inconsistent. An NPC may be "voiced" during one cutscene but not during another. Interaction with NPCs could switch between listening and reading in the middle of a video sequence—or even, in one memorable instance, halfway through a character's sentence. While it is perhaps understandable that some areas of the game could lack voiced characters for any number of reasons, the inconsistency *during* any given video sequence is less understandable. Our audial

experience of the narrative becomes a bizarre mixture of one-sided discussions, non-sequitur nonsense statements, and characters "vanishing" halfway through sequences for no apparent reason.[12]

Despite this potentially confusing audial experience, the game places heavy emphasis on conversation throughout the game. The first hour of gameplay for each new character involves embarking on a series of quests to convince the city guards to permit them to leave the city to go on their adventures.[13] Players are dispatched around their city of choice to complete minor tasks for a number of denizens as they learn the interactive rules of the game. Despite the focus on dialogue, not a single spoken word can be heard during this section of the game: all characters are unvoiced, and dialogue is delivered by click-through dialogue boxes. The emphasis on conversation continues throughout the game. While discussions with dedicated fans of the game suggest that the inconsistency of voicing throughout video sequences is an issue found mostly within older sections of *Realm Reborn* (especially those drawing upon the original assets shared with *FFXIV*), they also noted areas in which voiceovers are still intermittent in the newer areas of the game. Without the assistance of voice acting, music is therefore made more important throughout *Realm Reborn*'s narrative experience as the dominant sonic medium through which emotion is conveyed and narrative unity created.

Music in A Realm Reborn

To allow music to act as this emotive force throughout the game, the developers of *Realm Reborn* needed to develop a musical engine capable of dynamically responding to the on-screen action. The correct music has to be cued at the correct moment to convey the correct emotion. Similar to the methods used in games explored by Medina-Gray (2016: 53–72), musical experiences in *Realm Reborn* are not specific musical tracks like those published on OST albums. Rather, each music cue is formed predominantly of a number of distinct loops; during play, these loops transition from one to the next depending on the situation. This modular system is more variable than the soundtrack of more "traditional" games in the *FF* series or in other MMORPGs.[14]

Most of these loops are grouped using two categories. First, the interactive state during which the track plays (e.g., "exploration," "combat," "day," "night"). Second, the location or "zone" in which players are currently situated (e.g., the city of "Gridania" within the greater region of "The Black Shroud," or the city of "Limsa Lominsa" within the greater region of "La Noscea"). Each intersection between these two categories has its own group of loops that can be used. The music transitions freely between each category during play. Transitions between

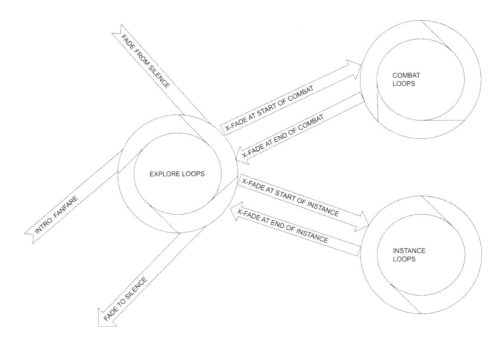

FIGURE 8.1: Players experience different selections of loops dependent on their current play-states and move between selections of loops dependent on their interactive states.

different interactive categories within zones use cross-fades to make the change as seamless as possible. Changes between different "zones" often utilize area-specific fanfares as introductory musical fragments to mark the transition to a new zone (see Figure 8.1).

The musical loops for each intersection are represented on the *Realm Reborn* OST (2015) in a fixed order as specific musical tracks (Table 8.2). It should be emphasized that while the majority of the music loops available at each intersection can be found on these selected tracks, they are not complete selections, nor do the loops appear in the same fixed order within the game. For example, "Serenity" contains only five of the six loops heard during exploration within "The Black Shroud," while the sixth loop is found as its own track on the OST, "Greenwrath." It would be possible for a player within the game to hear the loop found within "Serenity" in-between two tracks from "Greenwrath"—or in any other order. The length and number of loops within each intersection of interactive state and location also varies: some loops are several minutes long, while other loops are only fifteen or thirty seconds; some intersections have eight or nine possible loops, while others only have two or three. Music for specific interactive states often shares motivic material, as do tracks for

TABLE 8.2: A selection of tracks used for two areas within the game (middle and right column) to illustrate the music system.

Interactive state	Gridania // The Black Shroud	Limsa Lominsa // La Noscea
City Music (Day)	"Wailers and Waterwheels"[a]	"I Am the Sea"[b]
City Music (Night)	"Dance of the Fireflies"[c]	"A Sailor Never Sleeps"[d]
Combat Music	"The Land Bends"[e]	"The Land Breathes"[f]
Exploration Music	"Serenity"[g] and "Greenwrath"[h]	"On Westerly Winds"[i]

a *ARR-OST*, Track 026, Masayoshi Soken (composer and arranger); some fans have argued that there are similarities to Naoshi Mizuta's city theme for the "Windurst" area in *FFXI*, for which Uematsu took on the role of producer. Some of these similarities are: they share similar rhythms in both melody and accompaniment, have a similar musical structure, and use a similar timbral language for melodic instruments. However, they remain substantially different.

b *ARR-OST*, Track 017, Masayoshi Soken (composer and arranger).

c *ARR-OST*, Track 031, Masayoshi Soken (composer and arranger).

d *ARR-OST*, Track 023, Masayoshi Soken (composer and arranger).

e *ARR-OST*, Track 028, Masayoshi Soken (composer and arranger).

f *ARR-OST*, Track 019, Masayoshi Soken (composer and arranger).

g *ARR-OST*, Track 027, Masayoshi Soken (composer and arranger).

h *ARR-OST*, Track 032, Masayoshi Soken (composer and arranger).

i *ARR-OST*, Track 018, Masayoshi Soken (composer and arranger); there are some similarities in the music for Limsa Lominsa in *Realm Reborn* and for the same city in *FFXIV*: see "Navigator's Glory" on *Final Fantasy XIV Field Tracks*, which is credited to Uematsu.

each geographical location. For example, all battle themes each share topoi of time signature, rhythmic motif, thematic material, and key signature while varying the orchestration and some musical elements dependent on location (Table 8.3).[15]

When the music within the game approaches the end of a selected loop, it randomly selects another loop within the same intersectional category; when it reaches the end of that loop, it selects another one, and so forth. At any point during each loop, the music can fade out either leaving only the environmental sound of the area or cross-fading to a new selection to represent a shift to a new interactive state (e.g., moving from "exploration" to "combat" categories). The music will eventually fade back in from the silence and will do so at a random point within a random loop.[16] While most music falls within these intersections of location and interactive state, some music is dependent only on the interactive state of the user. For example, when riding specific animals around the world, the user will always

TABLE 8.3: Differences in orchestration between combat tracks in different zones throughout *Realm Reborn.*[a]

"The Land Bends" (Black Shroud)	"The Land Breathes" (La Noscea)	"The Land Burns" (Thanalan)	"The Land Breaks" (Coerthas)	"The Land Bleeds" (Mor Dhona)
Additional use of woodwind instruments, especially flute	Additional percussion instruments, additional brass instruments	Additional use of guitar and harp	Use of organ sound, some reharmonization, and additional brass stings	Additional brass stings, alternate middle section without bass instrumentation, use of choir and piano

[a] Table 8.3 makes reference to tracks 028, 019, 006, 071, and 086 from *ARR-OST*, which are credited to Masayoshi Soken (composer and arranger).

hear music specific to that creature: for example, riding a Chocobo results in loops from "Eorzea de Chocobo" playing until the player dismounts.

This system of generating the musical accompaniment to play allows the developers to closely tie music to narrative throughout the game. Through intersecting location and interactive state, players hear similar music in areas and situations that are narratively connected to each other.[17] For example, during the course of *Realm Reborn*, players frequently encounter members of an antagonistic, imperialistic foe: the Garlean Empire, led by Gaius and other members of the "Legatus" military faction. During video cutscenes utilizing these characters, players will hear loops presented in the "Imperial Will"[18] track on the OST. Similarly, during fights against these characters, players will hear loops presented in the "Steel Reason"[19] track on the OST. By consistently using the same selection of musical loops, the developers remind the players of the ongoing influence of the antagonists. This repetition serves an important purpose in connecting these quests thematically: as the music is shared between encounters, players are more likely to recall past events even when they are chronologically separated by many months of real time. As players are free to take as much time as they wish between continuing a questline, these musical connections are essential to unifying the narrative.

In some boss fights, music is also used to communicate further narrative information. For instance, some boss fights occur over several phases: in each subsequent phase, the boss utilizes a new set of unique abilities against the player. These abilities can be extremely powerful—such as instantly killing every character not standing in a specific place—and the abilities occur randomly during specific

phases. To signal to player that a new phase has been reached and that the boss may use new abilities, different musical loops are used. For example, in a fight against Shiva, players first hear an orchestral loop in 4/4 with a strong pulse and a choir. When players succeed in lowering the boss's health to 50 percent, they progress to the second phase of the fight and the music changes to a faster-paced rock track with a solo singer (Figure 8.2).

Some boss fights must be completed within a specific length of time; such is the case during the fight against Vishap—an encounter named "Steps of Faith." In the final few minutes, the music dramatically changes and transitions to an alternate selection of musical loops.[20] The musical changes support the developing emotion of the narrative through what Grasso describes as *ludomusical narrativity*: "[P]rogress in the game is matched in the music through logics of musical activation" (2020: 126, 130). Specific within this example from *Realm Reborn*,

FIGURE 8.2: Music changes during fight against Shiva.[a]

[a] Music for Shiva is credited as two separate tracks: "Footsteps in the Snow" and "Oblivion," both of which are credited to Masayoshi Soken on *Before the Fall: Final Fantasy XIV Original Soundtrack*, tracks 042 and 043, respectively.

musical changes support the narrative imperative of these fights by highlighting specific changes within the arc of the quest for players and emphasizing high-tension moments with high-energy music.[21]

A final thematic connection is found between the musical material for specific in-game locations. For instance, music accompanying the eerie "Sirensong Sea" storyline, which occurs within the "Limsa Lominsa" area, consists of a slower and denser orchestration of the area's associative music.[22] While not always as immediately obvious as the use of topoi and motif described above, this category of shared musical material provides links for players who attend more closely to details within the game—helping them to recognize how specific areas connect together to provide an extension and development of the game world's lore and history.

This modular system may seem familiar to those already familiar with video game music. While the increase in expected playtime for MMORPGs may necessitate larger-than-normal quantities of music being available,[23] the underlying systems are not necessarily different to those found in single-player games. How do these systems change when we examine multiplayer games?

Many players, many stories, one world: Managing asynchrony

With a heavy heart, I turn back toward the door of the study, stepping over the cooling bodies of my fellow heroes. Having sent me to the other side of the continent to resolve a tricky situation, their desperate cry for help arrived too late: despite rushing back as quickly as possible, I was unable to prevent their death. The music begins to swell into a sad, melancholy tune of mourning and loss when the unthinkable happens: the game crashes, yanking me out of my contemplative mood and into a momentary frustration. Hurriedly reloading the game, I curse whatever caused this to happen, perhaps even whoever designed this level—how could they disrupt my engagement with the narrative? It is only once the game reloads and I am stood outside, looking out over the sea, that I realize the melancholic tune has been abandoned in favor of a jaunty sea shanty. It is this jaunty sea shanty that accompanies me as I make arrangements for their funeral, load their bodies into a cart, and depart the city—never to return. Succinctly: the mood has been ruined.

When considering the musical scoring of *Realm Reborn*, we must contextualize it alongside the specific player experiences. MMORPGs have a unique complexity: while different players inhabit a shared virtual environment, they receive personalized and specific narrative experiences. Players must complete the same main storyline quests to unlock new areas of the game, a process which, for the most part, is designed to be tackled independently by players. Players have a quest journal and achievement log that record individual progress, independently of the

progress of any other player in the game. This is essential for the narrative that *Realm Reborn* portrays: it allows a player who first discovers the game in 2020 to start at the beginning of the story written in 2013 and experience the same journey of discovery.

This creates a conflict: players can choose how and when to progress the game's narrative(s); therefore, players do not tackle story events simultaneously, creating an asynchronous way of exploring the game among multiple players. Like many open-world games with a plethora of additional activities to complete, players are free (and encouraged!) to explore other areas of the game in-between making progress in the main storyline. Furthermore, while many players engage with a specific MMORPG such as *Realm Reborn* over the course of many years, they do so incongruently: players will often take breaks of weeks, months, or even years from play. This means that players will fundamentally encounter elements of the game's story at different points within the unidirectional timestream of all existence, as shown in Figure 8.3.

The game's extensive use of motif and topoi within the soundtrack may therefore help players to better understand the narrative: by repeatedly reusing the same musical material in specific interactive and narrative situations, it increases the chances of players connecting narrative events despite time spent pursuing other activities. Similarly, the use of specific music for each location may help players

FIGURE 8.3: Players of MMORPGs are free to explore the world's stories as they see fit. In this example, we see three different approaches to the main story quests: Player 1 gets distracted by exploring the world; Player 2 continues rapidly on to part 2 of the main story; and Player 3 begins the game much later than the others, but must still complete part 1 of the main story despite other players having already progressed further into the narrative.

to recall specific experiences within given zones of the map by distinguishing each zone as a separate musical world as well as a separate geographical area.

However, the use of topoi within specific in-game contexts does not avoid a second difficulty in this asynchronous player experience of multiplayer games: within single-player games, each player exists within their own specific version of the game world. Each player's version of the game world can be altered freely without affecting, or being affected by, the experiences of another player. Within multiplayer games, however, players have simultaneity: they inhabit the same spaces instantaneously in a *shared* world. In the case of MMORPGs such as *Realm Reborn*, these issues are exacerbated because there is no single-player mode at all. Even when players make the choice to try to play independently of other players, they remain mostly within a shared virtual world with players that have different specific experiences.

If players exhibit different game-states that are fundamentally incompatible, this creates a significant continuity problem. For example: Player 1 has completed the penultimate stage of the narrative, in which a major character dies. However, Player 2 is only at the beginning of the narrative and has only just met this character. As both players inhabit the same space within the shared world, developers of multiplayer games—especially MMORPGs—must find an answer to a central question: How can two incompatible, yet simultaneous, playthroughs of the same game co-exist? And, more pertinent to the present discussion, how can music be implemented that two such players inhabiting the same space both have a narratively appropriate audial experience?

To explore these difficulties, we should first imagine a single-player game. In this hypothetical game, the music engine is poorly designed. As a player explores a cave, the music suddenly shifts from relaxed exploration music to a fast, tense, energetic track. Yet the player finishes exploring the cave and finds nothing. The player is confused—the music does not reflect their current activity of exploration, and they cannot find a specific interaction that matches the emotional shift of the music. A month later, they return to the cave as part of a quest. The music shifts once again; only now the player discovers a boss that is only visible when embarking on *this* specific quest. The music accompanies the boss fight and the player is energized by the tense track: the player and the music are emotionally synchronized. A few months later, they are exploring the area again to see if they can uncover hidden secrets. They enter the cave, the music shifts, and they remember that the music accompanies a boss fight. They look around, but cannot find the boss and are confused. In this hypothetical, music fails to accompany the narrative: players can stumble across the musical interactions without any accompanying narrative interactions that would justify them. This may be confusing or misleading and perhaps even spoil the specific interaction that the music is supposed to support.

To continue our hypothetical situation, the music system is adapted to fix these issues: players now hear "cave music" unless they are on the specific quest. If they are on the specific quest, they will hear "tension music" as they explore the cave. As they approach boss monster, "fight music" starts, anticipating and supporting the action. Once the boss is dead, the player will hear "triumph music" to register success. This music plays until the player leaves the cave. This clearly offers a greater level of interactive connectivity, allowing players at different stages of play to engage with the environment in different ways. This would avoid our earlier hypothetical: if the player finds the cave and there is no boss to fight, they will not hear any "fight" music. They will only progress through the musical narrative when there are appropriate gameplay events to trigger each stage. In the first and third exploration, they only hear the "exploration" music, while in the second exploration (and ensuing boss fight), they receive the complete musical experience. This kind of "event-triggered music" is how many single-player games implement their music in this kind of situation.

However, within multiplayer environments, a secondary issue is posed: what if the player is not alone within the cave? Within MMORPGs, many players can occupy the same location simultaneously. Rather than the three explorations of the cave happening to one player across a period of many months, the three explorations of the cave can happen to three players simultaneously: most locations in *Realm Reborn* can be traveled through freely and—as the world is shared—players exist simultaneously in nearly all locations. Monsters and items that appear in shared locations throughout the game appear for all players simultaneously. However, where one player may visit a location to fight the monsters, a second player may coexist in the same location to, for example, gather flowers for a potion, and a third player may simply be passing through. The freedom of exploration creates a liminal space where alternate viewpoints exist simultaneously and can interact with each other. As a result, event-triggered music may not always succeed at delivering an appropriate experience if implemented carelessly.

To return to our hypothetical, two players are now independently embarking on the same quest. Player A discovers the cave and explores it. Unknown to them, Player B has already found this cave and is currently engaging with the final boss. As they approach the boss, Player A activates the event trigger for the "fight music." This moment of emotional anticipation is then immediately cut off by "triumph music": Player B has just finished killing the boss. While the players are unaware of each other, the game detected that the boss is dead and triggers "triumph music" for all players in the area to celebrate this success, even though Player A had not contributed to the battle unfolding just beyond the view of their character. Because of this oversight, Player A's narrative journey is no longer supported by the music. They may even feel cheated of an "epic" moment. The music

failed to provide insight into the emotional journey of the character or any connection to the emotional state of the player. As Player A was exploring for the specific purpose of discovering and killing this boss, we could even imagine Player A awkwardly listening to triumphant music while waiting for the monster to be respawned by the game's engine in an extreme form of audiovisual dissonance.

This example shows how specific player experiences can interfere destructively with each other as a result of problems inherent within the game's musical engine: while unintentional, Player B disrupted Player A's experience and enjoyment of the narrative. Player A and Player B have different specific emotional states at any given specific moment where they are at different stages of play. They may be at different stages of the overarching narrative, completely different stages of the game, playing through the game at different speeds, or take alternating approaches to issues.

Figure 8.4 presents a simplified version of one potential narrative experience emerging for three players simultaneously in three different ways. Player 1 watches the first cutscene for this experience, explores the dungeon, fights some monsters, continues exploration, and finally finds the boss. Upon defeating it, they then watch the final cutscene. Player 2 skips the cutscene as soon as possible and immediately progresses through the dungeon to the boss fight. They fail to succeed and respawn within the dungeon for a second attempt, which is successful. Player 3 watches the cutscene, begins exploring the dungeon, and encounters some monsters. They die fighting these monsters and decide to respawn at their home town, ending their experience. Most notably, while Player 1 is fighting monsters, Player 2 is fighting the boss and Player 3 is still watching the first cutscene. Each is experiencing a very different emotion at different stages of the same narrative.

P1	First Cutscene	Explore Boss Lair	Fight Monsters	Continue Exploration	Fight the Boss	Final Cutscene	
P2		First Cutscene	Explore Boss Lair	Fight the Boss	DEATH	Fight the Boss	Final Cutscene
P3			First Cutscene		Explore Boss Lair	Fight Monsters	DEATH

Progression of real-time clock

FIGURE 8.4: A demonstration of how players could have asynchronous but simultaneous experiences of a narrative event.

Realm Reborn must confront this issue in shared virtual worlds, but it is not immediately clear how the music can be implemented to avoid all problems.[24] As the players share a virtual world, then it is likely that delivering these three different musical experiences simultaneously will be difficult to implement as each specific experience may be confused by events happening to other players. In our hypothetical situation, we could imagine that the developers check whether the boss is currently on the map and use this to determine what music plays. Players may hear boss music at the wrong time as a result. As we see in Figure 8.4, Player 1 needs combat music, while (simultaneously) Player 2 needs boss music and Player 3 needs exploration music. The implementation team for *Realm Reborn* needed to find a way to deliver appropriate music to the player to cohesively integrate the essential communicative tool of music into the audiovisual narrative of specific players within the shared virtual space, as to permit these players to have their simultaneous but individual experiences within the shared virtual world.

One method frequently used throughout *Realm Reborn* to permit this flexibility is the use of "instances"—a private area of a shared virtual world that allows players to have independent experiences of a particular event. In effect, this creates a "single-player" mode for certain areas of the game, thus preventing other players from interfering destructively with your personal experiences. *Realm Reborn* frequently uses this for specific events such as boss fights, or in specific areas where musical cues are changed depending on player actions. In the example detailed in the introduction to this section, I recalled a quest in which I discover that all the NPCs I have recently traveled with have been killed. This area within the game is "instanced." Player A and Player B can enter this area simultaneously but have a very different individual experience as they are placed within their own personal version of the area. Player A may see their friends alive and healthy, while Player B may see their corpses. By instancing the area, the developers are able to prevent destructive interference between player experiences and deliver the correct music to help convey the intended emotional sentiment for each player within the same space.

My introductory example of disconnecting from the game server at a key moment in the narrative suggests a weakness in this method, however. Having been disconnected from the server during an emotionally key moment, my rapid return to the game and my immersive state within the narrative is lost to the tune of a jaunty sea shanty: melancholic music suited to the emotional content of the narrative has been displaced. This is due to an oversight in methods used to manage the asynchronous experiences of players within the shared virtual world: the game correctly shifts the musical language when players complete a specific stage of a specific quest, overwriting the expected music for a specific area. However, having left the instanced space and rejoined the shared virtual world just

before disconnecting, the game is now unsure of whether it should play the specific instanced music. It defaults to the jaunty music used within the area. Solving this issue is not straightforward. While instancing allows developers some flexibility in musical accompaniment to account for differences in specific narrative chronology between players, it is not always feasible to rely on it. At some point, players must return to a shared space and therefore utilize the music engine that defines the overall experience of the audiovisual narrative.[25]

However, a second issue with instancing in MMORPGs also exists: a major feature of an MMORPG is the ability to *share* a virtual world with other players. (As discussed in the introduction, one of the major issues facing *FFXIV* was the contentious decision to limit how many other player characters the game client could display at any given time.) Instances are a method of limiting how many players share a virtual world to minimize potential conflicts. The more instances a MMORPG has, the less multiplayer the game might seem; ergo, the less attractive it is to fans of the genre. Not only are there technical limitations on the use of instances within MMORPGs, but there is also a potential fundamental design conflict between the implementation of the music and the sharing of the virtual world.

Players of the genre do not necessarily expect to be "the" hero, but rather to have a shared collective heroicity as "a" hero alongside many others. They want to share the virtual world. Combining the use of narratives with event-triggered music can help to accommodate this desire without destructive interference: for example, "fight music" in *Realm Reborn* fades in when the player's game client detects that a monster has become aggressive to the character controlled by that client. This means that a player will only have their relaxed exploration of the virtual world disrupted by tense "fight music" when they are in danger themselves.

But how might players conceptualize each other as a result of their specific musical experiences? To return once more to our hypothetical cave, Player A kills the boss and hears triumphant music and begins their walk of victory back toward the exit. Player B is still exploring the cave. Player B is unaware of Player A's success and may conceptualize Player A simply as another explorer. Player A, however, is riding the high of individual success—Player B is reduced to "just another character." They have not contributed to Player A's heroic journey. While players may be sharing the same space, their audial and ludic experiences perpetually vary. The randomized elements of the sound engine—such as environmental sounds, musical loops, character lines, sound effects, and others—mean that there are ever-present significant differences between audial experiences. Where players are intended to collaborate in a collective experience, these differences may pose barriers to the shared social experience.

In the examples explored as yet, the music supports only the specific personal adventure of players rather than any potential collective adventures within the shared world. For example: monsters attacking Player B may not cause the music to

change for Player A if the monsters are only attempting to damage Player B. While the players are intending to overcome the challenge collectively, the musical interactions may lead Player A to feel somewhat excluded—why is their participation in this "epic" moment not rewarded through "epic" music? Does the game not value their participation?

We can recognize that, in such a situation, both players should feel the same tension at being engaged in a fight that they must overcome together. To create and perpetuate this tension, both players must receive the same musical experience that connects emotion and narrative through *Realm Reborn*. However, because of the interactive rules that underpin the music engine, there is potential for Player A to not hear the tense "fight music" that emphasizes their heroicity. This leaves one final question: how does the music engine of *Realm Reborn* accommodate collective multiplayer experiences?

Many players, one story: Hearing companionship

Realm Reborn offers many opportunities for players to team up together and tackle an adventure collaboratively. These shared adventures often use different music engines that engage with the interactive state of participating characters in a different way. While the underlying system of selecting loops at random remains unchanged, these new systems ensure that groups of players experience the same selection of loops together. This shared musical experience helps to create a shared emotional response to the narrative experience.

One of these opportunities for collaborative play is provided through the use of "Full-Active Timed Events" (FATEs). These are short, localized, collaborative events that appear spontaneously throughout the game world and disappear after a relatively short time. This means that players are implicitly invited to respond quickly to FATEs and work collaboratively to complete them before the timer runs out. For example, a FATE might ask players to break up a bar fight, or tackle an oversized monster, or fight off a horde of rabbits devouring a farmer's crops. While some events are possible to complete individually, most require teamwork.

FATEs spawn in predefined locations, but the selection of available FATEs is randomized. This means that players rarely wait for a specific FATE to occur, but instead find currently occurring FATEs by looking on their area map, where they are marked by a glowing red circle. When they travel to this area and enter the circle, the music cross-fades from specific zone music (e.g., "exploration" or "combat" music) to specific FATE music. When the FATE is completed or a player leaves the FATE area, their shared music experience ends: they are returned to the fully individual dynamic music engine that the game uses by default.

Player 1	Player is questing		Player enters FATE-zone	Player abandons FATE and continues with quest
Player 1 Music	ZONE MUSIC LOOPS		FATE MUSIC LOOPS	ZONE MUSIC LOOPS

Player 2	Player exploration	Player enters FATE-zone		Player exploration
Player 2 Music	ZONE MUSIC LOOPS	FATE MUSIC LOOPS		ZONE MUSIC LOOPS

Player 3	Player enters FATE-zone		DEATH	Player respawns in town
Player 3 Music	ZONE MUSIC LOOPS	FATE MUSIC LOOPS		TOWN MUSIC LOOPS

Normal play	FATE EVENT LIFESPAN	Normal play resumes

FIGURE 8.5: Three different experiences of a shared FATE.

One example of the differing experiences of three players is presented in Figure 8.5. Player 1 is exploring the area when they enter a FATE zone. While they are not interested in the FATE, they have entered the area and therefore hear the relevant music. When they leave this zone, the music fades back to the area music. Player 2 is actively seeking FATEs and enters the event shortly after it spawns. They hear the FATE music until the event is complete. Player 3 is actively seeking specific FATEs that they enjoy and knows where they are likely to appear. They remain at a known location for this adventure. When the FATE begins, they instantly hear the FATE music. Unfortunately, they die partway through the event and choose to respawn in the nearby town. Their music changes to the town music as they have left the FATE event.

Is this a truly collective experience, however? Music for many FATE events within the game draws from the same limited group of musical loops.[26] Players that engage in FATEs will therefore hear music from the same collection of musical loops as all other players within the glowing red circle. However, the music in these instances is still not synchronized: the cross-fade occurs when players enter the FATE and are cued independently. While players hear *similar* music, they still do not hear *identical* music: they each have a specific interaction; moments of synchronicity between players' musical experience are merely coincidental. While the musical experience is *shared*, it is not *collective*.

If we imagine ourselves as the heroic figure at the center of the musical soundtrack of a game, then music within FATEs continues to emphasize our own specific heroicity. Other players within the circle are reduced to side characters in a story focusing on our specific experience as we charge in to "save" them, and players that enter after us are little more than reinforcements for our own privileged adventure.

Each player experiences this same specific heroicity, focused on their own spe-cific experience: players are simultaneously side characters of another player's adventure and hero of their own. While some players may be satisfied with this compromise, we could nonetheless see this as disruptive to social play given the connections between narrative and music in *Realm Reborn*: experiencing individu-alized soundtracks encourages an individualistic viewpoint. As the music empha-sizes only our heroic journey through the quest, other players might be viewed as extensions of our own personal interactions with the shared game world, rather than as other heroic beings with whom we are sharing the virtual world.

A hypothetical alternate audial experience could be imagined to demonstrate the potential of synchronous musical accompaniment to multiplayer narratives. Rather than having the music for a FATE area cued dependent on a player's entry, the music could instead be time-coded to the area, having players cross-fade to a shared track for that specific instance of that specific FATE (e.g., when Player 2 enters the area after Player 3, the music cross-fades to the *same moment* of the musical track as Player 2 is currently hearing). The player's musical experience would become collective. As music is used in *Realm Reborn* to convey emotional information, this shared musical experience would encourage players to "feel" the same, developing the shared social experience and emphasizing the fundamental aspect of "multiplayer" in MMORPGs.

We should not be surprised, therefore, that this concept of a shared, *collective*, musical experience can be found throughout some collaborative elements of *Realm Reborn*. Throughout their narrative journey, players can elect to form a party, inviting each other to share their narrative journeys through the shared geograph-ical spaces. Once players choose to do this, they are offered several ways to col-laborate with others in the group. The game provides a private text chat, a list of members within the group, and displays the current location of each player on the world and local maps. Interactive elements of play also change when players are within a party. For example, if one member of a party pays to teleport to a dif-ferent location, all nearby party members may choose to teleport alongside them for free. Some support skills automatically target party members in addition to the caster, offering combat advantages (e.g., an increase in damage for all party members) and travel advantages (e.g., only one member of the party has to spend resources to teleport the entire party). These interactive changes are underpinned by narrative changes: for example, quests that ask players to kill a specific number of monsters to continue will count all monsters killed by all party members—even those players within the party who are not currently trying to complete the quest.

Unlike the individual musical experience of FATEs, joining a party connects the experiences of party members. For example: if one member of a party is engaged by an enemy, then all nearby members of the party will experience a shift to "combat

music."[27] This serves two purposes: first, to alert all party members to the potential threat facing one of their allies, and second, to create a shared emotional experience with a shared musical accompaniment. Randomization of musical loops is also shared between players, ensuring that they have an identical musical accompaniment to their shared narrative adventures. As players experience the shift in music simultaneously, they also experience the shift in interactive focus simultaneously: entering combat as a collaborative unit rather than as specific individuals. When "combat" is over for all players in the party, the music will then cross-fade to a shared "exploration" track for all players, unifying their musical experiences further (see Figure 8.6).[28]

This alternate party-based method of experiencing the world also expands to specific instances where players must tackle challenges together. These

FIGURE 8.6: A comparison of the potential musical experiences of players within the same space due to the use of the "party" function. When players are in "party mode," musical experiences are synchronized (e.g., all players hear combat music though only one is actively in combat).

challenges use instance-specific music, which functions as a microcosm of the dynamic music engine used throughout the game. Musical loops within these shared challenges may contain "combat" and "exploration" music for each section of the instance, alongside a selection of unique "boss" music for the bosses found in these areas. As these shared instances typically have a linear narrative, music can also be tied more closely to narrative experience: music not only shifting for specific phases of the "boss fight" but also shifting to represent players traveling deeper within the instance or encountering specific monsters. These changes happen simultaneously across the party's musical experience, encouraging them to view it as a collaborative experience. This may also allow players to identify when they should regroup with other players at key moments of the narrative: If a player hears the specific music for a boss fight, but has not yet reached the boss location, then they know that they need to press on quickly to join the fight.

This also helps to situate the players within a shared mindset for tackling specific boss fights. We have already discussed how the game utilizes music to communicate specific information regarding progression in some areas of the game (e.g., changing the music as a timer begins to run out). By unifying the player experience into a *collective* audial experience, players are able to draw the attention of other players to specific musical and audial cues to help them succeed as a *collective* entity.

The notion of the *collective* experience is also demonstrated best by one key change in the dynamic music engine used throughout *Realm Reborn*. As is the case in most games, death is a constant component. Newer players tackling more difficult bosses may find themselves dispatched repeatedly, and experienced players are still encouraged to experiment to find faster or safer ways of tackling specific boss encounters. It is likely that players will die hundreds of times each year. While not within a party, death marks a reset in your narrative experience: you must choose between waiting a period of time to respawn or returning to a nearby town. In either case, the combat event that has taken you to this point is considered to be over: the music fades out and you are left in a contemplative silence as you consider your options. While within a party, the combat music continues despite your untimely demise. While your specific story may have temporarily ceased, the *collective* story of your party continues: the intense heroic fight is not over simply because you have fallen, and the music chooses to prioritize your *collective* experience over your *specific* experience. Not only does this accentuate group unity, but it may also influence specific player actions: some characters have access to skills that resurrect characters. Tying the music to the shared experience may help players to feel that the benefits of resurrection (i.e., immediately rejoining the fight) outweigh the downsides and cost of the ability.

Conclusion

Music in *Realm Reborn* is an interpretative tool for players that allows them to perceive their adventures within the world through the predetermined creative lens of the designers. While there are few publicly available design documents surrounding the game, the topic of music was presumably discussed by the designers: should specific game clients act independently, creating a specific musical accompaniment for each player, or should developers create a situation where specific player clients communicate between themselves to create a shared experience when players elect to adventure together? There will always be some conflicts within virtual worlds. Pragmatically, it is impossible to completely synchronize player experiences, even using the tools explored in this chapter. But nonetheless, it is clear that the developers took the decision to invest the additional development time into creating a shared ludomusicological experience—one that is not without its difficulties, but one that clearly aims to create a collective audial experience.

While players may experience specific narrative moments in subtly different ways, the use of instancing and a dynamic music engine helps to ensure that players nonetheless receive an individual experience that is broadly similar to other players. These tools are developed further when considering collective experiences, where the designers of *Realm Reborn* conjoin audial experiences in a collective music engine for social play. The musical unity of *Realm Reborn* expresses itself not only through unifying interactive states and specific game locations but also through the unification of collective player experiences.

If we return once again to the imagined heroic focus that music can create, this collective music engine allows us to view our party members as collaborators and co-adventurers. The social experience that is core to MMORPGs such as *Realm Reborn* is reemphasized through the implementation of musical material throughout the game. Our successes and failures, progress, and setbacks are all shared between us as equals musically, shifting our emotional perspective on the narrative accordingly.

Music helps players understand not only the intended emotional power of the moment but also the intended social power of the moment. This promotes synchronicity both in individual experiences emerging at chronologically dissimilar times and in collective experiences emerging simultaneously, thereby creating a stronger sense of unity within a shared collaborative environment.

NOTES

1. For those seeking more information on the specific issues identified by players, "Speakers of Hydaelyn" (who produce one of the major *FFXIV* podcasts) released "The Fall and Rise

of *Final Fantasy XIV*," a YouTube documentary series (2016–17), which provides further insights into the issues and concerns that players had with the original game. See Speakers Network (2016).

2. Around 50 different soundtracks for versions of *FFXIV* have been released. Used throughout this document are composition credits and track numbers as listed in the English-language release of *A Realm Reborn: Final Fantasy XIV Original Soundtrack* (2014), which will hereafter be referenced as *ARR-OST*. It should be noted that *ARR-OST* cannot be considered a definitive list of music included in the game, nor of music that first appears in *Realm Reborn*. As explained early in this chapter, it seems likely that official crediting found on the soundtrack releases may not reflect the extent of other creative participants.

3. *ARR-OST*, Track 044, Nobuo Uematsu (composer) and Tsutomu Narita (arranger).

4. *ARR-OST*, Track 048, Masayoshi Soken (composer and arranger).

5. *Final Fantasy & Final Fantasy II Original Soundtrack*, Disk 2, Track 05, Nobuo Uematsu (composer and arranger).

6. *ARR-OST*, Track 022, Masayoshi Soken (composer and arranger).

7. See, e.g., "Chocobo Theme," *Final Fantasy & Final Fantasy II Original Soundtrack*, Disk 2, Track 13, Nobuo Uematsu (composer and arranger). A variety of Chocobo themes can be found throughout *Realm Reborn*, including some explicitly credited to Uematsu: e.g., "Bo-Down" (*Before Meteor: Final Fantasy XIV Original Soundtrack*, Track 059).

8. Less obvious examples of possible musical borrowing and/or musical inspiration can also be found throughout *Realm Reborn*. For example, one discussion with other players raised what appeared to be an ongoing debate surrounding similarities between "Teardrops in the Rain" (credited to Masayoshi Soken) and "Battle Theme 1" from *FFIX* (credited to Nobuo Uematsu). If the former is played back at 125 percent speed, then similarities can be identified in the opening motifs of the track. Some considered this to be deliberate, as the *Realm Reborn* track plays during an encounter with a character who originated in *FFIX*. In 2016, Soken posted on Twitter that he was unaware of similarities between the music in *Realm Reborn* and the music in *FFIX*, allowing the debate (here and in other similar examples) to continue among superfans of *FF* music. See https://twitter.com/SOKENsqu areenix/status/906842143179735040. Accessed December 14, 2021.

9. It is entirely possible that future content packs will revisit the music systems described within this chapter and alter them significantly. For example, additional music for some areas of the game were added after their release in both the *Heavensward* and *Stormblood* expansions. Some further research was conducted in the early part of 2020, by which time *Shadowbringers* (2019) had been released; no major changes were discovered to the underlying music systems that this chapter discusses.

10. The multiplayer elements of *Realm Reborn* also posed some questions for how any research into the topic should be conducted: as my focus was on the synchronicity of player experience in a multiplayer world, it was necessary to find a way to examine the same play event

from multiple perspectives. The immediate and apparently obvious solution of asking other players holds predictable issues: One friend decided after an hour of research-play that they were bored, loaded up the OST from the game on YouTube and began to randomly insert it into their audio channels. "Trolling" in this fashion is a common occurrence within internet communities and is hard to manage or prevent. The presence of in-game tools for mutating the soundtrack of the game (e.g., a jukebox) can also cause some issues where co-operators are unaware that it changes the musical rules of the game. Even with the invaluable help of several players and an in-game community that rapidly adopted my character, there were sessions that offered more demonstrations of player disruption than musical rules within the game. To conduct research, I was therefore required to use the only approach that permitted a controlled approach: setting up multiple computers and laptops, surrounding myself with monitors with earphones and headphones, and playing on multiple accounts at once. A consequent question does arise: Does playing the game in this fashion represent a typical player experience? While players may have many characters within the game, it is unusual for them to play multiple characters simultaneously in *Realm Reborn*. Further, the issues arising from using real players suggest that many do not make use of the complex dynamic music engine in the game. Both of these observations are true. However, this chapter examines the game as a designed text rather than a ludological experience. This chapter is not an examination of the modalities of play but rather an examination of the musical rules that bind the world of *Realm Reborn* together.

11. Hooper (2018) acknowledges many more forms of cutscenes and these do also appear infrequently throughout *Realm Reborn*. However, the game principally uses the two identified here as "video" and "text" cutscenes, which Hooper identifies as "cinematic" cutscenes and "fixed text" cutscenes, respectively.

12. The history of voice in JRPGs has been explored recently by Gibbons, who discusses the "unsettled and remarkable" transition toward voice-acting in the RPG genre (Gibbons 2019). Collins also identifies similar part-voiced experiences in other JRPGs: "Some games jump back and forth between text and voice, depending on whether the material is interactive or presented in a cinematic sequence" (2013: 68–69). An argument could be made, therefore, that this part-talkie experience is typical for the JRPG genre and potentially typical for the J-MMORPG genre. However, the specific peculiarity within *Realm Reborn* comes from the decision of when to move back and forth between "voiced" and "unvoiced." Unlike examples given by both Gibbons and Collins, where the designers focus on key moments of the narrative, it is not clear what factors determine the design decision of whether a cutscene should be "voiced." A number of suggestions did arise during conversation with dedicated long-term players, including legal issues surrounding the licensing of voiceovers in *Realm Reborn* after the creative failings of *FFXIV*, issues with the English dub that most western players use, or suggestion that the game was trying to emphasize important elements (as Gibbons suggests was the case in JRPGs of the 1990s). However, none of these could be applied with any consistency to the entire selection of examples.

The most likely explanation is that a combination of these factors resulted in intermittent issues throughout *Realm Reborn*.

13. New players and new characters are not synonymous in MMORPGs such as *Realm Reborn*. It is common practice for players to create multiple accounts, either to play on different "realms" (i.e., servers) with their friends, to unlock a variety of classes, or (in some cases) to be able to use multiple characters simultaneously (e.g., for the purposes of writing this chapter).

14. There are many other methods of implementing a music engine that aims to establish connectivity between an interactive audio-visual narrative and the sonic accompaniment to it. The issue of synchronicity was perhaps first explored in the Interactive Music Streaming Engine (iMUSE) system developed by Michael Land and Peter McConnell in the early 1990s for use in *The Secret of Monkey Island*. Rather than playing predetermined tracks, the game generated a MIDI accompaniment that would provide additional lengths of music as needed. While it seems unlikely that the "Crystal Tools" game engine (and the resulting music systems programable within it) developed by Square Enix in the early 2000s and used for *FFXIV* in 2010 was directly inspired by McConnell and Land's work, given the geographic and chronological gaps between the development of the two games, the sophisticated music engine used in *Realm Reborn* could be seen as the latest installment in a line of spiritual successors to the iMUSE concept.

15. One example of how interactive guidelines for music change as part of content releases can be found here: the combat music in the *Heavensward* expansion ("Melt," *Heavensward: Final Fantasy XIV Original Soundtrack*, Track 05, Masayoshi Soken) does not use the core combat motifs found in *Realm Reborn*.

16. This may help to extend the amount of time the player can spend within a zone without becoming consciously aware of the music: this helps maintain "inaudibility" of music as per Gorbman's (1987) principles of scoring film, which remains relevant to video game scoring.

17. For further discussion of "location-based cues" and "game-state cues" in RPGs, see Gibbons (2017).

18. *Before Meteor: Final Fantasy XIV Original Soundtrack*, Track 098, Nobuo Uematsu (composer) and Tsutomu Narita (arranger).

19. *Before Meteor: Final Fantasy XIV Original Soundtrack*, Track 099, Nobuo Uematsu (composer) and Tsutomu Nartia (arranger).

20. Music for "Steps of Faith" is credited as two separate tracks: "Faith in Her Fury" and "Unworthy," both of which are credited to Masayoshi Soken on *Before the Fall: Final Fantasy XIV Original Soundtrack*, tracks 058 and 059, respectively.

21. Further discussion of the functions of audio to alert players to changes within the dynamic state of games can be found in chapters 7 and 8 of Collins (2008).

22. "Dawnbound," *Stormblood: Final Fantasy XIV Original Soundtrack*, Track 012, Masayoshi Soken (composer and arranger).

23. The game originally contained over 120 tracks lasting a total of nearly seven hours. The music system continues to be expanded as part of their regular content updates, with most expansions including several hours of new music for use within the game.

24. At this point, readers may feel that there is some obvious solution to all of these problems that would work perfectly and *why hasn't this been done?* A slight sense of frustration that this obvious solution has been missed—by designers, researchers, players, or some combination thereof—seems likely and the sound of the resulting frustrated scream is already echoing between the pages of this book. It should be noted that, as with many things, the solutions to these issues discussed in this chapter are immensely more complicated to program during video game development than they are to set out theoretically. While they have been presented as relatively straightforward problems with simple answers, these issues and similar ones have plagued videogame developers since the first producer said "would it be difficult if…" and are, in fact, not simple at all to implement solutions for.

25. It perhaps goes without saying that if players never entered a shared space at all and simply experienced the game through a series of personalized instances, then the game could hardly be considered a "massively multiplayer online role-playing game" for the simple reason that a shared virtual world is the primary feature of an MMORPG, and using a series of personalized instances would, in effect, make the game experience single-player.

26. *ARR-OST*, Track 010, Masayoshi Soken (composer and arranger).

27. Players can become separated from the party at specific moments: e.g., a player dies or needs to return to a town to restock on supplies. Players who are not in the same geographical subzone as the party will revert to their own specific musical experience.

28. As players have variable load times, they inevitably will not have synchronized exploration music on first entering a zone. While the game client makes effort to unify the audial experience, it is not able to dynamically alter musical experiences to create synchronicity throughout zone loads. Instead, the music is synchronized as soon as is possible given the technical limitations (e.g., at the first cross-fade between interactive states such as entering combat).

REFERENCES

Collins, Karen (2008), *Game Sound: An Introduction to the History, Theory and Practice of Video Game Music and Sound Design*, Cambridge: MIT Press.

Collins, Karen (2013), *Playing with Sound: A Theory of Interacting with Sound and Music in Video Games*, Cambridge: MIT Press.

Gibbons, William (2017), "Music, Genre, and Nationality in the Postmillennial Fantasy Role-Playing Game," in M. Mera, R. Sadoff, and B. Winters (eds.), *The Routledge Companion to Screen Music and Sound*, New York: Routledge, pp. 412–27.

Gibbons, William (2019), "Song and the Transition to 'Part-Talkie' Japanese Role-Playing Games," in W. Gibbons and S. Reale (eds.), *Music in the Role-Playing Game: Heroes & Harmonies*, New York: Routledge, pp. 9–20.

Gorbman, Claudia (1987), *Unheard Melodies: Narrative Film Music*, London: BFI Publishing.

Grasso, Julianne (2020), "Video Game Music, Meaning, and the Possibilities of Play," PhD dissertation, Chicago: University of Chicago.

Griffiths, Daniel Nye (2013), "Square Enix Head Wada Steps Down: 'Extraordinary Loss' Predicted," Forbes, March 26, https://www.forbes.com/sites/danielnyegriffiths/2013/03/26/square-enix-head-wada-to-step-down-extraordinary-loss-predicted. Accessed September 10, 2020.

Hooper, Giles (2018), "Sounding the Story: Music in Videogame Cutscenes," in D. Williams and N. Lee (eds.), *Emotion in Video Game Soundtracking*, Cham: Springer International, pp. 115–42.

Medina-Gray, Elizabeth (2016), "Modularity in Video Game Music," in T. Summers, M. Kamp, and M. Sweeney (eds.), *Ludomusicology: Approaches to Video Game Music*, Sheffield: Equinox Publishing, pp. 53–72.

Messner, Steven (2017), "A Brief History of MMO Games," PC Gamer, July 28, https://www.pcgamer.com/uk/a-brief-history-of-mmo-games/. Accessed September 10, 2020.

Plante, C. (2017), "Why 'Final Fantasy XIV' Is in the *Guinness Book of World Records*," https://www.inverse.com/article/37691-final-fantasy-xiv-music-music-a-realm-reborn-masayoshi-soken-guinness-world-records. Accessed September 26, 2021.

Speakers Network (2016), "The Rise and Fall of *Final Fantasy XIV*," *YouTube*, December 10, https://www.youtube.com/watch?v=CJ9CmxaQ3q8. Accessed September 27, 2020.

Summers, Tim (2016), *Understanding Video Game Music* , Cambridge: Cambridge University Press.

Williams, Mike (2018), "*Final Fantasy XIV*'s Composer Was 'Literally Shaking' Listening to an Orchestra Performing His Music," Gamer, June 6, https://www.usgamer.net/articles/final-fantasy-xiv-orchestra-interview. Accessed September 10, 2020.

Yoshida, Naoki (2014), "*Final Fantasy XIV*: Behind *A Realm Reborn*," *Games Developer Conference 2014*, San Francisco, CA, March 17–21.

9

Music, Mediation, Memory:
Theatrhythm Final Fantasy

Julianne Grasso

Introduction

The year 2012 marked the 25th anniversary of the *Final Fantasy* (*FF*) series, whose first game was released in Japan in December of 1987.[1] Series producer Square Enix honored the occasion with a year-long celebration of sorts, hosting events across the globe that included concerts, art exhibits, contests, and television specials.[2] Part of Square Enix's commemoration of the series also included the development of a new kind of *FF* game, one different from any in the franchise thus far: a "rhythm-action" game titled *Theatrhythm Final Fantasy* (pronounced "theater-rhythm") for Nintendo's portable game console, the 3DS, developed by Japanese company indieszero.[3] As one might guess from a game genre designated "rhythm-action," the central interactive premise of *Theatrhythm* involves the rhythmic synchronization of one's actions in time with music: players wield a stylus upon the 3DS's touchscreen, using tap, hold, or swipe gestures in time with visual cues that align with the melody, accompaniment, and/or beat of the underlying musical track. This rhythm-action mechanic is not unlike other kinds of music games that test a player's sense of timing. For instance, performance games such as *Guitar Hero* (Harmonix 2005) rely on synchronized strumming on a guitar-like controller; dance games like *Dance Dance Revolution* (Konami 1998) require timed foot-taps on a dance mat (further examples abound).

 Theatrhythm sold well enough in 2012 to spawn a sequel, released in 2014: *Theatrhythm Final Fantasy: Curtain Call*, whose mechanics are largely the same as the first title, with an expansion of game modes. But what is particularly notable about both *Theatrhythm* games is that these rhythm-action mechanics are combined with a specialized repertoire of music. All of the playable stages in the *Theatrhythm Final Fantasy* games encompass music drawn from the combined soundtracks of prior

FIGURE 9.1: An FMS stage in *Theatrhythm Final Fantasy*, featuring objects and scenery reminiscent of the *FF* series (2012). Screenshot from Square Enix product website, North America (2020a).

FF games. The music derives primarily (but not exclusively) from the first thirteen numbered games of the series—in other words, the central releases of the franchise, *FF* (Square 1987) through *FFXIII* (Square Enix 2009).[4] Nobuo Uematsu's contributions to the franchise thus comprise the vast majority of selections.

In each playable stage in *Theatrhythm*, original soundtrack selections accompany a corresponding musical "scene" that features material from the original games. Familiar characters, objects, locations, and narrative cutscenes populate the game's visual design. Figures 9.1, 9.2, and 9.3 show screenshots of the game, demonstrating the artistic design and visual display of the game in its three primary modes of rhythm play (described in more detail further along in this chapter). While the design of the game adheres to an artistic style unlike a typical *FF* game, the scenes and characters are nonetheless legibly familiar.

Such familiar scenery certainly seems to be an appropriate design for a game release on the occasion of an anniversary. *Theatrhythm* looks and sounds like a digital time capsule for *FF*, a ludic celebration of the series' musical history—or perhaps, simply, its history. Indeed, in an interview about the 2012 release, Raio Matsuno, associate product manager for Square Enix, described how music is central to the series overall:

FIGURE 9.2: A BMS stage in *Theatrhythm Final Fantasy*, emulating the visual appearance of traditional *FF* battle sequences, with familiar characters, enemies, and positions on screen. Screenshot from Square Enix product website, North America (2020a).

FIGURE 9.3: An EMS stage in *Theatrhythm Final Fantasy: Curtain Call*, showing rhythm-based audiovisual cues atop a scene from *FFXI*. Screenshot from Square Enix product website, North America (2020b).

This is the 25th anniversary of a series that is filled with so many characters and memorable moments. And music is definitely one key pillar. [...] [The development team] wanted to do something that encompasses the whole brand, and the one thing they wanted to focus on was the music.

(Matsuno 2012)

Theatrhythm producer Ichiro Hazama further conveyed the particularly musically oriented sentimentality around *FF* in a press release for the sequel, *Curtain Call*, on Square Enix's product website:

Music is an integral part of the *Final Fantasy* experience that serves as a complement to the gameplay. As with the previous title [*Theatrhythm: Final Fantasy*], we envisioned a game where the music takes centre stage and the RPG gameplay enhances that experience. Our fans are definitely in for a treat as they'll be able to re-experience their favourite songs across the entire *Final Fantasy* catalogue.

(Square Enix 2020b: n.pag.)

By addressing an audience who has already played *FF* games, who are already "fans," Matsuno and Hazama both convey how the *Theatrhythm* games are not simply additions to the *FF* franchise. Rather, these games explicitly "mediate" experiences of memory—facilitating the remembering and "reexperiencing" of play. The *Theatrhythm* games are catered to an in-crowd of *FF* fans, using rhythm-action play to present music and summon up the experiences to which that music is connected. And while the 25th anniversary of the *FF* game series included plenty of special events and media, *Theatrhythm* was the only video game to receive a global release for the occasion, marking its musical gameplay as particularly significant.

This chapter considers *Theatrhythm Final Fantasy* along with its sequel *Theatrhythm Final Fantasy: Curtain Call*—henceforth referred to collectively as *Theatrhythm*—to explore what it means to "reexperience" video game music in a genre that places music itself on center stage. I argue that this shift in music from the background of play to music *for* play constitutes a kind of repackaging, or "remediation," of the *FF* series. This remediation is centered on the act of musical play that orients the player toward an ontology of *FF* that centers music as its key pillar. The rhythm-action mechanics of the *Theatrhythm* games call forth memories of play while also creating new ways to engage the series as a medium of musical gameplay.

First, I describe in more detail the "rhythm-action" play, or "mechanics," of *Theatrhythm*, explaining how the games both resemble and depart from the traditional role-playing game mechanics of *FF*. Using game mechanics as a central constitutive component of games, I describe the concept of mediation and

remediation in this comparison of *Theatrhythm* games and *FF* games, bringing in an analytical example from the first *FF* title and transcribing its rhythm-action play. Finally, I consider the ramifications of playing with memory, of this musically mediated reexperiencing of *FF*.

What constitutes a game? The mechanics of Theatrhythm *and* FF

Video game "mechanics" is a concept thrown about freely in game studies and game criticism, often eluding a clear, specific definition. In an article that addresses this problem of specificity, games scholar Miguel Sicart dives into the existing literature on game design as well as game analysis, emerging with an exceedingly broad definition that draws from video games' underpinnings in computer programing: "Mechanics are the methods invoked by agents designed for interacting with the game world" (Sicart 2008: n.pag.), where agents are human or computer, and methods are actions and behaviors. In other words, the concept of game mechanics entails how players (human or AI) are meant to interact with a game *as a game*. For instance, the act of "jumping" in a *Super Mario Bros.* game can be considered a mechanic. Meanwhile, turning a *Super Mario Bros.* game on or off is another kind of interaction with the game, but as an object rather than as a game. Games, as systems of rules, challenges, and interaction design, are experienced and enacted through play; play is constrained by the mechanics of a game. Sicart considers that this formalist definition of games is one common to game studies in defining an ontology of games (2008: n.pag.). In this ontology, a game's musical soundtrack is understood not as a formal component but rather as an aesthetic feature, superfluous to the underlying structure of interaction design and therefore separate from mechanics.[5] Of course, when music plays a more central role in interactive gameplay, as in *Theatrhythm* and other rhythm games, music is indeed implicated in mechanics and a game's formal structure—the main *FF* games, however, do not employ musical mechanics. Music is not inherently a formal feature of *FF*.

As Sicart further discusses, game mechanics are often understood to be hierarchical, as interactions vary in importance and frequency (2008: n.pag.). We can understand the notion of "importance" as the degree to which these various interactive mechanics lead to a game's "end state" or its ultimate goal. In this vein, game designers Katie Salen and Eric Zimmerman define a game's "core mechanic" as "the essential play activity players perform again and again in a game" (2003: 4). Again, the term "essential" is meant to refer to the kinds of interactions that can lead the player toward the end of the game. In games without a defined end state, such as many simulation games, discrete goals can be substituted for a single end

state for the purposes of this definition. Both "turning the game cartridge on or off" and "jumping" are common and repeatable actions in a game like *Super Mario Bros.*, but only "jumping" has the specific, goal-oriented capability of moving the player toward the end of the game—as its games are largely of the "platformer" genre, *Super Mario Bros.* entails varied topological landscapes that require the act of jumping for their successful traversal.

Most *FF* games—and all of the central numbered titles of the franchise—are largely of the "role-playing" genre: games that foreground exploration, strategy, and narrative progress with a group of playable characters. Even as other aspects of narrative structure and aesthetics vary from title to title, *FF* games share these genre characteristics and thus share generic mechanical features. Actions related to movement and text-based commands are constantly and consistently required in order to progress toward the end state. The player controls a group (referred to as a "party") of characters through the exploration of various world environments, fighting enemies along the way with commands given largely through menu-based text selection. By successfully defeating enemies, the party of characters gains points that increase fighting strength and health stamina, among other attributes such as defensive resistance and magical abilities. These battles are the central obstacles to progressing more of an unfolding narrative plot. In essence, *FF* games' mechanics are structured around three modes of play: exploration, fighting, and plot development. Core mechanics include movement through the world, selecting actions from menus, and reading narrative dialogue. Music, while omnipresent in *FF* games, typically offers aesthetic interest and affective framing of the game's actions and events, characterizing the world meaningfully but not usually participating explicitly in interaction design.[6]

As an example, let us take *FFVII* (1997), a title nearly halfway through the series as it currently stands. In the game, the player controls a party of characters on a quest to save the world from ecological disaster (among other issues) at the hands of an evil, fascistic corporation called Shinra. First controlling solely the central protagonist, Cloud (an ex-military mercenary figure with a very large sword), the player fights through battles and explores areas of the city of Midgar and its surrounding environment, gradually adding on to the party while progressing the ongoing narrative. Along the way, battles with Shinra agents and mythical monsters increase characters' attribute points and array of available skills, allowing players to inflict more damage with a greater repertoire of actions to choose from in battle menus. In addition to frequent fighting, gameplay is a combination of movements through Midgar and beyond, along with reading dialogue text as narrative elements unfold and details are revealed about characters, events, and motivations.[7] Accordingly, Nobuo Uematsu's celebrated soundtrack for the game frames these modes of play, with music for fighting, music for exploration, and

music for narrative events (typically in the form of character themes).[8] Each of the other central *FF* games, whether earlier or later than *FFVII*, offers slight variations on these three modes of play—each game features a different narrative universe, but similar and consistent enough to be identifiable as typical of the role-playing style of *FF* games writ large.

Theatrhythm offers players a way to experience (or "reexperience") *FF* mechanics with music in the foreground rather than the background, as ontologically central to the game's rules and systems rather than "just" an aesthetic and affective frame. In other words, *Theatrhythm*'s mechanics are musical, relying in some way on the player's attunement to musical materials in order to reach the goal, or end state, of the game.

Theatrhythm offers three modes of play that explicitly reference the three modes of play found in traditional *FF* games as previously described: exploration is portrayed in "Field Music Scene" (FMS) mode; battle is portrayed in "Battle Music Scene" (BMS) mode; and narrative is portrayed in "Event Music Scene" (EMS) mode. (*Curtain Call* adds two new modes, "Quest" and "Versus," but these are similar enough to the three primary modes of play and will not be explored separately in this chapter.) These three modes each use music that correspond to the different modes of play from the original *FF* games—but this time, the music is *essential* to gameplay mechanics. (Refer to Figures 9.1, 9.2, and 9.3 for representative screenshots of FMS, BMS, and EMS, respectively.)

Rhythm-action play is somewhat different between the three primary modes, but all three feature the same basic scheme: visual cues move across the screen, aligning with circular trigger points at a particular moment in musical time. At this alignment point, players must perform an indicated action—tap, hold, release, or swipe in a certain direction—which thus comprises the core mechanics of play. FMSs are depicted in a side-scrolling point of view. Cues appear across a single horizontal "lane," also delineating a path that the player's avatar (a character from one of the *FF* games) follows. Scenery, inspired by or directly derived from the landscapes of *FF* games, passes along in the background. The cue lane also follows a changing vertical contour (appearing to move up or down on the screen) and players must also follow this contour in time. Failing to follow the correct cues in time, at the correct position on the screen, can cause the character to trip and even fall, potentially failing to reach the end of the stage's journey (where they are typically greeted by another *FF* character who carries with them a treasure box). Thus, FMS enacts a distinctly musical journey through *FF* scenery.

BMSs are also depicted in a left-to-right scrolling point of view, this time with four horizontal lanes that correspond to four characters in the player's "party," in traditional *FF* fashion. Each character is displayed behind a circular trigger point, and the player must scan all four lanes at once to determine where and when the

side-scrolling cues will align with the trigger points (in this mode, the vertical position of the stylus is not taken into account). Each well-timed, correct action elicits an attack on the enemy that faces your party on the left side of the screen. Each missed cue allows an enemy attack against your party, too many of which lead to failure in the form of a lost battle. BMS thus enacts a traditional *FF* turn-based battle sequence, replacing menu selection with timed interactions and invoking musical parameters to "attack" and "defend."

EMSs use a single lane for cues and alignment triggers, but it is both horizontal and vertical, as cues move around the screen in any direction, rather than left to right, and may also change speed without notice. The position of the stylus does not matter here—only proper timing and the correct action in the midst of inconsistent movement of the cue. EMS is portrayed in a top-down view, with relevant *FF* narrative scenes playing out in the background as musical themes—ones narratively important in the original game—are heard. If the player misses too many cues, the music and scene simply stop. If the player is particularly successful with a high rate of accuracy and precision, they can unlock an additional portion of the musical track along with additional background scenes before ending the sequence. EMS literally foregrounds thematically significant music in front of their corresponding scenes, reversing the notion that this music is "background" as we might understand it in the original *FF* games.

In each of these three modes, music, particularly musical rhythm, is a mediating force to accessing familiar *FF* materials. Thus, there are two simultaneous conceptions of the ludic spectrum of "success" versus "failure" in *Theatrhythm*, diagrammed in Figure 9.4. On the one hand, dexterity, timing, and precision in rhythm play lead to a successful completion of the music as a fully realized track, where inadequate play leads to a premature end of the musical track. This is a common feature of rhythm, music, or dance games: the music simply stops if the player cannot keep up. On the other hand, this rhythm play also projects the traditional game modes—and traditional mechanics—of *FF* games: exploration, fighting, and narrative progress. Success is found in the completion of the journey, the vanquished enemies, and the fully realized narrative scene. In essence, it is only through skillful rhythm play that players can "reexperience" to the fullest extent the "scenes" of play from the *FF* series.

Furthermore, *Theatrhythm* not only replicates traditional *FF* modes of play but also frames these modes with a larger, broad narrative goal specific to *Theatrhythm* (but also a trope in the franchise): as players successfully complete stages, they obtain points called "Rhythmia," which restores light to a "Crystal." Players form a party of characters that act as avatars in their rhythm quest, and these characters earn experience points just as traditional *FF* characters would. This larger goal provides a structure for player progression that exceeds what we might call

FIGURE 9.4: A partial screenshot of the Square Enix store website (2020b) for *Theatrhythm Final Fantasy: Curtain Call.*

TABLE 9.1: Mapping success and failure in *Theatrhythm Final Fantasy* compared with traditional *FF* games.

Theatrhythm stage completion	Corresponding *FF* projection
Music plays through to its end (ludic success)	Journey/exploration is completed Enemies are totally vanquished Scene is fully realized
Music ends prematurely (ludic failure)	Journey/exploration ends prematurely Battle ends prematurely Scene ends prematurely

a "jukebox" model of music game, where players can pick and choose from any musical track to play for its inherent enjoyment, isolated from some larger goal. *Theatrhythm* is meant to resemble *FF* not simply as a retrospective trip down memory lane but through interactive mechanics and game structure that give players a sense that they are also "playing" a true-to-form *FF* game.

Theatrhythm thus presents a particularly interesting ontological argument for those concerned with mechanics as constitutive of a game. Is *Theatrhythm*

closer to a traditional *FF* game than a traditional rhythm game? Raio Matsuno alluded to this slippage in that 2012 interview: "What you think of *Final Fantasy* is actually in this game. All the characters have stats [...] your characters level up, gain new abilities and they actually do help you in each of the [rhythm] game modes". The only essential difference is that rhythmic timing dominates the mechanics: instead of guiding movements of a character, choosing fighting commands, or reading through dialogue, players progress through the game—to an end state—by precisely timed stylus gestures. Players thus experience *Theatrhythm*—and all of its allusions to traditional *FF* games—through the mediation of rhythm mechanics. The next section further explores how this mediation—or "remediation"—can be understood as part of a broader trajectory of new media that nonetheless finds a unique place in *Theatrhythm*.

Remediation: Redefining FF through rhythm mechanics

I use the term "remediation" as derived from a definition put forth by Jay David Bolter and Richard Grusin in their now-classic text *Remediation: Understanding New Media* (1999). In its simplest form, remediation refers to the ways in which new media builds and comments upon older forms of media. Film can be seen to remediate the novel inasmuch as a film tells a story using a different kind of audience engagement (most simply using screen images and sound instead of written text on a page). Video games can be seen to remediate film as their inherent interactivity with screen images and sound expands upon the particular limitations of the movie theater. Instead of understanding new media through a cycle of upgrades, replacements, and the obsolescence of older media, we can instead see media as more circular, borrowing from one another and creating even more forms of mediation. In this sense, video games do not replace the film but rather multiply its potential through remediation, and in turn, film might look toward games in its own cycle of remediation: for example, "[i]n an effort to create a seamless moving image, filmmakers combine live-action footage with computer compositing and two- and three-dimensional computer graphics" (Bolter and Grusin 1999: 6). Consider as well the increasingly popular interactive shows and movies that allow viewers to choose multiple branching narrative options, a feature that mimics games. Of course, such branching narrative is not a new form of mediation but rather draws from the popular "Choose-Your-Own Adventure" novel and other forms of improvisatory media that well predate film, let alone video games. Bolter and Grusin focus on this circular logic of remediation in new media:

[N]ew media are doing exactly what their predecessors have done: presenting themselves as refashioned and improved versions of other media. Digital visual media can best be understood through the ways in which they honor, rival, and revise linear-perspective painting, photography, film, television, and print. No medium today, and certainly no single media event, seems to do its cultural work in isolation from other media, any more than it works in isolation from other social and economic forces. What is new about new media comes from the particular ways they refashion older media and the ways in which older media refashion themselves to answer the challenges of new media.

<div align="right">(1999: 14–15)</div>

The authors further define what they call the "double-logic" of remediation: media commonly cobble together and multiply other media (hypermediation) while striving toward an experience of immediacy, "seek[ing] to put the viewer in the same space as the objects viewed" (Bolter and Grusin 1999: 6). The use of computer graphics in film, as mentioned above, is one example of this phenomenon of the double-logic of remediation: in the quest for increasingly high-fidelity experience, *more* media, not less, comes into play.

Bolter and Grusin point to video games as particularly remediated forms, arguing that video games can be considered to variously remediate books, film, and even the medium of video surveillance, as many games require players to scan the visual field of the screen for various kinds of signals. Role-playing video games like the *FF* series remediate fantasy table-top RPGs, which themselves can be considered remediations of Tolkienian fantasy texts. A table-top game like *Dungeons & Dragons* tells a fantastical story through interactive collaboration and rolls of the dice. Games like *FF* place such stories on a screen, altering the interactivity to fit the computational system of a video game, adding in layers of media (the console, the screen, the controller, the graphics, the sound, etc.) to facilitate a more "immediate" experience of the fantasy text. Indeed, Bolter and Grusin describe video game mechanics as part of this remediation, referring to mechanics instead as "functions" (likely due to the same kind of definitional vagueness that Sicart wrote about in his essay). Speaking mostly of early action and shooting games in which the player's main task is to scan the screen for enemies, Bolter and Grusin describe how the development of three-dimensional graphics changed the notion of space on screen, what video games could accomplish, and what players could *do*. "Designers could then make games remediate not only monitoring function of all video, but also the narrative functions of television and film" (Bolter and Grusin 1999: 94). In this way, video game mechanics are part and parcel of a remediative process, as interactivity is the central engagement with games as a form of video media.

Theatrhythm demonstrates a number of processes of remediation of other forms, the full scope of which would not be possible to cover in this chapter. As a video game, it remediates other screen-based media in the broadest sense—film, television, and so on—as described above. As a video game that uses a touchscreen, it remediates other forms of video games by allowing a kind of literal immediacy between player and screen that forgoes a separate controller or joystick. And in the true sense of the double-logic of remediation, by wielding the screen for this sense of touch immediacy, the game simultaneously *adds* the physical interface of the screen in a form of hypermediation.

Aesthetically, and as is evident in the titles of *Theatrhythm* and *Curtain Call*, the games remediate staged theater. *Theatrhythm* presents each gameplay stage as a literal stage, on which scenes from the *FF* games are played out, as if a part of a literal play (see Figure 9.4). *Theatrhythm* uses the idea of the theater as a medium of not just narrative presentation but also narrative "projection," relating to how a stage play projects a world and a story beyond the spatial and material limits of the stage in the theater itself. It is a comment on how *Theatrhythm* is not, itself, a literal amalgamation of *FF* games but rather something more magical: an interactive staging of memories projected through music.

Most important to this chapter is how game mechanics are remediated through the *Theatrhythm* games, thereby facilitating a new engagement with familiar *FF* materials. Music, and specifically musical mechanics, is one of the additional media by which *Theatrhythm* constitutes a remediation of the *FF* series and the process I focus on here. In order to dig into music as a mechanic and as a medium, I draw on several works of scholars who have studied rhythm games and their mechanics.

Rhythm mechanics as mediation

Music theorist Peter Shultz has described how players of rhythm games like *Rhythm Heaven* rely on a "rhythm sense" to play accurately, inasmuch as video games also rely on visual, auditory, and tactile senses (Shultz 2016). In *Rhythm Heaven*, players attend to audiovisual cues in each level, pressing the right buttons or using the correct gestures at the proper time. This is similar to the mechanics of *Theatrhythm*, which also relies on audiovisual cues tied to its musical tracks. Rhythm games, Shultz describes, "block audiovisual cues to encourage players to orient themselves by means of entrained pulses, and they organize their levels into grooves that players can learn to 'feel'" (2016: 264). This rhythmically oriented "feeling" defines rhythm games as more than just their methods of interaction, but also by the physiological and psychological ways in which players attune to the

environments of these games at large. In other words, rhythm games allow for a player's "rhythm sense" to come to the fore in a way that might mirror a musician feeling the groove as they perform on their instrument, for example. As much as a player needs to "hit the right button at the right time" in an instance of rhythm gameplay, players of other kinds of games might *also* develop a rhythm sense for broader aspects of play. Precision of timing is, after all, a part of many games, including the traditional *FF* series (think of any AI competitors, for instance, that may move in a particular pattern to which players must attune to predict their actions). *Rhythm Heaven* and *Theatrhythm* are games that use music, specifically, to key into this sense of rhythmic timing—a skill that comes in handy in nonrhythm games. Music, then, is a medium for rhythmic attunement, a way of providing a kind of immediacy to a groove of play that might otherwise be more difficult to tap into (say, if one were to play with just visual cues and mute the music).

Steven Reale (2014) has described similar aspects of rhythmic mechanics in various games such as *BIT.TRIP RUNNER* and *Guitar Hero*, focusing more on conceptual questions of the interactive "musical object" as it varies between genres of game. Reale discusses how the "ideal musical object" (IMO) is enacted only when players are successful within whatever rules and parameters the game indicates: in *Theatrhythm*, the full musical track does not reach completion unless the player reaches a minimum threshold of well-timed actions. How can we understand indeterminate and player-dependent game soundtracks as interactive musical objects in the same way that we might understand musical levels in a rhythm game? Indeed, Reale considers games that are not classified as rhythm/music, but whose musical elements nevertheless entail a kind of IMO that is only heard when players perform the correct actions. Examining the detective action-adventure game *L.A. Noire*, Reale describes how the soundtrack's musical cues indicate to the player states of success and failure, thereby constituting an IMO that is realizable through player interaction.

While Shultz's "rhythm sense" describes a form of immediacy of experience that is provided by rhythm mechanics, Reale's concept of an IMO offers another avenue for understanding the hypermediacy of music in a game like *Theatrhythm*. Bringing music, and particularly musical rhythm, to the forefront of play also necessarily implies that the music from *FF* is transformed into potential IMOs. In this remediative process, music shifts from a background aesthetic feature in *FF* to a medium of interactive play in *Theatrhythm*, now subject to ludic logics of "success" and "failure" on the part of the player.

To examine this transformation more closely, I have made an annotated transcription of a few bars of music as appearing in one example of a "BMS" in *Theatrhythm*. Example 9.1 shows a transcription of the first six measures of the battle theme from the first *FF* title, overlaid with a transcription of rhythm

TABLE 9.2: An adaptation of Figure 9.4, focusing on the correspondences between music for exploration in *FF* and *Theatrhythm*'s "FMS" stage.

Music in *FF*	*Theatrhythm* stage completion (FMS)	Corresponding *FF* projection
Field music with affective elements of hopeful adventure	Field music as "ideal musical object" plays through to its end (ludic success)	Journey/exploration is completed

gameplay: symbols that demonstrate the timing of actions and what those actions are. All three levels of difficulty are transcribed for comparison and are demonstrative of the central differences of play between levels of difficulty.

The three levels of difficulty show an increased frequency of required actions in the gameplay score, while the sounding music remains the same. In these six measures, players must complete eight actions at the Basic level, fourteen actions at the Expert level, and eighteen actions at the Ultimate level. In addition to an increased rhythmic density with higher difficulty level, variety of actions also increases slightly: in the same few measures, Basic requires four different actions: tap, left-swipe, hold, and release. Expert level requires five: tap, hold, release, up-swipe, down-swipe. Ultimate also requires five: tap, hold, release, left-swipe, and up-swipe, but the up-swipe is compounded with the tap-hold in measure 6, marking an increase in gestural complexity that is more difficult to master.

This scaling of difficulty seems to make perfect sense—more actions, and greater variety of actions, are more difficult to land with precision and accuracy. The IMO of this battle track is thus easiest to enact in Basic mode. But we can also look to the more musical aspects of this score, noting where in the music the actions occur for deeper insight into the experience of playing through this stage as musically mediated. At the Basic level, actions occur primarily on the beat of the underlying 4/4 meter—in other words, on beats 1, 2, 3, and 4. Given that the first beat of each measure contains the strongest metrical accent in this music, it is no surprise that there is a designated action for beat 1 of each measure. Actions on beats 2 and 3 are equally distributed, and there are no actions to be completed on beat 4 of any measure, the weakest metrical accent. As the top line of music ("1") conveys the melody, arguably the most salient component of the music, most actions also correspond with a note onset from the melody. (But there are too many notes to follow them all—at least in Basic mode.) Furthermore, it is notable that the "release" action in m. 6 is taken on beat 3, which corresponds to a relatively

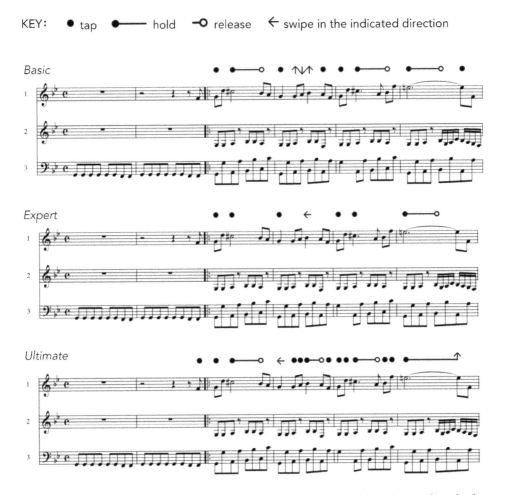

EXAMPLE 9.1: Annotated transcriptions of the first six measures of "Battle" in *Theatrhythm Final Fantasy*, originally from *FF* (1987). The "score" for player actions is notated as dots, lines, and arrows (see key) aligning with each measure in common (4/4) time.

strong underlying beat (and accompaniment) even though no changes occur in the melodic line.

Now, let us compare this beat-centric score with the score for the "Ultimate" level of difficulty (Expert level lies somewhere in between these two modes). Compared with Basic, the actions required for Ultimate follow the top melody line quite closely, featuring many actions that are both on and in between the metrical beats to correspond with melodic note onsets. This continues in m. 6, where the "release" action is moved from the strong metrical accent of beat 3 to the weak accent of beat 4, where the melody releases its hold as well.

At Basic difficulty, the game is truly a rhythm game in the sense described by Peter Shultz and others: players literally tap into a rhythm sense, entraining to the groove of the music, through its metrical framework, in order to accurately complete actions at the right time. But Ultimate difficulty overrides the groove and instead relies on a familiarity with specific musical parameters, focusing on the rhythmic contours of melodic lines that may or may not align clearly with the groove. Certainly, players should also be attuned to the underlying beat, but it is truly only through knowing the music quite well that players can be successful at the Ultimate level.

Thus, there is a fundamental difference in realizing the IMO between the "Basic" level of difficulty and "Ultimate," more than simply gestural complexity: if players have a good sense of rhythm but know nothing of *FF*, enacting the IMO is still quite possible at the Basic level. But players need a good sense of *FF* music specifically to enact an IMO at the Ultimate level. In other words, it is a test of musical familiarity, of your level of fandom: how well do you really know your favorite *FF* tunes? Placing this kind of "test" at the hardest end of the difficulty spectrum is an implicit argument that specific music familiarity is the highest skill one can achieve in this game, the "Ultimate" goal, not simply a well-attuned sense of rhythmic precision. This particular conflation of rhythm play and musical memory was alluded to in Robert Peeler's 2012 interview with Raio Matsuno:

MATSUNO: Anyone who is a casual rhythm fan can enjoy this game. But the people that get the most out of rhythm games by challenging themselves with the most grueling levels can definitely do that in this game.

PEELER: Or even just a really hard-core *Final Fantasy* fan: "I know this song, I can do this in my sleep."

(Matsuno 2012)

Peeler's conflation with musical familiarity and *FF* fandom writ large is the essential ludic argument of *Theatrhythm*: the music is the key to play. As *Theatrhythm* is both a challenge of rhythm skills and of *FF* familiarity, its particular processes of remediation are not simply relevant to its status as a novel visual medium, but also as a marker of fandom, a purveyor of memories.

One of the most accessible modern repositories for accessing such memories is the video upload site YouTube. There, hundreds of thousands of video game clips are uploaded (whether legally or not), including uploads of video game music alone, with no visual context. On these videos, viewers frequently comment on their personal memories of the game as heard through the music, along with demonstrating their appreciation for the music itself. Below is a small sampling of YouTube comments of uploads of *FF* music.

On an upload of the track "The Decisive Battle" from *FFVI* (abcdefghijklmnopqrmm n.d.): Jason-RPG writes, "Nobuo Uematsu is legendary. Enough said. xD" (2014). Marcos Vinicius writes, "Love this music theme [...] reminds me the old days more than 15 years ago" (2017). Other comments are often direct references (in this case, of boss battles once fought to this very music). On an upload of the "Main Theme" from the first *FF* (YoshiOSTs 2008), Car Buncle writes, "If you are a fan of Final Fantasy you know what this theme means to you" (2016). Larry the Gamer Guy comments, "It really puts the player in the mood to go on an adventure9" (2014). And arjun220 writes, "as a kid back in the day I watched my dad play final fantasy 1, I enjoyed watching the game while I'm playing with my toys [...] such memories!" (2016).

In the case of arjun220, this listener had not played the game themselves. Nonetheless, the music still unlocks aspects of a nostalgic memory (their father playing the game while they played with toys nearby). Clearly, this music holds a lot of meaning for many players, even divorced from its original context and uploaded as sound files on the internet.

William Gibbons and I have argued that *FF* music has become so beloved partially due to musical repetition (Gibbons and Grasso 2020) and that the franchise as a whole has wielded varying types of musical repetition to its advantage: *FF* games, especially the earlier titles in the series, feature (1) musical tracks that include internal repetitions (looping), (2) repeating use of discrete musical tracks in different places or situations throughout the same game, (3) repeated themes between games, and (4) music played and replayed beyond the games (including *Theatrhythm* as a large-scale form of musical repetition). Placing music aside for a moment, games as forms typically rely on repetition and repetitiveness—recall Salen and Zimmerman's definition of mechanics as actions that are done "again and again." *Theatrhythm* does not simply have repetitious music; it uses the inherent repetitiousness of play: stages are completed over and over again until (and sometimes after) they are successfully cleared. Such repetition likely only further instills these tunes in players' heads (and potentially helps sell concert tickets to now-popular *FF* symphony concerts worldwide).

Indeed, the affinity and familiarity that players obtain in their memories of *FF* seem to offer a certain ludic draw to *Theatrhythm* as a way of accessing one's personal "greatest hits." Matsuno described his personal experience playing his favorite *FF* track in *Theatrhythm*:

> "The Decisive Battle" in *Final Fantasy VI*, which I can only beat one out of five times in this game on the hardest level [...] it kinda gets to you when it's your favorite song and you can't beat [it], but it's great that way [...] it just gives you that willingness to keep playing.
>
> (Matsuno 2012)

Matsuno's comment returns us to the concept of remediation, turning to the ways that such engagement with this media can be experienced personally. Bolter and Grusin describe the ways in which a person may experience this process of remediation, primarily through the double-logic of "seek[ing] that immediacy through the acknowledgement and multiplication of media" (1999: 229). Indeed, such immediacy is considered a means of seeing *ourselves* in the media that we consume:

> When we look at a traditional photograph or a perspective painting, we understand ourselves as the reconstituted station point of the artist or the photographer. When we watch a film or a television broadcast, we become the changing point of view of the camera. When we put on the virtual reality helmet, we are the focus of an elaborate technology for real-time, three-dimensional graphics and motion-tracking.
>
> (Bolter and Grusin 1999: 213)

And when we play a game like *Theatrhythm*, we embody the characters that move through music as a medium of play and of the memories of play.

The authors point to a difference between immersive digital media (like many video games, particularly those with virtual reality capabilities and perhaps to some extent the 3D capabilities of the Nintendo 3DS) and hypermediated digital media (such as the internet). In the way that checking one's e-mail is quite different from immersing oneself in rhythm play, "networked environments [suggest] a definition of self whose key quality is not so much 'being immersed' as 'being inter-related or connected.' The hypermediated self is a network of affiliations that are constantly shifting" (Bolter and Grusin 1999: 232). It is this networked self at play in a game like *Theatrhythm*, which is indeed less of an immersive digital environment and more like a hypermediated set of interactive features predicated on musical rhythm and reliving memories. On the one hand, *Theatrhythm* (and more specifically *Curtain Call*) encourages online networking and competitive play in battle modes and "cards" that can be passed to nearby players—the more literal definition of a network. On the other hand, *Theatrhythm* by its very nature encourages an awareness of one's relationship to *FF* as a franchise and of the broader community of fans that come together through the music. Bolter and Grusin state,

> The remediated self is also evident in "virtual communities" on the Internet, in which individuals stake out and occupy verbal and visual points of view through textual and graphic manifestations, but at the same time constitute their collective identities as a network of affiliations among these mediated selves.
>
> (1999: 232)

See, for instance, the much-upvoted comments on YouTube uploads of video game music, a network of game players and fans meeting in a separate (but still virtual) space. This sets the player's identity as a rhythm player (and *FF* fan) in relationship with others through their specific set of skills in this game. On the other hand, there is a different set of "network" at play here, one that connects interrelated experiences within oneself. To engage with *Theatrhythm* as a new-comer to *FF* enacts a different kind of self than playing as a life-long fan. The life-long fan seeks out favorite games and favorite tunes to play, honing their familiarity, proving their knowledge, and enjoying a musically mediated trip down memory lane.

Conclusion

The promise of *Theatrhythm*, as mentioned in the introduction to this chapter, is that players can "reexperience" their favorite moments from the *FF* series. Indeed, the store website for the 2012 title led with a provocative all-caps tagline: "PLAY BACK YOUR AWAKENED MEMORIES." Such statements regarding gameplay are promises of a kind of immediacy that *Theatrhythm*'s rhythm mechanics can offer to players as they experience their "awakened" memories. In turn, *Theatrhythm* displays its double-logic of remediation by using music as an additional mediating force for these memories (where music was not used as such in the original games). I called *Theatrhythm* a kind of "digital time capsule" as it features music, characters, items, enemies, and other familiar *FF* features drawn together in one place. I also called it a "trip down memory lane." But that is not the whole story of *Theatrhythm*—it is still a game, with challenges, points, ways to succeed, and ways to fail. It is this ludic nature of *Theatrhythm* that makes our interaction with the music of *FF* different from that of an audience at, well, the theater. Whether a player's favorite moments were poignant storylines in "event" mode, tough enemies in "battle" mode, or simply the joy of wandering in "field" mode, play is figured as a familiar experi-ence with new mechanics. Instead of strategic fighting choices or movements over a map, for instance, such "decisions" are made through the mechanics of rhythm—success relies on the proper button presses in time with music and accompanying visual symbols displayed on screen. In its remediative processes, *Theatrhythm* claims an immediate path to memory, something inherently medi-ated by time. In other words, musical play is slated to transport us back to a different, prior experience. Perhaps, in a way, the games claim memory itself as a medium of play.

NOTES

1. Square Enix games were typically released first in Japan, followed months or years later by a broader release. The first *FF* was released in Japan in 1987, followed by its release in North America three years later in 1990.

2. Not only was the 25th anniversary the only anniversary celebrated by Square Enix through promotional events and merchandise, but it was also the only one to involve a dedicated music game. In 2007 (the twentieth anniversary), Square Enix developed a number of remakes of older games, along with the 2008 release of *Dissidia Final Fantasy*, a PlayStation Portable fighting game bringing various *FF* characters together in one-on-one combat. (Incidentally, *Dissidia* centers on a conflict between "Harmony" and "Discord," despite not being a music game!) For the 30th anniversary in 2017, the celebration was primarily promotional for several new games, including *FFXV*. The year also coincided with *FFVII*'s own twentieth anniversary, commemorated further with sneak-peeks of the upcoming remake.

3. *Theatrhythm Final Fantasy* would be released again for Apple mobile devices a few months after the Nintendo 3DS release. The sequel, *Theatrhythm Final Fantasy: Curtain Call*, was released in 2014 for the 3DS only (as of this writing). A similar game was developed to commemorate the *Dragon Quest* games (originally an Enix series before the Square–Enix merge) titled *Theatrhythm Dragon Quest*, released in 2015. The arcade variant for *Theatrhythm Final Fantasy*, titled *Theatrhythm All-Star Carnival*, was released only in Japan in 2016.

4. Each of the *Theatrhythm Final Fantasy* games includes tracks from spin-off or sequel titles, such as *FFX-2* (2003), and similar Square Enix games like *Chrono Trigger* (1995), which was primarily composed by Yasunori Mitsuda but featured significant contributions by Nobuo Uematsu. Typically, these extra games are cast as secret, unlockable stages rather than the central, essential stages in the game.

5. Nonetheless, much research and writing on video game music demonstrates how music is not superfluous, even when music is not a central, formal feature of video games. For example, one of the most studied effects of music is its immersive capabilities—how "background" music shapes a player's mental and physical engagement in a game's virtual world(s). Karen Collins, a music and interactive sound scholar, details many facets of this phenomenon. See Collins (2013).

6. Of course, there are a number of idiosyncratic "mini-games" and other musical moments in the *FF* series in which music plays a somewhat more prominent role. Likely the most cited example of this is the opera scene from *FFVI*, a sequence of musical numbers that involve player interaction. However, music does not explicitly guide player action—text and visual cues offer guidance through the opera's various acts. Furthermore, as touched upon in note 5, scholars have convincingly argued that music implicitly guides a player's interactions. For example, Sean Atkinson has argued that musical tropes in the airship music from *FFIV* foreshadow narrative events and thus affect player interactions with the game (Atkinson 2019). Nonetheless, *Theatrhythm* games are far more explicitly musical, and, as this chapter demonstrates, provide players with a special kind of musically mediated play.

7. For more on the particular kinds of musical framing typical to role-playing games, see Gibbons (2017: 418).
8. In 2013, Uematsu's soundtrack for *FFVII* reached number 3 on a popular-vote poll of "best classical music" by UK-based radio station ClassicFM. See ClassicFM Hall of Fame (2013).

REFERENCES

abcdefghijklmnopqrmm (n.d.), "*Final Fantasy VI*: The Decisive Battle Extended," YouTube, https://www.youtube.com/watch?v=Qjw35-qkb_s. Accessed June 20, 2020 [no longer available].

Atkinson, Sean E. (2019), "Soaring through the Sky: Topics and Tropes in Video Game Music," *Music Theory Online*, 25:2, https://mtosmt.org/issues/mto.19.25.2/mto.19.25.2.atkinson.html. Accessed August 17, 2020.

Bolter, Jay David and Grusin, Richard (1999), *Remediation: Understanding New Media,* Cambridge: MIT Press.

ClassicFM Hall of Fame (2013), "*Final Fantasy* Series (Including To Zanarkand, Aerith's Theme, Opera Maria and Draco, Kefka's Theme, Dancing Mad, One-Winged Angel): Nobuo Uematsu," https://halloffame.classicfm.com/2014/chart/position/7/. Accessed September 28, 2020.

Collins, Karen (2013), *Playing with Sound: A Theory of Interacting with Sound and Music in Video Games*, Cambridge: MIT Press.

Gibbons, William (2017), "Music, Genre, and Nationality in the Postmillennial Fantasy Role-Playing Game," in M. Mera, R. Sadoff, and B. Winters (eds.), *The Routledge Companion to Screen Music and Sound*, New York: Routledge, pp. 412–22.

Gibbons, William and Grasso, Julianne (2020), "'And So It Goes, On and On': Repetition in the Music of *Final Fantasy*," in A. Bean (ed.), *Surpassing the Limit Break: The Psychology of* Final Fantasy, Dallas, TX: BenBella Books, pp. 43–60.

Harmonix (2005), *Guitar Hero*, Mountain View, CA: RedOctane.

Konami (1998), *Dance Dance Revolution*, Tokyo: Konami Co.

Matsuno, Raio (2012), interviewed by Robert Peeler, E3 Interview, June 8, https://www.youtube.com/watch?v=5gx6eogD6x8. Accessed June 24, 2020.

Reale, Steven (2014). "Transcribing Musical Worlds; Or, Is *L.A. Noire* a Music Game?," in K. J. Donnelly, W. Gibbons, and N. Lerner (eds.), *Music in Video Games: Studying Play*, New York: Routledge, pp. 77–103.

Salen, Katie and Zimmerman, Eric (2003), *Rules of Play: Game Design Fundamentals*, Cambridge: MIT Press.

Shultz, Peter (2016), "Rhythm Sense: Modality and Enactive Perception in *Rhythm Heaven*," in M. Austin (ed.), *Music Video Games: Performance, Politics, and Play*, New York: Bloomsbury, pp. 251–73.

Sicart, Miguel (2008), "Defining Game Mechanics," *Game Studies*, 8:2, http://gamestudies. org/0802/articles/sicart. Accessed June 24, 2020.

Square Enix (2020a), "Theatrhythm Final Fantasy," https://store.na.square-enix-games.com/ en_US/product/281388/theatrhythm-final-fantasy-3ds. Accessed June 24, 2020.

Square Enix (2020b), "Theatrhythm Final Fantasy: Curtain Call," https://square-enix-games. com/en_US/games/theatrhythm-final-fantasy-curtain-call. Accessed June 24, 2020 [no longer available].

YoshiOSTs (2008), "FF1: Main Theme," YouTube, June 7, https://www.youtube.com/watch?v= Aua4qZwW29k. Accessed June 20, 2020.

PART 4

THE WORLD OF BALANCE

10

Feminine Themings:
The Construction of Musical Gendering
in the *Final Fantasy* Franchise

Thomas B. Yee

Introduction

[I]n the world of traditional narrative, there are no feminine endings.
(McClary 2002: 16)

This chapter explores gender representation in the *Final Fantasy* (FF) franchise, warranting an important disclaimer. I am not a woman, which shapes my analysis of gendered elements, musical and otherwise. While I believe that men can productively contribute to gender studies, I acknowledge that my interpretation of gender representation arises from a different lived experience than my women peers and readers, who experience the effects of gendered media culture directly. Thus, I welcome differing perspectives on the following character analyses and wish I could dialogue with them.

A comparative case study of two prominent heroines from the *Star Wars* film franchise serves as an illustrative starting point. The original trilogy's Princess Leia and the recent trilogy lead Rey are strikingly differentiated by multiple aesthetic and narrative factors, including their musical themes. The heroines' musical themes participate with other factors in conveying crucial aspects about each one's character and narrative role. The iconic "Leia's Theme," composed by John Williams, contains Romantic-era style and chromaticism, with predominant instrumentation of lush strings, flute, oboe, and the occasional French horn. Its melody is elegantly lyrical, rising and falling in balanced motivic repetition—except when rapidly ascending via fragmentation to a climax suggestive of an unbridled burst of romantic passion. The cue's initially delicate accompanimental textures yield

to a climactic orchestral tutti featuring expressive rubato, a soaring high string melody, and chromatically inflected major-mode harmonies. Narratively, Leia functions "primarily [as] an enabler for [the] male characters" like Luke Skywalker and Han Solo, serving their development arcs over her own through ceremonial recognition of their achievements (Bruin-Molé 2018: 227). In another example, Diana Dominguez observes that Leia places Luke's grief at the death of his aunt and uncle over her own after the total destruction of her adoptive family and home planet (Harrison 2019: 3). Though Leia repeatedly demonstrates her strength and competence, these feats are often undermined by problematic treatment elsewhere. For instance, Rebecca Fülöp recalls the impact of first witnessing Leia's infamous gold bikini scene at age 15:

> This iconic moment from *Return of the Jedi*, while contributing nothing vital to the plot, sums up quite succinctly the purpose of the character played by Carrie Fisher [...] the infamous gold bikini reminds us that alongside any of her empowering qualities, Leia also functions as an object of sexual desire and romantic pursuit. In this realm she demonstrates little self-contained purpose, for she is largely defined by her relationships to the male characters around her [...] Forced to wear the skimpy gold bikini, she serves as titillating eye candy for the villainous Jabba the Hutt and audience members alike in the final film of the original trilogy.
>
> (2012: 1–2)

Leia's music, like the gold bikini, paints her as an objectified caricature rather than a nuanced character in her own right, drawing audience attention to her "feminine rather than heroic attributes" (Fülöp 2012: 3). Later, Leia's theme is interwoven with music associated with Han or Luke, subordinating her to the male protagonists as an "essentially romantic and decorative character" (Fülöp 2012: 4). Though Leia's potential as an empowered heroine—and actress Carrie Fisher's feminist legacy—is noteworthy, the hopeful glimmers of positive gender representation are ultimately suppressed by narrative and music alike.

Introduced nearly forty years after *A New Hope*, Rey "transformed the franchise" as its first female lead protagonist, promising greater demographic diversity to fans alongside racially diverse protagonists like Finn and Rose (Harrison 2019: 1). After Disney acquired *Star Wars* in 2012, the series was "widely praised for its feminism," with Rey and fellow heroine Jyn Erso (*Rogue One*) being "hailed as feminist triumphs" (Bruin-Molé 2018: 225). "Rey's Theme"—also composed by John Williams—strikes a radically different style and tone that contrasts "Leia's Theme" at every turn. Rather than Romantic-era traits, the style of Rey's music is best described as minimalist in structure and rhythmic drive. Instrumentally, the theme's low-register flute/string ostinato and foregrounded brass-family chorale

subvert conventional female-theme patterns. The cue exhibits broadly Dorian-modal harmony, relatively constrained melodic range, and an overall lack of chromaticism that differs sharply from Leia's theme. Narratively speaking, Rey is neither sexually objectified nor made an accessory to a male character's development, as Leia repeatedly was. Though Rey does develop a romantic connection with her Sith rival Kylo Ren, the romance does not define her as a character, and the two catalyze each other's development in a reciprocal fashion. Rey thus fulfills the promissory note of Princess Leia, offering a multidimensional female lead with her own unique personality and trajectory, free of musical caricatures of what a woman must be like. This is not to say the modern *Star Wars* trilogy is entirely unproblematic; the initial lack of female characters like Rey or Captain Phasma in *The Force Awakens* toy product lines and director J. J. Abrams's remarks that *Star Wars* was "always a boys' thing" sparked the protest hashtag campaign "#Wheresrey?" (Scott 2017: 139, 141, 143). As a whole, however, Rey is regarded as a significantly more positive example of gender representation than Princess Leia. As Megen de Bruin-Molé concludes:

> In popular discussions, *Star Wars'* feminism was reframed as a progression from Leia (a powerful but solitary role model in the original trilogy) to Rey, who takes up the mantle of Jedi hero that previously belonged exclusively to the male protagonist of the films.
>
> (2018: 228)

The musical differences between "Leia's Theme" and "Rey's Theme" thus reinforce the contrasting impact of each heroine's gendered representation.

The above analytical sketches and the ensuing chapter flow from the broader project introduced by feminist musicology—bringing the analytical resources of musical semiotics to bear on the gendered meanings of musical conventions. Though western music history is steeped in gendered rhetoric and norms, the task of going beyond formalism to interrogate the musical signification of gender was left only to scholars of recent decades (McClary 2002). The scholarship of feminist musicologists, including Susan McClary, Heather Laing, and others, explores how music may reinforce and construct gender norms in art, media, and society. These findings can be outlined by the following principles:

1. Western musical conventions are gendered.

 Since the rise of seventeenth-century opera (at the latest), composers strove to develop a musical semiotics of gender: "a set of conventions for constructing 'masculinity' or 'femininity' in music" (McClary 2002: 7). These practices musically encoded cultural notions of traits typically exhibited by men and

women of the time; "masculine" music was thought to possess clarity, order, vigor, and rationality, while "feminine" music embodied softness, roundness, charm, and grace (Treitler 1993: 27). Though nearly every musical parameter could participate in this gendered dichotomy, two examples are particularly illustrative: "masculine" and "feminine" cadences and sonata form themes. As late as 1970, the *Harvard Dictionary of Music* contained an entry for the "masculine" and "feminine" cadence: "A cadence or ending is called 'masculine' if the final chord of a phrase or section occurs on the strong beat and 'feminine' if it is postponed to fall on a weak beat" (McClary 2002: 9). McClary elaborates that the "masculine" cadence was thought to be normative and satisfying, while the "feminine" cadence was weak, subversive, aberrant (2002: 10). As a second example, A. B. Marx in 1845 set the precedent of referring to a sonata-allegro form primary theme as "masculine" and the secondary theme as "feminine" (though sonata form pieces and analyses predated Marx by over a century), and Marx's terminology became a convention in form theory that persisted until the 1960s (2002: 13). This impacted the perception of musical form as narrative; the primary theme "occupies the narrative position of masculine protagonist," while the "feminine" secondary theme fuels the tonal arc of the "masculine" primary theme (2002: 19). Because sonata form demands the triumphant return of the primary theme and the conformity of the secondary theme to the primary theme's key area, McClary writes: "[I]n the world of traditional narrative, there are no feminine endings" (2002: 16). Dozens of parallel examples could be provided, but these two shall suffice to demonstrate the interweaving of gender and music.

2. Musical character themes communicate gendered information.

In narrative media like opera, film, or video games, musical themes presented along with a character's appearance (or mention) communicate vital information about his or her personality and gendered traits or roles. Film music conveys culturally encoded values that shape audience perception of tone, expression, and mood (Gorbman 1987: 30). When paired with a narratively foregrounded character, the music seems to "speak" his or her "emotions, thoughts and memories" (Laing 2007: 29–30). As an operatic parallel, Carmen's "Habanera" encodes the gypsy's "unpredictable, maddening" sensuality through pronounced use of chromaticism in its melody (McClary 2002: 58). It is crucial to note that the creation and/or perception of these musically gendered traits is frequently subconscious. McClary writes: "[W]hen composing music for a female character, a composer may automatically choose traits such as softness or passivity, without really examining the premises for such choices" (2002: 9). This forms a segue to the third principle.

264

3. Music, media, and the arts participate in socializing gender construction.

 Music does not exist in an artistic vacuum, but draws on—and, in turn, influences—wider culture. How one acquires a society's gender norms is intrinsically bound up in its narrative, artistic, and media culture. Music does not passively reflect social reality, but participates actively in its construction: "It is in accordance with the terms provided by language, film, advertising, ritual, or music that individuals are socialized: take on gendered identities, learn ranges of proper behaviors, structure their perceptions and even their experiences" (McClary 2002: 21). The arts provide "public models of how men are, how women are"—and are in turn created by those trained in its conventions (2002: 37). As a result of this cultural feedback loop, conventional gender representation is notoriously difficult to diagnose and dislodge, since it permeates human experience. Thus, Rebecca Fülöp writes: "Gender shapes our whole reality; it is impossible to disentangle it from other issues in studies of art, culture, history—anything that is part of who we are and how we relate to the world around us" (2012: 334). Video games, like opera or film, thus culturally construct gender—and its music plays a pivotal role in that gendering.

As the present discourse turns to a detailed analysis of music from *FF*, these principles will prove illuminating to the interaction of music, gender, and meaning in video games.

Damsels and opera floozies: The construction of musical gendering in the FF franchise

I'm a GENERAL, not some opera floozy!

(Celes Chere, *FFVI*)

As the 43-year *Star Wars* series marks the progression of gender representation in film, so does the 33-year *FF* franchise in video gaming.[1] The series' soundtracks are known for their "discrete [musical] themes associated with characters and locations" (Cheng 2014: 81), which help players "keep dozens of characters [...] straight" (Gibbons and Reale 2020: 2). These themes musically encode salient traits—including gendered ones—to aid player understanding of a character. As Tim Summers writes: "Game music does not exist in a musically sealed world, but draws upon a common lexicon from broader culture" (2016: 40). Thus, a character's music constitutes a key determinant of how players perceive and interpret that character.

Yet from the beginning it was not so. The earliest *FF* games contained few or no musical character themes, owing to hardware limitations on memory available

for music (the entire *FFI* soundtrack spans under ten minutes without looping). Debuting on the Nintendo Entertainment System (NES) in 1987, *FFI* features predominantly location-based music such as "Chaos Temple" or "Underwater Palace," prioritizing players' sense of sojourning through a vast fantasy world; no character-based themes are included.[2] Similarly, *FFII* (1988) contains no character themes, but adds a few event-based cues to reinforce important narrative events. Most infamous among these is the seduction of the protagonist Firion by the alluring Princess Hilda (Figure 10.1), scored with a sensual lyrical melody and flowing arpeggiated accompaniment (orchestrated in the *Dawn of Souls* remake with oboe and harp). "Temptation of the Princess" is a quotation of the iconic "Swan Theme" from Pyotr Tchaikovsky's *Swan Lake*, which is a fitting intertextual connection; Hilda is revealed to be the Lamia Queen in disguise, just as the ballet's black swan Odile impersonates the white swan Odette to entice Prince Siegfried. This reference communicates that the imposter Hilda is no chaste maiden, but rather a seductive *femme fatale*. Even before the *FF* series incorporated conventional character themes, its music participated in gendering a female character, shaping player perception of her as an archetypal woman.

Significantly, the first character theme in franchise history is also associated with a woman. *FFIII* (1990) includes exactly one track attached to a specific character: "Elia, the Maiden of Water," named for the serene and beautiful Aria Benett.[3] Aria's *dolcissimo*, highly affective theme stands out from the rest of the score, featuring a singing-style melody and gently arpeggiating accompaniment (English horn and harp in the Nintendo DS remake). Its other stylistic features include major mode, periodic phrasing, Romantic-style flourishes, and expressive chromaticism. As shall be seen, these are typical signifiers of the feminine in

FIGURE 10.1: Princess Hilda/Lamia Queen seduces Firion, *FFII*, NES (1988, left), iOS (2010, right).

music, marking Aria as the feminized ideal—although Sara is the game's princess, Aria plays a more traditionally feminine role, supporting the protagonists with healing magic and ultimately sacrificing her life to protect the heroes from harm. Aria's theme thus established a musical archetype that future female themes largely adhered to.

Beginning with the Super Nintendo Entertainment System (SNES) generation, the musical character theme became a staple of an *FF* soundtrack. For example, *FFVI* contains named themes for each of its fourteen playable protagonists—and its two main antagonists—that are heard whenever that character performs an important action or is the center of narrative attention. Please consult note 4 for a montage of the primary male and female character themes from *FFIV* through *FFXV*, exhibiting these themes' common musical features, divided by gender.[4]

A few broad observations are in order before delving into specific case studies. Strikingly, the male themes exhibit greater musical variety than their female counterparts. What explains this asymmetry? A key concept here is the theory of "markedness," derived from the field of linguistics and applied to musical semiotics by Robert Hatten. Defined as the "valuation given to difference," markedness involves an asymmetrical pair of terms—a specific marked term and a more general unmarked one (Hatten 1994: 34). Edwin Battistella explains: "A *marked* term asserts the presence of a particular feature, and an unmarked term negates that assertion" (Battistella 1990: 2, original emphasis). In other words, the marked term specifies a distinction from the unmarked term, subsequently modifying the unmarked term's meaning to be opposed to that of the marked term. When the opposition does not need to be invoked, the unmarked term alone suffices. Consider the example of the terms "cow" and "bull," where "cow" is an unmarked term that does not necessarily specify the animal's sex—but when contrasted with the marked term "bull," which specifies the male animal, "cow" now signifies the female animal (Hatten 1994: 34). Hatten proceeds to identify marked oppositions in music, including major and minor mode, expressive movement titles, the Picardy third, key relations, and musical topics; these observations remain foundational to musical semiotics.[5] However, for present purposes, understanding the broader linguistic concept is sufficient. It is fitting that Hatten's selected examples—"cow" versus "bull" and "man" versus "woman"—both involve sex or gender, as markedness is also central to the cultural construction of gender.

Musical markedness constitutes an analog to conventional gender dynamics in society via the relationships between masculinity, femininity, and hegemonic masculinity. In a poignant paradox, Edward Morris and Freeden Oeur observe: "Masculinity is everywhere at the same time that it is nowhere" (2018: ix). Normative masculinity typically hides in plain view, rendered invisible as the presumed "default" mode of manhood. In societal gender dynamics, masculinity and

femininity are dichotomously polarized in order to render each concept meaningful; normative "manliness" therefore becomes defined by what it is not, through "opposition to and/or interplay with a feminine 'other'" (Frühstück and Walthall 2011: 60). In terms of markedness, "masculinity" is unmarked, invisibly generic until contrasted with its negation; "femininity" is marked and specific, signified by a narrower range of conventional signifiers. Raewyn Connell's seminal concept of "hegemonic masculinity" describes precisely this marked relationship of cultural gendering, defined as the elevation of a particular mode of masculinity over femininity and other masculinities.[6] Hegemonic masculinity thus generates, reinforces, and legitimates power differentials "between men and women, between masculinity and femininity, and among masculinities" (Messerschmidt 2018: 28). Though it may seem that hegemonic masculinity requires a uniform standard of manliness, in reality, approved masculinities may enjoy quite diverse modes of expression—as long as they all are defined against a broader category considered to be less masculine (whether femininity or alternative masculinity). In parallel to societal gender dynamics, musical gendering exhibits marked relationships between the musical "masculine" and "feminine"—including in the male and female character themes of *FF*.

We may now turn to concrete musical features of *FF*'s male and female character themes. Each theme will later be treated individually; however, some preceding, generalized remarks are in order. As previously mentioned, the male character themes exhibit greater musical diversity than those for female characters, particularly in the parameters of instrumentation, genre/style, phrasing, mode, and tempo. When these themes do exhibit common musical traits, they tend to be hallmarks of the "heroic" musical topic. The heroic topic includes prominent use of brass and percussion, military style, driving and syncopated rhythm, and ascending melodic leaps suggestive of great athletic feats. The male character themes also tend to utilize full orchestral or ensemble texture, implying a *forte* dynamic, and often employ the modally-borrowed $^\flat$VI and $^\flat$VII chords in major mode, lending the music an "epic" sound. Particularly marked is the use of the $^\flat$VI–$^\flat$VII–I "Picardy-Aeolian cadence" (Leman 2013: 5.2), borrowing from Hollywood tropes signifying courageous exploits of usually male superheroes (cf. Alan Silvestri's iconic Avengers theme from *The Avengers*). Table 10.1 diagrams general male character theme traits (or parameters that typically vary), contrasting them with the female-theme traits explored below.

In contrast to the male character themes, the female character themes from *FFIV* through *X* bear an uncannily consistent musical profile, patterned after the precedent of "Elia, the Maiden of Water." These commonalities shall be explored shortly; however, a survey of female-theme gendering conventions in the cousin medium of film is necessary beforehand. Of all art and entertainment mediums,

TABLE 10.1: Table of conventional male and female character theme musical traits in the *FF* franchise.[a]

Parameter	Male Themes	Female Themes
Orchestration	Brass, percussion, otherwise varied; often *tutti* orchestra or thick texture	Flute, oboe, other woodwinds, harp, lush strings, female voice (soprano); sparse texture
Style	Varied	Romantic-Era, contemporary ballad-style
Topics / Genre	Martial, heroic topics; varied genre	Singing-style topic; ballad or aria genre
Dynamics	*Forte* (implied)	*Piano* (implied)
Melody	Active, ascending leaps	Stepwise, lyrical
Phrasing	Varied	Regular, periodic phrasing
Accompaniment	Varied; typically block chord	Arpeggiation, sustained chords
Harmony	Varied harmonic rhythm and chord progressions; ♭VI and ♭VII chords in major.	One chord per measure; circle-of-fifths and other sequential progressions; expressive chromaticism and secondary dominant chords
Mode	Varied	Major
Rhythm	Active, driving, syncopated	Regular, relaxed, on-beat
Meter	Varied; typically quadruple or duple meter	esp. Triple or compound meter
Tempo	Varied	Slow

[a] The attributes described in table should be understood as properties that cumulatively move a piece of music further toward conventional masculinity or femininity, but none is solely a necessary or sufficient condition for a passage being conventionally masculine or feminine. As in musical topic theory, a theme may exhibit musical masculinity or femininity to varying degrees and by employing different components of the paradigm. As Frank Lehman writes concerning film music cadences, the musical construction of conventional masculinity and femininity is "best formulated in terms of *paradigm cases* and *attributes*," gesturing towards paradigms with fuzzy boundaries rather than a transcendent Platonic form (Lehman 2013: 3.7–3.8, original emphasis). My aim in the present project concerning musical gender construction in video games is akin to Lehman's work with cadences in film.

the music of film and television exerts the most direct, tangible influence on video game music. Rebecca Fülöp's work analyzes the Feminine Romantic Cliché (henceforth "FRC") in early film, defined as "a recurring musical theme [...] [that] acts as a characterizing music for a female love interest as well as the love theme for the film's romantic plotline" (2012: 31). The female characters underscored by a FRC typically embody idealized romantic femininity and come to be defined by her romantic potential with a male character (almost always the lead protagonist). To recall an earlier example, "Leia's Theme" functions as a FRC that "links [Leia] to other characters rather than establishing her as an individual," contributing to the problematic gendered portrayal previously described (2012: 4). Broadly speaking, the FRC functions to strip the female character of agency and individual identity, treating her as narrative object rather than subject (2012: 34–35). Analyzing one hundred films from 1935 to 1955, Fülöp concludes that the FRC typically: (1) reinforces perception of women as passive, decorative objects to be acted upon by men (2012: 18); (2) communicates virginity and moral purity according to Hollywood's ethical Production Code (2012: 21); (3) obscures a female character's interior life and complexity in favor of presumed idealization (2012: 38); and

(4) defines a woman by her "feminine beauty and romantic potential" (2012: 47). The long-lasting influence of the FRC in musical gender representation is tangible even in twenty-first-century media culture.

Unlike the visual arts, which are capable of representing a female figure directly, musical gender construction relies on "cultural associations and conventions" thought to be so naturally apropos to femininity that they "generally go unremarked or unchallenged even in scholarly literature" (2012: 47). These conventions are frequently borrowed from the western concert music or operatic traditions, adapted for film music in the early twentieth century. The FRC features slow tempo and lyrical melodies to convey a "lilting, unhurried feeling" that Fülöp argues was thought to correspond to feminine characters' lesser physical vigor and heightened emotional expressivity (2012: 55). Its signature instruments include high strings, woodwinds like oboe and English horn, and harp; the FRC usually does not utilize brass and percussion. The accompaniment consists of arpeggiation or chorale textures that serve to foreground the melody. Fülöp also observes that the FRC is typically cast in major mode, to embody the woman's "positive and love-inspiring nature" (2012: 59). Though almost always diatonic, the music of the FRC contains a great deal of harmonic variety through Romantic-style expressive chromaticism (2012: 60). Finally, a FRC melody exhibits a balanced contour, alternating between gradual ascent and descent before climaxing on a high note late in the phrase and resolving by descent to a stable consonance (2012: 63). Again, "Leia's Theme" is a striking example exemplifying most of the FRC's musical features. Additionally, most of these telltale musical signifiers of the FRC find parallels in the female character themes of *FF*.

For the most part, the *FF* female character themes share common instrumentation, typically scored with prominent use of flute, oboe, or another woodwind instrument over harp or lush strings. Its singing-style melodies employ generally stepwise motion, lyrical character, periodic phrasing, alternation of ascending/descending contour, and balancing leaps with contrary motion by step. The accompaniment consists of arpeggiation or sustained chords, and its mode is nearly always major. Rhythmically, "feminine" music adopts a slow tempo and relaxed, on-the-beat rhythmic values and may be further marked by triple or compound meter. Additional features that are either not as prominent or not as ubiquitous include the use of (or allusion to) soprano voice, *piano* dynamic implied by sparse texture, harmonic rhythm of one chord per measure, circle-of-fifths chord progressions, expressive chromaticism, and either Romantic-era or contemporary pop ballad style.[7] With the FRC in mind, the association with Romantic-era style is readily explicable; however, why employ a pop ballad style for female character themes (*FFV*, *FFVIII*, *FFIX*, *FFX*)? In a Japanese context, this calls to mind the music genre known as "J-pop"—specifically the アイドル ("idol") cultural phenomenon, which

primarily features female performers and groups (Medium 2018). Minora Kitahara writes: "In idol culture women are the stars. There may be nowhere else in Japanese society where we're the driving force" (cited in McAlpine 2017: n.pag.).[8] Building on this association, the female character themes in *FFVIII* through *X* are instrumental versions of originally composed Japanese pop ballads ("Eyes on Me," "Melodies of Life," "Suteki da ne"),[9] which are heard in full during the game's ending credits or romantic scenes. This links a female character with the story's "happy ending," calling to mind the problematic, male-hero-centered "save the world, get the girl" trope common to media and narrative storytelling throughout history.

It must be noted that Nobuo Uematsu was the sole composer for the female character themes from *FFIV* through *X* (listed and analyzed below), which exhibit the greatest similarity to one another. Indeed, as shall be seen, when the series changes composers for *FFXII, XIII,* and *XV,* the female-theme pattern described thus far is subverted.[10] Nonetheless, due to these traits' resemblance to conventional musical "femininity" in other art and entertainment media—including the FRC in film—it is clear that they are not merely due to a personal compositional quirk of Uematsu's, but are rather a symptom of broader cultural practices. When paired in marked opposition with "heroic" male character themes, these readily recognizable conventions mark female characters as the feminized "other," legitimizing male protagonists' masculinity by negation. Reminiscent of cadences, sonata form themes, and "Leia's Theme," the music of *FF*'s heroines treads well-worn paths of problematic gender representation in music history.

The sonic picture the preceding analysis paints is one that is naturally generalized. Robust understanding is possible only through semiosis—detailed and nuanced interpretation of a specific case study. Accordingly, the remainder of the chapter is devoted to remarks on each primary character's musical and narrative gender representation.

Musical narrativizing: Male and female character theme analyses

Someday I will be queen, but I will always be myself.
(Garnet Til Alexandros XVII, *FFIX*)

For each main series *FF* title starting with *FFIV,* brief analytical summaries of each main male and female character's narrative role, primary musical theme, and gender representation are provided below; unfortunately, there is not ample space to treat either music or narratives with the nuance they deserve. Main male and female characters are often associated with multiple themes or variations of their theme, developed throughout the course of the game's narrative or presented

in significant moments of the story. However, to limit the scope of the present analytical task, only the character's primary (typically eponymous) theme will be discussed, except for a few passing references to secondary themes.[11] This results in a snapshot impression of a character's gendered presentation, but fails to provide the full picture of his or her musical development. Nonetheless, focusing on eponymous themes where possible bears distinct advantages, due to their relative clarity of association and potential freedom from narrative event-specific meanings. For example, "High Summoner's Daughter" (*FFX*) is another candidate for association with Yuna, as it is heard when she is initially introduced and is melodically related to "Yuna's Theme." However, "High Summoner's Daughter" also plays during narrative events not solely centered on Yuna, and the direct naming of "Yuna's Theme" serves to disambiguate it as specifically characterizing Yuna. Selection for transludic and transmedial adaptation—such as including "Aerith's Theme" over "Flowers Blooming in the Church" in the "Distant Worlds: Music from *Final Fantasy*" orchestral concerts—may also reinforce perceived links between music and character.[12] Primary character themes participate in communicating gendered expectations for the character due to "virtual agency," or music's "capacity to simulate the actions, emotions, and reactions of a human agent" (Hatten 2018: 1). One does not simply hear music, but encounters it directly as a coherent "other"; as Naomi Cumming writes: "Music could be thought of as subverting the boundaries between the material and the personal, commanding an attention more familiar in the encounter with other human beings" (2000: 284). Thus, hearing a character's music is akin to an interpersonal encounter, from which one cannot help but glean various kinds of information and character traits, including gendered ones. As a final disclaimer, *FFXI* and *XIV* will be omitted due to their MMORPG[13] nature, lacking clear, centralized protagonists or narrative. My analysis of each theme is diagrammed as a spectrum in Figure 10.2, based on its conformity to masculine or feminine musical conventions.

What follows is a series of concise remarks elaborating the rationale for each character's placement.

FFIV (1991)

Cecil exemplifies the chivalrous masculinity of the samurai tradition of *bushidō*.[14] Historically, *bushidō* is Japan's longest-lasting hegemonic masculinity, set forth as Japan's masculine ideal in Nitobe Inazou's *Bushidō: The Soul of Japan*. Inazou portrayed *bushidō* as "the perfection of Japanese men and the Japanese people," elevating it to a hegemonic ideal to which all honorable Japanese men must aspire (Frühstück and Walthall 2011: 63–65). Cecil embodies *bushidō* masculinity through his profession as a knight, his honorable character, and his dedicated

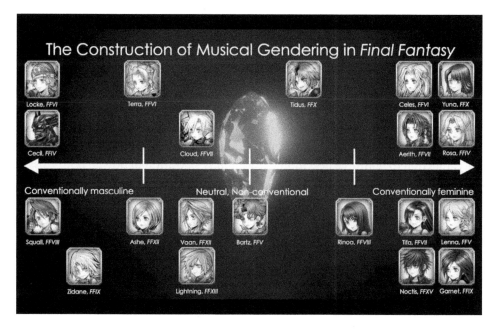

FIGURE 10.2: Conventional masculinity–femininity spectrum of *FF* character themes.

loyalty to his lord, the king of Baron—though the integrity of all three is later thrown into question. Cecil's theme "Red Wings" reflects his military origins, featuring brass and percussion, ascending melodic leaps, and an intertextual resemblance to Gustav Holst's "Mars, the Bringer of War." After Cecil decides to disobey his king's ruthless orders to slay innocent civilians, he is stripped of his command and exiled from Baron in dishonor; he appears to have transgressed the *bushidō* code and must therefore be emasculated as punishment. However, after the warmongering king is exposed as an imposter, the true king's ghost blesses Cecil and names him as his successor—thus restoring his title, honor, and affirming Cecil's loyalty to his true lord. Ultimately, Cecil's story illustrates that true *bushidō* is not blind obedience to one's superiors, but rather loyalty to the principles of *bushidō* itself. This insight is musically encoded in "Paladin" (associated with Cecil's transformation from Dark Knight into a holy Paladin), which features transcendent-topic harp arpeggiation, broad sustained string chords, and recontextualizes the brass melody from "Red Wings" in the relative major key (G minor → Bb major). Conventionally masculine heroic-topic signifiers in this track, including brass and percussion, ascending leaps, and modally-borrowed flatted chords, illustrate that it was Cecil—not his more compliant Baron military peers—who carried out the true path of *bushidō*. Thus Cecil nuances and clarifies, but does not ultimately displace, hegemonic *bushidō* masculinity.[15]

Rosa's "Theme of Love" showcases musical gendering at work, exhibiting virtually every common feature of female character themes. Its lyrical woodwind melody, arpeggiated harp, lush strings, Romantic style, expressive chromaticism, and periodic phrasing strikingly parallel "Leia's Theme" (especially in *Distant Worlds*' "Theme of Love" arrangement). Rosa is repeatedly sidelined by illness or abduction, and even when she acts independently to join the final battle, Cecil vows to protect her, as he has all along. Her story encapsulates the "emphasized femininity" archetype—women who, by completely embodying traditional femininity, function to reinforce hegemonic masculinity's position of power. Both Rosa's character and music thus conform to hegemonic gender norms, creating a standard (along with Aria) for later main female characters to follow, subvert, or defy.[16]

FFV (1992)

The fifth *FF* is an oddity in countless ways, including its hero, Bartz. Curiously, Bartz does not possess a personal musical theme, reflecting his status as an orphan and perpetual wanderer, drawing his chameleonic identity from wherever he travels. Though lacking a named theme, Bartz is typically associated with a piece of location-based music. "Home Sweet Home," the music of Bartz's hometown Lix, does not participate in the male–female musical gendering spectrum, since it is not primarily intended for a person. Its Dorian-mode melody, VII–i cadential harmonies, Baroque-era counterpoint, and rustic instrumentation suggest ancientness rather than masculinity or femininity. That Bartz develops no canonized romance is perhaps another reason he is not musically masculinized, functioning instead primarily as a surrogate through which players may immerse into the narrative.

Lenna, like many other folklore princesses, does not innovate female representation. Like "Theme of Love," "Lenna's Theme" conforms strongly to female-theme norms, with prominent flute melody, arpeggiation, string chords, and periodic phrasing throughout. "Lenna's Theme" fulfills a similar role to "Elia, the Maiden of Water," as her music is the only character theme for a playable protagonist in the game's soundtrack (with the above acknowledgment that Bartz's association with "Home Sweet Home" is a slant one). Considering the precedent of Aria Benett, this fact once more illustrates musical gender construction as a marked opposition, in Hatten's terminology—Lenna's femininity must be musically distinguished, while Bartz's gendering need not be remarked on by the score. In "Lenna's Theme," hints of "pop ballad" style emerge via the synthesized electric bass timbre, which foreshadows a feminized musical convention from later entries. Lenna's personality is defined by her compassionate and self-sacrificial nature—classic feminine traits in the West and (especially) in Japan. Her most memorable acts involve two separate acts of self-sacrifice in order to save a dying

dragon: (1) traversing a field of toxic flowers and (2) ingesting grass poisonous to humans in order to persuade an ill dragon it is safe to eat. Lenna does not notably digress from Rosa's precedent.

FFVI (1994)

FFVI is distinctive in gender representation, featuring not one but two lead female protagonists: Terra and Celes. "Terra's Theme" is the sole outlier to female-theme conventions in the series' early years, with a "mournful," "tragic" A section that contrasts serene, major-mode femininity through its minor-mode melody and military snare drum (Summers 2016: 207). Richard Anatone (2020) argues that the track's B section—in the relative major, with rising French horn and string melody, driving staccato chords, and rousing percussion—is Terra's true theme. If so, it is significant that "Awakening"—heard when Terra is first introduced by name—lacks this heroic B section, corresponding to Terra's memory loss and trau-matization from being mind-controlled by the Gestahlian Empire. By story's end, the heroic B section has swapped places with the tragic A section to occupy the primary position during Terra's portion of the "Ending Theme." This triumphant core of "Terra's Theme" most resembles the signature heroic topic of male themes, since she occupies the typical "male hero" position.

Celes and Terra share a considerable degree of their backstory; each was raised by an empire official as a Magitek Knight,[17] committed war atrocities in the name of the empire, and ultimately defected to the Returners with the aid of Locke. However, the two heroines then diverge—in both music and gender representation. Celes's musical identity is even further obscured than Terra's, as her introduction is underscored by "Under Martial Law," which is a location- and narrative-based theme associated with the imperial occupation rather than Celes in particular. It is only through the events of FFVI's narrative that Celes establishes musical agency independent from the empire. "Celes's Theme" derives from her iconic opera solo "Aria di Mezzo Carattere," initially donned as a dramatic persona with the intention of escaping her past and reinventing her identity; its adaptation into a personalized theme suggests Celes's internalization of aspects of her fictional oper-atic role (Thompson 2020: 124). This instrumental aria closely follows female-theme patterns including major mode, harp arpeggiation, lyrical melody, and periodic phrasing. A retransition at the cue's loop point utilizing $^\flat$III, $^\flat$II, $^\flat$VI, and $^\flat$VII chords constitutes an exception to the norm, contributing a heroic inflection that somewhat mitigates Celes's musical feminization. However, Celes becomes increasingly characterized by her romance with Locke; her theme plays only when pining for him, and their themes are interwoven in the "Ending Theme." Thus, while Terra musically defies gendered convention, Celes ultimately embraces it.

The treasure hunter (read: thief) Locke seems an unlikely protagonist—therefore, his music compensates, asserting clear heroic identity on his behalf. Tim Summers observes that "Locke's Theme" is replete with "standard signifiers of heroism" including major mode, rapidly ascending melodic leaps, military brass and percussion, staccato block chords, modally borrowed flatted chords in major, and fast tempo (Summers 2016: 207). The tender, bittersweet variant "Forever Rachel" plays in connection with Locke's tragic romantic backstory, but returns voiced by heroic French horn in the "Ending Theme." Musically, Locke is thoroughly, conventionally masculine.

FFVII (1997)

Like Bartz, Cloud has no named musical theme; rather, the "Main Theme of *Final Fantasy VII*" is perhaps his most closely associated music. This attribution is quite debatable, though the ambiguity does not greatly impact the present argument; if one does not associate the "Main Theme" with Cloud's development, then Cloud lacks any character theme and his musical gender representation simply falls outside the scope of the present investigation. That Cloud has no clear musical identity is appropriate, because he has suppressed his memories after traumatization, instead assuming an arrogant false persona as an ex-SOLDIER[18] mercenary. Only after departing from Midgar—the epicenter of SOLDIER operations and the lynchpin of Cloud's assumed identity—is the "Main Theme" heard, suggesting that the ensuing journey across the gameworld chronicles Cloud's arc of self-discovery and reconstructed individuality. The "Main Theme" is difficult to categorize according to gendering, as it spans many styles and textures, from lyrical ballad to lush symphonic climax—even a mechanistic, industrial aesthetic gesturing toward the narrative's darker themes. Its core melody is feminine in instrumentation, accompaniment, tempo, and style, while its "epic" orchestration, Picardy-Aeolian cadences (bVI–bVII–I), and foregrounded brass seem more masculine. If associated with Cloud, the "Main Theme" signifies his raw potentiality, his identity unfolding and evolving throughout the journey itself.

Aerith and Tifa split the position of primary female character, both involved in a love triangle with Cloud. "Aerith's Theme" largely conforms to female-theme patterns, particularly through its arpeggiated harp, singing-style oboe melody, Romantic-era style, and periodic phrasing. The unusual inclusion of a heroic brass countermelody in the A section's *forte* consequent phrase somewhat mitigates her theme's conventionality. A variation of "Aerith's Theme," "Flowers Blooming in the Church," features the theme's melodic material in a gentle, waltz-like compound meter, reinforcing her feminization. Preceding the appearance of "Aerith's Theme," "Flowers Blooming in the Church" is heard during Aerith's introduction,

inflecting players' first impression of her toward the feminine end of the spectrum. Like Rosa, Aerith is a frequent damsel-in-distress, and when she acts independently to stop the villainous Sephiroth herself, he impales her in *FF*'s most iconic death scene. Thus, Aerith mostly conforms to conventionally feminine narrative and musical expectations.

The no-nonsense Tifa might be expected to have less conventionally feminine music than Aerith, but this is not the case. "Tifa's Theme" displays virtually the same gendered properties as Aerith's. Summers writes: "Tifa's music conforms to musical stereotypes of a 'feminine' theme" with a *cantabile* melody and arpeggiating accompaniment (2016: 207). Though its primary melodic instruments are flute and oboe—familiar "feminine" instruments—the melody's repetition is played by bassoon, an unexpected choice for a female character due to its low registration. After Aerith's death, Tifa is increasingly characterized by her romantic potential with Cloud, especially while caring for him after his mako overdose.[19] On the other hand, Tifa does free herself from execution (while others are on the way to rescue her) and is named leader of the party while Cloud is unconscious, so she is granted a few empowered narrative moments.

FFVIII (1999)

No character theme tries as earnestly to be masculine as Squall's "Maybe I'm a Lion," combining with his taciturn demeanor to overcompensate for his internal insecurities. Opening with a hypermasculine shout from male voices, Squall's music exudes "manly" stereotypes, blending heavy metal electric guitars and tribal percussion. Heavy metal culture is "very much a male-dominated arena," promoting primal, aggressive, hypermasculine attitudes (Vocum Personae 2015). Despite this masculinist affectation, the track does not succeed in channeling authentic heavy metal, due to its slow (for metal) tempo of 110 bpm, rhythmically sparse drum set, non-rearticulated guitar chords, and melody generally on synth organ rather than guitar. Accordingly, Squall confesses to a comatose Rinoa that his brusqueness is a front, hiding his anxieties concerning what others think about him. Another track associated with Squall, the somber string *adagio* "The Oath," hints at his inner sensitivity and complexity.

Rinoa reprises Tifa's missed potential as an empowered heroine, though her music is less overtly feminized. "My Mind" features electric guitar and an ambiguous toy piano sound as melodic instruments; neither are traditional musical signifiers of femininity. The melody and accompaniment are rather typical, and the synthesized strings suggest a pop ballad style. The B section of "My Mind" is the chorus of "Eyes on Me," the pop ballad from the credits, inaugurating a trend seen in subsequent *FF* titles of calling to mind Japan's idol culture and linking the

heroine's identity to the game's "happy ending." Rinoa's initial independence transforms into increasing romantic attachment to Squall, and she is rendered a damsel-in-distress for him to rescue several times through capture, possession, and even floating adrift in outer space.

FFIX (2000)

To western audiences, Zidane hardly seems particularly "masculine;" for the original Japanese context, however, the lithe, confident ladies' man is a standard male archetype. "Zidane's Theme" encapsulates his flirtatious nature, which is foregrounded in the first half of the game. Exhibiting fast tempo, driving rhythm and military snare drum, *staccato* accompaniment, and leaping melody, the A section embodies confident, optimistic heroism. The B section consists of a jaunty swing tune reflecting Zidane's lighthearted lifestyle; aside from a French horn countermelody, nothing here is conventionally masculinized. The cue "Not Alone," prominently featured after Zidane has despaired, but learned to rely on his friends, bears greater musical depth and marks his growth as an individual. Zidane is a promising case for tracing development of gender representation throughout a game's narrative; his early association with "Zidane's Theme," however, is classically masculine.

"Garnet's Theme" includes conventionally feminine flute and oboe, major mode, slow tempo, triple meter, harmonic sequencing, and a simple melody derived from the credits' pop ballad "Melodies of Life." Crotales, the main melodic instrument, is not customarily gendered, nor is the *pizzicato* upright bass or sleigh bells that enter in the B section. Sean Atkinson (this volume) argues that a fast variant featuring a heroic brass fanfare, playing as Garnet leaps from a castle wall to escape, paints her as an independent heroine rather than a stereotypical, damsel-in-distress princess. This point is well taken; however, for the diagram's purposes, only Garnet's named theme is considered. A handful of other tracks incorporate melodic material from "Melodies of Life"; see Atkinson's chapter in this volume exploring potential connections between these and Garnet as a character.

FFX (2001)

The aspiring blitzball[20] champion Tidus lives in his father's shadow, who was widely considered an unrivaled blitzball player before vanishing ten years ago. Tidus often dreams of his father Jecht insulting him, demeaning his masculinity, and causing Tidus's mother to ignore him in favor of spending time with Jecht. However, Tidus unconsciously mirrors the demeanor and personality traits of the man he loathes most, including his carefree attitude and tendency to run

from responsibility. Tidus's mentor Auron, who traveled extensively with Jecht, points out Tidus's similarities in temperament to Jecht, admonishing Tidus on one occasion that he is "the one running away." "Tidus's Theme" is a relaxed ballad featuring acoustic guitar and melodica, borrowing the primary instrumentation of "Jecht's Theme," a twelve-bar blues featuring acoustic guitar and "clean," non-distorted electric guitar. The nonchalant timbre of the acoustic guitar in both tracks encodes Tidus's imitation of Jecht's easygoing manner and other qualities. In terms of gendering, Tidus's music exhibits conventionally feminine traits, including arpeggiation, lyrical melody, and periodic phrasing, without employing typical masculinist tropes like the military/heroic topic, brass and percussion, or *forte* dynamic and fast tempo. Tidus's character and music thus blur gendered boundaries, as he matures into a masculinity he can call his own, rather than inheriting behavior patterns that he despises in his father.

Like the preceding two female themes, "Yuna's Theme" derives from the game's pop-style ballad, "Suteki da ne." After a wistful Lydian-mode flute introduction, "Yuna's Theme" exemplifies conventionally feminine melody and accompaniment, played on a gender-neutral melodica to connect to "Tidus's Theme" and musically signifying their romantic relationship. This meaning is reinforced when "Suteki da ne" debuts during the extensive romantic cutscene between Yuna and Tidus. "Yuna's Theme" also contains a clear melodic reference to "Aerith's Theme" from *FFVII*, suggesting that her predecessor's famous self-sacrifice will be echoed in Yuna's giving her own life to defeat the calamity Sin; as noted in reference to Lenna, self-sacrifice in contexts like Aerith's and Yuna's is a conventionally feminine trait. Yuna is protected by a team of guardians, kidnapped for ransom, pressured to marry the villainous Seymour, and instructed to sacrifice her life to restore world peace. However, she does rescue herself from her forced marriage by leaping off a high rooftop and using her summoner abilities to break her own fall, exhibiting somewhat more empowered agency narratively—albeit not musically.

FFXII (2006)

Of all *FF* protagonists, Vaan is the most forgettable, with a backstory concerning his late brother—a knight and casualty of war—that resolves in the story's first half; accordingly, he has no named musical theme. Instead, "The Dream to be a Sky Pirate," heard when Vaan shares his dream to become one, is associated with him. This brief track opens with a feminine-inflected piano texture, moving into an adventurous orchestral flourish that leans toward male-theme conventions, but evokes a sense of flight and expansiveness more clearly than gender.

Shortly after her happy marriage, Princess Ashe's homeland is invaded and her new husband slain in battle. The game's narrative traces Ashe's quest to reclaim her

throne and decide whether to pursue peace or vengeance. "Ashe's Theme" defies easy classification, spanning a wide range of textures and reflecting her depth of character. The track consists of three stylistically distinct sections, and only one invokes conventionally feminine scoring. Overall, "Ashe's Theme" resembles conventional male character themes more than female ones. In both narrative and musical interest, Ashe, rather than Vaan, is the game's main character.

FFXIII (2009)

FFXIII's director Motomu Toriyama described Lightning as the series' "first female protagonist," claiming that "every person within the party [in *FFVI*] is a main character" (Engadget 2013: n.pag.). Whether or not his claim concerning *FFVI* is correct, Toriyama's statement demonstrates creators' awareness of Lightning's distinctiveness within the series' history of gender representation.[21] "Lightning's Theme" departs from the lush, orchestral style of its predecessors, defying prior female-theme conventions in a rousing, anthemic B section with heroic overtones. The A section's ethereal, jazz-inflected texture contrasts the stock emotionality of earlier female themes. "Lightning's Theme" models emotional expression in a character theme that transcends gendered generalizations, just as she learns to integrate emotion into her identity in her own way. As Square Portal writes: "[Lightning] continues setting a standard for other female and male characters—not to be like her, but who they are" (2015: n.pag.)

FFXIII contains three male protagonists, but none is elevated to a primary position, as Lightning is over other female characters.

FFXV (2016)

FFXV follows Prince Noctis's journey to reclaim his kingdom and reach maturity as king apparent. Director Hajime Tabata explains: "Noctis has grown up seeing his father both as a father figure and as the king of the country, so during the game he tries to grow as a person and develop [...] with his father as a role model" (Xbox On 2016). Centering on themes of duty, friendship, and self-sacrifice, the game's narrative is a coming-of-age story at its core, as Noctis learns how to contribute to society (*shakai ni kouken suru*) as his kingdom's central pillar. This theme of entering the working world as a socially responsible adult draws deeply from Japan's iconic salaryman masculinity, generalized as men enduring long commutes and oppressive work hours in the name of contributing to society and supporting their families (Frühstück and Walthall 2011: 140). As the modern successor to *bushidō* samurai masculinity, salaryman masculinity pervades politics and business today (17) as the backbone of society (Saladin 2019: 69) and the quintessential

masculine ideal (Dasgupta 2013: 34, 2). Noctis subverts hegemonic salaryman masculinity in the following four ways:

1. Practicing inclusive masculinity through close, equal friendship with a range of male archetypes (Morris and Oeur 2018: 41), mirroring Japan's increase in alternative masculinities like NEETs, freeters, *otaku*, and *sōshokudanshi* "herbivore men" (Frühstück and Walthall 2011: 140; Morioka 2013).
2. Wrestling with the duty to sacrifice his well-being for others—as his father had done—instead finding meaning in the journey itself. History is rife with the costs of salarymen "sacrificing their [...] well-being" for their work (Saladin 2019: 79), including familial neglect (Hidaka 2010: 161), divorce (Saladin 2019: 79), reluctance to go home, repeated relocations or living apart from family, and *karōshi*—literal death from overwork (Dasgupta 2013: 37).
3. Emotionally integrating grief, anger, and sadness through close homosocial relationships. One signature trait of hegemonic masculinity is emotional detachment, believing that emotional expressivity signifies weakness (Morris and Oeur 2018: 14, 17). Noctis at first lashes out at others in anger and grief from his father's death, but learns to express his feelings to his close male friends, which contrasts salaryman masculinity (Saladin 2019: 80).
4. Noctis refuses to degrade or objectify women and is not aggressive in romance, typifying the *sōshokudanshi* "herbivore man" (Morioka 2013: 8). The sexual objectification or degrading of women is another "base on which male superiority is maintained," which the party does not engage in despite two periods traveling with a woman (Morris and Oeur 2018: 14, 16).

Strikingly, "Noctis's Theme" has more in common with female character themes than male ones. According to *FFXV* composer Yoko Shimomura, "emotional resonance" and "[Noctis's] real deep feelings" are key to her compositional choices, an emphasis atypical for a conventional male character theme (Square Portal 2016). By frustrating expectations of how "heroic" masculine music should sound, "Noctis's Theme" presents the prince as a new breed of male protagonist—completing the game's narrative critique of hegemonic masculinity.[22] *FFXV* contains no female characters in the core party, focusing instead on Noctis and his male friends.

To make a few brief analytical remarks on the overarching findings of this study: as shown in the appendix on the comparison website (see Supp 10.1), the majority of *FF* primary character themes establish male and female gendered conventions that are remarkably consistent for female themes.[23] Though not demonstrated in a broad longitudinal survey like this one, some characters musically subvert gendered expectations by having multiple themes or via later thematic

variation and development. The overall analysis reveals a trajectory toward greater female agency and more nuanced presentation of masculinity and femininity over time; Cecil and Rosa adhere entirely to traditional gender norms, while Lightning and Noctis offer a hopeful promissory note for a way forward. Terra is a significant outlier in this progression, foreshadowing Lightning as an empowered female lead. Finally, though not as visible or celebrated a break in conventional gender representation as Lightning, Ashe is a robust, multilayered heroine who drives the game's central narrative and defies easy definition by romance or the will of men in her life.

Conclusion: Nobuo Uematsu's gendered musical legacy

I am simply myself. No more and no less. And I only want to be free.
(Ashelia B'nargin Dalmasca, *FFXII*)

The sweeping scope of the previous section warrants a few broad observations by way of conclusion, attempting to draw together multivalent threads from gender studies, musical semiotics, and video game narratives. First, as a scholar blending the roles of composer and music theorist, I offer three guiding principles for future musical gender representation that I hope will benefit scholars, composers, and listeners of video game music alike:

1. Tailor character themes to the individual, not the archetype.
 Music written to sound "masculine" or "feminine" in general flattens a character's unique personality into gendered stereotypes. In Robert Hatten's terms, a piece's individual traits are "strategic," while its conformities to expectation are "conventional." "Rey's Theme" exceeds "Leia's Theme" at conveying meaningful character qualities due to its emphasis on the strategic over the conventional. However, does this mean that conventionally gendered musical aspects should never be incorporated into male or female character themes? Not necessarily—if those gendered traits are apropos to the individual, not employed merely for their being a male or female character. The crucial prerequisite is breaking down the hegemonic gendering that elevates limited expressions of masculinity or femininity as acceptable while discouraging nonnormative ones. Cleansing society's gender representation palate in this way would remove the need to suspect that a conventionally feminine character like Rosa or Lenna is generated to conform to cultural expectations. In other words, removing the hierarchical pressure for characters to exhibit hegemonic masculinity or emphasized femininity promotes greater freedom for characters to be their authentic selves—even if they turn out to resemble conventional archetypes.

As James Messerschmidt writes: "The goal is not a simplistic androgyny in which everyone is the same, but *difference with relational equality*" (2018: 158, original emphasis). Then the signifiers for musically constructing traditional masculinity and femininity, explored in this chapter, may even be preserved for future usage along with novel conventions for alternative gender expressions—without being burdened by assumed value judgments.

2. Gender studies and musicology will benefit from further study of masculinity.
 As seen in McClary's work, feminist musicology typically focuses on musical representations of women and femininity. Whether problematizing gendered rhetoric in western music theory or highlighting empowered female characters (historical and modern), the work of feminist musicology is vital to equalizing gender representation in music. However, further study of masculinity is also critical, lest feminism's gains be perceived as an attack on masculinity in general. The potential for a musical semiotics of masculinity as a spectrum is extensive. How are alternative masculinities constructed in music, and what nuanced meanings are communicated by various "masculine" musical traits? These questions, too, deserve robust scholarly attention.

3. Hegemonic masculinity is decentralized by validating alternatives.

The oxygen that hegemonic masculinity breathes is the unquestioned assumption that its traits are ordinary, natural, unproblematic, and commonsense (Dasgupta 2013: 7). Thus, equal female representation and inclusive masculinity are both necessary to replace a hegemony with a "more varied [...] mass of personae" (Frühstück and Walthall 2011: 133). Susan Napier reports that such a diversity of masculinities emerged in twenty-first-century Japan, as illustrated in Noctis's party in *FFXV* (Frühstück and Walthall 2011: 140). Only by celebrating a range of alternative masculinities may the West join with Japan in saying: "[Today's] young men have broken the spell of 'manliness'" (Morioka 2013: 16–17). This requires subverting and rethinking how "heroic" masculine music should sound— as "Noctis's Theme" did—promising a new breed of men.

Given the purpose of the present volume, an evaluation of Nobuo Uematsu's legacy relating to musical gender representation is in order. In the music of *FF*, Uematsu inherited, adapted, and perpetuated traditionally gendered musical stereotypes, particularly in his female character themes. Like the FRC in early film, these musical traits mark female characters as the feminized "other"—secondary to the central narrative, characterized as an idealized woman rather than a unique individual, and valued as the object of a male character's romantic affection rather than an empowered agent in her own right. Despite establishing the

series' conventional male and female musical archetypes, Uematsu cleverly subverted that standard in subtle ways, signaling more nuanced depth of character; this is most prominent in the themes of Terra, Garnet, and Tidus. However, these notable exceptions also prove the rule; overall, employing conventionally gendered musical strategies for male and female character themes reinforces problematic disparities in gender representation. Though beyond the scope of this investigation, Uematsu's music is doubtless one of the most impactful in video game music history—especially to the Japanese role-playing game genre. Though he did not invent gendered musical conventions, his usage ensured their perpetuation in numerous video game scores in the following decades; exploring how other composers adopt or transform Uematsu's precedent in musical gender representation is worth further study. Ultimately, it was necessary to pass the torch to other composers—Hitoshi Sakimoto (*FFXII*), Masashi Hamauzu (*FFXIII*), and Yoko Shimomura (*FFXV*)—in order to innovate and reimagine how the franchise's male and female themes could sound. Uematsu's contributions to the series' trajectory remains foundational, and no more inferior to his successors' music than Mozart's music is to Beethoven's by virtue of preceding him.

The *FF* franchise has been present with me through my entire life. Doubtless it has influenced my and others' perception of gender norms throughout Japan, the United States, and the world. Music participates vitally in the societal construction of gender, whether in art, film, or video games. Gendered musical conventions inevitably evolve, dancing in a semiotic spiral with the musical culture and the individuals that produce them. Nobuo Uematsu's compositional voice is embedded in my musical soul, shaping how I hear, analyze, and create music.[24] As with the *FF* series, that impact cannot change—even as I choose to invite other voices into the conversation.

NOTES

1. Year calculations are from 1977 and 1987 to 2020, the year this chapter was written. Though it will appear and be read later, the calculation is correct at the time of composition.
2. Gibbons identifies categories for "location-based" and "game-state" cues in the RPG. The former refers to music that accompanies the player's exploration of the game-world (i.e., castle, dungeon, field, etc.), while the latter refers to situations like the game's title screen, the introduction, and ending sequence. See Gibbons (2017).
3. The NES version of *FFIII* has never received an official English-language translation, leading to ambiguity concerning Aria's name. In Japanese, Aria's name is エリア (lit. e-ri-a), leading to her being known as Elia prior to the worldwide release of the Nintendo DS remake in 2006. In the DS version, her name was localized as "Aria," most likely to

sound more natural as an English name. Because all subsequent English versions of the game (iOS, Android, PlayStation Store, Steam) have been ports of the DS remake, she has been known as "Aria" ever since 2006. Name changes from Japanese to English that are updated in later editions were common in early video games (e.g., Aerith's name initially appearing in English as "Aeris"). I use "Elia, the Maiden of Water" for Aria's music even though her name is different, as the DS title "Priestess Aria" is further removed from the structure of the Japanese title.

4. See Supp 10.1 to view the montage video, *The Construction of Musical Gendering in the Final Fantasy Series*. The video spans the main series *FF* games from *FFIV* to *FFXV*. *FFXI* and *FFXIV* are omitted due to being massively multiplayer online role-playing games (MMORPG), thus lacking a centralized narrative or main characters. *FFVI* and *FFVII* each contain two main female protagonists, both of whom are shown. *FFXIII* does not have a clear primary male protagonist, and *FFXV* does not contain any permanent female party characters. Sequel games are not shown. Finally, the attribution of musical themes for Cecil, Bartz, and Cloud bears some ambiguity, which is discussed in the game-by-game analysis in the subsection titled "Musical Narrativizing: Male and Female Character Theme Analyses."

5. See chapters 2 and 3 of Hatten (1994).

6. At the time of writing, it has become common in broader popular culture to refer to "toxic masculinity." I prefer "hegemonic masculinity" as a term and concept to toxic masculinity (though the two are not identical in meaning). Hegemonic masculinity is a foundational concept in academic gender studies and is value judgement-free and more precise in specifying the relationship between hegemonic masculinity, femininity, and alternative masculinities. The crucial insight is that hegemonic masculinity enforces unequal power dynamics on femininity and alternative masculinities—and therein lies its toxicity. Also, not all elements of a culture's hegemonic masculinity may be intrinsically toxic (e.g., the pursuit of honor in Japanese *bushidō* masculinity); however, when imposed as the ideal standard and discouraging alternative expressions, the normative masculinity perpetuates unequal power relationships between groups of people. Thus, the hierarchical structure itself may rightly be termed "toxic."

7. Interestingly, Nobuo Uematsu also composed the soundtrack to *Nakayama Miho no Tokimeki High School* (NES 1987), a dating simulation game that involves Miho Nakayama (a real-life Japanese pop idol), whom the player's avatar tries to date. The soundtrack contains several tracks that incorporate the pop ballad style. See Elkins, this volume.

8. Daniel Black's study of the virtual idol Hatsune Miku (in Galbraith and Karlin 2012) reveals a poignant parallel to female characters in video games. The real-or-virtual idol's *kawaii* femininity "evokes youthful innocence, vulnerability, and meekness, and a lack of remoteness or self-sufficiency" (Galbraith and Karlin 2012: 219). However, unlike real idols—who can betray her fans' adoration by falling from grace into controversy or scandal—a virtual idol like Hatsune Miku can never sully her *kawaii* purity (2012: 224). Thus, the conventionally feminine ideal, though "unlikely to be satisfactorily embodied in any living human

being" (2012: 219), may be realized as a virtual woman in a paradoxical "technologized, artificial, endearing, and seductive fantasy of femininity" (2012: 225). Thus, the connection between the *FFVII–X* female protagonists and J-pop idol culture may well bear more pernicious meanings than simply marking them as feminine rather than masculine. Considering the similarity of the FRC in film, idealizing—or, perhaps more fittingly, idolizing—fictional female characters as embodying the perfect femininity that real women cannot fulfill has a long and widespread pedigree.

9. Vocalists include Faye Wong ("Eyes on Me"), Emiko Shiratori ("Melodies of Life"), and RIKKI ("Suteki da ne"). That these themes were initially conceived as vocal pieces in a pop ballad genre and then retrojected into earlier parts of the score as instrumental versions is implied by Nobuo Uematsu's interview concerning the creation of "Suteki da ne" in *Beyond Final Fantasy* (2001): "Regarding the theme song, my first concern was to find someone to sing it." Similarly, Uematsu recalls writing ten versions of the song's music in an all-night composing session: "I completed the melody first so I had [Kazushige] Nojima write the lyrics afterwards. We both celebrated the night it was completed" (2001). Thus, Rinoa's, Garnet's, and Yuna's instrumental themes should be conceived as musically prefiguring their vocal pop ballad counterparts.

10. As mentioned in note 4, *FFXI* and *XIV* are omitted from this project's scope for a number of reasons: (1) as MMORPG games, the two lack centralized narrative and main characters, making narratological music analysis difficult; (2) Uematsu did compose a number of tracks for *FFXI*, in collaboration with Naoshi Mizuta and Kumi Tanioka. Thus, *FFXII* marks the clearest break from Uematsu's influence and involvement in the series; (3) the *FFXI* and *XIV* scores contain predominantly location-based and game-state tracks rather than character themes. *FFXI* contains unique character creation cues for each race, divided by male and female, but these are not true character themes. *FFXIV* contains character themes for guest character cameos from other *FF* games (e.g., Shantotto, Gilgamesh), which is more of an intertextual quotation or arrangement than a character theme for *FFXIV* per se.

11. Secondary themes mentioned include "Paladin" (*FFIV*), "Awakening" (*FFVI*), "Aria di Mezzo Carattere" (*FFVI*), "Ending Theme" (*FFVI*), "Forever Rachel" (*FFVI*), "Flowers Blooming in the Church" (*FFVII*), "The Oath" (*FFVIII*), "Eyes on Me" (*FFVIII*), "Not Alone" (*FFIX*), "Melodies of Life" (*FFIX*), "Suteki da ne" (*FFX*), and "Blinded by Light" (*FFXIII*).

12. Ultimately, selecting any musical theme as primarily exemplifying a character is somewhat artificial, and other readers or players may hold differing opinions about the themes I have selected in this chapter. I welcome analyses of other character themes—especially detailed case studies that draw together all of a character's associated themes throughout a game—to dialogue with the brief treatment I have provided in this chapter.

13. Massively multiplayer online role-playing game.

14. Japanese 武士道, literally "way of the warrior."

15. For an in-depth case study of the transformation of Cecil's themes, see Atkinson (2018).

16. Rydia and "Rydia's Theme" are not included because—despite the compelling nature of her development arc—Rydia more closely occupies the "second woman" position (in operatic terms) than the clear "first woman" archetype of Rosa. Also, including Rydia would entail including other prominent "second women" such as Faris and Quistis, further expanding the scope of the project. However, note that "Rydia's Theme" exhibits clear, conventionally feminine musical traits as described in this chapter, similarly to "Theme of Love," inflected with a greater degree of innocence corresponding to her youth. Her highly feminized theme repeats verbatim even after reuniting with the party as a fully grown woman and defeating the antagonist that the party could not overcome; thus, Rydia's music likewise genders her in problematic ways and denies her independent agency.

17. Soldiers of the Gestahlian Empire with a rare ability to cast magic and pilot the formidable Magitek armor.

18. An elite super-soldier military force boasting superhuman physique and combat skill.

19. A refined form of the planet's energy and the source of technological and magical power in the gameworld.

20. A ball-based sport played underwater, providing the gameworld's main source of entertainment.

21. One could also offer the (perhaps more compelling) argument that *FFVI* splits the main character role between Terra and Celes, with Terra foregrounded in the first half ("World of Balance") and Celes in the second ("World of Ruin"). Thus, Lightning's role as leading woman would be more complete than either *FFVI* heroine. Additionally, one could interpret Ashe as *FFXII*'s main character—as this chapter does—thus preceding Lightning as a main female character. However, Lightning's centrality is considerably clearer and more widely accepted than Ashe's, so it is appropriate that she is marketed and celebrated as a significant milestone for the series.

22. Jordan Hugh Sam (2020) explores suggestions of homoeroticism in the English language dub between members of Noctis' party and the outcry from groups of players critiquing *FFXV* as "being too gay." Other player communities celebrated the perceived homosexual relationships through the creation of fanfiction and fanart. This is a valuable research project, from which I do not wish to detract any significance. However, it does not complicate my reading of gender representation in *FFXV*, as my project is thoroughly semiotic in nature, while Jordan Hugh Sam's exists in the domain of fan studies. I am wary of driving too hard a distinction between semiotic analysis and reception history, as I have written elsewhere that communication is not a unilateral proclamation from sender to receiver, but rather a dynamic process integrating meaning-making contributions from the rhetor's selected design and an interpreter's own context, background, and values (Yee 2017). However, after discussing with Jordan Hugh Sam concerning the interaction of his paper and my findings presented in this chapter, two crucial differences emerge:

1. My research focuses solely on *FFXV*'s narrative and musical score as a meaningful text and generates a reading from those features, while Jordan Hugh Sam's explores player reactions and creative paratexts responding to the game-as-text.

2. My findings derive from the original Japanese sociocultural context and language rendering, while Jordan Hugh Sam's examine an anglophone (mostly American) social and linguistic setting.

Proceeding from my reading, Jordan Hugh Sam's analysis of reception history in the anglophone world shows that *FFXV*'s critique of Japanese hegemonic masculinity is not readily apparent when transplanted to international contexts, raises fascinating questions about script and voice-acting localization decisions, and highlights how far the United States has to go in order to dislodge hegemonic masculinity. However, these conclusions are not in tension with the reading itself.

23. See Supp. 10.2 for partial transcriptions of both male and female protagonist themes from *FFIV–XV*.

24. My earliest musical memory is hearing "Red Wings" while playing *FFIV* on the SNES, and Nobuo Uematsu's music was the primary influence motivating me to pursue music composition.

REFERENCES

Anatone, Richard (2020), "Rethinking the Idée Fixe and Leitmotif in Role-Playing Games: A New Methodology of Interpretation and Analysis," *Music and the Moving Image* (virtual conference), May.

Atkinson, Sean (2018), "Tropes and Narrative Foreshadowing in *Final Fantasy IV*," *North American Conference on Video Game Music*, Ann Arbor, MI, January 13–14, https://www.youtube.com/watch?v=2xJFkQoBhjA&t. Accessed September 26, 2021.

Battistella, Edwin L. (1990), *Markedness: The Evaluative Superstructure of Language*, New York: State University of New York Press.

Bruin-Molé, Megen de (2018), "Space Bitches, Witches, and Kick-Ass Princesses," in S. Guynes and D. Hassler-Forest (eds.), *Star Wars and the History of Transmedia Storytelling*, Amsterdam: Amsterdam University Press, pp. 225–40.

Cheng, William (2014), *Sound Play: Video Games and the Musical Imagination*, Oxford: Oxford University Press.

Cumming, Naomi (2000), *The Sonic Self: Musical Subjectivity and Signification*, Bloomington: Indiana University Press.

Dasgupta, Romit (2013), *Re-Reading the Salaryman in Japan: Crafting Masculinities*, London: Routledge.

Engadget (2013), "Lightning Returns: Carrying the Adventure Solo as *Final Fantasy*'s 'First Female Protagonist,'" https://www.engadget.com/2013-01-18-lightning-returns-carrying-the-adventure-solo-as-final-fantasy.html. Accessed April 7, 2020.

Frühstück, Sabine and Walthall, Anne (eds.) (2011), *Recreating Japanese Men*, Berkeley: University of California Press.

Fülöp, Rebecca (2012), "Heroes, Dames, and Damsels in Distress: Constructing Gender Types in Classical Hollywood Film Music," PhD dissertation, Ann Arbor: University of Michigan.

Galbraith, Patrick W. and Karlin, Jason G. (eds.) (2012), *Idols and Celebrity in Japanese Media Culture*, London: Palgrave Macmillan.

Gibbons, William (2017), "Music, Genre, and Nationality in the Postmillennial Fantasy Role-Playing Game," in M. Mera, R. Sadoff, and B. Winters (eds.), *The Routledge Companion to Screen Music and Sound*, New York: Routledge, pp. 412–27.

Gibbons, William and Reale, Steven (eds.) (2020), *Music in the Role-Playing Game: Heroes & Harmonies*, New York: Routledge.

Gorbman, Claudia (1987), *Unheard Melodies: Narrative Film Music*, Bloomington, IN: Indiana University Press.

Harrison, Rebecca (2019), "Gender, Race and Representation in the Star Wars Franchise: An Introduction," *Media Education Journal*, 62:2, pp. 1–6.

Hatten, Robert (1994), *Musical Meaning in Beethoven: Markedness, Correlation, and Interpretation*, Bloomington: Indiana University Press.

Hatten, Robert (2018), *A Theory of Virtual Agency for Western Art Music*, Bloomington, IN: Indiana University Press.

Hidaka, Tomoko (2010), *Salaryman Masculinity: The Continuity of and Change in the Hegemonic Masculinity in Japan*, Boston, MA: Brill.

Laing, Heather (2007), *The Gendered Score: Music in 1940s Melodrama and the Women's Film*, Burlington, VT: Ashgate.

Lehman, Frank (2013), "Hollywood Cadences: Music and the Structure of Cinematic Expectation," *Music Theory Online*, 19:4, https://www.mtosmt.org/issues/mto.13.19.4/mto.13.19.4.lehman.html. Accessed September 26, 2021.

McAlpine, Fraser (2017), "The Japanese Obsession with Girl Bands—Explained," BBC, June 30, https://www.bbc.co.uk/music/articles/84fd62c3-f5a4-49e6-9e3e-6f5217c1448c. Accessed August 14, 2020.

McClary, Susan (2002), *Feminine Endings: Music, Gender, and Sexuality*, Minneapolis: University of Minnesota Press.

Medium (2018), "What Makes Japan's Idol Culture Unique?," https://medium.com/@unseenjapan/what-makes-japans-idol-culture-unique-c182f30a2f55. Accessed August 14, 2020 [no longer available].

Messerschmidt, James W. (2018), *Hegemonic Masculinity: Formulation, Reformulation, and Amplification*, Lanham, MD: Rowman & Littlefield Publishing.

Morioka, Masahiro (2013), "A Phenomenological Study of 'Herbivore Men,'" *Review of Life Studies*, 4, pp. 1–20.

Morris, Edward W. and Blume Oeur, Freeden (eds.) (2018), *Unmasking Masculinities: Men and Society*, Los Angeles, CA: Sage.

Saladin, Ronald (2019), *Young Men and Masculinities in Japanese Media: (Un-)Conscious Hegemony*, Singapore: Palgrave Macmillan.

Sam, Jordan Hugh (2020), "Stand by Me: Sounds of Queer Utopias and Homosexual Panic in *Final Fantasy XV*," *North American Conference on Video Game Music* (held online), June 13–14.

Scott, Suzanne (2017), "#Wheresrey? Toys, Spoilers, and the Gender Politics of Franchise Paratexts," *Critical Studies in Media Communication*, 34:2, pp. 138–47.

Square Portal (2015), "Controversial, Groundbreaking and Iconic: Claire Farron from *Final Fantasy XIII*," https://squareportal.net/2015/03/09/controversial-groundbreaking-and-iconic-claire-farron-from-final-fantasy-xiii/. Accessed April 7, 2020.

Square Portal (2016), "Listen to 'Noctis' from *Final Fantasy XV* Soundtrack," https://squareportal.net/2016/09/07/listen-to-noctis-from-final-fantasy-xv-soundtrack/. Accessed April 7, 2020.

Summers, Tim (2016), *Understanding Video Game Music*, Cambridge: Cambridge University Press.

Thompson, Ryan (2020), "Operatic Conventions and Expectations in *Final Fantasy VI*," in William Gibbons and Steven Reale (eds.), *Music in the Role-Playing Game: Heroes & Harmonies*, New York: Routledge, pp. 117–28.

Treitler, Leo (1993), "Gender and Other Dualities of Music History," in Ruth A. Solie (ed.), *Musicology and Difference: Gender and Sexuality in Music Scholarship*, Berkeley: California University Press, pp. 23–45.

Uematsu, Nobuo (2001), interview, *Beyond Final Fantasy*, DVD extras, Japan: Square Co., Ltd.

Vocum Personae (2015), "A Bastion of Masculinity: Gender Dynamics within Heavy Metal," https://vocempersonae.wordpress.com/2015/05/03/a-bastion-of-masculinity-gender-dynamics-within-heavy-metal/. Accessed April 8, 2020.

Xbox On (2016), "FFXV Revealed! Tabata Insider Info," https://www.youtube.com/watch?v=ipTGqVSXwRg&feature=youtu.be&t=1m43s. Accessed April 8, 2020.

Yee, Thomas B. (2017), "Replies to Ravasio, Noble, and Kluth," *American Society for Aesthetics Graduate E-Journal*, 9:2.

11

Uematsu's Postgame: The Music of *Final Fantasy* in the Concert Hall (and Beyond)

Stefan Greenfield-Casas

An opening harp prelude, arpeggiating up and down a simple harmonic sequence; a night at the opera, interrupted by a villainous talking octopus. These are among the most famous sounds and scenes indexed by Nobuo Uematsu in his 8- and 16-bit contributions to the *Final Fantasy* (*FF*) series. And yet, as has been problematized elsewhere, the question of whether these are "authentic" articulations of the sounds they index has become a somewhat contentious topic of debate. William Gibbons (2015), for instance, has noted that when fans of the series hear concert arrangements of the music, they frequently label them as the *intended* sounds Uematsu heard in his inner-ear when composing. And while this is certainly a loaded and perhaps reflexive and uncritical opinion, it is easy to see why these listeners might believe this. There is a reason, after all, that Uematsu is hailed as the "Beethoven of Video Game Music" (ClassicFM n.d.). As clickbait-y a title as this might be, that Uematsu frequently uses the stylizations and trappings of classical instruments (e.g., violins, horns, and voice), even if "only" through the simulation of such instruments in the 8- and 16-bit era, is irrefutable.[1]

The *FF* franchise's and Uematsu's long-time success has cemented the two as exemplary paragons within the video game music canon (Hunt 2017; Gibbons 2020).[2] The cultural capital garnered by using these "classical instruments" almost certainly contributed to this—as did the fact that as early as 1989, just two years after the release of the original *FF*, Uematsu's music was being explicitly arranged *for* the concert hall. These two points in tandem—first, the indexing of western classical instruments, and second, the performance of this music in a concert hall setting—set the stage for Uematsu's music to not only explicitly garner cultural capital but also to gather it at perhaps an accelerated rate.

This chapter examines the movement of Uematsu's *FF* scores from their ludic origins to their various licensed adaptations and arrangements for the concert hall

(and beyond): from the 1989 *Final Fantasy Symphonic Suite* to the more recent *Final Symphony* concerts (2013, 2015); from the long-running *Distant Worlds* concert series (2007–present) to the various (non-soundtrack) albums released that feature arrangements of the music from the series.[3] While this chapter begins with a historical overview of these out-of-game arrangements, it continues on to examine the motivations for bringing the music outside of the games in the first place. Here, I draw primarily from the musico-philosophical writings of Peter Szendy (2008) on musical arrangements and transcriptions. My case studies examine two of the various strategies used to arrange this music (which was, at least initially, not recorded with acoustic orchestral instruments). The first strategy—arrangement—is based on freely adapting the music from the games into "proper" classical forms (e.g., Masashi Hamauzu's *Final Fantasy X—Piano Concerto*, arranged from various pieces in *FFX* [2001]). The second strategy—transcription—keeps much of the music the same, but focuses instead on changing the timbre, orchestration, or genre of the piece (e.g., adapting the 16-bit timbres of *FFVI*'s [1994] "Dancing Mad" to fit into everything from a solo piano transcription to the Black Mages' prog rock instrumentation). I conclude the chapter with a reflection on Uematsu's placement within the video game music canon.

Uematsu and the concert hall

The history that I consider within this chapter is in many ways a two-part, interconnected history: that of the general history of video game music concerts, and that of the *FF* series and its music.[4] Elizabeth Hunt (2017) has written at length on the former, tracing the history of these concerts back to 1987 Tokyo, with the *Family Classic Concert*. This first video game music concert would set the stage for subsequent concerts to follow, with the initial program highlighting Kōichi Sugiyama's music for the then-fledgling *Dragon Quest* series. Just two years later, the *FF* series would receive its own special treatment, with the 1989 *Final Fantasy Symphonic Suite*. Like the first *Family Classic Concert*, the *Final Fantasy Symphonic Suite* focused on arrangements of Uematsu's music from the *FF* games, then only the first two installments in the series. Hunt writes:

> Although *Family Classic Concert* is an annual production, *Final Fantasy Symphonic Suite* was a standalone presentation of music which was also released on CD. This concert is significant as music from the *Final Fantasy* series has become some of the most performed music in the video game concert repertoire, featuring in concerts such as 2017's *Symphonic Odysseys*. Uematsu's work has also garnered critical acclaim in classical music circles, for example he has been included numerous times

in ClassicFM's annually updated Hall of Fame [...] Concerts dedicated to Uematsu's work are increasingly common and consistently popular.

(2017: 19)

Important here is the timing of these first two concerts. They demonstrate that the music of the *FF* series entered not only the video game music canon early on but also the *concertized* performances of video game music in its infancy. The two reinforced each other, further cementing Uematsu as a classic(al) video game music composer.[5] As Hunt focuses on video game music concerts writ large—that is, she does not focus on any particular composer at length—Uematsu's particular canonization within video game music concerts does not receive any extensive discussion in her dissertation. Be that as it may, Uematsu's music continued to be performed in concert over the subsequent years. After the *Final Fantasy Symphonic Suite*, Uematsu's music was performed in the *Orchestral Game Music Concerts* (1991–96).[6] As with the *Final Fantasy Symphonic Suite*, these concerts were also recorded and released on CD, further documenting these performances (as well as commodifying them as material artifacts).[7]

Following the *Orchestral Game Music Concerts*, a special, *FF*-centric concert was produced in the early aughts. Titled *20020220: Music from Final Fantasy*, the concert took place on February 20, 2002 (and thus the year [2002], month [02], and the day [20]). Uematsu's music was the focus of this concert as well, including arrangements from the then-new *FFX* for the PlayStation 2. A series of new concerts and concert series ensued, including the *Dear Friends: Music from Final Fantasy* concert in 2004—the first *FF*-centric concert performed outside of Japan.[8] Critical to the history of *FF* concerts was conductor Arnie Roth's involvement with this concert tour. He would come to lead the most popular *FF* concert series: the ongoing *Distant Worlds* tour.

The interplay between both concertized events and documentary recordings of these events is perhaps best exemplified by the *Distant Worlds* series. Helmed by Arnie Roth, this concert series has been in production since 2007 (with its first performance on December 4 in Stockholm, Sweden, in celebration of *FF*'s twentieth anniversary) and exclusively focuses on the music from the *FF* franchise. The *Distant Worlds* concerts are full-on audiovisual productions. In these concerts, scenes from the games are displayed on screen behind the orchestra, visually accompanying the orchestra as it plays arrangements of pieces from the franchise. In terms of recorded albums, at the time of this chapter's writing, there are currently five *Distant Worlds* albums available with music spanning from the original *FF* (1987) to *FFXV* (2016). There have also been what might best be understood as "spin-off" versions of the *Distant Worlds* concert series, including the *Music from Final Fantasy: The Journey of 100* concert, a special program that took place

on January 22, 2015 in Osaka, Japan, to celebrate the 100th performance in the *Distant Worlds* concert series, as well as the *A New World: Intimate Music from Final Fantasy* program, which focuses on "intimate" chamber music arrangements, rather than the full symphonic orchestration of its sibling concert series.[9]

While Arnie Roth's *Distant Worlds* and its "spin-offs" are perhaps the most popular and best-known *FF* concert series, Merregnon Studios' Thomas Böcker has also had a significant impact on both *FF* music concerts and game music concerts in general.[10] Under his leadership, the *Symphonic Game Music Concerts* first came into being in the early aughts, running from 2003–07. Then, from 2008–11 Böcker led the creation of a quartet of special concerts focusing on specific video game music composers and companies. These game concerts, or *Spielekonzerte*, differ from other video game music concerts as they align themselves closer to traditional classical music concerts. In these concerts, for instance, there is no accompanying screen—the music is the sole focus of the concert. The first of these concerts was *Symphonic Shades*, held on August 23, 2008, and dedicated to the music of the German composer Chris Hülsbeck (perhaps best known as the composer for the *Turrican* series). Following this concert, *Symphonic Fantasies* took place on September 12, 2009, and focused on the music of some of Square (Enix)'s best-known series, including *Secret of Mana*, *Chrono Trigger*, *Kingdom Hearts*, and, of course, *FF*.[11] The program comprised four large pieces, each a "fantasy" or *fantasia* on the music of each of the respective game series. After these first two concert programs, a third production, *Symphonic Legends—Music from Nintendo*, followed on September 23, 2010. Finally, completing the quartet was *Symphonic Odysseys*, which took place on July 9, 2011, and focused exclusively on music by Nobuo Uematsu. Thus, Uematsu's music was featured on two of these concert productions. This ultimately led the way to perhaps the most famous concert series under Böcker's direction—the *Final Symphony* program.[12]

On May 11, 2013, the Wuppertal Symphony Orchestra premiered the *Final Symphony*—a set of orchestral arrangements based on Nobuo Uematsu's music for the *FF* series—at the Historische Stadthalle; just two years later, the London Symphony Orchestra released a recording of the *Final Symphony*. Even among the ever-growing brand of game music concerts, the *Final Symphony* stands apart with its extreme "highbrow" aspirations: rather than a set of orchestral suites and standalone pieces based on orchestral transcriptions of 8- and 16-bit music (as frequently happens in these game music concerts), the *Final Symphony* program instead borrows the music from three of the *FF* games (*FFVI, VII* [1997], and *X*) and freely arranged the music from these games into "proper" classical symphonic forms (a symphonic poem, symphony, and concerto, respectively).[13] This initial concert was followed on August 29, 2015, by *Final Symphony II*, which featured

similar symphonic arrangements of the music from *FFV* (1992), *FFVIII* (1999), *FFIX* (2000), and *FFXIII* (2010).[14]

Arrangement and the Final Symphony

In this section I focus on Masashi Hamauzu's contribution to the first *Final Symphony* program: his *Final Fantasy X—Piano Concerto*. This piece is somewhat unique in the scope of the original *Final Symphony* program, as *FFX* was the first main-series game in the franchise for which Uematsu was not the sole composer. Indeed, Hamauzu was one of two additional composers (along with Junya Nakano) on the game's soundtrack. With his contribution to the *Final Symphony*, Hamauzu took pieces from the soundtrack originally composed by both himself and Uematsu and arranged them into a virtuosic concerto.[15] This piece, then, aligns itself with a specific musical tradition, directly orienting itself with classical music, contributing to what William Gibbons (2018) has termed the "classifying" of game music. Here, I consider this process in terms of musical *arrangement*, using the *Final Fantasy X—Piano Concerto* as my case study. In this section and the next, I will draw from Peter Szendy's (2008) pontifications on arrangement and transcription: two different approaches to understanding how pre-existing music can be revisited—or perhaps in the language of video games, re*played*.[16]

Christopher Huynh indirectly notes this process of arrangement in his online analysis of the concerto, stating that "Hamauzu's piano concerto [...] purposely [does] not hav[e] clear ties to the narrative and characters of its game. Although he chooses a handful of recognizable themes, Hamauzu doesn't shy away from giving them far-removed variations to craft a new experience" (2015: n.pag.). Though Huynh claims this toward the beginning of his analysis, much of his analysis *does* try to tie his reading of the concerto back to the game. That is, he primarily frames his analysis by tracking motivic fragments and quotations as Hamauzu arranges and transforms them across the concerto. While Huynh chooses to focus on the motivic development across the concerto, I am instead interested in more specifically why the *concerto* as a musical genre was chosen in the first place. I would contend that the appeal of the concerto is its classical associations of the relationality between the individual and society—namely the soloist and their relationship to the accompanying ensemble.

Elsewhere, I have argued that *FFX* represents a hyperreal retelling of Japan's history, though through an imagined western lens (Greenfield-Casas 2017). Crucial to this point is the use of the diegetic "Hymn of the Fayth" as a way of framing the Yevon religion of the gameworld in the western sacred music tradition. This ultimately culminates with a literal "death of god" at the game's narrative epoch, one

marked by "drastic harmonic changes to the hymn" (Greenfield-Casas 2017: 4). Pertinent to my reading of the *Final Fantasy X—Piano Concerto* is that the game's focus is on Yuna, a summoner who undergoes a religious pilgrimage in order to defeat the evil "Sin" incarnate of the gameworld. Along the way, however, she forsakes her sacred pilgrimage after finding out the dark truth behind the religion in which she once so faithfully believed. In this sense, Yuna becomes the crucial lynchpin in the masses' ultimate disillusionment with Yevon. And yet, it is not until the end of the game when players defeat Yu Yevon, the god of the gameworld, that the people of Spira completely embrace the change Yuna represents. That is, along the way Yuna becomes persecuted for her changed beliefs—an individual against society in terms of narrative conflict.

The understanding of the concerto (or, more specifically, the concerto grosso) as representative of the relationship between the individual and society was perhaps made most famous in Susan McClary's (1987) well-known analysis of J. S. Bach's Fifth Brandenburg Concerto.[17] For McClary, "[t]he concerto grosso involves two principal performing media: a large, collective force (the concerto grosso—literally, the 'big ensemble') and one or more soloists. The two forces enact metaphorically—and as a spectacle—the interactions between individual and society" (1987: 23). Tied to her analysis is the "politics" of Bach's time: the eighteenth-century Enlightenment. The larger point of her essay, that music should be understood not in a kind of "Pythagorean," metaphysical sense but as "artistic production as social practice" (1987: 60), was indicative of her own time within the field of music studies: the so-called new musicology of the late 1980s and early 1990s. For some, her hermeneutics pushed the interpretive envelope too far, perhaps in large part because of the grand societal (rather than local agential or biographical) narrative she mapped onto the absolute music.[18] And yet, I wish to make a similar hermeneutic analysis with Hamauzu's *Final Fantasy X—Piano Concerto*, one where such a history is directly (and overtly) tied to its music.

As I have previously argued, the history of Spira aligns itself in a kind of hyperreal turn to the Enlightenment (Greenfield-Casas 2017). In this sense, a concerto is formally, or perhaps *genre*-ically, the perfect musical representation of *FFX*. Even if Hamauzu claims that "[h]is inspiration for the material in this concert is more a reflection of that bigger vision [seeing the *FF* series 'more as a continuum than as a series of separate scenes and stories'] and not so much connected to any certain story-arc or a set of characters" (Game Concerts n.d.: n.pag.), the form and genre of the concerto paint a different picture. Formally, the order of the movements *does* roughly align with the game's narrative. It opens with a movement titled "Zanarkand," which aligns not only with where the *in media res* opening credits take place before players start the game proper, but also where players actually start in the game: the Zanarkand of the past before Tidus is dragged into

the future.[19] The second movement, which I will discuss in more detail below, is titled "Inori" (translated in English as "Hymn of the Fayth"), the musical synecdoche for both Spira and a hyperreal Japan. Finally, the third and last movement, "Kessen" (Eng. "Final Battle") is based on merging both the music played when the party confronts both Sin (a piece titled "Assault") and the music played when battling the game's final boss (the aforementioned "Final Battle").[20]

In terms of the genre of the piece, the interactions between the individual and society are tied to Yuna's narrative within the gameworld—the piano, then, becomes representative of Yuna as the game's heroine. And yet, just as McClary's keyboard player occupies a double role as both accompanist and as soloist, so too does the piano here reflect part of the society with which it is interacting.[21] This is most apparent in the second movement of the concerto, "Inori." As mentioned above, this movement takes as its main motivic material the "Hymn of the Fayth," a sacred song of the Yevon religion (Greenfield-Casas 2017: 6–18). The hymn (and/or chorale) as a musical topic evokes not only religious connotations but those of community as well (Sánchez-Kisielewska 2018). The song, then, is not just Yuna's song—instead, it is one that belongs to all the people of Spira. And yet, it is largely because of Yuna's progression in her journey that Spira undergoes the changes it does in the game.[22] That the solo piano plays a highly decorated variation on the Hymn in this second movement, against a kind of *cantus firmus* on the Hymn played by the accompanying orchestra before moving uninterrupted into the third movement, signals not only the musical but the narrative ties between the two as well. This is doubly reinforced with the ending of the concerto: just before the halfway point of the final movement, a full voiced iteration of the Hymn is played again by the solo piano. This is then reiterated in the antepenultimate phrase of the movement, just before the concerto ends. The Hymn governs not only the second movement, then, but also extends forward to the "decisive battle" that concludes the narrative of the game and, ultimately, the piano concerto itself.

With this concerto, Hamauzu provided his own take, not only on the music of *FFX* but also on the narrative of the game. In his program notes to the *Final Symphony*, Hamauzu states:

> In this instance I could give more priority to my feelings and sensitivity when composing music than often is the case. Naturally I also had the storyline of the game strongly in my mind, but I also got ideas from the real world outside the creations of the FINAL FANTASY-world.
>
> (Game Concerts n.d.: n.pag.)

Hamauzu's quote aligns with Szendy's discussion of his love of arrangers, that is, those who "don't hesitate to set their name down next to the author's. Bluntly

adding their surname by means of a *hyphen*" (Szendy 2008: 35, original emphasis). Here, Hamauzu adds a hyphen by not only Uematsu (Uematsu-Hamauzu) but arguably also Hironobu Sakaguchi, the creator of the *FF* series and executive producer of *FFX*; thus: Sakaguchi-Hamauzu... or perhaps even Sakaguchi-Uematsu-Hamauzu. This is by no means to say Hamauzu's score is derivative—at least not in any negative sense of the word. Instead, it is a *specific hearing* of *FFX* and its music. In Szendy's words: "[W]hat arrangers are signing is above all a listening. *Their* hearing of a work. They may even be the only listeners in the history of music to *write down* their listenings, rather than *describe* them (as critics do)" (2008: 36, original emphasis). In this sense, Hamauzu's view (or hearing) of the music of *FFX* is instructive: "There were a few things I couldn't express well enough while I was working originally on the music of FINAL FANTASY X, and I feel like I could express those things this time around" (Game Concerts n.d.: n.pag.).

As I have shown in this section, Hamauzu's hearing is still very much in line with the narrative of *FFX* and its story. Perhaps it is no accident, then, that the mythic first words heard spoken in the *FF* franchise writ large are these: "Listen to my story." This line is spoken by *FFX*'s playable character, Tidus, in the game's introductory cinematic, directly imploring that players of the game *listen*. *FFX* and Hamauzu's *Final Fantasy X—Piano Concerto*, then, can be heard as an auspicious example of how listening directly connects to arrangement. That Tidus's plea is spoken over Uematsu's "Zanarkand," for instance, directly reinforces Hamauzu's adaptation of the piece into the opening of his concerto, prompting us from the outset to remember to *listen*. Indeed, with this concerto, Hamauzu simply invites us to listen to the worlds of *FF* as he hears them.[23]

"Transcribing" mad

In contrast to the concerto arrangement of *FFX*'s soundtrack, which took the many themes of the game and arranged them into a "proper" classical symphonic form, *FFVI*'s "Dancing Mad," the music that accompanies players as they battle against the game's final boss, has remained relatively immutable in the various "transcriptions" of the piece. This, I argue, has much to do with "Dancing Mad" already existing as a kind of (neo-)Romantic "work" (Goehr [1992] 2007)—that is, the piece, with its multimovement form, extended duration, and clever use of quotation (both intertextual and leitmotivic), makes for an already ambitious piece that would be difficult to adapt into an arrangement featuring other pieces as well.[24]

As with my discussion of Hamauzu's piano concerto, it is not my intent to provide an in-depth formalist analysis of the piece here—this has been accomplished

elsewhere (Plank 2018: 236–93; SWE3tMadness 2009; Harris 2016). Instead, I would like to consider the various versions of "Dancing Mad" as types of "transcriptions" of the piece. As opposed to arrangements, whereby composer-arrangers take pre-existing musical materials and adapt them to their own purposes, transcriptions take what music theorist Leonard Meyer (1989) deems the primary parameters of a piece (a piece's melody, harmony, and rhythm) as generally immutable and focus instead on changing its secondary parameters (instrumentation, timbre, dynamics). In Szendy's terms:

> The body that shapes transcription is thus *plastic*. As is also […] our listening to an arrangement, torn between two parallel lines, one present and the other ghostly or spectral: our listening is stretched, stretched to breaking point like a rubber band, between the transcription and the original. That is to say […] between the piano score and the original score.
>
> (2008: 58, original emphasis)

Szendy's discussion of transcription focuses on Franz Liszt's transcriptions of Beethoven's symphonies, what Liszt called "piano scores" (rather than, say, piano reductions). While the versions of "Dancing Mad" that I will deem its "transcriptions" are perhaps not all as obvious as Szendy's Lisztian example, I argue that the technologies of the present and recent past (e.g., game systems) require new ways of adapting Szendy's theory to the current time and its music.[25]

I focus on three transcriptions of "Dancing Mad" in this section. These include the versions featured on: (1) the *Piano Opera: Final Fantasy IV/V/VI* (2012) album, transcribed and performed by Hiroyuki Nakayama; (2) the Black Mages' (Uematsu's first prog rock band) cover of the piece, featured on their eponymous debut album (2003); and (3) the *Distant Worlds II: More Music from Final Fantasy* (2010) recording by the Royal Stockholm Philharmonic Orchestra, Elmhurst College Concert Choir, and Earthbound Papas (Uematsu's second prog rock band).[26] One of the interesting facets of these various transcriptions is how they each choose to conclude the piece. As noted by a number of video game music scholars (Collins 2008; Phillips 2014; Thompson 2018; Summers 2020), video game music is often looped and left intentionally "open" to help facilitate more seamless repeats. This makes writing definite endings for these pieces a political act; that is, one where conscious and very intentional decisions have to be made—where a certain stance is taken. While some video game music transcriptions might lend themselves to simply tacking on a sustained chord at the piece's "end," I contend that the epicness of "Dancing Mad" would be lost—or at the very least marred—by such a sudden and jarring ending. We might consider how these transcribers choose to conclude this piece, then, as political *hearings* (a la Szendy).

Before engaging with the respective endings of these various transcriptions, however, a cursory overview of the form of "Dancing Mad" is in order. The piece is divided into four (or five) separate sections, reflecting the stage of battle in which players are engaged with the nihilist jester-turned-god Kefka. These include, per the original soundtrack: (1) a ponderous intro, (2) an off-kilter march, (3) an extended eighteenth-century-style "organ" feature, and (4) a direct quotation of the game's opening (and probable allusion to Richard Strauss's tone poem *Also sprach Zarathustra*) that leads into (5) an epic, prog rock conclusion.[27] With the exception of the fourth section (which is more of an introduction to the final section of the work than a standalone section on its own terms [Plank 2018: 281–88]), these sections will loop and repeat as needed while players battle Kefka. Thus, in the context of the game, sections do not have definitive and overtly teleological endings. Perhaps counterintuitively, this is especially true of the final section as heard in the game. Rather than a grand cadence and/or heroic fanfare announcing Kefka's defeat with the final blow in the game, the music instead abruptly fades out and an extended sonic rendering of Kefka's pixelated deterioration takes over.[28] Indeed, even on the *FFVI* original soundtrack (OST), the final section simply loops and eventually fades out, implying that the music (as well as this epic battle) could continue on *ad infinitum*.

This musical ending, unceremonious and abrupt as it is, then, does not particularly lend itself to transcription (neither formally nor sonically). Such a claim is especially true if "Dancing Mad" is conceived of as a kind of musical work, with all the cultural and aesthetic baggage that comes with the term (Goehr [1992] 2007). As Tim Summers notes, "popular music studies have too often uncritically dealt with recordings as ultimate incarnations of 'works'" (2016: 25). He continues, reflecting that "[a] game, or a piece of music, exists as a domain of performative possibilities. Just as performances of music vary upon repetition of the same piece, so do performances of games, often with implications for the music as sounded during play" (2016: 29). Following Summers's claim, neither "Dancing Mad" as heard on the *FFVI* OST nor the various transcriptions of "Dancing Mad" should be understood as "ultimate incarnations" of "Dancing Mad."[29] To return to a point mentioned in the introduction to this chapter, questions of authenticity surrounding video game music can become very tricky, very quickly. And yet, this does not mean we should abandon hope in terms of considering these transcriptions in relation to the original. Rather, I believe that if questions of definitive authenticity can be placed to the side, questions of specific (political) *hearings* might prove to be worth considering. With this, I now turn to this section of the chapter's three case studies.

Hiroyuki Nakayama's transcription of "Dancing Mad" is perhaps the most akin to the Beethoven-Liszt "Piano Scores" both Szendy and Summers discuss.[30]

This is largely because many of the primary parameters of Uematsu's original "Dancing Mad" remain the same in Nakayama's transcription of the piece. That is, the piece (for the most part) is a one-to-one mapping of the original 16-bit track to a piano transcription (or piano *score* in a Lisztian sense).[31] Indeed, this is to the extent that Nakayama's transcription is the only version of the piece analyzed in this chapter that includes the fourth section of "Dancing Mad." Following an extended cadence at the end of the third section, the piano transcription quotes the opening of the game. As Dana Plank notes of this fourth part:

> "Dancing Mad Part 4" is simply an introduction to the final form of Kefka, bringing the game full circle by repeating the opening gesture of the game—the theme that plays over the title screen with the ominous dark purple and black clouds and lightning when the player turns the game on [...] Every time a player restarts the SNES, this theme recurs, and so it is one of the most-heard tracks in the game. And yet it reappears verbatim in the second to last part of the final boss fight—coming full circle with the musical material.
>
> (2018: 281)

That this portion of "Dancing Mad" is present might not seem particularly noteworthy—it is a part of the game after all, announcing Kefka's ultimate incarnation. And yet, as mentioned above, this transcription is the only one among the versions I consider in this chapter that retains this fourth section. It is perhaps because the circularity that Plank notes is generally absent from these transcriptions in isolation. That is, players have not just started up their respective Super Nintendos (or Super Famicoms) and have not resultantly just heard the opening of the game. Thus, the circularity and *specificity* to *FFVI* is lost in these other transcriptions.

Be that as it may, Nakayama's transcription includes this fourth section and unproblematically proceeds to the fifth section's prog rock ending. By way of ending the piece, Nakayama includes some newly composed material that oscillates between the major and minor modes of the concluding key. Just as how Liszt scholar Jonathan Kregor suggests that "one of the most impressive aspects of Liszt's late [transcriptions] is the way in which he added material that maintained the vestigial presence of the source composer yet still managed to bring forth his own artistic profile" (2010: 218), so too does Nakayama's composed ending support both the source material as well as his own hearing. Nakayama's oscillation between modalities affords a concluding Picardy third, harkening back to the Baroque period and, more particularly, a religious ending.[32] In this way, Nakayama's transcription almost seems to accept Kefka's godhood, giving the piece a new, religious closure unheard in the game's sounding of "Dancing Mad." An alternative, redemptive hearing might pit the ending minor and major modalities against each

other in a kind of "Fateful" Beethovenian struggle, with the redemptive major mode (here representative of the in-game party) ultimately overcoming the antagonistic minor mode (here associated with Kefka).

In direct contrast to Nakayama's transcription, which equalizes the parts of the original piece into a version with a singular instrument and lone performer, the Black Mages' transcription (one might also productively use the term "cover") adapts the piece for Uematsu's first prog rock band.[33] That is, rather than just the last section of "Dancing Mad" gesturing toward prog rock, in this version (and still one of Uematsu's Szendian "hearings" it should be noted!), the entirety of the piece is performed by a prog rock band. And while certain sections of the piece may seem somewhat less overtly "proggy" than others (the third section, for instance, still maintains its status as a faux-eighteenth-century organ solo), the genre is certainly cemented with the extended guitar solo at the end of this version.[34] Indeed, while the repeats that are inherent in the individual sections of the game are generally ignored in the various transcriptions of the piece, the final section in this cover includes not just two but *three* vamps to allow for an extended guitar solo by the band's guitarist, Tsuyoshi Sekito. And yet, this is not where the piece ultimately concludes, even with the blistering sixth octave C# that concludes Sekito's solo. Instead, the piece returns to the beginning—not the beginning of the game (as quoted in "Dancing Mad's" fourth section), but the beginning of "Dancing Mad" *itself* before concluding with a chiming bell that fades out over a pedal drone. Thus, the cover is cyclical not in the context of the grand narrative of the game (to which the missing fourth section would allude) but rather intramusically to itself. Indeed, as this is the first licensed version of the piece outside of *FFVI* and its OST, this cover set the musical precedent for concluding all subsequent iterations of "Dancing Mad." This precedent is reflected in the *Distant Worlds* transcription.

The *Distant Worlds* recording (arranged by Arnie Roth and Adam Klemens) functions as a kind of amalgamation of the two transcriptions I have already discussed, yet also differs in a critical aspect: as part of the *Distant Worlds* tour, it features an orchestral transcription of Uematsu's music, thus providing the acoustic, "real" timbres the instruments of the 16-bit soundtrack index. And yet, this "Dancing Mad" transcription stands out even on the *Distant Worlds* album on which it is recorded, as it features Uematsu's second prog rock band, the Earthbound Papas, in the final section of the piece.[35] Perhaps because Uematsu himself was involved with both transcriptions (or both "hearings") of the piece, the *Distant Worlds* ending is very much in line with the Black Mages' ending—that is, it allots for an extended guitar solo that then cycles back to the beginning of the piece, recapitulating "Dancing Mad's" slow introduction to end the piece. In contrast to the Black Mages' ending (with its use of bells that fade out and end the piece), however, the *Distant Worlds* recording instead makes use of a Picardy

third at the end of the recapitulated introduction-*qua*-ending, akin to Nakayama's transcription. This transcription thus ends in a spectacularly epic fashion, providing listeners an additional and engaging "hearing" (or *re*hearing) of Uematsu's work, one that aspires to a religious experience.[36]

While I have called each of these three pieces "transcriptions," I hope to have problematized this term a bit, especially in relation to video games and notions of definitive "works" within them. Just by nature of the affordances of the instruments, ensembles, and number of bodies playing these pieces, each transcription chooses to highlight (and/or diminish) certain aspects or parameters of the source piece, based on each transcriber's respective hearing of it. Nakayama's piano transcription, for instance, not only entirely removes the timbres of the original soundtrack but also simplifies some of the textures of the original piece while ornamenting others—a necessity in order to play the piece with only two hands rather than the eight channels of the original game. The Black Mages and *Distant Worlds* transcriptions, on the other hand, add a dramatic flair to the piece with their respective ensembles and associated timbral palettes, yet leave out part of the music heard in the context of the game. To complicate questions of authenticity, however, both of these recordings can be considered as Uematsu's rehearings of "Dancing Mad" as he was involved in both their respective productions. To reiterate: it is not my intention to say that any one of these transcriptions is inherently "better" (or, per the introduction, more "authentic") than the others. Instead, I am more interested in drawing attention to the process of transcription itself and examining the many ways it can be enacted in respect to a singular piece of music, thus highlighting the unique merits of each transcription and each transcriber's respective hearing.

The end?

By way of conclusion, I would like to reflect on Uematsu's status within the video game music canon. Part of the reason for Uematsu's success in present-day video game concerts, I have argued, is his long-time association with these concerts (from near their inception). In this respect, Uematsu is very much a "classical" video game music composer. This classical-ness is multifaceted. Thus, Uematsu can be considered a classical composer vis-à-vis: (1) when he was composing this music in the history of video games, (2) the sounds of the instruments to which his 8- and 16-bit soundtracks index and allude, and (3) his music's direct adaptation to the concert hall. The second and third points are certainly interconnected, with the former helping to facilitate the latter. These live symphonic concerts in turn helped build the cultural capital of the *FF* series' music and Uematsu's reputation, helping to solidify him as the so-called "Beethoven of video game music."[37]

Moreover, the language used around Uematsu and his music cloaks him in almost as mythic an aura as Beethoven. Consider his inclusion in ClassicFM's "Hall of Fame" (alongside the likes of Mozart and Beethoven), which itself recalls the legendary hall, Valhalla, of Norse mythology.[38] Take also Böcker's tribute to Uematsu, *Symphonic Odysseys*, here tethering Uematsu and his music to Homer's epic *Odyssey*. Indeed, the very fact that his music is being arranged and transcribed as it is today recalls Liszt's preoccupation with "monumentalizing" and "mythologizing" Beethoven (Kregor 2010: 112–48) within Liszt's proposed "musical Museum" (Goehr [1992] 2007: 205).

While the title is certainly intended as praise, and while Uematsu is certainly an accomplished composer in his own right, it is not unproblematic to compare him to a German composer from the long eighteenth century. Each composer existed in his own respective time, with different life experiences, influences, and technologies (musical or otherwise). Ultimately, Nobuo Uematsu is no one other than Nobuo Uematsu: a celebrated video game music composer whose soundtracks have escaped the confines of the games for which they were written and are now performed for and listened to by adoring fans across the world. This, then, is ultimately Uematsu's contribution to what comes (or perhaps remains) after the *FF* games: his music. The arrangements and transcriptions of his music, in turn, provide new "hearings" of the many worlds of the *FF* series, allowing for new and nuanced sonic experiences outside of these beloved games and within our own world.

Acknowledgments

The author would like to thank Richard Anatone for his editorial labor and comments, Benyamin Nuss and Eric Roth for their insightful thoughts on Nobuo Uematsu's music and video game music transcriptions, Thomas Gaubatz for sharing his speculative musings on JRPGs and their soundtracks, and especially Elizabeth Hunt for her generous review of this chapter in draft form.

NOTES

1. It should be noted, however, that Uematsu also frequently writes music in more rock-oriented styles as well (as I will discuss regarding "Dancing Mad").
2. Indeed, the first issue of the recently released *Journal of Sound and Music in Games* (*JSMG*) featured a colloquy on canons, with three of the four contributors (Gibbons 2020; Park 2020; Cook 2020) mentioning Uematsu in this light.

3. Though there are many compelling fan arrangements of the music of the *FF* series, I choose to focus on the licensed releases in large part to limit my corpus. Future scholarship in the field would benefit from taking these fan arrangements on their own terms, as has already been addressed by some scholars (Gibbons 2015; Waxman 2016; Grasso 2020; Smith 2020).

4. Brooke McCorkle (2016, 2020) has written at length on the related history of "cine-concerts."

5. Thomas Böcker (to be discussed later in the chapter) notes Uematsu's contributions to video game music concerts in an interview:

> I think that—having said this—it is natural that the compositions of Nobuo Uematsu and Masashi Hamauzu have been chosen for this premiere [of *Final Symphony II*], though: their soundtracks define what video game music stands for. We should not forget that Nobuo Uematsu was one of the first few pioneers in putting on video game concerts in Japan, so the whole concert movement is partly in thanks to him.
>
> (2015: n.pag.)

6. It is worth noting that music from the *FF* series was not performed on the third (1993) or fifth (1996) of these concerts.

7. Many of these early recordings are quite rare and/or expensive. Fortunately, the *Video Game Music Database* has chronicled an enormous amount of this material.

8. Hunt notes:

> From the first *Family Classic Concert* in 1987 to the final *Orchestral Game Music Concert* in 1996, the documented concerts of video game music were Japanese in origin, production, and performance. A likely reason for this is Japan's prominence in the video game industry at this time.
>
> (2017: 20)

9. Eric Roth, Arnie Roth's son, is the music director, producer, conductor, and arranger for the *A New World* series. This series also differs from *Distant Worlds* in that no visual accompanies the chamber ensemble.

10. This is especially true of video game music concerts outside of Japan. Indeed, Böcker was involved with the *Distant Worlds* tour in its early years as a production consultant.

11. *Symphonic Fantasies* would also eventually be performed in Tokyo, Japan, on January 7 and 8, 2012, as the first European game music concert to take place in Japan.

12. Other *FF* concerts have taken place since the *Final Symphony* programs. These include (1) the *Dreams of Zanarkand* concert, which took place on October 8, 2016, and was dedicated exclusively to the music of *FFX*; (2) the *Eorzean Symphony*, which premiered on September 23, 2017, and is based on the music from *FFXIV* (2010); and, most recently, (3) the *Final Fantasy VII: A Symphonic Reunion* concert, which was performed on

June 9, 2019, at the Dolby Theatre in Los Angeles in association with and anticipation of the long-awaited *FFVII Remake* (2020).

13. Uematsu himself states that "[w]hat makes *Final Symphony* so different is that it is interpreted more freely, in an artistic manner. There are even aspects that are closer to contemporary classical music" (n.d.a: n.pag.; cf. Gibbons 2018: 170).

14. Unlike the pieces for the original *Final Symphony*, the pieces arranged for this concert were all single-movement works. Also, unlike the original *Final Symphony*, only the piece associated with *FFIX* (Roger Wanamo's *For the People of Gaia*) is in a traditional "classical" form (a piano concerto).

15. Uematsu notes in an interview that with all of the *Final Symphony* pieces the various arrangers "developed fragments of the melodies I wrote into complex, highly sophisticated music" (n.d.b: n.pag.).

16. Julianne Grasso has discussed a related point in terms of phenomenologically "reliving" a game while listening to a video game music concert:

> "Relive" is a term that seems to suggest that the music will allow the listener more than recall: an access to an embodied memory that perhaps *enacts* something about experiences of play—not dissimilar to the kind of affective arrangement I described above.
>
> (2020: 84)

17. Though McClary was perhaps the first to tie the socio-historical milieu of Bach's time to her analysis, as far back as Heinrich Koch, the notion of a dialogue between soloist and orchestra has been noted:

> The expression of feeling by the solo player is like a monologue in passionate tones, in which the solo player is, as it were, communing with himself; nothing external has the slightest influence on the expression of his feeling. But consider a well-worked-out concerto in which, during the solo, the accompanying voices are not merely there to sound this or that missing interval of the chords between the soprano and bass. There is a passionate dialogue between the concerto player and the accompanying orchestra. He expresses his feelings to the orchestra, and it signals him through short interspersed phrases sometimes approval, sometimes acceptance of his expression, as it were. Now in the allegro it tries to stimulate his noble feelings still more; now it commiserates, now it comforts him in the adagio. In short, by a concerto I imagine something similar to the tragedy of the ancients, where the actor expressed his feelings not towards the pit, but to the chorus.
>
> (1983: 209; cf. Kerman 1999)

18. Charles Rosen's chapter on "The New Musicology" is one such example. See Rosen (2000: 255–72, esp. 264–65).

19. Huynh's analysis of this movement also convincingly focuses on the use of the piece "Besaid," which I will not rehash here. Indeed, he provides a more thorough list of the specific pieces used across the concerto as a whole, concerned as he is with the micro units of the piece. In direct contrast to his methodology, I am concerned in my discussion with the (super)macro piece as a whole and its genre.

20. All of these pieces have various titles based on how the original Japanese was translated. These include "To Zanarkand," "At Zanarkand," and "Zanarkand"; "Hymn of the Fayth," "Song of Prayer," and "Inori"; and "Decisive Battle," "Final Battle," and "Kessen."

21. Anyone who has served as an accompanist knows the almost complete lack of recognition that comes with that position. As an active keyboardist, Bach was very familiar with this role and—if the narrative of this piece can serve as an indication—with its attendant rewards and frustrations. For in this concerto (in which he would have played the harpsichord part himself), he creates a 'Revenge of the continuo player': the harpsichord begins in its rightful, traditional, supporting, norm-articulating role but then gradually emerges to shove everyone else, large ensemble and conventional soloists alike, out of the way for one of the most outlandish displays in music history. The harpsichord is the wild card in this deck that calls all the other parameters of the piece—and their attendant ideologies—into question.

(McClary 1989: 25–26)

22. As McClary notes in her analysis:

Certainly, social order and individual freedom are possible, but apparently only so long as the individuals in question [...] abide by the rules and permit themselves to be appropriated. What happens when a genuine deviant (and one from the ensemble's service staff yet!) declares itself a genius, unconstrained by convention, and takes over? We readily identify with this self-appointed protagonist's adventure (its storming of the Bastille, if you will) and at the same time fear for what might happen as a result of the suspension of traditional authority.

(1989: 40)

23. "And [we] *listen to him listening*" (Szendy 2008: 60, original emphasis).

24. Lydia Goehr (2007) first discussed the "work-concept" in relation to proverbial "classical" musics, though Tim Summers (2016) has recently discussed the notion of the work as pertaining to video game music. And though I suggest it is difficult to arrange this piece, it is certainly not impossible. Take, for instance, the use of "Dancing Mad" in the "Final Boss Suite," which was performed as an encore for the aforementioned *Symphonic Fantasies* concert, as well as its inclusion in *Final Symphony*'s symphonic poem, *Final Fantasy VI—Symphonic Poem: Born with the Gift of Magic*. A related example is the final track of Square Enix's *Last SQ* album (2015), which combines the pieces "Chaos Shrine," "Dancing Mad," and "Prologue" from both the original *FF* and *FFVI*.

25. Summers makes a similar connection between the piano scores and video game music arrangements: "Liszt's solo piano transcriptions and his fantasies of music from earlier operas might be seen as akin to the adaptions of video game music for live performance in events such as the *Video Games Live* or *Zelda* orchestral concerts" (2016: 29). Summers's more recent (2020) claim that video game music is inherently *queer* when contrasted to other types of music (citing, e.g., the frequent use of loops in video game music) is, I think, one provocative way of engaging Szendy's theory with consideration of new technologies.

26. There is also a *Distant Worlds* version that does not include the prog band—aside from the missing guitar solo, however, the orchestration and formal design are essentially the same.

27. For an extended discussion of the *Also sprach Zarathustra* allusion, see Anatone, this volume. The concluding prog rock section of "Dancing Mad" shares many similarities to the title track of Emerson, Lake, and Palmer's album *Tarkus*. I am thankful to Thomas Gaubatz for sharing this observation with me.

28. On rendering, Michel Chion suggests:

> The film spectator [or, in this case, video game player] recognizes sounds to be truthful, effective, and fitting not so much if they reproduce what would be heard in the same situation in reality, but if they render (convey, express) the feelings associated with the situation.
>
> ([1990] 1994: 109; cf. Buhler 2019: 254–56)

29. Brian Kane (2017) has theorized a useful method of discussing such intricate musico-ontological relations via networked chains of "replication" and "nomination." Though Kane specifically focuses on jazz standards in his article, he notes that his model is applicable to a number of different genres and styles of music.

30. For further discussion of Liszt and his transcriptions, see Kregor (2010).

31. The piece *does* differ from the original in some interesting ways. This includes a kind of slow *pre-introduction*, an unusual addition considering the original opening of the piece is itself already a kind of slow introduction. James Hepokoski and Warren Darcy discuss slow introductions in terms of formal "parageneric spaces" (2006: 295–300).

32. Further still, this Baroque-style ending recalls the earlier third section (the "organ" section) of the piece. For an extended discussion of the musical meaning associated with the Picardy third, see Hatten (1994).

33. Michael Harris suggests this version is not only "the best arrangement of 'Dancing Mad,'" but also "the best *Final Fantasy* music arrangement yet…" (2016: n.pag.).

34. And yet, even if the purely *rock* aesthetic is not as overtly present in this section, prog rock bands did not shy away from incorporating classical instruments into their instrumentation. This is especially true of the organ, and the Hammond organ in particular. See Macan (1997).

35. Indeed, this was the new band's inaugural performance. The Earthbound Papas released their own recording of "Dancing Mad" on their sophomore album *Dancing Dad* (2013).

Though similar to the Black Mages' cover of the piece, the Earthbound Papas' cover makes some notable deviations. This includes an electric guitar doubling portions of the contrapuntal organ section.

36. Relatedly, Edward Macan notes that prog rock took on an almost religious and "liturgical" role for many of its fans (1997: 66–68).

37. Further still, the proliferation of Uematsu's music via the recordings of these concerts (e.g., *Distant Worlds*, *A New World*, *Final Symphony*) helps maintain and solidify Uematsu's status within the video game music canon (cf. Gibbons 2020).

38. I am indebted to Elizabeth Hunt for this astute observation.

REFERENCES

Böcker, Thomas (2015), "Final Symphony Creator Thomas Böcker on Why Osaka Concert Is a 'Triumph for All,'" interview by Chris Kerr, Side One, June 9, https://web.archive.org/web/20181005165343/http://www.sideone.co.uk/final-symphony-creator-thomas-bocker-on-why-osaka-concert-is-a-triumph-for-all-music/. Accessed October 5, 2018.

Buhler, James (2019), *Theories of the Soundtrack*, New York: Oxford University Press.

Chion, Michel ([1990] 1994), *Audio-Vision: Sound on Screen* (trans. C. Gorbman), New York: Columbia University Press.

ClassicFM (n.d.), "Uematsu—Final Fantasy Series," https://www.classicfm.com/composers/uematsu/music/final-fantasy-soundtrack/. Accessed May 5, 2020.

Collins, Karen (2008), *Game Sound: An Introduction to the History, Theory, and Practice of Video Game Music and Sound Design*, Cambridge: MIT Press.

Cook, Karen (2020), "Canon Anxiety?," *Journal of Sound and Music in Games*, 1:1, pp. 95–99.

Game Concerts (n.d.), "Final Symphony," http://www.gameconcerts.com/en/concerts/final-symphony/. Accessed May 5, 2020.

Gibbons, William (2015), "How It's Meant to Be Heard: Authenticity and Game Music," Avid Listener, September 21, http://www.theavidlistener.com/2015/09/how-its-meant-to-be-heard-authenticity-and-game-music.html. Accessed May 5, 2020 [no longer available].

Gibbons, William (2018), *Unlimited Replays: Video Games and Classical Music*, New York: Oxford University Press.

Gibbons, William (2020), "Rewritable Memory: Concerts, Canons, and Game Music History," *Journal of Sound and Music in Games*, 1:1, pp. 75–81.

Goehr, Lydia ([1992] 2007), *The Imaginary Museum of Musical Works: An Essay in the Philosophy of Music*, rev. ed., Oxford: Clarendon Press.

Grasso, Julianne (2020), "On Canons as Music and Muse," *Journal of Sound and Music in Games*, 1:1, pp. 82–86.

Greenfield-Casas, Stefan (2017), "Between Worlds: Musical Allegory in *Final Fantasy X*," master's report, Austin: University of Texas at Austin.

Harris, Michael W. (2016), "The Music of *Final Fantasy VI*—Act IV: 'Dancing Mad' and the Insanity of Kefka," Temp Track, August 20, https://www.thetemptrack.com/2016/08/20/the-music-of-final-fantasy-vi-act-iv-dancing-mad-and-the-insanity-of-kefka/. Accessed May 5, 2020.

Hatten, Robert (1994), *Musical Meaning in Beethoven: Markedness, Correlation, and Interpretation*, Bloomington, IN: Indiana University Press.

Hepokoski, James and Darcy, Warren (2006), *Elements of Sonata Theory: Norms, Types, and Deformations in the Late-Eighteenth-Century Sonata*, New York: Oxford University Press.

Hunt, Elizabeth (2017), "From the Console to the Concert Hall: Interactivity, Nostalgia and Canon in Concerts of Video Game Music," MRes dissertation, Liverpool: University of Liverpool.

Huynh, Christopher (2015), "*Final Fantasy X* Piano Concerto Listener's Guide," VGMOnline, 23 April, http://www.vgmonline.net/ff10concerto/. Accessed May 5, 2020.

Kane, Brian (2017), "Jazz, Mediation, Ontology," *Contemporary Music Review*, 37:5&6, pp. 507–28.

Kerman, Joseph (1999), *Concerto Conversations*, Cambridge, MA: Harvard University Press.

Koch, Heinrich Christoph ([1782–93] 1983), *Introductory Essay on Composition: The Mechanical Rules of Melody, Sections 3 and 4* (trans. N. K. Baker), New Haven, CT: Yale University Press.

Kregor, Jonathan (2010), *Liszt as Transcriber*, Cambridge: Cambridge University Press.

Macan, Edward (1997), *Rocking the Classics: English Progressive Rock and the Counterculture*, New York: Oxford University Press.

McClary, Susan (1987), "The Blasphemy of Talking Politics during Bach Year," in R. Leppert and S. McClary (eds.), *Music and Society: The Politics of Composition, Performance and Reception*, Cambridge: Cambridge University Press, pp. 13–62.

McCorkle, Brooke (2016), "Fandom's New Frontier: *Star Trek* and the Concert Hall," *Journal of Fandom Studies*, 4:2, pp. 175–92.

McCorkle, Brooke (2020), "Liveness, Music, Media: The Case of the Cine-Concert," *Music and the Moving Image*, 13:2, pp. 3–24.

Meyer, Leonard (1989), *Style and Music: Theory, History, and Ideology*, Philadelphia: University of Pennsylvania Press.

Park, Hyeonjin (2020), "The Difficult, Uncomfortable, and Imperative Conversations Needed in Game Music and Sound Studies," *Journal of Sound and Music in Games*, 1:1, pp. 87–94.

Phillips, Winifred (2014), *A Composer's Guide to Game Music*, Cambridge: MIT Press.

Plank, Dana (2018), "Bodies in Play: Representations of Disability in 8- and 16-Bit Video Game Soundscapes," PhD dissertation, Columbus: Ohio State University.

Rosen, Charles (2000), *Critical Entertainments: Music Old and New*, Cambridge, MA: Harvard University Press.

Sánchez-Kisielewska, Olga (2018), "The Hymn as a Musical Topic in the Age of Haydn, Mozart, and Beethoven," PhD dissertation, Evanston, IL: Northwestern University.

Smith, Jeremy (2020), "'Wear People's Faces': Semiotic Awareness in Fan Adaptations of the Music from *The Legend of Zelda: Majora's Mask*," *North American Conference on Video Game Music* (held online), June 13–14.

Summers, Tim (2016), *Understanding Video Game Music*, Cambridge: Cambridge University Press.

Summers, Tim (2020), "Queer Aesthetics and Game Music, or, Has Video Game Music Always Been Queer?," *North American Conference on Video Game Music* (held online), June 13–14.

SWE3tMadness (2009), "*Final Fantasy VI*'s Dancing Mad: A Critical Analysis," Destructoid, December 15, https://www.destructoid.com/final-fantasy-vi-s-dancing-mad-a-critical-analysis-157570.phtml. Accessed May 5, 2020.

Szendy, Peter ([2001] 2008), *Listen: A History of Our Ears* (trans. C. Mandell), New York: Fordham University Press.

Thompson, Matthew (2018), "'There's No Doubt You'll Be Popular after Performing These in Front of Your Friends!': The Pedagogy and Performance of Piano Transcriptions of Video Game Music," *North American Conference on Video Game Music*, University of Michigan, Ann Arbor, January 13–14.

Uematsu, Nobuo (n.d.a), interview by Game Concerts, Vimeo, https://vimeo.com/130751534. Accessed May 5, 2020.

Uematsu, Nobuo (n.d.b), interview by Game Concerts, Vimeo, https://vimeo.com/119326867. Accessed May 5, 2020.

Waxman, Jonathan (2016), "Playing Games/Playing Music: Amateur Musical Arrangements from Video Games," *Music and the Moving Image Conference*, New York University, New York, May 27–29.

12

Historical Narratology and the "Hymn of the Fayth" in *Final Fantasy X*

Andrew S. Powell and Sam Dudley

The mythical worlds in which *Final Fantasy* (*FF*) titles take place are detailed and expansive creations, seemingly alien yet simultaneously familiar. Social structures, iconography, politics, and religion are common components of these fictional realms, often drawing influence from our own institutions. Such is the case for *FFX* (2001), whose primary narrative is structured around its own in-game faith known as "Yevon." Scenario writer Kazushige Nojima's detailed mythos for Yevon borrows concepts from a number of real-world religions, particularly Buddhism, Shintoism, Catholicism, and Islam, and the faith displays the kind of lore and historical significance that typifies an institution that has been sewn into the societal fabric for many generations. Specifically, the hierarchical structure closely resembles the Catholic church, with various positions of power and titles relating to rank within the institution.[1]

This (western) Catholic power structure seems at odds with eastern-influenced practices, including Buddhist rituals and iconography, and Shinto temples and *kagura* (music and dance to pacify spirits, or *kami*). This internal/external duality is mirrored by Yevon's practitioners: the (internal) leaders of the faith have hidden the dark secrets of the religion and true nature of the world, while the (external) followers remain blissfully unaware and blindly follow their faith in the hopes of salvation. This promulgation of atonement through specific religious doctrine, damnation for diversion from the Word, and physical suppression of those deemed heretical closely parallels the Catholic church's own past.[2]

Within Spira, Yevon holds a great deal of political and cultural power, and its dogma is maintained and mass-communicated through practice and the arts. Locals earnestly recite scripture, and iconography of its alphabet clearly adorns all temples. Recurring imagery, practiced behaviors exhibited by the nonplayable characters (NPCs), and the soundtrack itself affirm that Yevon has permeated

much of the Spiran way of life. The music that has formed the foundation of the Yevon faith likewise extends beyond the halls of the temple, pervading physical and emotional well-being.

The history behind the central religion of Spira in *FFX* provides a strong parallel to real-world orthodoxies, and the influence of this history on its music displays similar traits within the game. The foundational religious theme, "The Hymn of the Fayth," embraces an origin as a western liturgical chant in design and function, but its incorporation and evolution through the narrative reveals a near-identical trajectory that mimics reality. Led by protagonist Tidus, the group of guardians protecting the summoner Yuna uncovers the gradual corruption of the western-influenced hierarchical power structure and teachings. A genuine investigation of the central themes of the score not only embraces this in-game function but also draws from historical antecedents in liturgy. Contextualizing the various settings of the central chant exposes the entwined narrative and historical implications that unveil Yevon's corruption, leading to the religion's rejection and dissolution. The dissection of the chant's text reveals that the practice, firmly entrenched in eastern religious influences, supersedes the authority of humanity and its corruptive effect in its pursuit of power.

A primer on Yevon and Faith/Fayth in Spira

Essential to the game's narrative and the unfolding discussion is the prevalence of religion in the past and present within the world of Spira, as well as its connection to the various members of the main party. As Dennis Washburn summarizes,

> [*FFX*] establishes an alternative history—and in doing so creates a fully developed game environment—that does not necessarily have to be plausible in the sense of achieving the reality effects of historical narratives, but that must be at least internally coherent *as narrative* in order for the player to be able to understand or read the game.
>
> (2009: 151)

This traversal of past and present simultaneously explores the birth and unspoken corruption of the central faith of the game's world, known as *Yevon*. The religion itself is named after *Yu Yevon*, a summoner who lived one thousand years prior to the main events of the game proper in the city of Zanarkand, home to the summoners. During this period, Zanarkand was engaged in conflict with the city of Bevelle in what was known as the Machina War, and Zanarkand's defeat was all but certain due to Bevelle's far superior weaponry (machina). To ensure

the persistence of Zanarkand's memory, Yu Yevon ordered the surviving residents of Zanarkand to relinquish their physical forms and become *Fayth*, whose souls would be sealed in statues in a perpetual dream state. This would allow Yu Yevon to conjure a utopian version of Zanarkand removed from its attackers as well as the rest of the planet's mainland. To protect himself from harm during this state of summoning his "dream city," Yu Yevon created an armor to surround himself, forming a creature known as *Sin*. The exertion of creating and maintaining the Dream Zanarkand as well as generating Sin rapidly destroyed Yu Yevon's humanity, and he (as Sin) destroyed the original Zanarkand. Sin continued to roam the seas of Spira, targeting areas of high populations or gatherings as well as locations that used machina or displayed advancements in technology.

Despite the constant presence of Sin, a period of respite could be achieved, and its secrets were tied to Yu Yevon's daughter Lady Yunalesca. This process became known as the Final Summoning, whereupon someone who shares a deep bond with a summoner completing their pilgrimage becomes the Fayth for the Final Aeon. This Final Aeon is capable of piercing Sin's armor, defeating the creature and bringing upon a period known as the Calm. Following her successful victory over the original Sin, Lady Yunalesca remained in the destroyed remains of Zanarkand as an "Unsent" (the spiritual remnants of the deceased who have not crossed over to the gathering place for the dead, known as the Farplane). Yunalesca's form thus remained in the Zanarkand ruins to instruct summoners at the end of their pilgrimage how to perform the Final Summoning in order to defeat Sin.

During the original Calm following Lady Yunalesca's defeat of the original Sin, the people began to repair Spira and the damage caused by the creature, with emphasis placed on Bevelle. Machina cities had been completely destroyed, and technology in general had become viewed as antithetical to productive or positive living through its attraction to Sin. It was also during this time that "teachings" appeared in the reconstructed city and temple of Bevelle, with a mythos associating these doctrines to Yu Yevon and Lady Yunalesca. Yu Yevon's true story was lost—if ever known within Bevelle—and he became honored as a figure of salvation, a beacon of hope against the literal manifestation of evil that seemingly punishes the world. The "teachings" were in fact created by the temple itself as a means of population preservation and improving quality of life, opposing the machina that led to war and presenting Sin as the manifestation of the ills of humanity. Sin's presence was a sign of impurity of the people and could only be truly cleansed through atonement of the past.

Similarly lost in the creation of the deceptive religion is Lady Yunalesca's fate. As the Fayth were relocated throughout Spira in various temples of Yevon (established by Bevelle), Yunalesca's Unsent form remained in the ruins of Zanarkand. Summoners seeking to bring a new Calm in the name of Yevon would partake a

pilgrimage, traveling to the temples and praying to the Fayth; should the Fayth answer their prayers, the summoner would be granted a powerful creature known as an aeon to assist them in battle. The final destination of this pilgrimage was the Zanarkand ruins, where Lady Yunalesca would reveal the truth of the Final Summoning: the summoner would be killed by the act, and the Final Aeon will, in time, ultimately become the next Sin. Sin could not be defeated, only halted. The temple and church were well aware of the truth, but had buried this reality within its leadership. The people of Spira were ignorant of their hopeless reality, blindly accepting false hope from the manufactured religion.

Hymn as chant: Establishing topics from western religion

For the "Hymn of the Fayth" to serve as a functional narrative device, the player's recognition of the song as a religious icon is paramount, connecting the piece to a significant spiritual experience or process. The visual and narrative elements of the ludic medium facilitate this identification, combining a tradition of film practices with cultural codes and aural signifiers to generate meaning. In specifically discussing the capabilities of film music, Claudia Gorbman suggests, "Narrative film music 'anchors' the image in meaning. It expresses moods and connotations which, in conjunction with the images and other sounds, aid in interpreting narrative events and indicating moral/class/ethnic values of characters" (1987: 84). Moreover, as Gorbman further argues, "these meanings were inherited from a long European tradition whose recent forebears included theatrical, operatic, and popular music of the latter nineteenth century" (1987: 85). While Gorbman's focus is on providing meaning to the visual scene, one may argue that the reverse also holds validity: musical cues may gain meaning and context from visual information. In addition, the modification or layering of additional implications may be achieved independent of or in conjunction with such visual setting.

For the "Hymn of the Fayth" itself, its association as an aural token relies on narratological, visual, and aural elements to establish its meaning and temporality—more specifically its association with western religion and Gregorian chant. The "principal" melody itself is first heard within the temple on Besaid Island, as Tidus completes the Cloister of Trials and approaches the party protecting the summoner Yuna, who is praying to the Fayth of the aeon Valefor. A solo female voice is heard singing the hymn, presented in Example 12.1, as Wakka explains the summoner's pilgrimage within the temple and prayer to the aeon.

This solo chant is only presented by the Fayth themselves, and the voice is always reflective of the physical representations of the human bodies that imbue the summoners of the aeons:

EXAMPLE 12.1: Nobuo Uematsu, *FFX*, "Hymn of the Fayth." Transcription by authors.

- *Valefor*—a relatively young female (though the voice used is of an older female soprano)
- *Ifrit*—a relatively young, physically imposing male (tenor)
- *Ixion*—a muscular, large male (baritone-bass)
- *Shiva*—a mature female (soprano)
- *Bahamut*—a young male child (alto).

In addition to the five primary aeons, two of the three "lost" aeons present their own iteration of the melody that reflects the human origins of the Fayth:

- *Yojimbo*—the "stolen samurai," a magisterial male mercenary (baritone)
- *Anima*—the "grieving mother," Seymour Guado's human mother who willingly gave her life to become his final aeon, but now despairs at her perceived failures to prepare him for his life as a summoner and human/Guado hybrid (mournful alto).

The Magus Sisters do not possess a unique monophonic line of the chant, reflecting their role as a "performative trio" as well as Remiem Temple's unique status as a prewar structure that predates the founding of the Yevon faith. The solo "hymn" is clearly evocative of a more archaic form of western liturgical music, specifically early plainchant. Such an aural parallel to a distinct topic necessitates particular stylistic features, or at the least reasonable approximations within expected boundaries that players can recognize as reflective characteristics that override atypical attributes. Jeremy Yudkin summarizes two key features of plainchant in the western liturgical tradition:

> One is the unity of text and music in this repertory: the notes mirror the structure
> of the text. The other is the ability of the music to create pitch centers, even though
> it is monophonic. It is crucial to realize that chant, despite being constructed out

of a single line of music, depends upon a highly developed, fluid system of pitch goals and expectations. Composers could exploit these for artistic purposes and manipulate them both in obvious and, sometimes, in extremely subtle ways. The pitch system of the Middle Ages was not the same as that of later music, but it was at least logical, and in many ways more colorful.

(1989: 51)

One of the most salient features of the "Hymn of the Fayth" is its *syllabic* setting, using one note per each syllable of text for its near entirety and placing clear emphasis on its text. Its formal structure similarly echoes antiquated musical patterns, more specifically a highly simplified German bar form, incorporating an AA′B phrase design with each phrase further divided into two subphrases (abcbde). Its designation as "hymn," somewhat peculiar in modern religious lexicon, is rather apt in the medieval mass setting, for the hymn would usually be set in a syllabic style (Yudkin 1989: 61).

The melodic and harmonic design of the chant further establishes its western plainchant liturgical identity for the player and the narrative. Its relatively compact profile, spanning a seventh, and closing formulaic patterns identify a clear *finalis* ("final pitch"). Additionally, the centricity of the pitch a perfect fifth above this *finalis* as a logical goal in the second phrase is suggestive of a "reciting tone," or *confinalis*, which further confirms the ancient modality underlying the design. Such melodic/harmonic construction undoubtedly places the chant within the *protus* authentic mode, generally described as Dorian from Greek terminology and the so-called church modes.[3] As depicted in Figure 12.1, the composition of the melody undoubtedly aligns with classical modal designs found in early western liturgy.

These firmly established musical codes align with consistent visual and cultural codes to entrench this presentation of the hymn as a uniquely (western) religious token, associated with the faith/Fayth temples of the in-game Yevon religion. Every presentation of the faith-as-chant occurs not only within the Yevon temples but specifically by only the individual Fayth, and only within the Chamber of the Fayth after the completion of the Cloister of Trials. The chant is heard as Yuna is praying to the Fayth or upon return to the chamber, when seeking further guidance and wisdom from the spirit. The Fayth assumes the role of priest or cantor,

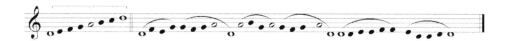

FIGURE 12.1: *Protus* authentic mode and "Hymn of the Fayth," with *confinalis* and "functional" *finalis* identified.

intimately communicating the truths and secrets of their powers to their genuine followers (the summoners) during the religious experience.

This use of the chant as a distinctly spiritual experience is aligned with the *mythos* of Yu Yevon's origins, but not the teachings that have been created by and propagating from the church. This separation of genuine origin from its evolution is paramount when tracing its appearances throughout the game. References, disruptions, and significant alterations to the established cultural codes of the music mirror narratological (internal) as well as social (external) conflicts of religious ideologies, adding significant meaning to the overall plot.

Evolving topics, tropes, and historical influence on musical religion

Fundamental to the core conflict of the established western religious influences of the Fayth's chant is the narratological and historical evolution unfolding within the music itself, mirroring the internal gameworld's constructed religion and its external associations. Achieving this complex web are musical and extramusical associations established through various methods, any and/or all of which the player may identify and associate with real-world parallels. The explicit elements of the "Hymn of the Fayth" that establish its clear temporal and functional role within western liturgy align with Robert Hatten's definition of a *topic*, which he articulates as "a complex musical correlation originating in a kind of music [...] used as part of a larger work" (1994: 294–95). David Lidov further defines topics as "richly coded style types which carry features linked to affect, class, and social occasion such as church styles, learned styles, and dance styles. In complex forms these topics mingle, providing a basis for musical allusion" (Hatten 1994: x). Essential to the formulation of these definitions and development of topics is the fundamental principal of opposition. Byron Almén summarizes:

> [T]opics acquire meaning insofar as they differ from other possible configurations of musical elements that might instead be employed. That makes possible, on the one hand, a clear understanding of the ways expressive correlations are created [...] and on the other, a way of mapping expressive terrain using possible stylistic choices from a small number of oppositional parameters.
>
> (2008: 73)

Almén further stresses:

> Recognition of musical topic also requires listener interpretation, although, by their very nature, topics are culturally coded so that those familiar with the contemporary

318

or stylistic use of musical language will be likely to recognize them. [...] Recognition will of course be more problematic for listeners who approach the music as outsiders with respect to culture or time period, but in general, since topics are simpler in constitution, they are less subject to varying interpretation than are narrative structures.

(2008: 77)

Contrasting with these established norms are the juxtaposition of two (or more) established types, a method described by Hatten as *troping*. Hatten defines the process, when akin to metaphor, as "when two different, formally unrelated types are brought together in the same functional location so as to spark an interpretation based on their interaction" (2004: 95). Sean Atkinson condenses this notion, suggesting that "it is the combination of two or more established musical topics that lead to the emergence of a trope" (2019: 2). While Hatten and Almén utilize topics and tropes in narrative readings of music alone, the application of such concepts in the fields of film and video game music has generated considerable results. In proposing a continuum within the medium of film, David Neumeyer suggests:

> The distinction between topic and trope, as maintained here, is close to one made in traditional rhetoric between stock devices (or schemata) and those figures of speech that change the meanings of words. From this we can derive the sense of topics as stable (even though they are, of course, contingent on a historical scale) and tropes as shifting, creative, or altering.
>
> (2015: 184)

The visual nature of the cinema, Neumeyer contends, necessitates the additional meaning(s) applied to the overall scene as a unified element, rather than individual components. Undoubtedly, this benefit of a visual element, let alone the potential for dialogue, story, and so on, all enhance the application of extramusical meaning. Tim Summers is quick to note, however, that the interactivity of the ludic medium does not rely on the same topic/trope qualities outlined through filmic means, despite the similarities between processes that have emerged between narrative music practices. Summers identifies this precarious position in which video game music finds itself, caught between filmic tradition established over nearly a century of image–sound pairing, as well as enculturation of the typical listener and the development of particular expectations associated with given sounds:

> Music in the video game must strike a careful balance between playing an active part in supporting and articulating the aspects of the medium that are special to video games, and at the same time, conforming to the players' media music expectations in order to be compatible with ingrained modes of understanding music for

319

the moving image. Game music can find itself caught between the weighty precedent of Hollywood film music and a medium that is distinctly different from films in many significant ways.

(2016: 157–58)

With religion at the core of the narrative of *FFX*, its encoded musical meanings are intimately tied to its real-world influences in both design and history. While the original chant itself and its sacred experience are firmly rooted in the origins of the Catholic liturgy, the manipulation and distortion of the theme throughout the game reveals a similar trajectory along musico-historical pathways. Significant modifications in key features of the theme, identifiable through various topics, tropes, and codes (musical, filmic, ludic), provide a unique relationship between the history of the in-game religion and the evolution (and corruption) of its western-influenced hierarchy over time, in conjunction with the developments of primarily liturgical— and eventually secular—music that blossomed from its original kernel. This western influence and history are simultaneously cast in conflict with the eastern practices that permeate Yevon's overall design, creating an amalgamation that directly confronts the discord between structure and practice, imperialism and traditionalism.

Influence of the masses: "Song of Prayer"

While the "Hymn of the Fayth" is the most consistent example of the Fayth's religious iconography from a musicological and narratological perspective, it is not the first instance of the melody encountered in the game, nor is it the most frequently encountered. Prior to descending into the Chamber of the Fayth, Tidus hears a form of the chant as he enters the Besaid temple.[4] Surrounding Tidus are various townspeople praying to statues of summoners who previously defeated Sin.[5] Filling the temple is the sonorous strains of the "Song of Prayer," a setting of the original chant for full choir (see Example 12.2).[6] This arrangement has undoubtedly taken the original chant and harmonized the melody within the Dorian mode, providing a highly suggestive interpretation of a Lutheran chorale. Such a use would not only be reflective of the evolution of the church itself with respect to time (progressing approximately 600 or 700 years from the chant's original form), but also, far more importantly, bring a communal experience of singing to the religion. Thomas Yee suggests: "In Spira, as in religious congregations, the collectivism of choral singing can signify positively valenced unity in will or purpose in some situations even as it suggests negatively valenced suppression of individual will in other contexts" (2020: 15). An additional key historical feature would be the translation of the chant from original Latin to a vernacular language, reaching the larger population and invoking a participatory experience; while the literal text itself has not

EXAMPLE 12.2: Nobuo Uematsu, *FFX*, "Song of Prayer." Transcription by authors.

changed, its arrival to the masses has made the prose available to the people rather than only a higher—or ethereal—being.

The matching cultural and cinematic codes reinforce the transition of the chant from its monophonic, syllabic origins and function of its original intimate setting, meeting the larger religious role and context. The supplementation of additional voices through full choir permits a clear, genuine harmonic vocabulary and field, revealing both religious innovations as well as narrative foreshadowing. The harmonies are largely tertian (constructed of thirds) in nature, characteristic for a chorale, though there is a predilection for the (dissonant) seventh throughout the melody and the ninth at cadences. The closing structures of the second and third phrases bring elements of the past and future into "compressed focus," incorporating quartal (E-A-D) and quintal (G-D-A) harmonies that both hearken back to early explorations of polyphony and foreshadow the perversion of a critical icon within the church through its voiced dissonance, to be discussed below.

The "Song" is heard predominantly in the Yevon temples, appearing in all but Bevelle's, reinforcing the piece's ties to larger overall religion while insinuating its removal from the "genuine" liturgical function associated with Fayth. No longer a sacred commune between Fayth and the summoner, the chorale offers hope and peace to the followers of Yevon, a reaffirmation in their beliefs of the prospects that the teaching provides. This absence of the chorale-like "Song" in the temple of Bevelle is a subtle nod to the underlying corruption that has befallen the church and acknowledgment of the temple's dissociation from the Yevon community. The "Song's" appearance following the failed mission of Operation Mi'ihen as Tidus

surveys the death and devastation recalls the original chant's repurposing and evolution into its (new) chorale form: from a song of defiance against Bevelle during the Machina War into a "holy song" incorporated into scripture for its belief to pacify the unresting deceased.

Evocation in practice: The Sending

Following Sin's attack on the island town of Kilika, numerous villagers are killed and their spirits are left in grief. Fulfilling her role as a summoner, Yuna performs a ritualistic dance over their entombed bodies known as a "Sending" to allow these souls to find peace and reach the Farplane, with the surviving and grieving residents observing from the distance.[7] The chant sounds in a unison female choir, singing the first phrase, before a male chorus joins in a unison response. This antiphonal style, beginning with a female tessitura, creates a liturgical parallel with the chant's original function. Yuna is cast in the role of "canticle" in this iteration, fulfilling the position once held by the Fayth, with her call of the chant being answered by the spirits of the deceased.

Though antiphons are an integral part of the Catholic mass (and remain a contemporary practice), the significance of the event lies in its occurrence outside of the temple, converging sacred and secular spaces into a singular sphere. Reflecting the substantial influence of eastern religion sources, especially Shinto *kagura*, the scene brings a significant influx of secular (read: nonwestern) instruments to the accompaniment. Immediately heard are a multitude of percussion, including various *taiko* (general term for Japanese drums) such as *shime daiko* and *byo uchi daiko*, as well as a *kane* (metal percussion instrument). The use of the *kane* becomes a ludic analog for the Shinto *kagura-suzu*, a tiered bell instrument used by female shrine attendants during the ritual. Additional instruments are added to the texture, including a piano and a *koto* (Japanese stringed instrument), as Yuna's ritual reaches its peak, bringing the religious music further away from its western origin. This infusion of eastern percussion within the secular space affirms the separation of structure/origin and genuine practice within the narrative. While the followers of Yevon are still beholden to a power structure rooted in preordained dogma, the actual practice of the in-game religion and its genuine effects can be identified and *experienced* in its eastern influences.

Corruption of internal hierarchical structure: Grand Maester Mika

In describing the concept of musical troping, Sean Atkinson identifies the Turkish March from the final movement of Beethoven's Ninth Symphony as an excellent example, noting:

High-pitched, metallic percussion, a sign of a nonwestern other, is paired with a march, a marker of high discourse associated with regality and wealth. The former lowers the discourse of the march to bring the finale's message of brotherhood to all people, not just the other class.

(2019: 2)

Drawing upon the previously established topic of early Catholic chant, as well as characteristic tropes of military music, provides significant depth to the game's unfolding narrative, adding to the apparent religious significance of the "Hymn of the Fayth" and foreshadowing the conflict with the church hierarchy.

The party's first encounter with Grand Maester Yo Mika, the head of the Yevon faith and the spiritual leader of the Spiran people, presents an excerpt of the "Hymn of the Fayth" within a militaristic setting, introducing a visual and cognitive dissonance very unbefitting of the character (see Example 12.3). Mika is first established as an elderly, sage, calming (if not outright grandfatherly) figure that is highly revered by all Yevonites, for his arrival is in celebration of his 50th anniversary as Grand Maester. Yet his entrance is announced with a bombastic, triumphant fanfare march more suitable for regality, especially if one is approaching the inferior or conquered. Its opening gesture is drawn from the initial two-measure motive of the chant, but its heavily chromatic harmonic nature, generated from quartal harmony, creates a significant amount of dissonance, greatly disrupting the appearance of serenity or peace the Grand Maester should afford. The addition of bass and snare drum unquestionably adds a martial flair to the moment, and the increase in tempo by nearly 20 percent (to approximately 115 beats per minute) is far more distinctive of a British military march.

Surrounding Mika as he disembarks his vessel includes Maester Seymour Guado, eventually revealed to be one of the primary antagonists throughout the quest, as well as six musicians arranged on either side of the gangway.[8] The scene clearly loses its religious connotations and becomes more oriented toward royalty, insinuating the raw power that Mika commands. The inclusion of numerous secular instruments, both aurally and visually, further removes Mika from Western hierarchical arrangements associated with older religious organizations, particularly if viewed within the context of the papacy, and positions the character as the monarch of Spira.

The abundance of aural cues within Mika's theme foreshadows the parallel shift in the Yevon organization away from religion and its preservation of power, one which Tidus seems to recognize in his status as an outsider. Upon hearing that Mika has arrived in celebration of his 50th year as Maester, Tidus instantly identifies that the amount of time seems far too long for a typical religious leader to remain in such a position of power. (*Fifty years? Shouldn't he be, uh, retired*

EXAMPLE 12.3: Nobuo Uematsu, *FFX*, "Grand Maester Mika," 0:00–0:15. Transcription by authors.

by now?) Wakka, a blindly devout follow of the religion, obstinately refuses to ponder the thought and willingly accepts the gift from Yevon for the long life of the seemingly benevolent ruler. (*Hey! Mind your mouth, now.*) In failing to question the possibility of something amiss in Mika's longevity—let alone the kingly

and martial announcement of his presence—Wakka fails to identify the malice clearly lurking within the music and scene. Mika and the church care not for the individuals of Spira, but rather for the power and control that comes from their positions with the church's authority. This belief is confirmed as Seymour is kept as an Unsent following his defeat at the hands of the party to preserve the image of peace and stability within the church. Far more importantly, though, it is revealed that Mika is also an Unsent, whose death occurred well before the primary events of the main narrative. His persistence as the head of the church is tied to the desire for power and control, maintaining false hope over the people of Spira and the church itself. Mika rebukes the party as the true essence of Yevon, and the cease-less spiral of death within Spira, is revealed in a private trial:

> Men die. Beasts die. Trees die. Even continents perish. Only the power of death truly commands in Spira. Resisting its power is futile [...] No matter how many sum-moners give their lives, Sin cannot be truly defeated. The rebirth (of Sin) cannot be stopped. Yet the courage of those who fight gives the people hope. There is nothing futile in the life and death of a summoner. Indeed, that is the essence of Yevon. Yevon is embodied by eternal, unchanging continuity, summoner.

Corruption of iconic figure: Lady Yunalesca

The discovery of Lady Yunalesca's Unsent form and learning the genuine nature of the Final Summoning lays bare to the party the dark truths underlying the "teach-ings" of the Yevon religion, presenting the futility of their pilgrimage as well as the primary belief system of the people. Their initial meeting is met with despair and incredulity, fearing Sin's eternity and the perpetuation of false hope. Underlying this meeting, the revelation of Yevon's true face and Spira's endless spiral of death is an "evolved" form of the original chant, which reflects the development of the religion and its purpose within the society (see Example 12.4).

The immediate religious connotations are the abundance of parallel fifths above and below the original chant, suggestive of potential parallel organum in liturgical practices and the emergence of polyphony. The presence of three unique voices and the use of quintal harmony in the first eight measures, however, far exceed the norms of medieval polyphonic or chordal tendencies, creating a literal harmonic dissonance that matches the narrative dissonance emerging in Yunalesca's mono-logue.[9] The removal of the original chant in its final phrase introduces several new contrapuntal techniques that further break from the fundamental liturgical prac-tices and move scene and sound away from western religious iconography. The highest voice preserves a subphrase of the original chant, transposed at the fifth, while the bass voice introduces the same motive in contrary motion, producing a

EXAMPLE 12.4: Nobuo Uematsu, *FFX*, "Hymn–Yunalesca." Transcription by authors.

style more reminiscent of twelfth-century discant. The successive parallel thirds simultaneously hearken to the fifteenth-century technique of *contenance angloise*, compressing time and style at the moment of greatest narratological conflict for the party.[10] The abrupt harmonic shift in the closing subphrase clearly removes all previously established religious parallels, bringing a series of highly chromatic harmonies that undergirds the true nature of Yunalesca's presence and persistence.

Corruption of a demigod: A Contest of Aeons

A strong tendency of the role-playing game (RPG)—especially the Japanese role-playing game (JRPG)—is the use of the "god-slayer trope" for its final battle sequence.[11] Through both his acclimation of power in the form of Sin and the achievement of god-like status in the (false) teachings of his name, Yu Yevon has appropriated this position both physically within the gameworld and metaphorically within the narrative. The deterioration of his humanity and obliviousness of "his" religion only further removes Yu Yevon from any semblance of a genuine deity, and musical reflection of such iconography would undermine the narrative trajectory.

As the party approaches Yu Yevon, the sounds of the original "Hymn of the Fayth" in a male baritone are heard, but the chant itself is heavily manipulated through various electronic means, depicting the infusion of machina into the church and religion that bears his name. The male voice is heavily distorted with

the addition of echoes and pitch bends (eerily reminiscent of Yunalesca's obscure "modulation"), creating both a sense of distance and an oscillating effect from the overlapping voices. The aural atmosphere blends with the unearthly ambiance of the physical background and corruption of Yu Yevon's human mind and the now-warped views of his original intentions. As the party is drawn into battle against the demigod, Yuna must call upon and face her aeons, each possessed by Yu Yevon. Announcing the beginning of the battle sequence is "A Contest of Aeons" (see Example 12.5), combining elements of the militaristic troping seen previously for Grand Maester Mika, the abundance of harmonic dissonance through his daughter Lady Yunalesca, and the synthetic timbres of electronic instrumentation.

The layering of militaristic percussion and synthesizer brass in conjunction with the abundance of secundal harmony leaves little doubt to the narrative conflict present in the scene, but the complete rejection of *human* vocalizations in favor of overbearing, nonnatural, artificial sounds replicating man-made (and,

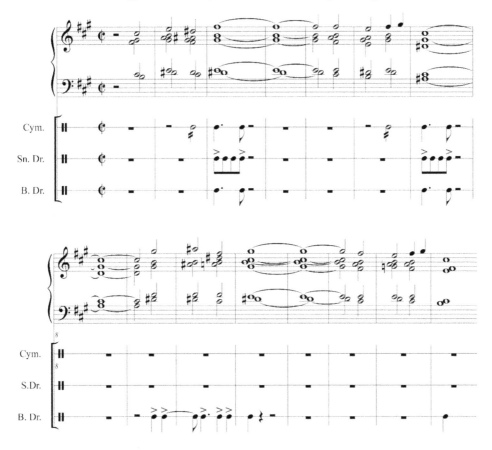

EXAMPLE 12.5: Junya Nakano, *FFX*, "A Contest of Aeons." Transcription by authors.

barring other information, secular) instruments imitates the outright desecration of the western liturgical origins of the chant. Ludic/filmic tropes, combined with the evolution of the chant with respect to its internal and external history, reveal the corruption of Yevon in person and faith to the fullest extent; the party, whose journey has confronted the hypocrisy and historical corruption of both forms, is placed in final physical confrontation with the last remaining barrier of the in-game religion in the form of the corrupted aeons. The music all but confirms the narrative and historical confluence unfolding in the final duel: the rejection of such distorted western religious influence.

Abandonment and dissolution of western faith: Ending theme

The party's victory over Yu Yevon within the body of Sin ensures the Eternal Calm, the removal of Sin's presence from Spira, and an everlasting peace over the land, as well as the termination of the Yevon faith. The original perceived duality of good (Yevon) and evil (Sin) no longer has a psychological or physical hold on the denizens of Spira, and the Fayth that provided aeons and the Dream Zanarkand may find peace. With the religion no longer serving any functional, structural, or liturgical use, all characteristic topoi that signified its influence have been removed in the chant's final appearance.[12] Following the destruction of Sin, Yuna performs a final sending for her aeons during a cinematic, allowing the Fayth to reach the Farplane and find tranquility for the first time in a millennium.

Aside from the abandonment of voices in deference to instruments, with the oboe prominently featured carrying the principal melody, the most significant alteration to the theme's presentation in this final statement is the clear establishment of tonality, in this case C minor.[13] The abundance of largely triadic harmony and, most significantly, clear functional progressions that establish a tonal center unquestionably shift the temporal locus of the music at minimum nearly seven hundred years in music history. Yuna's defeat of Yu Yevon is a literal release of all that his presence, both literal and spiritual, held firm, including the people of Spira, the Fayth who conjured Dream Zanarkand, and the aeons who continued to fight Sin and Yu Yevon himself. With no musical memories of the past remaining, as Yuna and the music have progressed beyond the bounds of the religion's identity, all that has been tied to Yevon is free to dissolve into the æther and move on to the Farplane.

Monastic evocation through Japanese wordplay

As previously stated, the "authenticity" of the "Hymn of the Fayth" as a religious token within the game's narrative relies heavily on its musical parallels to early

religious music from the player's perspective, primarily Gregorian chant within the Roman Catholic church. The prevalence of a monophonic and/or monosyllabic setting, as well as the use of parallel organum, helps tie the hymn to a chronological period more than a millennium in the past, prevalent in Central and Western Europe in the ninth to eleventh centuries. Such sacred songs were frequently performed in Latin, and the hymn's syllabic structure is arranged in such a way as to conjure the aesthetic of early Catholic chant in the absence of a genuine Latin text. As described by Yudkin, "[t]he central role of music in the liturgy of the early Church was that of a vehicle for words: music was to carry the words of worship to the people and also to God" (1989: 40).

While distinctly not in Latin, the evocation of a lost or deceased language indeed serves an important role in developing meaning for the chant itself. The syllabic separation preserves the approximation of Latin vowel pronunciation, facilitating Romance-language association. The technique of forming the chant's text relies through a combination of the stylistic origins of Uematsu's theme as well as the intricate wordplay of scenario writer Kazushige Nojima's text:

Ieyui
Nobomeno
Renmiri
Yojuyogo
Hasatekanae
Kutamae

The implementation of such wordplay is most certainly not foreign within *FF* titles to evoke a sense of the sacred through text manipulation, particularly within a chant-like setting. "Liberi Fatali," from *FFVIII* (1999), uses a combination of an anagram to create a similar "faux-Latin" opening phrase, in conjunction with a genuine Latin text to produce a work that strongly echoes Carl Orff's "O Fortuna," from *Carmina Burana* (1935–36).[14] The anagram forms the first verse, a single line repeated three times: "*Fithos Lusec Wecos Vinosec.*" The text is not actual Latin but rather the English translation of two principal themes within the narrative of the game: "Succession of Witches" and "Love." Its appearance during the opening video sequence intimately ties these central themes within a multitude of levels of the narrative: star-crossed pair Squall and Rinoa, whose union has yet to transpire; Rinoa as the next in line of the "succession of witches" following Edea; the dueling of fates between Squall (Rinoa's love and protector) and Seifer, who comes to view himself as sorceress Edea's knight; and the "Fated Children" of the (mis)translated Latin title who form the entire party of the game.[15]

TABLE 12.1: Syllabic orientation of Nobuo Uematsu, *FFX*, "Hymn of the Fayth," first four lines.

I	E	YU	I
NO	BO	ME	NO
RE	N	MI	RI
YO	JU	YO	GO

The puzzle that forms the lyrics for the "Hymn of the Fayth" is considerably more complex, using a syllabic arrangement of the Japanese text to create the synthetic "Latin" sound of the chant. The text is a byproduct of *tategaki*, or vertical writing, method of the original prose, where the syllables are arranged into columns. To reconstruct the "original" Yevon text (or "deconstruct" the nonsensical in-game chant), the original language is placed into a series of grids; the first four lines are placed into a 4×4 syllabic structure seen in Table 12.1.

A Romantic (Latin) reading of the syllables and words, as indicated by the arrows and numbers in Table 12.1, would progress from left to right and descend by line, producing the results performed by the Spirans in their calls to their deity. When interpreted through the lens of *tategaki*, however, a much more textually significant result is generated. Rather than progressing in the previously described manner, *tategaki* would be written *vertically* and move from *right to left*. The result would not only be a reflection of the original text but, far more importantly, an *inversion* first of the original syllables as well.

When the syllables are recombined through this reading, a new, comprehendible text in Japanese becomes apparent:

Inorigo, yume miyo	Dream, child of prayer
Ebonju, inoreyo	Pray to Yu Yevon

Following a similar pattern with the remaining two words and building an additional syllabic block will produce the remaining two lines of the chant; the lone difference is the extension of the table to create the asymmetrical layout as shown in Table 12.3.

TABLE 12.2: Reorientation of "Hymn of the Fayth," with *tategaki* reading.

I	E	YU	I
NO	BO	ME	NO
RE	N	MI	RI
YO	JU	YO	GO

TABLE 12.3: Reorientation of "Hymn of the Fayth," *tategaki* reading, final two lines.

HA	SA
TE	KA
NA	E
KU	TA
	MA
	E

The final result produces a four-line Japanese text that becomes "corrupted" through its textual manipulation to serve as the foundation of the sacred song to Yevon (Oribitalflower 2018):

Inorigo, yume miyo	Dream, child of prayer
Ebonju, inoreyo	Pray to Yu Yevon
Sakaetamae	Grant us prosperity
Hatenaku	Forever![16]

By combining elements of a more traditional written script with contemporary reading (and writing) methods, the resulting vocal sound of the "Hymn of the Fayth" creates a strong intertextual parallel between the game and culture. The origins of the Yevon faith within the world of Spira can be traced to the war between Bevelle and Zanarkand, predating the primary events of the game by one thousand years and embodied by the use of the older *tategaki* writing practice. Following the war, as described by roaming scholar Maechen, the song was "adopted" by the temple of Yevon and accepted into the scripture before spreading through Spira as a holy song with particular power to soothe the souls of the deceased. Its ability even to pacify Sin, seen on multiple occasions as the creature—or, at least, the remnants of the guardian who became the creature—reveals its apparent power not through its text but rather its sonorous characteristics.

The scholar Maechen's rather peculiar description of the hymn as being "made scripture" and postwar adoption lends further credence to the notion that the present text is not truly its original setting but rather a manipulation over time. Such a transformation into its current form would parallel the syllabic puzzle used to generate the in-game text. This matches the distortion of the original Japanese used to create an understandable prayer into its reflective "Latin" shell that ultimately has lost a true translation—and, far more importantly, distorted the genuine teachings associated with the religion. Just as the original chant has lost its meaning, so too has the power structure of the temple of Yevon become corrupt and convoluted over time. The use of ancient machina, which has been outlawed by the teachings, has been readily embraced as guns and electronic machines are highly prevalent among holy places and individuals; the dead govern the living; and the people of Spira are consistently fed false hope by their religious leaders, who had already abandoned faith in achieving the Eternal Calm. This desecration of the original teachings emulates the gradual perversion of the chant itself, losing its meaning as the methodology behind its text is likewise lost over time. What remains is somewhat reminiscent of the religion's original intent, just as one may correlate the authentic sound and religious implications of the chant, but its authenticity remains lost in the past.

Concluding remarks

Religion within *FFX* is a paradox, forming both the foundation of daily life for the majority of Spira's denizens while affording nothing but the false hope of salvation. The music associated with the in-game religion mirrors this in-game conflict with respect to its internal evolution and its external influences. It creates a narrative that both reflects on its mythological history and foreshadows its own downfall—a byproduct of its internal corruption and power struggle as it embraces standard topics and tropes firmly entrenched in filmic and ludic lore while abandoning its own sacred origins. The original chant creates its own levels of holy experiences for followers and practitioners, evolving in historical methodology yet embracing its dualistic inspirations.

Yevon cannot survive the folly of man, whose relentless pursuit of power and self-gain leads to its ultimate downfall. Just as the religion was created through a web of false promises, so too does it persist within Spira. As the music suggests, its meaning and intent cannot remain stable, and its ultimate dissolution is inevitable. Meaning through Yevon, at least for the main party, comes through practice and experience, which dissociates from its western liturgical antecedents and embraces elements of eastern practices in both sound and substance. Once the veil of corruption has been lifted and Sin has been defeated, the people of Spira can find meaning—and similarly break free from the corruption and oppression—for themselves.

NOTES

1. Within the Yevon faith, the equivalent of Pope is given the title "Grand Maester," while the equivalent of Cardinals is known as "Maester." The next level is "High Priest," a representative for each of the five temples throughout the world, but they do not have any authority within the High Court. Below the High Priest are priests who attend to the temples. Summoners, who partake a pilgrimage in pursuit of the Final Aeon to battle Sin and also perform sendings for the deceased, are below priests. The lowest level of the Yevon hierarchy is the acolyte, the equivalent of a deacon or nun.
2. It is worth noting that many of the nonhierarchical aspects of Yevon and the character of Yu Yevon show strong parallels to Jōdo-shū, the most widely practiced form of Buddhism in Japan.
3. It must be stressed that the classification of this mode as *protus* authentic rather than "Dorian" is intentional to separate the use of modes within early chant and Renaissance or contemporary music settings. The differences in harmonic vocabulary and closing structures, as well as the melodic implications through the establishment of the pentachords and *confinalis*, are indicative of its medieval time period.

4. See Supp. 12.1, *FFX*, Besaid Temple, Tidus hears "Song of Prayer."

5. The "Song of Prayer" precedes the statement of Valefor's solo version of the hymn; it is only after completing the Cloister of Trials in the temple and entering the Chamber of the Fayth that the player encounters the solo voice form. This change in setting parallels the textual supplementation as Wakka provides background information concerning the summoner's pilgrimage.

6. The nomenclature for this specific cue, as well as the general term "hymn," is rather problematic. The term "hymn" has been used as both a generic name for all appearances of the main melody in any capacity, not simply the specific use of the monophonic line performed within the Chamber of the Fayth. This dual usage appears in both public forums as well as official sources, including the original soundtrack (OST). The cue under discussion has been translated into a variety of different names, including "Song of Prayer" from the immediate Google (2020) search as well as Square Enix Music Online (2006). Other sources identify this chorale setting by the same "Hymn of the Fayth" name as the specific chant, including both Wiki collections available through Wikipedia (2020) and the Final Fantasy Wiki (2006), and is recognized as an alternate title to "Song of Prayer" from Square Enix Music Online (2006). The cue has also been identified as "Hum of the Fayth" through Apple Music's release (2001), as well as Wayô Records (2020), who work directly with Japanese companies and composers (including Nobuo Uematsu). To help alleviate potential confusion, the term "hymn" will be reserved only for the specific, monophonic melody; the terms "chant" and "melody" will be the normal identifying terms for this musical element. The chorale-like setting will only be identified as "Song of Prayer" or the shortened designation "Song" to distinguish a terminological difference and remove any issues in translation for the present discussion.

7. See Supp. 12.2, *FFX*, Yuna performs the sending.

8. See Supp. 12.3, *FFX*, Grand Maester Mika's "processional."

9. Stefan Greenfield-Casas proposes that this use of quintal harmony "might suggest that this was Spira's way of addressing the issue of temperament and sonic ratios—prioritizing fifths (over the octave) with a symmetrical construction around a middle voice (rather than a harmony generated from the bass voice)," see Greenfield-Casas (2017: 14). Greenfield-Casas approaches the construction of harmony from an historical perspective as a means of establishing narrative significance, rather than using a narratological reading as the primary method of analysis.

10. Greenfield-Casas affords a similar conclusion, noting:

> [I]t comments on the fact that the party is talking to an entity anachronistic to their era, thus a deconstruction of time; because Yunalesca is a powerful spirit [...] her mythic powers alter the music in an unexpected way; finally, her calmly-stated pivotal

plot-twist is signaled by the subtly written stepwise movement to a distant key (if it can even be called such) and a completely unexpected "resolution," which itself is voiced in as mercurial a position as possible.

(2017: 14–15)

11. Yee defines this trope as "one in which the final boss or mastermind that the protagonists(s) must defeat is the god of the gameworld." Yee further divides the trope into different variants, including the "classic" (god associated with light/goodness), "evil god," "seizure of divinity," "advanced alien," and "pantheon," see Yee (2020: 2–3).

12. See Supp. 12.4, Nobuo Uematsu, *FFX*, "Final Theme," mm. 1–8. Transcription by authors.

13. There are, unquestionably, modal remnants that remain, particularly within m. 5 of the transcription. It is also significant to note that the piano arrangement previously identified contains an incorrect pitch in the melody in this measure (A), which is more suggestive of tonality rather than modality.

14. It is important to note that "Liberi Fatali" is not the first instance of Uematsu evoking such a "sense of the sacred" through the implementation of a Latin text or the evocation of *Carmina Burana*. "One-Winged Angel" from *FFVII* (1997) precedes "Liberi Fatali," but there are two critical differences that have resulted in its omission from this discussion. The text for "One-Winged Angel" is entirely in Latin, rather than *evoking* the language to create a religious effect, and the "simulation" of Latin is not achieved through some form of wordplay.

15. The rough translation of the piece, "Fated Children," uses the singular form of "fate" (*fatali*), rather than the plural form (*fatales*).

16. The Final Fantasy Wiki offers a different methodology for reconstructing the text, which omits the *tategaki* methodology, and this different process results in the reversal of the first two lines. The method used for the 4×4 grid arranges the words vertically first and then proceeds in columns from left to right; the text is then read horizontally from left to right ("across the columns"). The procedure for the last two words essentially remains the same. See Final Fantasy Wiki (2014).

REFERENCES

Almén, Byron (2008), *A Theory of Musical Narrative*, Bloomington, IN: Indiana University Press.

Atkinson, Sean (2019), "Soaring through the Sky: Topics and Tropes in Video Game Music," *Music Theory Online*, 25:2, https://mtosmt.org/issues/mto.19.25.2/mto.19.25.2.atkinson.php. Accessed April 20, 2020.

Gorbman, Claudia (1987), *Unheard Melodies: Narrative Film Music*, Bloomington, IN: Indiana University Press.

Greenfield-Casas, Stefan (2017), "Between Worlds: Musical Allegory in *Final Fantasy X*," MM thesis, Austin: University of Texas.

Hatten, Robert (1994), *Musical Meaning in Beethoven: Markedness, Correlation, and Interpretation*, Bloomington, IN: Indiana University Press.

Hatten, Robert (2004), *Interpreting Musical Gestures, Topics, and Tropes: Mozart, Beethoven, Schubert*, Bloomington, IN: Indiana University Press.

Neumeyer, David (2015), *Meaning and Interpretation of Music in Cinema*, Bloomington, IN: Indiana University Press.

Orbitalflower (2018), "Hymn of the Fayth Lyrics and Meaning," https://orbitalflower.github.io/games/ff/hymn-of-the-fayth.html. Accessed July 12, 2020.

Summers, Tim (2016), *Understanding Video Game Music*, Cambridge: Cambridge University Press.

Washburn, Dennis (2009), "Imagined History, Fading Memory: Mastering Narrative in *Final Fantasy X*," *Mechademia*, 4, pp. 149–62, https://doi.org/10.1353/mec.0.0089. Accessed October 1, 2020.

Yee, Thomas (2020), "Battle Hymn of the God-Slayers," *Journal of Sound and Music in Games*, 1:1, pp. 2–19, https://online.ucpress.edu/jsmg/issue/1/1. Accessed February 1, 2020.

Yudkin, Jeremy (1989), *Music in Medieval Europe*, Upper Saddle River, NJ: Prentice Hall.

Contributors

RICHARD ANATONE is a professor of music theory at Prince George's Community College (PGCC) where he serves as applied music coordinator and program director. He teaches a variety of courses in both the traditional and commercial music programs, including music theory, aural skills, commercial music theory, and song writing, as well as composition and piano lessons. Prior to teaching at PGCC, he served as a faculty member at Ball State University and Anderson University in both the theory and history departments. He earned his DA and MM in piano performance from Ball State University and holds a BM in piano performance from Rhode Island College. His primary research interests include musical semiotics and the leitmotif in video game soundtracks. He has presented his research at a variety of conferences, including those of the American Musicological Society, the *North American Conference on Video Game Music*, *Music and the Moving Image*, and the International Musicological Society's Music and Media Study Group, among others.

SEAN ATKINSON is associate professor of music theory at the TCU School of Music where he teaches a wide range of courses, including freshman and sophomore music theory and aural skills, form and analysis, graduate seminars on music analysis and musical meaning, and a media studies class for the TCU Honors College. Prior to joining the faculty at TCU, Sean served on the music faculty at the University of Texas–Arlington. He has earned both the MM and PhD degrees in music theory from Florida State University and holds a BM in music theory and trombone performance from Furman University. Sean's research, which broadly address issues of musical meaning in multimedia contexts, has been published in numerous journals, including *Music Theory Online*, *Indiana Theory Review*, *The Dutch Journal of Music Theory*, and *Popular Music*. He is also active in the video game music (ludomusicology), with presentations at the *North American Conference on Video Game Music* and *Music and the Moving Image Conference* at New York University.

SAM DUDLEY is a composer and game audio designer based in London. His recent credits include music editing and arrangement on PS5 titles *Sackboy: A Big Adventure* and *Returnal*. His primary academic research interest is in the harmonic language of early video game music and its relationship to traditional forms of classical and pop music. He is currently working as an audio QA technician at Creative Assembly.

ALAN ELKINS is a PhD student in music theory at Florida State University. His research interests include form in early-twentieth-century popular music, the work of Wendy Carlos, and style and function in early video game music. As a composer, his compositions and arrangements have been performed in the United States and abroad, and he continues to remain active as a professional violist. When not focusing on musical endeavors, Alan enjoys spending time studying Japanese language and culture.

JULIANNE GRASSO is a visiting assistant professor of music theory at the University of Texas at Austin in the Butler School of Music. She earned her PhD at the University of Chicago in 2020 with a dissertation on musical meaning in video games. She has published and presented on the topic in various journals and conferences, including meetings of the Society for Music Theory, the *North American Conference on Video Game Music*, and the Society for Cinema and Media Studies. Her other interests include music cognition and perception, inclusive pedagogy, and public music theory online.

STEFAN GREENFIELD-CASAS is a PhD candidate in music theory and cognition at Northwestern University, where he also earned an interdisciplinary certificate in critical theory. His dissertation examines the arrangement of video game scores for the concert hall, situating this process and product in a dialectics of formal analysis and fandom. He has presented his research at national and international conferences, including meetings of the International Musicological Society's Music and Media Study Group, the International Association for the Study of Popular Music, the Royal Musical Association's Music and Philosophy Study Group, *Music and the Moving Image*, *Ludomusicology*, and the *North American Conference on Video Game Music*. Stefan has additional forthcoming publications in *The Oxford Handbook of Arrangement Studies* and *The Oxford Handbook of Video Game Music and Sound*. He has also contributed shorter essays to the American Musicological Society and Ludomusicology Research Group's respective blogs.

JESSICA KIZZIRE earned her PhD in musicology from the University of Iowa and studies music in popular media, including film and video games. Her research has

included explorations of the intersection between video game music and player nostalgia in *Final Fantasy IX*, as well as her most recent research exploring the interrelation of multiple villain themes across several games in the *Final Fantasy* franchise. Jessica also studies the role of music in multimedia adaptations, and she is currently working on her first book, which analyzes the narrative implications of musical adaptations of Lewis Carroll's *Alice's Adventures in Wonderland*.

Ross Mitchell is a PhD student in musicology at the University of California, Los Angeles (UCLA). He holds a double bachelor's in musicology and Russian language and literature as well as a master's in musicology, all from UCLA. His primary research focus on the intersection of music theory and mysticism in the music and philosophy of Alexander Skryabin, on which he has published a senior thesis titled "Scriabin's *Ecstasy*: When Poetry and Music Meet" in the *UC Undergraduate Journal of Slavic and East/Central European Studies*. He is currently working on a dissertation on the same topic. His secondary areas of research are the infiltration of White nationalist discourse into the games industry, reading the issue through the reception of *The Witcher III: Wild Hunt*, as well as the rhythmic construction of retro RPG battle music. His favorite *Final Fantasy* game is *Final Fantasy IX*, and he replays it at least once annually.

Andrew S. Powell completed his PhD in music theory from the University of Kansas, where his research focused on the relationships of music and narrative in the collaborations of Danny Elfman and Tim Burton. His work on film and video game music has appeared throughout the world through the *North American Conference on Video Game Music, Music and the Moving Image*, and the Ludomusicology Society of Australia. Andrew continues to explore the interaction of music with narrative and its relationship with viewer and player, with special interest on the interactive drama, as well as the worlds of *Final Fantasy* through *Final Fantasy VII: Remake*.

James L. Tate studied for a bachelor's in music and a PhD in music at the University of Surrey in the United Kingdom, with a thesis regarding using play and gameification to make music education more accessible. James has delivered conference proceedings previously at *Ludomusicology*, University of Surrey, and the University of Jyvaskyla in Finland, with research interests in Nobuo Uematsu, video game music canonization, and the use of popular music in video games. James now works as a healthcare scientist at Public Health England, performing SARS-CoV 2 testing and antibiotic resistance testing and research. Even while working in science, James has interests in blending science and music, in particular sonifying genomic information to compose music.

JAMES S. TATE is a teacher, musicologist, and composer. Currently teaching as subject leader for music at Prudhoe Community High School in Northumberland, United Kingdom, he is currently pursuing a PhD at Durham University under the supervision of Professor Nick Collins. His thesis, titled "Creating a Coherent Score: The Music of Single-Player Fantasy Computer Role-Playing Games," addresses musical cohesion within computer role-playing games (CRPGs). He has spoken at a variety of international conferences related to ludomusicology. His current research includes a deeper investigation into the score of the *Final Fantasy VII* universe.

STEPHEN TATLOW works with music and sound. He is currently completing a PhD project examining the intersection of music, sound, and virtual reality at Royal Holloway, University of London, United Kingdom, where he is based jointly in the Department of Music and the Department of Media Studies. Alongside his thesis research, he has ongoing research interests in game studies, digital communities, music education, and immersive sound design. His research appears regularly at academic conferences, including *Ludomusicology* and *North American Conference of Video Game Music*, and has been published in the *Journal of Sound and Music in Games*. He is the European staff moderator of the *Ludomusicology* Discord server. Alongside his academic interests, Stephen also sustains a professional career as an educator and musician, with a particular focus on providing access to music for disadvantaged children. He enjoys playing video games, cycling to the duck pond to write his thesis, and winning at board games.

THOMAS B. YEE Some composers found their love of music at the symphony hearing Brahms or Beethoven—Yee (b. 1992) discovered his from the beeps and boops of the family *Super Nintendo*. Blending the roles of composer and music theorist, Thomas specializes in writing for percussion, wind ensemble, and Holocaust remembrance music; his research focuses on music semiotics and the representation of gender, race, and religion in video game music. Thomas completed his DMA at the University of Texas at Austin and is assistant professor of instruction in music theory at the University of Texas at San Antonio.

Index of in-game musical cues

Page numbers in **bold** refer to tables. Endnotes are indexed as 231nxx.

Suishō no Dragon
ending music 198

Tokimeki High School
ending music 199

Tower of Druaga
stage clear/victory music 190

Xanadu
La Valse Pour Xanadu 186

Index of terms, people, games, consoles, and characters

Page numbers in **bold** refer to tables. Endnotes are indexed as 305nxx. Characters are listed by their first name.

Milton Keynes UK
Ingram Content Group UK Ltd.
UKHW051904050324
438971UK00024B/335